CULTIVATING PERCEPTION THROUGH ARTWORKS

CULTIVATING PERCEPTION THROUGH ARTWORKS

Phenomenological Enactments of Ethics, Politics, and Culture

HELEN A. FIELDING

INDIANA UNIVERSITY PRESS

This book is a publication of

Indiana University Press
Office of Scholarly Publishing
Herman B Wells Library 350
1320 East 10th Street
Bloomington, Indiana 47405 USA

iupress.org

Manufactured in the United States of America
First printing 2021

Library of Congress Cataloging-in-Publication Data

Names: Fielding, Helen, 1963– author.
Title: Cultivating perception through artworks : phenomenological enactments of ethics, politics, and culture / Helen A. Fielding.
Description: Bloomington, Indiana : Indiana University Press, [2021] | Includes bibliographical references and index.
Identifiers: LCCN 2021021323 (print) | LCCN 2021021324 (ebook) | ISBN 9780253059352 (hardback) | ISBN 9780253059345 (paperback) | ISBN 9780253059338 (ebook)
Subjects: LCSH: Art—Psychology. | Visual perception.
Classification: LCC N71 .F54 2021 (print) | LCC N71 (ebook) | DDC 701/.15—dc23
LC record available at https://lccn.loc.gov/2021021323
LC ebook record available at https://lccn.loc.gov/2021021324

Dedicated to the memory of
 my grandmother, Marie Zwergfeld
 my father, Herbert Fielding
 my mother, Bridget Mary Fielding
 and my sister, Christine Mary Fielding
From whom I learned the meaning of courage, the
importance of doing the right thing, how to see, and
how to love.

CONTENTS

Acknowledgments ix

Introduction 2

I. Enacting Ethics
1. Perceptual Ethics: Rembrandt's *Bathsheba* 26
2. The Ethics of Embodied Logos:
 Joan Mitchell's Abstract
 Expressionist Paintings 60

II. Enacting Politics
3. Experiencing Public Space:
 Anne Truitt's Minimalist Sculptures 88
4. Building Different Worlds:
 Louise Bourgeois's *The Welcoming Hands* 122

III. Enacting Culture
5. Polyphonic Attunement:
 Janet Cardiff's *Forty-Part Motet* 152
6. Decolonizing Reason:
 M. NourbeSe Philip's *Zong!* 180

Bibliography 211
Index 223

ACKNOWLEDGMENTS

MY THINKING FOR THIS PROJECT emerges from the intertwining of many motivating strands. I am indebted to my extraordinary teacher, the late Samuel Mallin, who not only opened up the amazing world of phenomenology but also provided me with a practical methodological approach. Dorothea Olkowski, along with her unwavering friendship, support, and an academic lifetime of intellectual debate, read and commented on several chapter drafts, offering sound advice.

There are other dear friends and colleagues who showered me with encouragement and stimulating dialogue, some providing feedback on chapter drafts: Antonio Calcagno, Jonathan De Souza, April Flakne, Rita Gardiner, Erika Lawson, Carolyn McLeod, Mariana Ortega, Mary Rawlinson, Chris Roulston, Kari Townsend, Kim Verwaayen, and Francine Wynn. Other colleagues and friends afforded opportunities for me to present work in progress or publish early versions of chapters: Juan Ardila-Cifuentes, Debra Bergoffen, Emmanuel de Saint Aubert, Ulrike Kadi, Rajiv Kaushik, Stefan Kristensen, Lawrence Hass, Gabrielle Hiltmann, Luce Irigaray, Leonard Lawlor, Emily Lee, Patricia Locke, Steve Lofts, Rachel McCann, Ann Murphy, Felix Ó'Murchadha, Gerhard Unterthurner, and Gail Weiss.

The International Merleau-Ponty Circle has sustained my scholarship from the beginning; I have learned so much from this dedicated group of extraordinary scholars, among them not yet acknowledged are Alia Al-Saji, Galen Johnson, Kym Maclaren, Glen Mazis, David Morris, and Gayle Salamon. The European Feminist Phenomenology Group provided a warm intellectual community of friends; special thanks to Christina Schües and Silvia Stoller. I am very grateful to NourbeSe Philip, who shared Zong! with my students and invited me to participate in an all-night group reading of her amazing poems. Indeed, thank you to all my students, from whom

I have learned so much, in particular those in my undergraduate feminist theory and continental philosophy courses, and in my graduate courses on Merleau-Ponty, feminist phenomenology, and critical phenomenology. I also appreciate the stimulating discussions with my Merleau-Ponty reading group, including Rachel Bath, Eva Cupchik, Kim Dority, Julian Evans, Levi Hord, John Jenkinson, Mary McLevey, Annaliese Pope, and Christopher Viger. Thank you to Dolleen Tisawii'ashii Manning for being not so much my student as my teacher and to Kevin Rogers for introducing me to Anne Truitt's sculptures.

My Berlin community nourished me with the best of friendship, conversation, and wonderful meals over two sabbatical years of writing; my gratitude, in particular, goes to Coco Gediehn, Marc Kurepkat, Milena Schaeffer-Kurepkat, Theresa Kurepkat, Luise Kurepkat, Olaf Trenn, and Christoph Graf Vitzthum. My brother, Paul Fielding, and his family— Jenn Thomas, Harley Fielding, Zander Fielding, and Cocoa—provided the best of distractions along the way, along with lots of love and support.

Thank you to Dee Mortensen, senior editor at Indiana University Press, for her enthusiastic support for this project from the beginning and to Ashante Thomas, assistant acquisitions editor, for her encouragement and seeing it through to the end. I am grateful for the invaluable feedback from the anonymous reviewers and to Emily Monaghan for preparing the final manuscript with her careful reading and thoughtful suggestions, as well as to Amelia Walford for her guidance. Finally, I can only express immeasurable gratitude to John Spencer, who read and edited countless chapter drafts. More than that, he has shared my love of art and my life.

Some of the research was supported by funds received from the Social Sciences and Humanities Research Council of Canada and the University of Western Ontario. Nascent versions of some chapters have appeared previously, including "A Phenomenology of 'The Other World:' On Irigaray's 'To Paint the Invisible,'" *Chiasmi International: Trilingual Studies Concerning Merleau-Ponty's Thought* 9 (2008): 233–248; "Multiple Moving Perceptions of the Real: Arendt, Merleau-Ponty and Truitt," *Hypatia* 26, no. 3 (2011): 518–534, and "Touching Hands, Cultivating Dwelling," in *Luce Irigaray: Teaching*, ed. Luce Irigaray and Mary Green, 69–79 (London: Continuum, 2008). In all cases the papers have been extensively rewritten and expanded for this volume.

CULTIVATING PERCEPTION THROUGH ARTWORKS

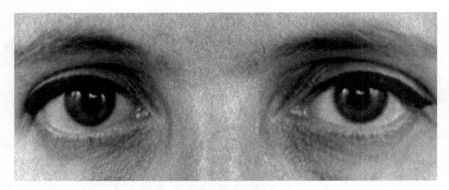

Fig. I.1 Zineb Sedira, *Silent Sight*, 2000. Still, single-screen projection, 16 mm film, 4:3 format, 11 min 10 sec. Sound by Edith Marie Pasquier. Production: Westminster Arts Council & Artsadmin, London. Collection: The mumok—Museum moderner Kunst Stiftung Ludwig Wien collection. © Zineb Sedira / DACS, London. Courtesy the artist and kamel mennour, Paris/London.

INTRODUCTION

THE FIRST TIME I SHOWED Zineb Sedira's powerful short film *Silent Sight* (2000) to my senior feminist theory students, I found myself watching them watch the film.[1] Or, rather, I watched them not watch the film. They were able to expertly glance back and forth between their laptops and the screen at the front of the classroom, keeping an eye half open for whatever information they thought they should take in while engaging in other tasks their digitally structured lives had on offer. I was captivated. Clearly, this was not a matter of one or two disengaged students. It was an almost unanimous response from bright and motivated young people who have learned how to usefully navigate the world in this age where we have forgotten how to trust our senses. Instead, we tend to rely on efficient frameworks that often do not actually touch on the world we live. Unlike the regulatory systems that belong to this age, perceiving bodies are inherently open, which means they are also open to the same systems that close them down. Thinking alongside artworks that speak to embodied perception is one way of opening up our thinking and putting it in touch with alternate ways of experiencing and living the world.

The second time I showed Sedira's film, I asked the students to close their laptops and pay attention to their experience of viewing. During the first viewing, they had been able to swiftly calculate with the odd glance at the film that nothing as such was happening. The second time they actually watched the film. This time they did not know what to expect because I had asked them to reflect on the experience of perceiving: on how they perceived and how that shaped what they perceived. This time they paid attention to their own perceptual encounter to experience what the film had to show them. They encountered a woman's eyes that spanned the screen for the entirety of the eleven-minute black-and-white film, often looking directly at the viewer (see fig. I.1) but also intermittently looking over to

the side or down. The eyes are lively and engaged. Even closed as they are for the first minute, they still move visibly beneath the veil of eyelids (see fig. I.3).

Accompanying this visual is the atonal twang of a bow on a piano string and a voice—Sedira's own. According to the narration, as a child when she and her mother arrived in Algeria from France, her mother immediately put "it" on.[2] Never naming the Algerian veil, or haik, which is suggested by the bands of white space framing the eyes in the film, Sedira recounts the anxiety she felt fearing she would lose her mother, that she would confuse her mother with someone else, that her mother would not love her anymore.[3] She describes missing her mother's "soft skin," recalls feeling angry and upset, and notes that it "wasn't fair." Her voice falls silent. After what seems a long moment, a tear wells up in the corner of each eye—Sedira's eyes, as I later learn—and she remembers wondering if her mother could still hear her, see her, love her. Sedira describes the transition in her own perceptual experience of her mother's face but from the temporal gap of her adult self remembering the fear. In the recounting, the past experience is given new meaning both for the adult Sedira narrating the film and for the viewer perceptually encountering it. This moment of transition is then marked by the cessation of sound, both voice and music. What remains is the confusion, interrupted only by one utterance that refers to the way time will provide new meaning: "Perhaps I will understand later will be my only answer." As the narrative resumes, we hear how the child realizes that her mother's "lovely face shines through her eyes" and that her voice has not changed. The anxiety "could be lifted with a single gentle glance from her." She could feel her mother's "loving presence, and that was enough." She "accepted it."

This book is about cultivating perception through thinking alongside and according to artworks. Artworks like Sedira's can set to work if we are open to encountering them and allowing them to cultivate how we perceive. Many artists work with this understanding. They know the world is encountered first through perception, which is a making sense of what is there according to an embodied and "conceptless" logos—a logos that speaks to bodies.[4] This means that encountering artworks can shift how we make sense of the world. I take my overarching theme for this book from Luce Irigaray, for whom cultivating perception concerns our relational being.[5] Because it is our inherent openness to the world, perception takes place in the present even as it is shaped by past experience and anticipation of the future. When we do not attend to who or what we perceive and instead rely on sedimented concepts as frameworks to "represent the

real," we invoke past structures and pass over "the potential of our senses" to generate new meaning. Imposing past structures gives us the sense of planning securely for the future, but it does not open the future to creative possibilities that might break those structures open.[6]

What I call the "real," following Irigaray and the other philosophers I engage in this book, is not the same real evoked in an empiricist framework. The empiricist account of the real assumes a direct, unmediated correspondence between sense organs—or the technology that often stands in for them—and an objective material reality. My account of the real takes into account a material reality, but it is one that both shapes and resists perceptual structures. It also resists any idealist or discursive account of the world as completely constructed by language and culture, even as it takes them as inextricably intertwined with what is there. My understanding includes the relational world discounted by the imposition of formal structures that foreclose in advance the relational and the opening up of perception to new creative possibilities of making sense. Perception is the making sense of a sensible world; it takes place in the gap between the sensible and sensing where meaning is made in the act of perceiving. This gap, which provides the possibility of making sense in new ways, is where, as we shall see, the political, ethical, and cultural possibilities of perception can be found.

Imposing formal systems is a danger of approaching artworks through the art historian's lens. It tends to preclude these transitional possibilities. Encountering Sedira's film first through embodied perception works differently than situating it within a movement or comparing it to other works by the same artist or other artists. Instead, the film speaks to bodies through a "silent" logos that is accessible, but not reducible, to description in language.[7] Although art historians' observations eventually have their place in helping understand the work, as a starting point, they always already to some extent enframe the viewing, making it more difficult to actually encounter the work.[8] In the discussion that followed the second viewing of the film, some students reported they had at first felt bored, but as they stayed with the film, moving into the world it opened up to them, they felt uncomfortable looking at the gaze that often returned their own. They were at once mesmerized by the eyes—watching for any small change, blinking, or turning away—but also self-conscious of the intrusiveness of their own looking. They found themselves attending to the way they perceived. It seems they experienced a shift from observing the eyes as objects of study to encountering the eyes and their style of existence. Other students described how they immediately

experienced anxiety as they encountered the gaze. But as they became accustomed and attuned to it, like the young Sedira herself, their anxiety began to dissipate. Like her, they "got used to it." Sedira observes that her mother "didn't seem unhappy. She was very happy in fact. She seemed at ease. She felt protected by it [the haik]. It was part of her home, *her* home, my home," part of her family's culture. The child moves from her anxiety about losing her mother to realizing her mother is still the same. Nothing happens, but change nonetheless takes place in Sedira, in the film, and in the viewers.

Those who encounter the film gear into the world it opens up through embodied perception. They begin to perceive "according to" the film and experience a subtle shift in the ways they perceive—a shift they are later able to cognitively reflect upon.[9] While the film opens up a "sensible structure" that is understood "through its relation to the body, to the flesh," the "invisible structure can be understood only through its relation to logos, to speech."[10] The world of an artwork provides a dimension that "possesses its symbols, its equivalents for everything that is not itself," even as it overlaps with other worlds.[11] Similarly, each sense opens onto the world but does so in its own way that, while overlapping with, being shaped by, and communicating with the other senses and with cognition, is not reducible to them. For this reason, Merleau-Ponty wants to "replace the notions of concept, idea, mind, representation with the notions of *dimensions*, articulation, level, hinges, pivots, configuration."[12] Viewers of Sedira's film can reflect on that shift, as we did in the classroom, since the experience of viewing provides something to describe and reflect upon, which, in turn, opens the viewer's perceptual structures through a reversible relation that allows the idea to be taken up in embodied existence and embodied existence to be sublimated into language. It is an "expression of experience by experience."[13]

The phenomenological description of artworks thus requires reflecting not only on the experience of encountering the artwork but also on the ways I am implicated in the encounter. Merleau-Ponty calls this reflection that takes account of itself, as well as "the changes it introduces into the spectacle," "*hyper-reflection (sur-réflexion)*."[14] But even without this deliberation upon the situatedness of how we perceive, embodied perception is inherently intertwined with, and overlaps with, reflection, although it cannot be reduced to it. Embodied subjects are structural wholes that cannot be parsed into bodies and minds. Perception provides the openness to the world upon which thinking relies, even as it is always already infused with making sense of what is there. This means that even though perception

is primary, this primacy is obscured by the emphasis on cognition as calculation that belongs to this age, in part because this emphasis, in turn, also reversibly structures perception. For this reason, shifting perception by attending to it and cultivating it also affects how we make sense of the world, as well as how we think. The term *making sense* captures the ways reflection and sensing are coimplicated in one another, as well as the co-constitution of meaning between the one sensing and that which is sensed. When my students first viewed the film, their understanding of it was framed in terms of calculating what needed to be known. Many of them barely glanced at the film. With the second viewing, they focused on the film while reflecting on how they perceived. Their thinking was opened up to what they perceived and how they perceived, to that which was other to what they already knew.

Throughout this book, I refer to the thinking that acknowledges this inextricable structural unifying relation as embodied perceptual cognition.[15] This is thinking that is reflexively in touch with the sensible, motile affective world that makes it possible. It is not unlike what Merleau-Ponty refers to in the *Phenomenology* as an "intentional arc" that situates humans in a temporal and material world as the relational gathering of their ethical, political, and cultural situations: "This intentional arc creates the unity of the senses, the unity of the senses with intelligence, and the unity of sensitivity and motricity."[16] Although perception is primary, it is also inextricably intertwined with movement and affect. There is no perception without movement, and perception is solicited by that which attracts or is repelled by that which does not. In this age we tend to understand the body, which includes affect—what Merleau-Ponty variably refers to as sensitivity, desire, or sexuality—along with movement, perception, and even sensibilities we do not know about, since we do not yet know "how to measure them," as subservient to mind.[17] But as we have seen, the body is not the "bearer of a knowing subject."[18] It is characteristic of this age that we do not attend to, let alone creatively cultivate, this primordial openness that is embodied perception. The act of perception tends to be covered over through its accomplishment in the giving of objects, which means this openness remains largely in the background unless it is brought to the fore to be reflected upon. Artworks like Sedira's can allow for such reflection. They can help our thinking to be opened up by our perceptual encounters with the works by bringing the ways we perceive into appearance and allowing us to actually encounter what is there rather than imposing past derivative frameworks that prevent us from attending to our perception of the world around us. Because perception is a making sense

that is inherently ambiguous and open-ended, such encounters require being attentive to experience and not projecting in advance the meanings that will surface.

Film provides the unity of two sensible openings: listening and seeing. But because our bodies are open to existence as a whole, we each bring to the viewing our own sedimented perceptual structures that include the interlacing of all the senses we have with the ways we make sense of the world. *Silent Sight*, which is about perception and communicates through perception, reveals this phenomenon: between Sedira's description and the liveliness of the gaze, we feel her mother's loving presence and the softness of her skin. Even though what is seen is tightly framed, and the camera does not roam, the filmic frame nonetheless opens onto the expressive, perceptual world of existence.[19] Each of us in that classroom brought particularized perceptual structures to our viewing, depending on our lived experiences, including our cultural backgrounds, where we grew up, and the life events that shaped the ways we make sense of the world. But this does not mean that encountering an artwork is completely subjective. The work has a material presence. The longer one stays with it, the more that presence asserts itself and begins to cultivate the perception of the one perceiving.

Merleau-Ponty begins his late essay on art, "Eye and Mind," by decrying the science of his day that "manipulates things and gives up living in them."[20] He was not critical of science as such; he drew on scientific research throughout his oeuvre, maintaining all the while that scientists need to be aware of the perceptual faith that provides the foundation for their claims and that even the most abstract of scientific claims relies on the perceptual opening to the world that recedes into the background in favor of the objects under investigation. He is critical of the science that forgets there is a meaning-making process embedded in gathering data, instead imposing its experimental apparatus as though contexts and situations were interchangeable. The experimental process that reduces thinking to testing, operating, and transforming results in "phenomena, more likely produced by the apparatus than recorded by it."[21] Experimental science described as such "comes face to face with the real world [*le monde actuel*] only at rare intervals," for the real world is the situated, relational, and experiential world that cannot be collapsed into concepts and representations.[22]

Phenomenological methodologies work differently. They bring to appearance the structures, horizons, and frameworks that shape our everyday ways of encountering the world so that we can reflect upon how we

make sense of it.[23] While classical phenomenology focuses on exposing the "transcendental structures" that usually remain in the background while allowing us "to make sense of things," the critical and feminist phenomenological approach I employ interrogates the "contingent historical and social structures" that shape the ways we see and the ways we make sense of the world.[24] Merleau-Ponty's account of perception provides the primary phenomenological grounding for this book, although I draw on it critically alongside the works of other phenomenologists and thinkers. I begin from his intuition that "the world is not what I think, but what I live."[25] Our bodies do not "explain" or "clarify" the world.[26] But because they are sensible, they have an object-side that can be perceived. As sentient, they are inherently open to the world; they "unquestionably communicate with it," although they do not "possess" it.[27] Embodied being is, in fact, a "prototype" of being. We are not simply in the world; we belong to and are part of a world that is visible.[28] For this reason we do not have "visibles" before us as "objects" we stand over and against. They are not only around us, but they shape who we are from within. They structure the ways we perceive by teaching us how to see, touch, and hear, as well as how to gear into the world.[29] They beckon us but also resist us. Not everyone perceives the world through vision, but the world can be perceived through multiple senses. It is a world that is at once visible, audible, and palpable, even for those who cannot see, or hear, or touch, since we never inhabit a world on our own. Our various senses are all openings on existence, which means we can only encounter the real as situated from within.[30]

This is why Merleau-Ponty is critical from early on of what he calls intellectualism (or the analytic attitude) and empiricism. The first relies on a world represented by the thinking subject and the second on a material world that can be known independently of subjective encounter. For either method, "there is *no one who sees* at the center of this mass of sensations and memories . . . and, correlatively, no solid object protected by a sense against the swarm of memories."[31] The world is not given to us either solely in the materiality of things or through the projection of analysis or judgment upon what is there. Instead, there are perceptual, relational, and meaningful structures to which things, world, and living bodies belong. If we try to isolate one aspect of perception, whether it is an aspect of the thing or the subjective attention of the viewer, we lose the structure of the whole to which meaning and form both belong. Perception is always of something, and yet that something does not represent itself as impressions but is rather intelligible from within a field. If a "truly homogenous area" is given to the senses, there is *"nothing to perceive."*[32] There are no pure sensations, and we

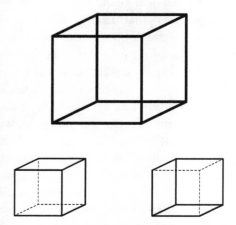

Fig. I.2 Necker cube by Peter Hermes Furian ©
Shutterstock. Necker cube ambiguous line drawing.
The lower drawings clarify different possibilities of how
the gaze might settle depending on whether one looks
down from above or up from below.

do not conjure a world through analysis or judgment that exists only for a transcendental ego.[33] Sensation is similar to the experience of "an undifferentiated, instantaneous, and punctual 'jolt.'"[34] Unlike perception, sensation is quantitative, not qualitative. It is more or less intense, but it does not give us a context or world. Nor does it give us the one who perceives.[35]

Perception, as a making sense of what is there, takes place between a sensible world and the one who senses. It begins with the "most basic sensible" as articulated by Gestalt theory: a figure against a ground.[36] Explaining the Necker cube helps elucidate this. The presentation of the image of a box in depth can shift in the act of perception so that one of the six sides might at first seem to be the deep side of the box but then, without any change in the image itself, becomes its front side. What changes is the way one sees it. Merleau-Ponty concludes from this example that both readings of the cube are solicited or motivated by the image itself and that, at the same time, our vision tries to see something and so works with the motivation of the forms until it makes sense of them.[37] Our eyes grasp the box because there is something to see. Nonetheless, the visual grasping is actively initiated by the viewer. Cube and vision belong to the same subject-world sense structure (see fig. I.2).[38]

As embodied, we gear into and take up the world we live. But in this age, we paradoxically take up a world governed by closed frameworks imposed

on what is there that alienate us from our embodied perception. Martin Heidegger calls it enframing (*Gestell*), which is the essencing or way of being of technology described as a reckoning with what is there through planning, calculation, switching about, and striving for efficiency.[39] Since ultimately all humans are excluded from the disembodied standpoint that belongs to this age, we have experienced its loss of validity in our contemporary world. But this loss is not experienced in terms of returning to a perceptual embodied world of the senses, one that provides for the common sense that guarantees a shared world. Instead, we seem to have completely lost touch with the real. To think as embodied already challenges the understanding of the individual as the view from nowhere. Hannah Arendt argues that the real is not "the totality of facts and events" since when someone gives an account, they tell a story. What might be contingent facts "acquire" meaning in the telling from the particular point of view of the one making sense of them.[40] Although having multiple situated points of view means the points of view cannot be situated in the same place, this does not then mean that each viewpoint is either isolated or relative, as Einstein would have it. In Merleau-Ponty's reading, Einstein begins by dismissing perceptual faith—our lived everyday experience of the shared world we perceive—because perceptual experience is not based on the scientific measurement that gives us "the paradox of multiple times, each linked to the observer's standpoint."[41] This dismissal of perceptual faith is the dismissal of the experience of simultaneity, of discovering our shared perception of the real from different points of view: the "intersection of our perceptual horizons and those of the others" is given no "ontological value." Merleau-Ponty concludes that for Einstein, "what is is not *that upon which we have an openness*, but only *that upon which we can operate*."[42]

If it is not possible for multiple viewpoints to open upon a shared world, then relativism implies that all approaches or ways of understanding the world are equally valid or equally adequate; it depends only on where one stands. To avoid such postmodern relativism, we need factual truth to ground multiple perspectives and opinions.[43] This understanding of multiple viewpoints on the world or worlds does not imply, as relativity does, that each point of view is locked in on itself and cannot be shared, understood, influenced, or interpenetrated by other points of view. Relativity reduces time to space, allowing for reversibility and rendering encounters impossible. It cannot account for lived time or, consequently, ethics, politics, or culture. Instead, we need meaningful accounts of embodied subjects as interrelated within the world or worlds they inhabit, thereby providing more points of view on the whole.

Rather than taking these points of view as all relative, with Merleau-Ponty I understand them as being simultaneous; they happen at the same time in "a spatial and temporal pulp where the individuals are formed by differentiation."[44] This is an understanding of being as essencing, as a style or way of being that proliferates through resonance among different entities. Because "we are experiences, that is, thoughts that feel behind themselves the weight of the space, the time," the existence of what they are thinking about, it is in experience that temporality and spatiality are uniquely given. Experience is the making sense of what is given in time and space. Time and space "exist by piling up, by proliferation, by encroachment, by promiscuity . . . brute essence and brute existence, which are the nodes and antinodes of the same ontological vibration."[45] This means we cannot think of space and time in terms of series but rather more as force fields where there are points of reinforcement and amplification.[46]

I thus align my thinking with understandings of the world according to which observers perceive from their particular and partial viewpoints that nonetheless overlap.[47] This means there is a possibility for encounter among different points of view on a shared world. This understanding of simultaneity, moreover, brings the thickness of lived embodied experience with it: the present, in which we perceive as embodied beings, is always infused with the past and the future of particular points of view, as well as of the social and political structures that shape who we are, how we perceive, and how we are perceived. But, as Arendt points out, the past as well as the present, which both rely on "factual truth," cannot be changed. It is the future that is open to new possibilities and transformation, that is opened up through action. But if "the past and present are treated" as future in the sense of being open to the "potentiality" of a "boundless field," which is what propaganda and fake news effects, then "the political realm is deprived not only of its main stabilizing force but of the starting point from which to change, to begin something new."[48] It is easy to manipulate humans when their actions cannot found new beginnings. Instead, "we enter into a cultural regimen where there is neither truth nor falsity . . . into a sleep, or a nightmare, from which there is no awakening."[49]

But even if we trust sensibility, what Merleau-Ponty calls perceptual faith, we cannot rely solely on individual perception, especially if this means we still put ourselves at the center.[50] If, as I have elsewhere argued, we are to recognize the relationality and responsivity of all that is, we must begin with situational being and accept that there is no center. There are, instead, multiple meaningful points of view.[51] Nonetheless, even though this decentered subject is not the singular and autonomous

subject of Western philosophy, neither is it a subject who is multiple and dispersed. The embodied subject implied here inhabits and acts in the space between what is interiorly felt and thought and the experiential outer world of ethics, politics, and culture.[52] It provides a point of view on the world that is informed by the intertwining and overlapping of perceptual, affective, moving sensibilities that encompass experience and world. It is also a subject who can inhabit multiple worlds. Mariana Ortega describes what she calls the "multiplicitous self" as a self who inhabits more than one social identity. This self, "while flexible and decentered," may or may not be a "fully integrated" self. Nonetheless, there is a gathering together of a sense of self experienced as "oneness" even though different aspects might come to the fore depending on the situation or world in which the self engages.[53]

I am thus still working with a notion of the subject even though it is radically different from the autonomous universal subject of Western philosophy. The subject I address is the one viewing Sedira's film. This is the subject who perceives and is shaped by what is perceived. It is also the subject who is visible in the act of perception. I watched my students watching the film. This subject is also capable of reflecting in the present upon what and how they perceive, as well as upon how that perceiving shapes them. This subject has a past that can be ascribed new meaning—although the past itself cannot be changed—and a future that is open to possibility. Perception, which takes place in the present, provides the opening or hinge between the two. In *Silent Sight*, the present expands in the silent pause following Sedira's observation of her younger self, for whom the only answer was that perhaps she would understand in the future. With Sedira, although from a different point of view, I experience the fullness of temporality in this pause; it includes her being reminded of a present that is now past when she did not understand, her looking back as an adult when she does, and her anticipation of a future shaped by this new understanding. And all this is overlaid by the social and political structures that render the "Muslim veil" "hypervisible" and Sedira's mother and her own experience of wearing a haik invisible.[54] This overlapping experience of temporalities—the narrator's childhood experience and adulthood reconfiguring through remembering—is there to be encountered by the viewer in the present tense of watching the film where the viewer is also open to a reconfiguration of the making sense that is perception. Phenomenologically, there is someone there, a point of view who feels, senses, perceives, and is responsible for how they perceive as well as for what they do.

The methodology I draw on for encountering artworks is my own reworking of Samuel Mallin's body hermeneutics, which I address in chapter 1.[55] The starting premise is that phenomenal artworks communicate with embodied perception. We do not encounter them through unmediated sensation or through ideal representations or concepts projected onto the works. Perception does not work that way. If we attend to—that is, reflect on—the ways we perceive, we engage in a sensemaking dialogue made possible by the gap between the noncoincidence of the materiality of the work and our senses. Encountering artworks can open us to other ways of being in this age, ways of being that are in relation to what is actually there. I think alongside or according to the artworks rather than draw on them as examples for philosophical ideas. Thinking according to artworks requires reflecting on the ways our embodied perception gears into, takes up, and is altered by the works. This reflection can also allow us to better understand how we are shaped by the imposed enframing of our age. Bringing this enframing to appearance so that it can be reflected upon already opens up possibilities for change.

I am also somewhat unfaithful to Mallin's methodology, as I am to the other phenomenologists I think alongside in this book. If I remained completely true to their methods and ways of thinking, I would not remain faithful to the spirit of phenomenology, which is always to rethink the world anew, to rethink the ways we come to know. The phenomenologists whose works I draw on are also shaped by the being of this age, as well as their own often unexamined points of view. They cannot be read without taking this into account. As Irigaray reminds us, cultivating perception requires attending not only to "what is perceived" but also to "the one who perceives."[56] The feminist and critical phenomenological approach I engage requires asking: What questions are posed, and who does the posing? How are the questions shaped by the ethical, political, and cultural structures that shape their questioning?

The encounters with artworks I describe in this book are phenomenal. My descriptions of them allow me to bend my thinking into and alongside the works, opening them up to embodied perception. Each chapter takes up my encounter with an artwork or artworks from a single artist. I encounter the works I address from my own situated individual viewpoint. I am a white, educated academic who grew up in Canada between foothills and prairies as well as the child of English-speaking immigrants, one of whom was a Holocaust survivor. My experiential world is shaped by these facts, as well as the ways I live them, which, in turn, shape the ways I encounter each work. But each work has a material presence of its own. The descriptions

of my encounters are thus engendered somewhere between these worlds: the world in which I dwell and the material situated being of the artwork that sets to work in the encounter. The success of my phenomenological descriptions lies in whether or not they bring the phenomena they describe into appearance for the reader who likely has not encountered the artworks themselves but, as embodied, can make sense of the descriptions nevertheless.

I am a philosopher, not an art historian, and I think alongside and according to artworks. There are other philosophical works that have made a substantial contribution to Merleau-Ponty's phenomenological approach to art as well as those that address phenomenology and art more broadly.[57] But for the most part, phenomenologists have engaged primarily with the philosophical ideas or addressed artworks that belong to the art historical canon, which means works by women and artists of color are more rarely addressed.[58] This book is not *about* artworks or *about* concepts as such. The artworks described are ones that immediately engaged me and opened up philosophical dialogues I wanted to pursue, ones that altered the ways I think—that is, the ways I perceive. I have been working on this book for a long time. I have returned to works as the questions shifted or needed clarification. With some works, the conversation has continued over many years. Mallin's methodology requires spending time, over several visits, to allow for the materiality of the work to assert itself over my day-to-day preoccupations and concerns.

Cultivating perception is in itself a resistance to the systematizing tendencies that belong to this age to which we are all differentially but nonetheless unavoidably exposed. I do not want to argue that cultivating perception precedes or is more important than instituting structural change. I do want to suggest they are both inextricably interconnected; structural changes shift the ways we perceive, and understanding what structural changes are needed is more effective if we take responsibility for the ways we perceive the world and those around us. Encounters with artworks can cultivate perception by simply conditioning the ways we perceive; encounters can also motivate reflection on how we perceive what we perceive, revealing the possibilities of a more deeply relational world. Such encounters can bring to the fore the ways we are shaped by the world and the ways we move into and take it up, encouraging us to think about how we live in the world and how we want to live this world. Showing, revealing, and describing are not neutral. In Merleau-Ponty's words, "the phenomenological world is not the making explicit of a prior being, but rather the founding of being; philosophy is not the reflection of a prior truth, but rather, like art,

the actualization of a truth."[59] Cultivating perception begins with reflecting on the experience of perception. Reflecting on the experience opens up possibilities of perceiving otherwise—that is, of making sense of the world in creative new ways, which allows for engaging it differently. We learn how to perceive because the world around us shapes the ways we encounter it. But we are not determined by either discourse or a material world because we are able to reflect upon our experiences and the ways we make sense of the world. Nonetheless, how, when, and where one is inserted in the world profoundly affects the agential possibilities for creative perception.

A feminist and critical phenomenology is concerned with what is ethically and politically right, and what is right does not always come to appearance. Sometimes it is precisely that which is not perceptible from within the structural forms imposed on what or who is there. Although it is possible to read any one of the six chapters in this book as standing on its own, if read in order, they lead up to the final chapter, where I encounter M. NourbeSe Philip's poem cycle, *Zong!* (2008).[60] For these poems she turns to the judgment of *Gregson v. Gilbert*, an insurance claim for the loss of cargo. The judgment is the only remaining record of the murder of approximately 150 Africans who were thrown overboard from the slave ship *Zong* in 1781 when the ship ran off course and was short of food and water. The captain believed he could claim the loss if those enslaved did not die a "natural" death.[61] There are no names provided for the murdered in the archives, no details of who they were. Since they died at sea, there are no bones. There is no making sense of this murder within the logos of embodied perceptual cognition; the logic employed belonged to a violently imposed colonialist reasoning. But Philip's poems work to break open being and allow the breath, the grunts and groans, the souls and spirits of those murdered that have no form, that have no matter, to nonetheless exist.

This book follows its own journey to this point in three sections. In section 1, I seek to show how the artworks phenomenologically described enact ethics, in section 2, how they enact politics, and in section 3, how they enact culture. As already pointed out, the ethical, political, and cultural provide the milieu for the intentional arc of individual lived existence. Although Merleau-Ponty stops short of developing a phenomenological ethics, he does assert that "the perception of others founds morality by realizing the paradox of an alter ego, of a common situation, by placing" him, his "perspectives," his "incommunicable solitude, back in the visual field of another and of all the others."[62] Described as such, the ethical is always already implied by the perceptual availability of our intersubjective being with others.

I begin with ethics and turn to painting to show how the gaze cannot stand over and above that which it surveys. It is implicated from the start in the field opened up by the work. Chapter 1 explores Rembrandt's *Bathsheba at Her Bath* (1654) alongside Merleau-Ponty's reflections on seeing. This work, which was painted at a turning point in modernity during the European colonial expansion into Africa and the Americas, offers another way of perceiving than the dominant one of this age. *Bathsheba* challenges both the concept of the nude as the ideal human subject in the Western aesthetic tradition and the vanishing point of Renaissance perspectivism. It raises questions about what and who is covered over and who is recognized when we phenomenologically reveal, especially when revealing is tied to light and visibility. I pose these questions out of my situated encounter with this work from my own embodied perceptual point of view, which does not coincide with Rembrandt's or his contemporaries. Ideas or essences belong to particular historical and geographical milieu, which is why "the space or time of culture is not surveyable from above." But this does not mean they are inaccessible to those who do not belong to that spatiohistorical milieu because they are also accessible through what Merleau-Ponty calls the "wild region" of embodied being from which all cultures originate and which allows for "communication" between them.[63]

In the second chapter, I argue that Merleau-Ponty's artist as phenomenologist *makes* the invisible appear as visible and *gives* us the world to see. But cultivating perception requires acknowledging alterity and its giving. Appropriating what is other into an artwork, into the ways we perceive, without acknowledging the alterity that exceeds perception and also contributes to who we are reduces human perception to a kind of sensation that forgets it belongs to a milieu. The abstract expressionist paintings of Joan Mitchell alternatively resist the imposition of ideas and representations, inviting embodied perceptual cognition to engage in the creation of meaning. Drawing on Irigaray, I show how cultivating perception requires the coparticipation of what or who is perceived. Here I nuance Merleau-Ponty's phenomenological approach to consider what it means to perceive without appropriating what is there for one's own purposes as well as what it means to perceive the invisible as invisible and not simply as transcendence, thereby rethinking what is meant by the real.

In section 2, I consider how cultivating perception contributes to sharing a public space that acknowledges the coconstitution of meaning making and, in so doing, enacts politics. For both chapters in this section, I take up sculpture because sculpture creatively institutes space and place,

providing, perhaps more insistently, for the overlapping of points of view in the spatial temporality of the political. Fred Evans even argues that public art can be installed in order to strengthen democracy.[64] If we understand politics in its aesthetic dimensions—that is, as both expressive and as instituting the new—then we cannot assume a "supposedly pre-existent rational sense."[65] Instead, drawing on Arendt, I show in chapter 3 how Anne Truitt's vibrantly colored minimalist sculptures enact the political as a making sense of what we do according to a reality that consists of multiple meaningful points of view. The stability of reality is provided by contingent, changing viewpoints on a material, factual world. A politics that denies the coexistence of these multiple perceptions of a factual and material reality risks becoming an ideology, cut off from the movement of life as well as the particularity of the spatial and temporal "circumstances to which it owes its birth."[66] For Merleau-Ponty, "liberty becomes a false ensign" that accompanies violence "as soon as it becomes only an idea and we begin to defend liberty instead of free" people.[67] Imposing systems on the real means anything is possible, for it does not have to touch on what or who is there; it does not have to make sense. In chapter 4, I show how Louise Bourgeois's public sculptures *The Welcoming Hands* (1996) cultivate being in touch with what is there. They bring passersby in touch with that aspect of human being: the uncanny ability to be in relation to being and to others. Participating publicly in the same world requires recognizing that we also dwell in different worlds, otherwise we become complicit with a culture that obscures the real.

The works in the last section enact culture. For this reason, I chose works that meditate on sound and language: sound because it allows the temporal and situational aspects of place to be revealed and language because it is coconstitutive with perception in making sense and hence in shaping culture. What emerges in chapters 5 and 6 is that culture understood in terms of the ancient Greek *ethos* cannot be separated out from ethics; it has ethics at its core. It is also political, not only in the sense of opening up and instituting a public space of appearance "in which we are held," but also in the way we "hold ourselves and thus 'dwell,'" when we act.[68] In chapter 5, I take up Janet Cardiff's *Forty-Part Motet* (2001), a sound artwork that installs a polyphonic time-space that encourages freedom of movement. I consider how attunement to what exists is not only an attunement to the epochal but also how that difference is essential to the epochal structure itself. Shifting our understanding of both space and time, the work reminds us of our capacity to be held together by something beyond our own agentic power, which is nevertheless dependent upon

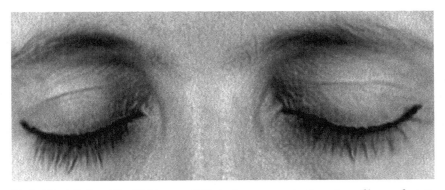

Fig. I.3 Zineb Sedira, *Silent Sight*, 2000. Still, single-screen projection, 16 mm film, 4:3 format, 11 min 10 sec. Sound by Edith Marie Pasquier. Production: Westminster Arts Council & Artsadmin, London. Collection: The mumok—Museum moderner Kunst Stiftung Ludwig Wien collection. © Zineb Sedira / DACS, London Courtesy the artist and kamel mennour, Paris/London.

human-made technology and creation. This chapter leads into the final and sixth chapter discussed previously. Here I consider how Heidegger's house of language is a closed system when it is cut off from the open system of embodied perception. Ethos for Heidegger entails not only how we hold ourselves but also "our more enduring way of Being that is brought about temporally in and throughout the unfolding of human experience."[69] But human experience must refer to particular bodies and not all bodies, and what they experience is recognized within the being of this age. Enacting the destruction of colonialist culture, the *Zong!* poem cycle questions what happens when one does not exist as a subject in a system of language that is closed to one's being. How does one bring to appearance that which does not appear, that cannot be seen, heard, or touched? Philip, a poet trained as a lawyer, takes up the closed system of legal language that rendered Africans as property and, poem by poem, drawing only on the words found in the judgment, slowly destroys the system, allowing the obliterated voices to emerge. What is evoked is a polyphonic and living chorus that reveals how existence cannot be suppressed even when it is excluded from the logos or reasoning of an age. These poems do not enact culture, they destroy it.

Notes

1. Zineb Sedira, "Silent Sight," 2000, posted February 20, 2011, YouTube video, 11:11, https://www.youtube.com/watch?v=9G2FP9rWE5Q.

2. Joseph McGonagle, "An Interstitial Intimacy: Renegotiating the Public and the Private in the Work of Zineb Sedira," *French Cultural Studies* 18, no. 2 (2007): 230. According to McGonagle

the stringed instrument is a piano, accompanied by a flute, and the filmed eyes are Sedira's own (McGonagle, "An Interstitial Intimacy," 221).

3. The haik is a white full-body covering.

4. Maurice Merleau-Ponty, "Eye and Mind," trans. Carleton Dallery, in *The Primacy of Perception and Other Essays on Phenomenological Psychology, the Philosophy of Art, History and Politics*, ed. James M. Edie, 182; originally published as *L'Œil et l'esprit* (Paris: Gallimard, 1964), 71.

5. I first found this phrase, "cultivating perception," mentioned in Luce Irigaray's *To Be Two* shortly after its publication, and I have been working with it ever since. *To Be Two*, trans. Monique M. Rhodes and Marco F. Cocito-Monoc (New York: Routledge, 2001), 41. Cultivation is also raised by Martin Heidegger in his essay "Building Dwelling Thinking," where he describes building as including both construction and cultivating things that grow; in his essay he only addresses construction. In *Poetry, Language, Thought* (New York: Harper and Row, 1971), 147; "Bauen Wohnen Denken," in *Vorträge und Aufsätze*, GA, vol. 7 (Frankfurt am Main, Germany: Vittorio Klostermann, 2000 [1959]), 153.

6. Luce Irigaray and Michael Marder, *Through Vegetal Being* (New York: Columbia University Press, 2016), 46. For the initial development of these ideas, see also Luce Irigaray, "Being Two, How Many Eyes Have We?" *Paragraph* 25, no. 3 (November 2002): 143–151.

7. Maurice Merleau-Ponty, *The Visible and the Invisible*, trans. Alphonso Lingis (Evanston, IL: Northwestern University Press, 1968), 38; originally published as *Le visible et l'invisible* (Paris: Gallimard, 1964), 154; Samuel B. Mallin, *Art Line Thought* (Dordrecht, Netherlands: Kluwer, 1996), 261.

8. Mallin explains this phenomenon as part of his methodology that I will describe in more detail in chapter 1 (Mallin, *Art Line Thought*, 262). The problem is that one encounters the work first through someone else's reading rather than through one's own embodied perception.

9. Merleau-Ponty, "Eye and Mind," 165; *L'Œil et l'esprit*, 24.

10. Merleau-Ponty, *The Visible and the Invisible*, 224; *Le visible et l'invisible*, 273.

11. Merleau-Ponty, *The Visible and the Invisible*, 223; *Le visible et l'invisible*, 272.

12. Merleau-Ponty, *The Visible and the Invisible*, 224; *Le visible et l'invisible*, 273. Italics in original.

13. Merleau-Ponty, *The Visible and the Invisible*, 155; *Le visible et l'invisible*, 201.

14. Merleau-Ponty, *The Visible and the Invisible*, 38; *Le visible and l'invisible*, 60.

15. I want to thank Dorothea Olkowski for the term *embodied perceptual cognition*.

16. Maurice Merleau-Ponty, *Phenomenology of Perception*, trans. Donald A. Landes (Evanston, IL: Northwestern University Press, 2012), 137; originally published as *Phénoménologie de la perception* (Paris: Gallimard, 1945), 158.

17. For this account of sensibilities, see Dorothea E. Olkowski, *The Universal (In the Realm of the Sensible)* (New York: Columbia University Press, 2007), 13.

18. Merleau-Ponty, *The Visible and the Invisible*, 136; *Le visible et l'invisible*, 177.

19. Donald A. Landes explores this theme of perception as expression in *Merleau-Ponty and the Paradoxes of Expression* (New York: Bloomsbury, 2013).

20. Merleau-Ponty, "Eye and Mind," 159; *L'Œil et l'esprit*, 9. Merleau-Ponty is drawing on Heidegger for this discussion.

21. Merleau-Ponty, "Eye and Mind," 160; *L'Œil et l'esprit*, 10.

22. Merleau-Ponty, "Eye and Mind," 159; *L'Œil et l'esprit*, 9.

23. See Gail Weiss, *Refiguring the Ordinary* (Bloomington: Indiana University Press, 2008).

24. Lisa Guenther, "Critical Phenomenology," in *50 Concepts for a Critical Phenomenology*, ed. Gail Weiss, Ann V. Murphy, and Gayle Salamon (Evanston, IL: Northwestern University Press, 2019), 11–12. While Guenther is writing specifically about critical phenomenology, I see feminist phenomenology as engaged in a very similar project, and I draw on both articulations of this method. For my introduction to feminist phenomenology, see Helen A. Fielding, "A Feminist

Phenomenology Manifesto," in *Feminist Phenomenology Futures*, ed. Helen A. Fielding and Dorothea E. Olkowski (Bloomington: Indiana University Press, 2017), vii–xxii.

25. Merleau-Ponty, *Phenomenology of Perception*, lxxx; *Phénoménologie de la perception*, xii.

26. Merleau-Ponty, *The Visible and the Invisible*, 136; *Le visible et l'invisible*, 177.

27. Merleau-Ponty, *Phenomenology of Perception*, lxxx–lxxxi; *Phénoménologie de la perception*, xii.

28. Merleau-Ponty, *The Visible and the Invisible*, 136; *Le visible et l'invisible*, 177.

29. Merleau-Ponty, *The Visible and the Invisible*, 137; *Le visible et l'invisible*, 178.

30. For important work on phenomenology and disability, see Tanya Tichkosky, *Disability, Self, and Society* (Toronto: University of Toronto Press, 2003).

31. Merleau-Ponty, *Phenomenology of Perception*, 23; *Phénoménologie de la perception*, 29 (italics in original). Steven Pinker, for example, explains the mind in terms of the brain as information processing, or computation, of complex machinery that we can come to know. Beliefs and desires are understood as information: a commodity "that is colorless, odorless, tasteless, and weightless yet can have physical effects without resorting to any occult or mysterious process. Information consists of patterns in matter or energy, namely symbols, that correlate with states of the world." Steven Pinker, "How the Mind Works," *Annals New York Academy of Sciences* 882, no. 1 (1999): 119.

32. Merleau-Ponty, *Phenomenology of Perception*, 4; *Phénoménologie de la perception*, 10. Italics in original. This is why James Turrell's light field artworks take us away from the world into the realm of the spiritual; in immersing viewers in a light field, the objective world seems to fall away, although it never does completely since our own bodies, or the bodies of other viewers, are still peripherally visible.

33. Merleau-Ponty, *Phenomenology of Perception*, 215; *Phénoménologie de la perception*, 241.

34. Merleau-Ponty, *Phenomenology of Perception*, 3; *Phénoménologie de la perception*, 9.

35. Irigaray, *To Be Two*, 41.

36. Merleau-Ponty, *Phenomenology of Perception*, 4; *Phénoménologie de la perception*, 10.

37. Merleau-Ponty, *Phenomenology of Perception*, 275; *Phénoménologie de la perception*, 304.

38. But contemporary neuroscientists make sense of such phenomena with experiments that allow for tracking the neural activity of subjects who switch between "two or more stable interpretations" of the same image in order to closely consider the neural underpinnings of conscious awareness. They are still focused on the mind. See Hinze Hoogendorn, "From Sensation to Perception: Using Multivariate Classification of Visual Illusions to Identify Neural Correlates of Conscious Awareness in Space and Time," *Perception* 44 (2015): 71–78.

39. See Martin Heidegger, "The Question Concerning Technology," in *The Question Concerning Technology and Other Essays*, trans. William Lovitt (New York: Harper & Row, 1977), 23; originally published as "Die Frage Nach der Technik," in *Vorträge und Aufsätze*, GA, vol. 7 (Frankfurt am Main, Germany: Vittorio Klostermann, 2000 [1959]), 24. Heidegger's concern is that the ways of measuring, ordering, and calculating that belong to modern physics become not simply one way of presencing into appearance but the only one, or certainly the one that takes sway over everything that is in this age, so that we no longer experience things even as objects we stand over and against. Instead, they become caught up in processes we represent to ourselves. See also Patricia Glazebrook, *Heidegger's Philosophy of Science* (New York: Fordham University Press), 246–248.

40. Hannah Arendt, "Truth and Politics," in *Between Past and Future* (New York: Penguin Books, 1993), 261.

41. Maurice Merleau-Ponty, "Einstein and the Crisis of Reason," in *Signs*, trans. Richard C. McCleary (Evanston, IL: Northwestern University Press, 1964), 195.

42. Merleau-Ponty, *The Visible and the Invisible*, 18; *Le visible et l'invisible*, 35. Italics in original.

43. Arendt, "Truth and Politics," 258–259.

44. Merleau-Ponty, *The Visible and the Invisible*, 114; *Le visible et l'invisible*, 151.

45. Merleau-Ponty, *The Visible and the Invisible*, 115; *Le visible et l'invisible*, 152–153.

46. Diana Coole argues that Merleau-Ponty's understanding of human relations as force fields is "complementary" to his ontology of "flesh." She suggests further that "the flesh remained an experimental emblem for Merleau-Ponty and that he consistently developed an alternative sense of Being as a field of forces. In this form his later ontology more obviously anticipates Foucault's analysis of power and resistance, but it also sustains that sense of agentic efficacy that resistance requires." *Merleau-Ponty and Modern Politics after Anti-Humanism* (Lanham, MD: Rowman & Littlefield, 2007), 234, 225.

47. See Dorothea E. Olkowski, *Postmodern Philosophy and the Scientific Turn* (Bloomington: Indiana University Press, 2012), 60, 142. The science that Olkowski identifies as supporting such an ontology is open-system thermodynamics. Rather than drawing on the Archimedean standpoint, the view from nowhere, which classical physics enables, this ontology insists on viewing the universe from the inside, from a point of view where there is causality and time is irreversible. Both are required for ethics, as Olkowski explains. In physics, classical dynamical systems prioritize space over time because they are characterized by a "trajectory" that negates each preceding point so that the past does not affect the present, for "each past point is a unique, infinitesimal position on an x/y axis, and nothing more; *it does not enter into the present.*" It is a world where "space and time are given, not emergent." Rather than relying on a preestablished space-time manifold, Olkowski suggests with Fotini Markopoulou that "the model of quantum causal histories specifies that spacetime and the states that evolve, *the stage and the actors, evolve together*" (Olkowski, *Postmodern Philosophy and the Scientific Turn*, 121, 85, 142, italics in original).

48. Arendt, "Truth and Politics," 258.

49. Merleau-Ponty, "Eye and Mind," 160; *L'Œil et l'esprit*, 12.

50. Merleau-Ponty, *The Visible and the Invisible*, 18; *Le visible et l'invisible*, 35.

51. Fielding, "A Feminist Phenomenology Manifesto," viii.

52. Fielding, "A Feminist Phenomenology Manifesto," viii.

53. Mariana Ortega, *The In-Between: Latina Feminist Phenomenology, Multiplicity, and the Self* (Albany: State University of New York Press, 2016), 76–78.

54. Alia Al-Saji, "The Racialization of Muslim Veils: A Philosophical Analysis," *Philosophy and Social Criticism* 36, no. 8 (2010): 882.

55. Mallin, *Art Line Thought*, and *Body on My Mind: Body Hermeneutic Method* (unpublished manuscript).

56. Irigaray, *To Be Two*, 41.

57. Those who focus on Merleau-Ponty's contributions to art include: Emmanuel Alloa, *Resistance of the Sensible World*, trans. Jane Marie Todd (New York: Fordham University Press, 2017); Jorella G. Andrews, *The Question of Painting: Rethinking Thought with Merleau-Ponty* (London: Bloomsbury, 2018), and *Showing Off* (London: Bloomsbury, 2014); Veronique Fóti, *Tracing Expression in Merleau-Ponty* (Evanston, IL: Northwestern University Press, 2013); Galen A. Johnson, *The Retrieval of the Beautiful* (Evanston, IL: Northwestern University Press, 2010); Rajiv Kaushik, *Art, Language and Figure in Merleau-Ponty* (London: Bloomsbury Academic, 2015), and *Art and Institution* (London: Bloomsbury, 2011); Mallin, *Art Line Thought*; and Martín Plot, *The Aesthetico-Political: The Question of Democracy in Merleau-Ponty, Arendt and Rancière* (London: Bloomsbury Academic, 2014). Those that more broadly address phenomenology and art include: Paul Crowther, *The Phenomenologies of Art and Vision* (London: Bloomsbury Academic, 2013), and *Phenomenology of the Visual Arts (Even the Frame)* (Stanford, CA: Stanford University Press, 2009); Günther Figal, *Aesthetics as Phenomenology*, trans. Jerome Veith (Bloomington: Indiana University Press, 2015); Ariane Mildenberg, *Modernism and Phenomenology* (London: Palgrave Macmillan, 2017); and John Sallis, *Senses of Landscape* (Bloomington: Indiana University Press, 2015). There are also a number of edited volumes.

58. Jorella Andrews's work is an exception, although she also takes up the canon.

59. Merleau-Ponty, *Phenomenology of Perception*, lxxxiv; *Phénoménologie de la perception*, xv.

60. M. NourbeSe Philip and Setaey Adamu Boateng, *Zong!* (Middletown, CT: Wesleyan University Press, 2008).

61. Although, of course, as Philip points out, there is nothing natural about dying under such conditions; Philip, *Zong!*, 189.

62. Maurice Merleau-Ponty, "The Primacy of Perception and Its Philosophical Consequences," in *The Merleau-Ponty Reader*, ed. Ted Toadvine and Leonard Lawlor (Evanston, IL: Northwestern University Press, 2007), 102.

63. Merleau-Ponty, *The Visible and the Invisible*, 115; *Le visible et l'invisible*, 152.

64. Fred Evans, *Public Art and the Fragility of Democracy: An Essay in Political Aesthetics* (New York: Columbia University Press, 2018), 2–3.

65. Plot, *The Aesthetico-Political*, 42. As Plot points out, it is to renounce "the certainty of total vision and knowledge of the field of the social—a politics that renounces the certainty of a total foresight and predictive knowledge of the unfolding of historical time." Plot, *The Aesthetico-Political*, 43.

66. Maurice Merleau-Ponty, *Humanism and Terror* (Boston: Beacon Press, 1969), xxiv.

67. Merleau-Ponty, *Humanism and Terror*.

68. William McNeill, *The Time of Life: Heidegger and Ethos* (Albany: State University of New York Press, 2006), xi.

69. McNeill, *The Time of Life*, xi.

I.
ENACTING ETHICS

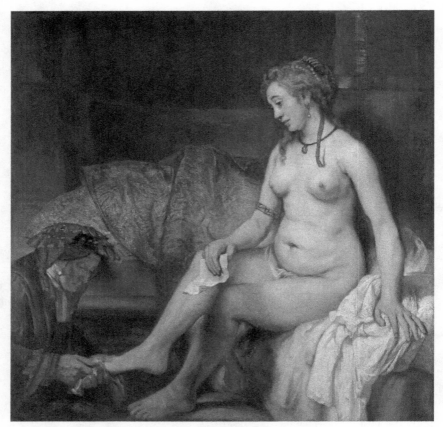

Fig. 1.1 Rembrandt Harmensz van Rijn (1606–1669), *Bathsheba at Her Bath*, 1654. Oil on canvas, 142 × 142 cm. Inv.: MI957. Photo: Mathieu Rabeau. Musée du Louvre © RMN-Grand Palais/Art Resource, NY.

1

PERCEPTUAL ETHICS
Rembrandt's *Bathsheba*

I STAND BEFORE REMBRANDT'S PAINTING of *Bathsheba at Her Bath* (1654), which hangs in the Louvre Museum (see fig. 1.1).[1] I am held transfixed by Bathsheba's sorrow, communicated in the entire demeanor of her extraordinarily luminescent flesh. Bathsheba holds a letter. It is turned over. The words themselves are not visible, but the effect they have on Bathsheba is. I see a woman transfigured in the moment of knowing something she did not know before. I do not know precisely what she feels or thinks, but I see that she suffers. I see her in a moment when she should not be seen. She is not painted as a nude to be looked at. Nonetheless, I do see her. And I am aware that I see her. My eye is drawn to her inwardly turned gaze—a gaze that itself does not see. I am touched by her, and I hear the silence that governs the moment caught by the painting. To encounter the work requires that I stay with it and move into the world the artwork opens to my gaze, that I begin to perceive and feel according to it. I do not need to know the biblical story of Bathsheba to be drawn into the event. Bathsheba mesmerized me from the first moment—and held me there in the sphere of light that seems to emanate from her body rather than shines on it. My first encounter with this work that beckoned me so insistently reveals the centrality of embodied perceptual cognition: the ways that seeing, hearing, touching, and feeling belong to this ethical moment of creative, contemplative transformation.

I begin with Rembrandt's painting because it provides insight into what it means to perceive. Displayed in an art historical museum, it coincides with, even quietly announces, a turning into the modern age, with its focus on what it means *to be* human. Rembrandt came into his own during the Netherlands' golden age, when it was expanding its colonial empire into Africa and the Americas. The wealth that flowed in and out of the colonies was dependent on an active slave trade, which helped pay for

the extraordinary production of art. Artworks predominantly served this project as aesthetic objects employed in the service of defining the modern self whereby reason and rationality were established in a binary relation against emotion and embodiment, with the binary extending along racialized and gendered divisions. At the same time, European cultures were establishing what it meant to be an ideal self—an ideal that emerges as rational, male, European, and white and ultimately refers to no one in particular but nevertheless is required to have its others. Artworks served this binary project by helping frame what it meant to be cultured or without culture. Many of the works produced at this time contributed to this project of articulating what it meant *not to be* human.[2] Against this backdrop, Rembrandt's painting reveals another possibility for paintings.

I argue that this painting enacts ethics. Inherent to the modern age is the imposition of concepts and forms on entities and living beings, which too often prevents us from encountering who or what is actually there. But Bathsheba is not given to us as an idealized form. She recedes from and resists the knowing gaze that imposes binary ways of understanding. Rembrandt does not paint the mind and body as separate. His work solicits embodied perceptual cognition, opening up alternative ways for viewers to make sense in this age. If humans are "condemned to sense," since to perceive is to make sense of what is there, then Rembrandt's *Bathsheba*, in cultivating viewers' perception, exposes ways of knowing and understanding to an interrelatedness of all beings.[3] His painting opens up the closed system of the aesthetic object and creates points of view on both sides of the canvas: Bathsheba is situated within the framing of the painting, but she also extends beyond it, gesturing to a register of embodied perceptual cognition that includes materiality, the symbolic, perception, affect, and even the registers we have not yet imagined.[4]

I. Philosophers' Vision

My claim is that we philosophers have calculative systems in place that impede our ability to perceptually encounter what is actually there. Of course, whether we recognize it or not, we still perceive, and perception still guides our cognition, but our epochal forgetting of cognition's reliance on embodied perception means we rarely reflect on how we perceive or the creative possibilities perception opens up for us. Instead, in the modern age, we tend to impose categories and ways of knowing that shape, in advance, what we perceive. A painting like Rembrandt's *Bathsheba* can teach us what it means to override these systems and recognize how embodied perceptual cognition—cognition that is reflectively aware of its

embodied affective ground—gives us an account of the real that is not dependent upon an absolute divide between materiality and ideas. It shows us that the real cannot be so ruptured. Perhaps for this reason, I should not have been so surprised to discover how many philosophers had written about this painting. It is a work that insists on its presence, to which they are drawn, but they still tend to see it according to a logos or system that precedes, rather than responds to, the work. Nonetheless, once it sets to work through the viewer's encounter, the painting resists being completely subsumed to such systems. Even in these philosophers' accounts, its glory shines through.

I want to explore the limitations of imposing cognitive-linguistic systems on what we perceive. Paradoxically, this cognitive logos—or logic that has at best forgotten its inherent interdependency on perception, motility, and affect—seems to rely on vision, as illustrated by metaphors such as "I see" that link seeing to understanding. When we look at something, we tend to impose forms, concepts, and categories on what we see. It is not that we do not see the appearance but rather that what appears is cognitively appropriated to calculative systems of understanding. Linking vision to understanding traces its roots to ancient Greek philosophy. According to Martin Jay, since classical Greece, vision has been tied to knowledge as the "state of having seen."[5] The problem is that for the Greeks, specifically Plato, it was vision of the mind—the contemplation of ideals—that was privileged over embodied perception: "Speculation can be construed as the rational perception of clear and distinct forms with the unclouded eye of the mind."[6] In this account, embodied vision is subject to failure, but Platonic ideals are not embroiled in the muddiness of situated, perceptual relations.

Heidegger reveals another possibility in early Greek thinking for understanding the relation between vision and logos that draws on the ways things appear. Humans are coparticipants with what is perceived in the emergence of meaning when they speak about categories and ideas.[7] In his reading of Aristotle's *Physics*, Heidegger explains that categories are not given in advance. A category—which includes the "agora," or the "public view as its root"—is "to address something as this or that" so that it comes "into the open, as manifest."[8] This means categories are not given in advance but instead arise out of experience and are a special kind of addressing what is there. We name something—for example, a house or a tree—only insofar as we have "already beforehand, and without words, addressed what we encounter." Naming brings that thing into public view. Categories "sustain all our habitual and everyday ways of addressing things" as

well as our judgments. In other words, they hold the knowledge we have of the world as it appears, which is the knowledge that is logos.[9] In this reading, categories are first and foremost phenomenological in that they address the ways things have come into appearance for humans and the ways humans have made sense of the world.

But in our modern world, the coconstitutive relation between perception and logos or logic has broken down; it is not so much that thinking reflects and flexes into and along the lines of perception but rather that it imposes its forms and categories upon what we perceive in a way that can actually deny what is there—that is, reality. As Frantz Fanon explains in his phenomenological description of colonizing perception, it is not that he does not appear in a racist world but rather that his appearance is always already racialized, "fixed," determined in advance.[10] But if perception opens up to the coconstitutive possibilities of meaning, then meaning cannot be simply imposed. Rembrandt's *Bathsheba* shows us why.

Bathsheba at her bath was an oft-painted theme in Rembrandt's time. In some interpretations she is a seductress and in others a victim; above all, the story provided an opportunity to paint a nude, which was meant to present the visible ideal of Western humanity.[11] But Rembrandt's *Bathsheba* stands out from the others. Jean-Luc Nancy and Federico Ferrari, in their musings on this painting, point out that the representation of the nude in the Western tradition going back to the Greeks is not so much about the body as about trying to capture a sensible—in fact, specifically visible—ideal of humanity.[12] Just as young children first experience an ideal image of themselves in a mirror, a gathering together of a fragmented sense of self, so too in this account does the nude work to provide an ideal image of "man." Nonetheless, this ideal is necessarily abstract even as it is fixed as a "visible form."[13]

Nancy and Ferrari approach the appearance of this ideal visible form through their own deconstructive system, which makes Bathsheba appear as the absence of sense. For them, Rembrandt's painting is modern. Instead of presenting an ideal image, Bathsheba resists the imposition of a form. She is instead a body exposed and lovingly portrayed, naked, imperfect, wordless—a work that stands out from other nudes of its time.[14] Modern art, in announcing the end of humanism, has shown us the end of the "nude" as such. Rembrandt's *Bathsheba* reveals there is no meaning: this is a "nude [that] reveals . . . that there is nothing to be revealed, or that there is nothing other than revelation itself."[15] This painting is of a "wounded, and disoriented woman" who stands in for the crisis of representation in the modern age: the "crisis of every 'metaphysics' of the

sign," of "every will" to signify, classify, systematize, grant sense, or reveal essences.[16] The letter on her lap is indecipherable, even as it requires a response she cannot give: "words fail her" and "sense is suspended."[17] What is left is the "immanence of a body"—a body that has "no answers," is "totally exposed," and has "no protection."[18] There is no sense that emerges from the depths of this body, since "the nude is the surface of sense." Bathsheba's body is neither a signifier nor a signified. It does not represent Bathsheba or any idea for which she might stand in. It signifies nothing other than the singularity of her presence.[19] But in denying the portrayal of the ideal of man by describing a woman who is a stand in for the crisis of meaning, Nancy and Ferrari do not address what is central to the work: Bathsheba is a woman.

This was not the case for Hélène Cixous. She was also moved by this painting of a "thoughtful body" that "is not a nude" but "a nude woman thinking."[20] Rather than being about the surface of the body, as one would expect from a nude, this painting is about interiority: "There is no smile: no exterior. No face that lets itself be looked at."[21] We can only wonder about what she is thinking. Yet there is an "interior radiance." Rather than surface, Bathsheba draws us into that which has receded from appearance in this age: "the dough, the depth, the tactile that which we lose, which we have lost, we who live flat, without density, in silhouettes on a screen."[22] The soul emerges from this thoughtful body as "the secret fire that emanates from the flesh."[23] In this work, thinking is a withdrawal we are called to witness. Though this thinking woman inhabits a fleshy "room of palpitating folds," she nonetheless "abandons us." "She is elsewhere."[24] This painting inspires thinking—thinking that waits for what is there to appear—rather than disengaged cognition, which has always already imposed its own codes and meanings. The creative transformation that belongs to writing, thinking, and painting does not impose in advance but rather encounters what is there.[25] The work visually reveals the moment of Bathsheba's silent transformation, "a place of passage."[26] Paradoxically, then, viewers are invited to witness this moment of encountering the "otherness we carry with us."[27]

In this beautiful description, the alterity created in the work is the alterity of the subject to herself created through the gathering of temporal duration. Bathsheba is alone. Cixous convincingly describes how the weight of aging draws Bathsheba's body downward, along with the viewer's eyes, from her young breasts to her more mature belly and thighs and finally to the older servant who is washing her feet. Although Bathsheba's name "invokes David," the woman in this painting does not. What remains

of him is the surrounding blackness; the only couple in the painting is "day and night," since the servant has been absorbed as merely another side of Bathsheba.[28] Perhaps the servant "is a remainder" from a Rembrandt drawing of a Bathsheba-like nude wearing the same "exotic and foreign" cap worn by the servant: "This nude cut in two, the body is Bathsheba's the coif is the older woman's . . . the cap! is at work."[29] Further installing this binary relation whereby one term is defined in relation to its other, the "servant's gaze moves off toward the future in the East. Bathsheba's gaze withdraws toward the occidental future." The two gazes intersect without seeing one another.[30] What does Cixous mean by this? In my reading of her description, the servant's role is to serve as Bathsheba's exotic otherness within, rehearsing a splitting between East and West that reconfirms the colonial Orientalist narrative.

But Bathsheba is not alone. As I hover close to the work, the space of the painting seems closed and claustrophobic. Bathsheba's luminescent body seems to fill the frame, and the details of the room are submerged in the nondescript dark mass Cixous refers to as dough. But when I stand back, from a distance the details of the space begin to come into focus. I am surprised to see the wooden slats that line the walls of the pictorial space. As I approach again, they disappear. As I stay with the painting, the darkness begins to lighten. The work becomes brighter as my sight enters into the lighting level established by the painting, similar to the way things slowly appear when one steps from a brightly lit room into relative darkness. As I move into the world the space offers to my vision, the details of the background do not reappear. But where the servant's face was shrouded in darkness from a distance, up close it too begins to quietly shine into appearance. Light draws attention to the servant's ear and hands as she attends to Bathsheba. Although Bathsheba at first seems to be looking at her servant, as I attend more closely, I realize Bathsheba clearly does not see her. But I do. Slowly, more details come into view. At first glance, the servant is a dark and receding figure on the margins of the painting. But with time her facial expression comes into focus, and she too begins to draw me in with her concern. As with Bathsheba, we cannot know precisely what she is thinking, yet she seems attuned to her mistress's sorrow. The servant also belongs to this hermetic space where there is nothing to be done. And yet she does do something; she washes Bathsheba's feet. Although the painting refers to the biblical story of Bathsheba, it is reminiscent as well of another biblical event: Jesus washing the feet of his apostles at the Last Supper.[31] It is an act of humility and love but at the same time one that reverses the hierarchy of master and

servant. Knowing he will soon leave this world, Jesus calls on his apostles to serve others as he, as "master," has done, calling into question the hierarchy of binary logic.

To ignore the servant is not to see the work. Although this astonishingly compelling work has generated substantial analysis, for the most part, the servant's role is described as helping to establish the sparsely depicted biblical narrative. But not really seeing the servant furthers the partial historical narrative of the Netherlands' golden age, covering over the slavery, exploitation, and appropriation that sustained the domestic economy. Simon Gikandi points out that "modern identity was premised on the supremacy of a self functioning within a social sphere defined by humane values"—in other words, "on the existence of free and self-reflective subjects, not bodies in bondage."[32] Nonetheless, even as free subjects were closely aligned with the Enlightenment project of rationality and the autonomy of aesthetic judgment, wealthy families favored the shadowy appearance of servants in the portraits they commissioned since it allowed them to further show off their wealth.[33] At the same time, aesthetics, as "the system of judging art," was in the process of becoming a science beholden to rationality, which means it was becoming split from everyday lived sensibility.[34] Modern subjects relied on "their faculties of reason and judgment," making the individual "the sole arbiter of meaning and identity." Citing, in particular, Immanuel Kant and David Hume, Gikandi reminds us, however, that "the black was excluded from the domain of modern reason, aesthetic judgment, and the culture of taste."[35]

Although aesthetics developed at this time to support Enlightenment rationality, artists like Rembrandt resisted this task.[36] In his "compelling" work titled *Two Negroes*, he transforms the two Black men, who were likely brought to the Netherlands as "slaves or servants, into elevated subjects through art."[37] Gikandi contrasts Rembrandt's work to a receipt for slaves dated 1659. While the painting portrays each of the two men as unique, thereby "implicitly question[ing] the undifferentiated image of the black as fetish or stereotype that was dominant in the records of Dutch travelers" at that time, the receipt was written by the "Dutch merchant Pedro Diez Troxxilla" and depicts the enslaved as objects of trade.[38] For Gikandi, Rembrandt "used his genius to reclaim the human from the detritus of enslavement." At the same time, the depicted otherness of Africans in other forms provided an outside central to the "construct of the interiority of modernity itself," and "attempts to reconcile commerce and taste" meant that paintings like Rembrandt's, where African figures were central, were few.[39]

Gikandi encounters Rembrandt's painting as an individual work within a cultural terrain while Monique Roelofs approaches aesthetics as a "social technology." It is "an art of constructing and deconstructing formulations of whiteness and blackness," whereby Hume, for example, believed that deficient rational capacities translated into diminished taste: "true taste is then reserved for white, European, middle-class males who go through a requisite process of cultivation involving practice, the making of comparisons, and a freeing from prejudice."[40] Roelofs describes "cultivation" as a social concept that belongs to the establishment of a class system tied to race. It is the "aesthetic production" of race that "enables white, middle-class men of taste to seek out one another's company to their mutual satisfaction and edification."[41] This arrangement further supported the heterosexual matrix that designated social places for middle-class men and women. Middle-class white men brought "reason and knowledge to women" while women provided a "cultivating influence" on men.[42] This cultivating influence was to work at both the individual level—between people—and at the public level—cultivating a middle-class population.[43] This analysis provides an important background to understanding how aesthetics can become a social, political, and cultural system. But it does not help us understand how works like Rembrandt's challenge this system.

II: FROM METAPHYSICS TO MERLEAU-PONTY'S ONTOLOGY OF THE FLESH

Important as this social context is, I instead argue for a different kind of cultivation that goes beyond a matter of taste: the cultivating of perception that Rembrandt's *Bathsheba* enacts in extending beyond the closed hermetic space of the canvas. This cultivation has ontological implications. In his late work, Merleau-Ponty transposes metaphysics into an oneiric universe of carnal essences—an ontology of the flesh.[44] He works out this ontology through art because the painter provides an account of the real that is not reached through inspections of the mind, or "operational science," but rather through embodied perception. The problem with metaphysics, as deconstructionists explain, is that it provides grand narratives that clarify the way things are from the view from nowhere.[45] As we saw in the previous discussion, for thinkers like Nancy and Ferrari who eschew overarching accounts, there are no essences, only the presence of singularities. But Merleau-Ponty describes a radically altered account of the real that begins with multiple points of view and visibility as the grounding principle: "To see is to enter into a universe of beings that *show themselves*."[46] Things can be hidden, one behind the other, but the sides I cannot see are "virtually"

available through their situatedness among other things.[47] Painting addresses itself to this principle, making sense of the ways even that which is invisible, including touch and sound, nonetheless belongs to this visible world. We can see the silence that reigns in Rembrandt's *Bathsheba*.

Painting allows us to make sense of the relational world in its complexity and plenitude.[48] For Merleau-Ponty, Paul Cézanne is the artist who best reveals the prereflective world of perceptual coming into appearance for a reflective subject. In this age we generally do not attend to what or how we perceive. We are, for the most part, perceptually beckoned by that which speaks to our immediate and practical needs or confirms what we already know. But Cézanne shows how we nevertheless "unquestionably communicate" with the world not through thinking about it but by living an inexhaustible world we do not possess.[49] His works invite us to reflect upon and question the ways we habitually make sense of the world—that is, to question the ways we think we perceive and the ways we think we are in touch with what's there. If we actually attend to what we perceive, we make sense of the real not because we stand over and above it but rather because we are immersed within it. Some paintings give us the real, the things in themselves, not as objects laid out before us or as framed through a governing idea but rather as they are in the world, a material world that juts through its cultural shaping. They draw on phenomenal perception to create what is there not through simply mirroring the experience of immersion but rather, like the experience of perception itself, by drawing on the "fabric of brute meaning" and bringing the world into being through expression.[50] Like the philosopher, painters question the world, exploring and interrogating what is there through embodied perceptual cognition. They learn how to see through looking because the things teach them how to perceptually gear into what is there. Unlike automatons that have physiological responses as reflexes to stimuli, artists understand that bodies have their own logos or interpretive ability to engage with the world—one that overlaps with and sustains cognition. In fact, embodied perception opens up the cognitive-linguistic region of existence to the world even as it is, in turn, also accessible to reflection in much the same way that vision, hearing, and touch are different senses that nonetheless work together.[51] I hear the hardness of glass as I see it break on the pavement.

In his ontology, Merleau-Ponty privileges the painter's account of reality over that provided by a philosophy of science that understands the scientist as autonomous to what is measured in the experiment. In this age, scientists tend not to recognize the perceptual ground upon which their experiments are based. They abstract from perception, systematize this

abstraction, and then reapply it to an objectified world in order to discover the real. But they reckon with the world through the frameworks provided by these second-order measuring systems interchangeably imposed on the real. This is the problem with the experimental approach to science that emerges out of traditional metaphysics; the experiment is not understood to be a phenomenon or situation, and science is not seen as belonging to a world.[52] Removing living organisms from their natural habitats ignores the "indecomposable structure of behavior."[53] The experimental apparatus is applied without regard to the ways extracting one aspect of the structure shifts the whole or the ways the apparatus itself influences or even determines in advance the results that will appear. The body is understood as machine rather than as responsive to situations; meaning and form are divided.[54] But as Merleau-Ponty points out, there is, in fact, no actual reality for the scientist who looks down from above at the object in general or for the body rendered as machine.[55]

The experiment aligns with Renaissance perspectivalism, which brings objects together in a unitary spatial system organized according to a single vanishing point on the horizon arranged for a single spectator. It was understood to be a rational, mathematically calculated expression of perspective and space.[56] Perspectivalism, in assuming the single spectator before whom the world is arranged, is likened to a god who can be everywhere at once. The paradox of this arrangement is that even the world is organized for the solitary spectator who is not in relation to anything or anyone, as the spectator can only be in one place at one time.[57] This introduction of perspective both instituted and sedimented the distance produced from objectifying reality according to mathematically precise rules. At the same time, it destroyed distance by tying the plane to the individual eye, which Erwin Panofsky, quoted by Merleau-Ponty, describes as a "distance-denying human struggle for control."[58] Distance is at once established and simultaneously destroyed. Although Renaissance perspective was only one means of expression, one technique that belongs to a particular age and culture, its proponents understood it to be the only way to accurately represent the world.[59] But there is no method that can once and for all reproduce the world to a flat plane or canvas. Renaissance perspective attempts to lay out a rational optical world but ultimately fails because the perspective is always connected to one ultimately desituated eye.

Phenomenal visual perception begins instead with two eyes working together in binocular vision toward the realization of the object for the gaze. If I hold up a finger in front of my face, the image is at first double. But the act of actually looking at the finger brings the two monocular images

together into a kind of synthesis. But this synthesis is not one that belongs to "consciousness."[60] It is rather a "progressing toward the object *itself* of finally having its carnal presence." The "monocular images" hover before the landscape but are not situated in the world until the act of looking grounds them there.[61] Perception is motivated. It relies on the ways the world emerges into presence and solicits my gaze, my touch, or my hearkening to a sound. This phenomenal motivation is noncausal.[62] It describes a coconstituting relation between my body and the world it lives. My phenomenal perception tries to deepen its grasp on the things that beckon to it. I draw nearer to see what is there; similarly, that grasp fades for things that are further away, such as the fabric Rembrandt paints with exquisite details in the foreground that begin to blur as they recede in depth.

If we give up on the view from nowhere, we must recognize that knowledge emerges from particular, situated, multiple, and overlapping points of view. These are not the same as the perspectival vanishing point, although it is possible to conflate the two since "points of view" cannot be seen. They are "imperceptible" because they cannot in themselves become objects of perception.[63] What sets Rembrandt's painting apart from most of its contemporaries is that it reminds viewers of their own points of view, that they even have one, that their own gaze is implicated in their seeing. When I attend to Bathsheba, I see her anguish because, in that moment, we belong to the same horizon of being. I also feel the intrusion of my gaze in this private moment of her suffering, and I recognize I cannot know precisely what she is thinking, only that she suffers. Although I relinquish the transcendental all-knowing view from nowhere, I do not give up on objectivity. The painting has a material presence. But our accounts of reality become richer the more points of view we bring to the work. Appreciating the genius of Rembrandt's *Bathsheba* is not merely a subjective judgment—it is objectively so even if interpretations of why it is a great painting vary. Nonetheless, the brilliance of the painting shines through.

This is the heart of phenomenal perception. Points of view are not limited by situation. We can reflect upon what we perceive. Humans can vary their points of view both through shifting their situations and through imaginative reflection that allows them to consider other points of view. As I view the work, I can imagine what Bathsheba might be thinking. In part this is because perception is in itself reflective. It is intentional and directed toward a world it gears into and grasps. Our eyes probe in order to see; they run over the texture of things, allowing us to make sense of them and see them take shape before us. We move closer to something to get a better look, for "we see only what we look at."[64]

We can also reflect upon how we perceive—the ways we see, or touch, or listen, the ways we are open to and caught up in the fabric of the world. Through this reflection we can shift the ways we think. Even though our bodies are caught up in the fabric of the world, this does not mean we are fused with it. Our bodies are "simultaneously" both seeing and visible. The body "sees itself seeing; it touches itself touching; it is visible and sensitive for itself."[65] The gap provided by this nonfusion is the one that allows for reflection and change.[66] Just as our senses overlap and support each other as part of that fabric without being reducible one to the other, there is a dehiscence, spread, or *écart*—a chiasm—between what is perceived and the perceiver that allows for this reflection and this perception of perception. The chiasm is not a causal relation. It is, rather, a relationship between two or more entities that allows for their mutual intertwining without fusion or domination. The water in the pond reflects the overhanging trees, and the reflected light from the pond shimmers off the leaves of the trees. This is not an optical illusion but rather evidence of the reversible and chiasmic interrelation of things and beings situated in the world. The water might "materialize" in the pool, but it is not "contained there." It has an "active and living essence" that can also be taken up in a painting.[67]

In his later work, Merleau-Ponty calls this folding over of the sensible and the sensing—this intertwining of ideas and matter, the overlapping, encroachment, and promiscuity that also carry "the weight of the past"— "flesh [*la chair*]."[68] He first uses the term *flesh* in his 1951 lecture, "Man and Adversity," as a way to describe something that had not yet been thought in Western philosophy.[69] There were no concepts available that would allow him to think this intertwining of a material, natural, and fleshy world with ideas, significations, and phenomenal bodies. It is not just that humans are affective, motile, and perceiving beings whose inherence in vital, cognitive, and social structures means a shifting in any aspect of their being will affect the entire structure. He also, according to Mallin, began to understand how thinking in terms of structures can invite the transcendental imposition of blueprints or wholes that lead us back to the knowing subject. For even to reposition the subject does not quite capture the sense of interlacing viewpoints, sensible and living worlds, and temporally situated perspectives that emerge in his phenomenological descriptions.

Thinking ontology as flesh allows Merleau-Ponty to account for the multiplicity of visions that overlap with his own. Because he is capable of touching and seeing his own living body as well as the world, he is in touch with himself reflexively. His body is "made of the same flesh as the world," which means it is perceived; reciprocally, the flesh of his body is

also "shared by the world"—that is, "the world *reflects* it, encroaches upon it and it encroaches upon the world."[70] Reflection is not only cognitive but also corporeal: he is not only "open to the things" but also capable of perceiving some of the ways he is shaped by the world.[71] Flesh is the overlapping and encroachment of multiple viewpoints, perceptions, ideas, and ways of taking up the world: "Each landscape of [his] life, because it is not a wandering troop of sensations or a system of ephemeral judgments but a segment of the durable flesh of the world, is qua visible, pregnant with many other visions besides [his] own."[72]

Artworks are phenomenally effective when they set to work not because they offer a thought or representation to another mind but rather because they draw on an embodied logos that communicates with other bodies. Painting is a "likeness only according to the body."[73] Viewers are invited to enter into the world offered by the painting. They are able to be sensitive to the artwork's world to the extent that what they perceive finds an echo in their own bodies, which respond to the colors, sounds, and textures they encounter in the work. These echoes, or carnal essences, like the essence of the water in the pool, are "internal equivalent[s]" of the things.[74] The visible, when caught by the painter's brush, can evoke carnal essences that provide the viewer with the accompanying muscular sense, the smells and sounds of existence. Synesthesia, this working together of the senses, is the home of the artist's vision. Rembrandt paints the softness of the fabrics and the firmness of Bathsheba's flesh, as well as the silence of the moment. He works to incorporate all the senses into this visible landscape so that the texture of his imaginary is drawn from and intertwines with the texture of the real.[75] Corporeal essences provide evidence of the interrelatedness of the world; the light illuminating Bathsheba's skin and her servant's ear belongs to a logic my body understands. This is a different kind of essence than that of the "idea of man" that is imposed from above. The first can be understood as a way of being, perhaps better understood as essencing.[76] The second belongs to a platonic understanding of universals that inhere outside time and space. When ideas are merely imposed on a painting, the work does not come to life. But when an artwork grants carnal essences that viewers can gear into and corporeally understand, it means they do not so much look at the work as an aesthetic object as "see according to it, or with it."[77]

Artists often create what would be incompossibles for the mind but not for phenomenal perception, which responds without us having to reflect upon it: "it works in us without us."[78] This does not mean that our bodies are automatons but rather confirms that our phenomenal bodies

have their own logos and their own ways of understanding, interpreting, and taking up the world that overlap with cognition. Incompossibles are not accidents or mistakes in an artist's work. In great works, they reveal essences—they give us movement, space, and time—and give us being. If one stands in front of a Cézanne landscape, there are often several paths that lead the viewer's gaze into the scene because it does not depend upon the vanishing point of perspectival vision. The landscape opens up as a world that invites the viewer in. A path leading across the canvas can eerily reverse direction when a viewer moves from one side of the canvas to the other, offering an entrance into the landscape from either side of the work. Similarly, if I position myself on the far left of Rembrandt's painting, I find myself looking toward Bathsheba while standing slightly in front of the servant. This view changes quite dramatically when I stand directly in front of the work; the servant recedes into the corner.

While space is given by multiplying the points of view on the canvas, time is provided through creating modulations of the viewer's point of view, suggesting movement made "visible by its internal discordance."[79] In Rembrandt's painting, Bathsheba's temporal movement is rendered through a kind of stillness as she reflects upon past and future. The movement of varying points of view is provided by the viewer's body, which does not occupy just one perspectival position in relation to the work. Rembrandt extends Bathsheba's torso and enlarges her hand in the foreground, suggesting the viewer's moving relation to this body in much the same way Cézanne achieved the liveliness of a still life by creating multiple perspectives on the canvas. The viewer cannot remain outside the painting as a detached observer; their body is implicated in relation to *Bathsheba* through movement. Even the shadow thrown over her lap suggests the viewer has entered the world of the canvas, a place they should not be. Nonetheless, Bathsheba lost in thought is indifferent to their presence.

The painting thus "rests upon a total visibility." It makes visible what is invisible to everyday vision. Artists perceive the ways this shadow, that burst of light, that overlapping of forms give us the actual world we inhabit. They know how to "unveil" this thing, how to "make us see the visible" by making the invisible visible.[80] We see the things themselves: Cézanne's mountain taking shape before us. A world without shadows would be a strange one, and yet, when we look around us, it is not the shadows we see. To see the object, "it is necessary *not* to see the play of shadows and light around it." Everyday "profane" vision "forgets its premises" and forgets this background that is nonetheless visible and allows us to see this thing as real—this mountain, this event, this thoughtful woman.[81]

This total visibility supports colonial racist vision precisely because we do not see the structures that support that vision, the ways of thinking, or the historical events that belong to the metaphysics of the flesh.[82] It obscures what makes it possible for the servant in Rembrandt's painting to remain in the background or for the viewer to simply collapse her into another aspect of *Bathsheba*. Even the idea of "Man" has its reverberations in the flesh of the world since it is always more than just an idea in the ways it is imposed in patriarchal and colonizing structures. To understand the world ontologically as flesh means there are no absolute binaries between ideas and things. Ideas such as "structuring hierarchies" can be both imposed and taken up as corporeal essences that shape the ways humans "experience" themselves to be.[83] Cultivating perception entails becoming more sensitive to this total visibility, perceiving what supports this thing coming into appearance and not that one. For Merleau-Ponty, painting is the artist's interrogation of the real. He questions after that vision, those carnal essences that articulate themselves in him; they are sketched out both delineating and supporting his vision. The trees look at him in the sense that they beckon to him and hold his attention, and he is compelled to question them through painting. This means that the work, as his interrogation of the real, is also particular to his own style of being.[84] But Merleau-Ponty does not question what happens when a body does not extend easily into the world, when the world does not reflect it back, or when the world reflects it back as distorted. These are questions to which we will have to return.

Merleau-Ponty's ontology of the flesh assumes situated, multiple, overlapping, and hence simultaneous points of view—simultaneous because there is the possibility for an encounter in space and time. Being is a "circuit" of the visible and the invisible, of nature, humans, and expression. Vision is the sense that allows him to see that "beings that are different, 'exterior,' foreign to one another, are yet absolutely together, are 'simultaneity.'"[85] Like an event such as the French Revolution, an artwork can even institute a new way of perceiving or understanding because artworks, like ideas, are not separate from the world itself.[86] Indeed, "great" artworks often establish the field of perception from which they themselves later come to be understood.[87] For this reason, artworks teach us the limits of metaphysics. Artists could never expect to paint the one final work or solve all the problems of painting because painting is an ongoing interrogation, a questioning of being that can never settle once and for all because the ground of being, that which is, also shifts. Since we are all "enmeshed in a single, identical network of Being," nothing can be laid out, possessed, or

fully understood.[88] Every aspect of being connects in some way or provides another dimension of the whole. Art, like philosophy, provides points of view on the same total being that is the inexhaustible depth of the world.

But there is a tension in Merleau-Ponty's ontology that he does not fully work out. It is particular to the phenomenal body to move into the world and take it up, but this means we gear into a world that is structured according to calculative measures. The very openness that allows phenomenal perception to gear into the world is the same that allows bodies to attune to a world structured according to efficiency and reckoning. Since perception gears into and creatively sediments new structures, an event like Renaissance perspectivalism actually changes the ways we think we perceive, organizing the ways we make sense of what we see according to its cognitively calculated linear lines; phenomenal perception, which actually allows us to encounter the real, moves to the background of our existence. But because we do not phenomenally see the world according to Renaissance perspectivalism, phenomenal perception cannot be completely colonized by calculation.

The goal of cultivating perception is to bring the phenomenal world of embodied perception to the foreground in order to be able to reflect on it. This is not to understand vision in terms of the "mind's inspection, judgment, [or] a reading of signs." Rather, since the mind "thinks with reference to the body" and not to itself, becoming aware of perception as phenomenal is to become aware of how we perceive *as* we perceive. Phenomenal perception takes place without reflection in the way that, for example, one hand clasps another in greeting, conforming to that hand with which it momentarily joins with no reference to its size and shape.[89] But cultivating perception requires reflectively encountering a world in which we are always already intertwined. We do, of course, reflect upon things we have seen in the past; we represent what is there to ourselves. But this is different than the vision that actually takes place in the present, the vision "of which we can have no idea except in the exercise of it." Reflecting on what and how we perceive must happen in contact with that which is perceived, in the presence of the world, in the presence of the artwork. This is not the "thought of seeing" but "vision in act."[90]

Cultivating perception includes recognizing that perception, as belonging to the flesh, is also expressive in that it responds to what beckons to us, as Bathsheba did to me on that first encounter in the Louvre. Since perception is expressive, it is also creative.[91] Our creative accounts of reality also contribute to bringing that reality into appearance—that is, into being. Merleau-Ponty privileges painting because the world, for him, is

first and foremost visible: "Vision alone makes us learn that beings that are different, 'exterior,' strange to one another, are yet absolutely *together*, are 'simultaneity.'"[92] The painter is able to capture space, movement, duration, the reversibility of depth—in other words, being—because being has a presence that is carved out in a visible world. Even the invisible has a presence as "a certain absence," as "the invisible lining."[93] Vision allows us to see things at a distance, such as the stars and the sun. It allows for this ubiquity we experience—how we are able "to be everywhere all at once"— because we can imagine ourselves elsewhere.[94] And this makes embodied phenomenal perception an open system: open to light, to other beings, and to the world. My task is to describe this open system through phenomenological descriptions of my encounters with artworks.

III: Art Historical Approaches to Rembrandt's Bathsheba

If we approach Rembrandt's *Bathsheba* from the perspective of a cognitive system, it is easier to make sense of it. Art historians have systems at their disposal that allow them to approach a work of art by analyzing the composition of the work or the techniques employed, by situating it within the biography of the artist or comparing it to others created at the same time or in the same art movement, or by explaining how the work institutes something new. These systems can help explain the work but make it very difficult to phenomenally encounter. Eric Jan Sluijter's analysis exemplifies the use of these systems. He compares Rembrandt's *Bathsheba* to others of its time and makes sense of it from within this tradition.[95] He assumes that the letter on her lap is evidence Bathsheba knows she is being watched, and he interprets her to be a passive victim: "Rembrandt did not portray her as an obviously dishonorable seductress but rather as the passive victim of her own fateful beauty to which no man—least of all the viewer—can offer effective resistance."[96] He argues that Rembrandt could not possibly have had a real model sitting before him since "the structure and proportions of the torso and legs appear to be quite peculiar."[97] We clearly "see different parts of the body from different angles, so that more of the body is shown than would be possible if it were seen from one viewpoint," and, indeed, the upper and lower torso "can never be perceived in this way at the same time."[98]

Sluijter could only make such a claim if he approached the work as a static perspectival representation and not the overlapping of multiple points of view that would emerge from living and moving bodies encountering one another in the world. For we never see only one perspective. Our eyes roam over a scene as they try to grasp what is there; not only is

the gaze in motion, but so too is the whole body. The different angles of Bathsheba's body given to the viewer create this temporal lived experience of movement on what would otherwise be the static surface of the canvas. Nonetheless, even for Sluijter, this extraordinary achievement shines through. Although maintaining Rembrandt was striving for an "ideal type," Sluijter also acknowledges that "paradoxically, with the unnatural structure and proportions, [Rembrandt] strove to attain the suggestion of an entirely natural attitude of complete tranquility."[99] Although Sluijter might argue that Rembrandt could not have had an actual model sit for him since the body's proportions are all wrong, they are only wrong if one assumes a single privileged perspective. For the phenomenologist, they give us the living and moving bodies of the artist and model. Bathsheba breathes.

Rembrandt creates a world we live because he brings into appearance the incompossibles that allow us to phenomenally perceive. For some commentators these incompossibles are confusing. For Ernst van de Wetering, Rembrandt's *Bathsheba* creates an "imaginary space" in which viewers seek to find their place. The viewer is given the "feeling that he is slightly looking up at Bathsheba," even as the painting provides few obvious perspectival cues.[100] One cue is provided by "the imaginary lines" that run from Bathsheba to her servant. Since Bathsheba's "furthest eye" is "lower than the nearer one [it] provides a perspectival cue that we look up at her." But the servant's furthest eye "is also lower, which conveys the distinct impression that her eyes are somewhat above the level of those of the spectator. Thus, the somewhat awkward position of Bathsheba's lap, which, along with the rising fold of the navel, is in conflict with the impression of a view from a low vantage point. It thus confuses the spectator by contradicting the expectations raised by the perspectival cues just described."[101] As Wetering observes, although Rembrandt would have known the "rules of geometric perspective" prevalent in his day, for the most part, he did not employ them: "Why should her left foot (which is not hit by that cast shadow) be much darker than the other foot held by the old woman? And why should her lit left thigh be darker in tone than her belly, and that in turn less radiant than her breasts, while her face (lit by the same light) is somewhat toned down?"[102] Wetering concludes that these lighting "tactics were all consciously applied to reduce the number of places in the picture that may compete for the beholder's attention."[103]

But Rembrandt understands flesh. For empiricists, light and shadow might obscure what is actually there, but for Rembrandt, light and shadow give us the real, revealing the interrelationality of all beings. The folds of

material in the foreground of the painting "are crisply defined," allowing the eyes to clearly gear into and grasp them, while material closer to Bathsheba's thigh is not as sharply rendered.[104] This makes sense phenomenally since our gaze has a clearer grasp on things that are closer. But for Wetering, Rembrandt was likely working with the cognitive idea that "the eye can *estimate* the distance to a rough surface much more accurately than to a surface that provides no relief texture on which to focus" and similarly that the spaces with less tonal contrasts seem further away than those that are more sharply defined.[105] Wetering explains Rembrandt's achievement by focusing on technique. Technique is critical, but in Rembrandt's painting, it works to support phenomenal perception that presents us with carnal essences or ideas. In *Bathsheba*, it is lighting that leads our gaze across Bathsheba's radiant flesh. For Wetering, although Rembrandt employs "the most subtle control of light intensity," the viewer "tends not to register that her skin is rendered in greatly varying intensities of light."[106] Yet it is this subtlety that gives us her flesh.

Mieke Bal addresses the ethical implications of viewing but does so through focusing on the semiotics or sign systems the work provides, which she takes as being incomposible with the real.[107] In many interpretations of the story, Bathsheba's beauty is blamed for the king's transgressions; she is painted as seductive and found to be complicit in the deed. But this common interpretation that blames Bathsheba does not, in fact, correspond with the biblical story.[108] Instead, it provides a convenient excuse for transgression since Bathsheba's visible flesh relieves viewers of their ethical responsibility, imposing it instead on the one who is viewed. In other words, the viewer could not have seen her naked flesh and responded otherwise.[109] But in Rembrandt's painting, Bathsheba's apparent sorrow refers to a future she could not know in the moment of bathing he depicts. Phenomenologically, the melancholy in her face reveals the temporal narrative flow in the closed space of the painting. As Bal points out, the letter on her lap invites a sense of narrativity to the painting.[110] But in the biblical story, Bathsheba never held a letter. She did not know that she would be raped and her husband killed and that her child, the product of this rape, would die: "Although the image clearly makes sense as a whole, what sense it makes cannot easily be decided. We are left with a sense of narrativity that is not fulfilled; with a sense of wholeness that does not satisfy; with a frustrated need to position ourselves in relation to the viewing situation the narrative should bring forth but does not."[111] Bal concludes there are two incomposible possibilities of interpreting this painting, the semiotic and the real, but "the letter as sign for text and the look as sign for the real

are mutually exclusive."[112] The choice of interpretation comes back to the viewer. Phenomenologically, however, it is the incompossibles in the painting that work together to give us the idea or essence of the work.

Although a strong work carries its meanings in its very materiality, the phenomenal presence of the work can often be obscured from within the discourses of art history. Svetlana Alpers maintains there is another story at play behind this rendition of Bathsheba, one drawn from the contemporary events of Rembrandt's own life.[113] Although not confirmed, the prevalent assumption is that the model for this work was Hendrickje Stoffels, the woman Rembrandt lived with after his wife, Saskia, died. Alpers supports this assumption since, as she argues, artists of this time painted mistresses, not wives. He would never have painted Saskia as a nude. Rembrandt could not marry Hendrickje because he would have needed to relinquish Saskia's estate, as dictated by her will. In painting Hendrickje, Rembrandt both confirmed the church's condemnation of the relationship—that he was "keeping her in the 'whore-like' situation denounced by the church council"—as well as, like David, his "desire [for her] outside the bonds of marriage."[114] If we continue to read the painting in terms of signs, we are led to the colonial logic to which Rembrandt would undoubtedly have been exposed. The luminescent hue of Bathsheba's skin seems to assert her inherent purity, thus absolving her of shame and contradicting the claim that Bathsheba is to blame for her own rape. Moreover, the darker hue of the servant's skin seems to draw the servant into David's unsanctionable plan.[115]

Rather than dismissing technical details, in a strong work, they provide entries into a phenomenological interpretation, since all levels of the painting work together, including materiality, color, form, and ideas. In this case, as Alpers argues, the technical details support her reading that Hendrickje ultimately resists Rembrandt's hold on her. She reflects on how different Rembrandt's Bathsheba is from that of his contemporaries, who depicted Bathsheba as open to David's gaze and his seduction. But for Alpers, although Bathsheba's torso is turned toward the viewer, her head and legs are seen in profile: "the gaze is averted, the head bent, the eyes lowered."[116] It is known from an X-ray of this work that Bathsheba's head was originally held higher and that she was looking out at the viewer in a more conventional pose.[117] Alpers's point is that Hendrickje turns away from Rembrandt: "He is enthralled with her as this and other paintings record. But his painting shows us a naked woman, lost in thoughts, impossible, so it appears, for the eye to possess. Her body—torso twisted outward, head bent and turned away, legs unresolved, strong right arm lovingly

enhanced—is not unsettling simply because her mind is not on display. More fundamentally, her body eludes a comprehensive view."[118] Ultimately, "Rembrandt does not possess what he so loves. Hendrickje, one sees, has her own resources."[119]

Berys Gaut's account is more clearly phenomenological. Although she begins by comparing Rembrandt's painting to Drost's, unlike other commentators, she fully encounters the work. The greatness of Rembrandt's painting lies in the complexity of the person and the situation the painting reveals. This is why it is such a beautiful work.[120] Bathsheba is not on display for the viewer. She is "seen through her own eyes: the picture conveys a real sense of interiority, of a mind well aware of [the] situation into which she has been thrown by the King's attention, and cognisant of the moral implications of what is to happen."[121] That Gaut comes to these conclusions through phenomenally encountering the work is revealed in her description of that encounter: "details . . . emerge only very gradually. . . . Above all, once the eye has grown accustomed to the painting's subdued tonality, the initially muted colour scheme proves to be subtly powerful: the colours seem gradually to gain in hue and saturation, and almost to glow with a quiet inner light."[122] She describes how she allows her perception to gear into the world offered by the work, and she begins to perceive according to the work. Gaut moves from reflecting on this experience of how her perception shifts to understanding this process as integral to the meaning of the work: "This experience of looking at this work, of discovering hidden beauties and new forms, creates an analogue of Bathsheba's contemplation, but with a pictorial object, and it reinforces the sense of an inner, interior life at work that the painting so powerfully conveys."[123] The essence or meaning of the work appears not only in the painting as object but also in her description of her encounter with the work setting to work. In Gaut's descriptions, Rembrandt's Bathsheba performs ethics.

These art historical accounts are by no means wrong, but many of them, in focusing on the technical and comparative aspects of the painting, miss the essence of the work that is given through encounters with the painting described. Rembrandt paints a thoughtful woman who resists the appropriative gaze. She makes interiority as withdrawal manifest, but precisely what she thinks remains invisible. The interiority he paints is sensibility, thinking, and feeling, the other side of the exterior sentient world of experience that is the social and political world he inhabits. Rather than providing the nude—a body open to appropriation by the gaze—Bathsheba shows us the limits of appropriation, the limits provided by individual points of view that belong to the same flesh. At its heart, Rembrandt's

Bathsheba calls for a different kind of seeing: one that does not appropriate, that does not absorb the other as its own through imposing concepts or forms on what is seen. The painting, in so doing, enacts ethics, showing the viewer how David imposing his power and acting on his desire are wrong. Rembrandt seems to respect the subjects he paints by allowing them to show themselves in their own way, exposing the limits of appropriation. In acknowledging the limits of his own vision on the canvas, he paradoxically opens new possibilities for perception. His work shows how vision is "a participation in and kinship with the visible," and this is because seeing is itself visible and inhabits a visible world.[124] The gaze of the viewer on Rembrandt's *Bathsheba* becomes, through its chiasmic reversibility, visible.

IV: Body Hermeneutics

While some art historical systems can actually obscure the meaning of the work, Mallin's body hermeneutics provides an approach to philosophy that begins with existence—that is, with the artworks themselves. He turns primarily to Merleau-Ponty for his "analysis of the non-cognitive regions" of existence. As Mallin explains, Merleau-Ponty aims at a "deeper logos than the logic of reason." Rather than taking reason as grounded primarily in rationality, Merleau-Ponty describes the ways "reason is more deeply grounded in existence rather than the reverse."[125] Describing encounters with artworks is an "articulation of the non-cognitively dominated structures that visual arts present."[126] This existential phenomenological methodology reveals how artworks open up our "awareness" of our "*contact* with being."[127] The starting point is perception, which is primary because it provides for this contact to the world in the present where past and future overlap. Although perception intertwines with intelligence as the cognitive-linguistic, motricity, and affect-desire in an "intentional arc" of existence, it tends to fall into the background as the prereflective ground.[128]

Nonetheless, these four regions of existence *are* intertwined and open up on to the same world even as they specify it according to their own particular ways of encountering what is there. When Merleau-Ponty writes about the total part of being, he means that each region has a grasp on existence as a whole, but this grasp is nonetheless necessarily partial since it is restricted or limited by the ways it opens onto the world even as it "strains" to "maximize its articulation of being." This means that "these regions are perpetually articulating themselves and expanding their grasp on being through translating and adapting the structures of the other regions to their own."[129] This is an ongoing process of unifying that nonetheless

"remains disjointed and essentially incomplete."[130] This translating, adapting, even appropriating tendency that belongs to the various senses tends to remain unacknowledged since awareness of phenomenal perception falls into the background even as it provides the sinuous structures of our relations with alterity.

Working with artworks allows for phenomenal perception to come to the fore since it becomes apparent how the cognitive-linguistic region of existence must rely upon embodied perceptual structures to articulate contact with the artwork. When I write alongside artworks, the four regions of existence communicate with one another, each bending the other to its own ways of being. Writing with the work is a responding not only to the artwork itself but also to the interlacing of these regions in the presence of the work. This process allows thinking and writing to bend into and alongside the works, altering in response to the encounter. It is essential to the methodology that the philosopher reflects upon this process of altering, a process also referred to by Merleau-Ponty as hyper-reflection. Hyper-reflection allows for reflecting upon how we perceive, which normally remains in the background. This is what it means to perceive "according to" the work rather than looking at it since artworks provide the structures that perception responds to in order to encounter the "perceptual world." This "according to" opens up questions about truth and the world that concern existential phenomenologists. It initiates questions that allow the cognitive-linguistic region of existence to bend into through dialoguing with the work.[131] This perceptual world is, in turn, a field, which can be understood as "a chiasm of lines whether it occurs in consciousness, culture or nature."[132] These structures do not give us copies of the world but rather lay out the ways the world opens up to bodies: "an artwork can be relevant, in all its contingency and eventfulness, to philosophy because it is a chiasmically dense particular whose constant emergence or radiance can bend our thinking about the world in ever deeper and more extensive ways," especially since the cognitive-linguistic region of existence ultimately relies on the other three regions even as it reorganizes them as a "metastructuring."[133]

This metastructuring means the "true world" given to us through reason relies upon the other three regions of existence, even though philosophy has focused its attention on only the one region of existence, "consciousness."[134] When I write about art, I am "already thematizing, abstracting, [and] bringing [it] into a second order logos."[135] Visual art "parallels the phenomenological reduction by taking us to the phenomena themselves of the lived visual world." It "resuscitates" the "openness" that belongs to our embodied

perceptual cognition. At the same time, it also aids me in performing "the other side of the reduction," which requires me to set aside "some of the prejudices that sustain the natural attitude."[136] While making artworks is a way of bending into and responding to lines of being, viewing or encountering artworks is a way of responding to the "natural reflexivity within and between all regions of existence," aspects of being that the artworks have brought into presence.[137] Writing in response to the encounter with the work holds the possibility of articulating the ways my body is affected, altered—that is, indebted to the working of the work.

Writing as *describing* my encounter with a work is a different process than writing *about* the work. In describing my encounter, I consider the ways the work alters my being, revealing truths about being that are primarily given through perceptual contact with it. Writing *about* the work tends to set it up as an object. The ways we speak and write about the world also allow being to presence since these ways also bend into the world and respond to its lines. But the responding that belongs to *writing about* reveals the tendency for the language we speak to bend us into the representational systematicity or being of this age as the efficiency, switching about, reckoning with, and rationalism that do not touch upon that which is there, not even to objectify. It belongs to the extreme emphasis on the cognitive-linguistic realm of existence, sometimes articulated as the mind/body split.[138] Alternatively, phenomenologically describing artworks both contributes to and is "continuous with the articulation of the same phenomena that the artwork itself undertakes."[139] It is inherently relational.

Attending to the regions of existence—including perception, the "affective-social," and the "motor-practical"—in the encounter with the work allows for more fully opening up the cognitive-linguistic region of existence to other possibilities, including the sinuous lines of nature and alternate ways of being. This chiasmic exchange among the regions of existence depends upon the regions sharing the common structures provided by "the action of specification, articulation and sedimentation which, more generally still, is that of 'differentiation' and 'making visible.'"[140] Perception is, in itself, a differentiating process that takes place from within the fabric of what is there. We only perceive where there is difference. If we attend to these structures that belong to the deepening of perception and the overlapping regions of existence, we allow our thinking to attune to, bend into, and further articulate what is there in its own way of doing so—through language. In this way we allow the language we engage to become more dynamic, fluid, and in touch with what is there. To paint is

not to speak about the world, which is to speak about "space and light," but rather to "make space and light, which are *there*, speak to us."[141] Painting "meditates primarily on our visual ways of being in the world and attempts to articulate them in their own terms," speaking to us with "voices of silence."[142]

Describing artworks is a way for philosophers to bend their thinking into and alongside the work, opening it up to new ways of being. And this is what I do throughout this book. Artworks are not merely aesthetic objects, available as commodities on the market. Rather, a strong artwork that sets to work opens up the world around it, allowing entities in its presence to be revealed as what they are in themselves through our contact with being and not through the projection of cognitive representations or ideas, which is the tendency of this age. An artwork is a clearing that touches "the depths of the entities in its milieu allowing them to resound in themselves and in their distances"—that is, in their relations with other entities around them.[143] The artwork that sets to work has a presence that cannot be easily subsumed to imposed forms. In beckoning those around it to a full encounter, the artwork brings embodied regions of existence to the fore, allowing for other entities in its presence to also be more fully encountered on their own terms.

The artist works with and alongside nature, with what is, and reveals these undulating and sinuous lines in the works that are produced. This insight is in keeping with Heidegger's understanding of *techne* whereby the artist is just one aspect of the four causes of a work's genesis; the artist coproduces the work along with the material, form, and purpose. Beginning with the ancient Greek understanding of nature, or *physis*, as "that which lets something originate from itself," being as physis can be understood as inherently temporal and spatial in that it comes into presence and fades away.[144] Like the presencing of physis, artworks come into being not simply as the artist's making in terms of the imposition of an *eidos* or blueprint on that which is there—for example, the construction of a bed or table from wood or metal. Artworks are also indebted to the particular materials employed, as well as to the world around them, the ways of being, and the questions raised in the age from which they emerge. The artwork is thus generative and, like physis, through its emergence reveals what is there, which is not the same as being crafted through the genius of the artist or the artisan who requires an eidos or blueprint to be set out in advance.[145] This means that artworks set to work to reveal our contact with the world because they are "of the same kind as the natural," that is, of being.[146]

Merleau-Ponty does not completely realize the implications of his "astonishing" intuitions, as he still tends to succumb to the metaphysical tendencies that belong to this age.[147] In "Eye and Mind," unlike in his earlier discussion of Cézanne's painting, he does not address the artworks themselves but rather tends to take up only what the artists say *about* their works. Similarly, he was not fully aware of the importance of the material the artist draws upon. Rembrandt understood the limitations of the two-dimensional surface of painting but was able to work with it and draw on the *n*-dimensionality inherent to sinuous lines while never leaving the two-dimensional plane. Merleau-Ponty, however, writes about "the indifference of the white paper."[148] He does not seem to recognize how the materials chosen also lend their matter to the emerging work, to the lines the artist flexes into and around. It is revealing that he refers to the line in Paul Klee's work as a blueprint (*épure*), which refers more to "a rough projection sketch," the imposition of the line in advance.[149] In Mallin's view, Klee relies heavily on the "inventions of symbol systems," although Mallin concedes that "Klee's art lines even when intending to encode, nonetheless are placed with a great artistic hand and eye and, therefore, bend often into one another with most of their inflexions. The result is that they always show up much more of the world than explicitly planned."[150]

This occasional tendency to metaphysical lapse also means that even though Merleau-Ponty's reflections on chiasmic ways of relating in terms of thickets and clusters that involve "non-human entities" are astoundingly helpful for understanding structures as loosely formed intertwinings of relationships, he only describes chiasms "where the human is involved with the world, with other humans or with itself."[151] He falls back on the work as an "icon" of the artist's relationships to the things rather than an "icon" of the thing itself.[152] He begins with his own body and accounts for the world in relation to it. This means to think "self-holding invisibility" in terms of inexhaustibility still implies that everything is capable of being unconcealed even if such an exhaustive revealing cannot be achieved.[153] But chiasmic intertwinings take place without human awareness: "We now know that our vibrations and inflexions to alterity (what alters us) are truthfully generalizable, but are partial as well, insofar as we are moved and can be sustained in these interchanges only because there is more than we can ever attain or retain from them. There is a binding or relating that we call *a-human* because it is manifest both by the human and non-human."[154] The world is given in terms of overlapping relationships, as "inter*flows*, in*fluxes* and cross*currents*."[155] On the one hand, Merleau-Ponty asks that we return to the things themselves without imposing our cognitive measures

on them: making space and light, which are there speak to us. On the other hand, he still positions humans at the center since the world is accounted for through human perception, and the things must be made to speak to him: "'Chiasm' helps us to see how *presumptive* it is to take the genesis or *physis* of an entity as the way *we* understand it, that is, bend to it with any of our regional styles of openness to the world. . . . Merleau-Ponty says explicitly that the artist paints the 'internal equivalent or fleshy formula that things bring forth in me (*suscitent en moi*).'" In other words, the painter provides "fleshy essences" of his own "bendings to things" rather than the "fleshy essences of the things themselves."[156]

There is a tension between Merleau-Ponty's call to "see the things themselves"—to encounter what he also refers to as *l'être sauvage* (wild being)—and his attempt to account for the essences of things in terms of the ways he experiences them and appropriates them into his own embodied being.[157] Dolleen Tisawii'ashii Manning reminds us that Claude Lévi-Strauss "dedicated *The Savage Mind* to Merleau-Ponty," thereby drawing attention to the explicitly colonialist history of this term.[158] As she points out, Western philosophy is structured by the appropriation of other ways of being and thinking that remain unacknowledged. Acknowledging other ways of being requires a different relation with the world and one's self. Manning's "mother and formative teacher, Rose Manning Mshkode-bzhikiikwe baa, a first-language Ojibwe speaker, described this as a kind of attentiveness toward what approaches from a distance or what is apprehended from the corner of one's eye (perhaps days or even years in advance)."[159] However, Manning also points out that although Merleau-Ponty is clearly "influenced by anthropological interpretations of Anishinaabe [first peoples'] thought"—as "these seem to inform and shift his thinking"—"he does not redeploy them as his 'original' contributions, instead offering a philosophical method that interpenetrates intellectual, embodied and relational being-in-the-world." Although he does not acknowledge his indebtedness to first peoples' thinking, he also does not appropriate their ideas as his own discovery or invention, as too often occurs; instead, he responds to what appears to him in the world.[160]

Being is not dependent upon the human subject—in particular the philosopher—for its presencing. Merleau-Ponty's work clearly opens up ontological possibilities that stretch beyond metaphysics. He quotes Robert Delaunay, who writes about the convergence of railroad tracks: "The rails converge and do not converge; they converge in order to remain equidistant farther away. The world is in accordance with my perspective *in order to be* independent of me, is for me in *order* to be without me, to be a

world."[161] Ultimately, following the promising threads of Merleau-Ponty's chiasmic ontology of the flesh allows us to understand how an artwork can be nonrepresentational—that is, can have its own being independent of human conception (*Vorstellen*)—and, instead, can provide an opening in which the things and beings in its vicinity more clearly become themselves.[162] What we are seeking here is an ontology, or account of being, that does not presume a privileged point of view but rather depends upon multiple relational intertwinings of the real.

Notes

1. Rembrandt Harmenszoon van Rijn, *Bathsheba at Her Bath*, 1654, oil on canvas, 142 × 142 cm, Louvre Museum, Paris. To see the image in color, go to http://www.louvre.fr/en/oeuvre-notices/bathsheba-her-bath.

2. See David Theo Goldberg, "Heterogeneity and Hybridity: Colonial Legacy, Postcolonial Heresy," in *A Companion to Postcolonial Studies*, ed. Henry Schwartz and Sangeeta Ray (Oxford: Blackwell Publishing, 2005 [2000]), 75.

3. Merleau-Ponty, *Phenomenology of Perception*, lxxxiv; *Phénoménologie de la perception*, xiv.

4. See Olkowski, *The Universal (In the Realm of the Sensible)*, 13.

5. Bruno Snell, *The Discovery of the Mind: In Greek Philosophy and Literature* (Oxford: Blackwell, 1953), 198. Quoted in Martin Jay, *Downcast Eyes: The Denigration of Vision in Twentieth-Century French Thought* (Berkeley: University of California Press, 1993), 29. Snell points out that "the Homeric Greeks did not have a body in the modern sense of the word." Snell, *The Discovery of the Mind*, 8.

6. Jay, *Downcast Eyes*, 29.

7. See Martin Heidegger, "On the Essence and Concept of *Physis* in Aristotle's *Physics B, 1*," in *Pathmarks*, ed. William McNeill (Cambridge: Cambridge University Press, 1998), 193; originally published as "Vom Wesen und Begriff der *Physis* Aristoteles' *Physik B, 1*," in *Wegmarken* (Frankfurt am Main: Vittorio Klostermann, 1976), 322.

8. Heidegger, "On the Essence and Concept," 193; "Vom Wesen und Begriff," 322.

9. Heidegger, "On the Essence and Concept," 193; "Vom Wesen und Begriff," 322.

10. Frantz Fanon, *Black Skins, White Masks*, trans. Charles Lam Markmann (New York: Grove Press, 1967), 116; originally published as *Peau noir masques blancs* (Paris: Éditions du Seuil, 1952), 93.

11. Kenneth Clark, *The Nude* (New York: Doubleday, 1956).

12. Jean-Luc Nancy and Federico Ferrari, "Bathsheba," in *Being Nude: The Skin of the Images*, trans. Anne O'Byrne and Carlie Anglemire (New York: Fordham University Press, 2014), 11. Nancy draws on Kenneth Clark's pivotal study on the nude.

13. Nancy and Ferrari, "Bathsheba," 11. I am referring, of course, to Lacan's mirror stage.

14. I refer here to John Berger's reworking of Clark's distinction between the naked and the nude. For Clark, the nude provided an ideal form to which to aspire. Clark, *The Nude*, 23–54. For Berger, to be nude is to be objectified for the viewer's gaze: "Clark maintains that to be naked is simply to be without clothes, whereas the nude is a form of art. According to him, a nude is not the starting point of a painting, but a way of seeing which the painting achieves." John Berger, *Ways of Seeing* (London: BBC and Penguin Books, 1972), 53.

15. Nancy and Ferrari, "Bathsheba," 2.

16. Nancy and Ferrari, "Bathsheba," 16.

17. Nancy and Ferrari, "Bathsheba," 14, 12.

18. Nancy and Ferrari, "Bathsheba," 16.

19. Nancy and Ferrari, "Bathsheba," 12–13.

20. Hélène Cixous, *Stigmata: Escaping Texts*, trans. Catherine A. F. MacGillivray (New York: Routledge 2005 [1998]), 3, 7. Hannah Arendt also wrote briefly about Rembrandt's *Bathsheba* in her correspondence with Heinrich Blücher. For Arendt, Bathsheba's face "emancipates itself from the beautiful and used body." This imperfect body is "'dominated' by its face." Arendt's thinking about the body is notably ambivalent. It is in overcoming the body as nature that humans have the capacity to make choices—that is, to act. Bathsheba's face reveals her as someone who comprehends and experiences a fate she neither accepts nor can do anything about. Lotte Kohler, ed., *Within Four Walls: The Correspondence between Hannah Arendt and Heinrich Blücher, 1936–1968*, trans. Peter Constantine (New York: Harcourt, 2000), 33.

21. Cixous, *Stigmata*, 4.

22. Cixous, *Stigmata*, 5.

23. Cixous, *Stigmata*, 5.

24. Cixous, *Stigmata*, 6-8.

25. Cixous, *Stigmata*, 19.

26. Cixous, *Stigmata*, 16.

27. Cixous, *Stigmata*, 5.

28. Cixous, *Stigmata*, 3.

29. Cixous, *Stigmata*, 7.

30. Cixous, *Stigmata*, 7.

31. John 13:1–17. I thank Marc Kurepkat for reminding me of this parable in relation to the painting.

32. Simon Gikandi, *Sensibility and the Culture of Taste* (Princeton, NJ: Princeton University Press, 2011), 4.

33. Alison Blakely, *Blacks in the Dutch World: The Evolution of Racial Imagery in a Modern Society* (Bloomington: Indiana University Press, 1993). Cited in Gikandi, *Sensibility and the Culture of Taste*, 10.

34. Gikandi, *Sensibility and the Culture of Taste*, 13.

35. Gikandi, *Sensibility and the Culture of Taste*, 4–5.

36. Gikandi, *Sensibility and the Culture of Taste*, 13.

37. Gikandi, *Sensibility and the Culture of Taste*, 1.

38. Gikandi, *Sensibility and the Culture of Taste*, 1.

39. Gikandi, *Sensibility and the Culture of Taste*, 1–2, 11–12. As Gikandi writes: "Like the other great works of the major Baroque painters of the period—Diego Velasquez and Peter Paul Rubens, for example—Rembrandt's painting was unique for placing Africans at the center of the frame of the picture and not confining them to borders as was the case in the worlds of an earlier generation of European court painters, including Anthony van Dyck's portrait paintings" (Gikandi, *Sensibility and the Culture of Taste*, 4).

40. Monique Roelofs, *The Cultural Promise of the Aesthetic* (London: Bloomsbury, 2014), 86.

41. Roelofs, *The Cultural Promise of the Aesthetic*, 90.

42. Roelofs, *The Cultural Promise of the Aesthetic*, 92.

43. Roelofs, *The Cultural Promise of the Aesthetic*, 95.

44. Merleau-Ponty, "Eye and Mind," 169; *L'Œil et l'esprit*, 35.

45. Heidegger refers to this view as a metaphysics of presence, which is the emphasis on what is objectively present in the moment and does not take into account the ways things are given in terms of a historical understanding of them.

46. Merleau-Ponty, *Phenomenology of Perception*, 70; *Phénoménologie de la perception*, 82. Italics in the original. This idea is taken up and developed by Jorella Andrews in her excellent book on Merleau-Ponty and art, *Showing Off*, 59.

47. Merleau-Ponty, *Phenomenology of Perception*, 70–71; *Phénoménologie de la perception*, 82.

48. This is a different perspective than the feminist critique of occulocentrism—of vision as objectifying.

49. Merleau-Ponty, *Phenomenology of Perception*, lxxx–lxxxi; *Phénoménologie de la perception*, xii.

50. Merleau-Ponty, "Eye and Mind," 161; *L'Œil et l'esprit*, 13.

51. Merleau-Ponty, "Eye and Mind," 162; *L'Œil et l'esprit*, 16–17.

52. Merleau-Ponty, "Eye and Mind," 159–161; *L'Œil et l'esprit*, 9–13. This is not to detract from science. We need science more than ever to help us solve pressing problems such as climate change, especially those that have arisen from the ways we objectify rather than relate to the world. The task is rather to connect science and ways of knowing to a sensible world of living beings. A number of Indigenous scientists and philosophers remind us we cannot divide up a relational world—that science, health, and art are inextricably intertwined with existence. See, for example, Dolleen Tisawii'ashii Manning, *Mnidoo-Worlding: Merleau-Ponty and Anishinaabe Philosophical Translations* (PhD diss., University of Western Ontario, 2018); Kyle P. Whyte, "What Do Indigenous Knowledges Do for Indigenous Peoples?" in *Traditional Ecological Knowledge: Learning from Indigenous Practices for Environmental Sustainability*, ed. M. K. Nelson and D. Shilling (Cambridge: Cambridge University Press, 2019), 57–82; and Gregory Cajete, *Native Science: Natural Laws of Interdependence* (Santa Fe, NM: Clear Light, 2016), among many others.

53. Maurice Merleau-Ponty, *The Structure of Behavior*, trans. Alden L. Fisher (Boston: Beacon Press, 1963), 46.

54. Maurice Merleau-Ponty, *Nature: Course Notes from la Collège de France*, trans. Robert Vallier (Evanston, IL: Northwestern University Press, 2003), 166; originally published as *La Nature: Notes cours du Collège de France*, ed. Dominique Séglard (Paris: Seuil, 1995), 219. According to Francisco J. Varela, Evan Thompson, and Eleanor Rosch, cybernetics, which was the precursor to cognitive science, provided a way of understanding the mind in terms of logical calculation, a way of understanding that still persists in its contemporary form. See Varela, Thompson, and Rosch, *The Embodied Mind: Cognitive Science and Human Experience* (Cambridge, MA: MIT Press, 1991), 39. John Jenkinson further explains that in contemporary neuroscience experiments, "the experimental context is often one in which the individual is taken not as a subject, but an object. What is meant by this is that the states of the individual are taken as measured, whether via imaging techniques that detect objective properties of behavioural states such as changes in blood flow in the brain, or motor response time. The information collected with these measures amounts to third-person data of the phenomenon being investigated that are physical-functional descriptions of behaviour." Jenkinson, *A New Framework for Enactivism: Understanding the Enactive Body through Structural Flexibility and Merleau-Ponty's Ontology of Flesh* (PhD diss., University of Western Ontario, 2017), 9, https://ir.lib.uwo.ca/etd/4383/.

55. Indeed, there seems to a slippery correlation between physical brain and mind that structures much contemporary research and seems to understand mind as a material extension of the body. Meaning making becomes purely functional.

56. In fact, linear perspective can include one point or two points, although the principle remains the same. As well, Renaissance artists drew on atmospheric perspective, which, for example, portrayed objects in the foreground as clearer than those in the background. Fred S. Kleiner and Christin J. Mamiya, *Gardner's Art through the Ages: The Western Perspective*, vol. 2 (Belmont, CA: Wadsworth, 2004), 425.

57. Berger, *Ways of Seeing*, 18.

58. Erwin Panofsky, *Perspective as Symbolic Form*, trans. Christopher S. Wood (New York: Zone Books, 1991), 67. Quoted in Maurice Merleau-Ponty, *Institution and Passivity: Course Notes from the Collège de France (1954–1955)*, trans. Leonard Lawlor and Heath Massey (Evanston, IL: Northwestern University Press, 2010), 98n27; originally published as *La Institution, la passivité: Notes de cours au Collège de France (1954–1955)* (Paris: Belin, 2003), 141n83. Merleau-Ponty

reflects further on Panofsky's work in his 1954–1955 lectures on institution at the Collège de France.

59. As Lawrence Hass points out, Descartes's "philosophy laid down the terms, categories, and problems that shaped—and continue to shape—much western thinking about mind, reality, and knowledge. Indeed, to a significant extent we remain Cartesians." Hass, *Merleau-Ponty's Philosophy* (Bloomington: Indiana University Press, 2008), 11.

60. Merleau-Ponty, *Phenomenology of Perception*, 241; *Phénoménologie de la perception*, 269.

61. Merleau-Ponty, *Phenomenology of Perception*, 242; *Phénoménologie de la perception*, 269.

62. Merleau-Ponty, *Phenomenology of Perception*, 270; *Phénoménologie de la perception*, 300.

63. Merleau-Ponty, *The Structure of Behavior*, 217.

64. Merleau-Ponty, "Eye and Mind," 162; *L'Œil et l'esprit*, 18.

65. Merleau-Ponty, "Eye and Mind," 162; *L'Œil et l'esprit*, 18.

66. Drawing on Henri Bergson, Alia Al-Saji calls this interval one of "hesitation" that allows for the possibilities of critical reflection. See Al-Saji, "A Phenomenology of Critical-Ethical Vision," *Chiasmi International* 11 (2009): 382.

67. Merleau-Ponty, "Eye and Mind," 182; *L'Œil et l'esprit*, 70–71.

68. Merleau-Ponty, *The Visible and the Invisible*, 123; *Le visible et l'invisible*, 164.

69. Emmanuel de Saint Aubert, *Être et chair* (Paris: Vrin, 2013), 21.

70. Merleau-Ponty, *The Visible and the Invisible*, 248; *Le visible et l'invisible*, 302.

71. Merleau-Ponty, *The Visible and the Invisible*, 249; *Le visible et l'invisible*, 302.

72. Merleau-Ponty, *The Visible and the Invisible*, 123; *Le visible et l'invisible*, 164.

73. Merleau-Ponty, "Eye and Mind," 165; *L'Œil et l'esprit*, 24. Galen Johnson reminds us that "Eye and Mind" is a response, in part, to Descartes's "Optics." As Johnson writes, the "Optics" "contains the central themes that riveted Merleau-Ponty's concern and attention: the theory of vision and a new and far-reaching metaphysics uniquely combined with Descartes' own brief commentary on painting and drawing." Johnson, *The Retrieval of the Beautiful*, 23.

74. Merleau-Ponty, "Eye and Mind," 164; *L'Œil et l'esprit*, 22.

75. Merleau-Ponty, "Eye and Mind," 165; *L'Œil et l'esprit*, 24.

76. Merleau-Ponty, *The Visible and the Invisible*, 115; *Le visible et l'invisible*, 152.

77. Merleau-Ponty, "Eye and Mind," 164; *L'Œil et l'esprit*, 23.

78. Merleau-Ponty, "Eye and Mind," 167; *L'Œil et l'esprit*, 29.

79. Merleau-Ponty, "Eye and Mind," 185; *L'Œil et l'esprit*, 79.

80. Merleau-Ponty, "Eye and Mind," 166; *L'Œil et l'esprit*, 28.

81. Merleau-Ponty, "Eye and Mind," 167; *L'Œil et l'esprit*, 30.

82. See Al-Saji, "A Phenomenology of Critical-Ethical Vision," 375–398, in particular 376.

83. David Scott, "The Re-Enchantment of Humanism: An Interview with Sylvia Wynter," *Small Axe* 8 (September 2000): 205. As I have described elsewhere, whiteness itself can establish a level against which all relations appear. See Helen Fielding, "White Logic and the Constancy of Color," in *Feminist Interpretations of Merleau-Ponty*, ed. Dorothea E. Olkowski and Gail Weiss (State Park: Pennsylvania State University Press, 2006), 71–89.

84. Merleau-Ponty "Eye and Mind," 167; *L'Œil et l'esprit*, 30–1.

85. Merleau-Ponty, "Eye and Mind," 187; *L'Œil et l'esprit*, 84. Italics in original.

86. Merleau-Ponty, "Eye and Mind," 179; *L'Œil et l'esprit*, 61.

87. Merleau-Ponty, "Eye and Mind," 179; *L'Œil et l'esprit*, 62.

88. Merleau-Ponty, "Eye and Mind," 189; *L'Œil et l'esprit*, 89.

89. Merleau-Ponty, "Eye and Mind," 176; *L'Œil et l'esprit*, 53–54.

90. Merleau-Ponty, "Eye and Mind," 176; *L'Œil et l'esprit*, 54.

91. See Landes, *Merleau-Ponty and the Paradoxes of Expression*.

92. Merleau-Ponty, "Eye and Mind," 187; *L'Œil et l'esprit*, 84. Translation modified.

93. Merleau-Ponty, "Eye and Mind," 187; *L'Œil et l'esprit*, 85. Translation modified.

94. Merleau-Ponty, "Eye and Mind," 186; *L'Œil et l'esprit*, 83.

95. For example, Willem Drost (1654), Cornelis Bisschop (1660–1665), and Govert Flinck (1659). Eric Jan Sluijter, *Rembrandt and the Female Nude* (Amsterdam: Amsterdam University Press, 2006), 364–367.

96. Sluijter, *Rembrandt and the Female Nude*, 365.

97. Sluijter, *Rembrandt and the Female Nude*, 356.

98. Sluijter, *Rembrandt and the Female Nude*, 357.

99. Sluijter, *Rembrandt and the Female Nude*, 356–357.

100. Ernst van de Wetering, "Rembrandt's *Bathsheba*: The Object and Its Transformations," in *Rembrandt's 'Bathsheba Reading King David's Letter*,' ed. Ann Jensen Adams (Cambridge: Cambridge University Press, 1998), 29.

101. Wetering, "Rembrandt's *Bathsheba*," 29.

102. Wetering, "Rembrandt's *Bathsheba*," 31.

103. Wetering, "Rembrandt's *Bathsheba*," 32.

104. Wetering, "Rembrandt's *Bathsheba*," 30.

105. Wetering, "Rembrandt's *Bathsheba*," 30. Italics added.

106. Wetering, "Rembrandt's *Bathsheba*," 31.

107. Mieke Bal, "Reading Bathsheba: From Mastercodes to Misfits," in *Rembrandt's 'Bathsheba Reading King David's Letter*,' ed. Ann Jensen Adams (Cambridge: Cambridge University Press, 1998), 140.

108. After his siesta, while walking along the roof of his palace, David sees Bathsheba bathing. Taken by her beauty, he orders that she be brought to him, and he rapes her. When she lets him know she is pregnant, he recalls her husband, Uriah, from battle so that Uriah will assume the child is his own. But Uriah does not sleep with his wife—it does not seem right when the other soldiers still sleep in the field. David decides Uriah must die in battle, which he arranges with a letter to the commander. He takes Bathsheba as his own wife, and the child of their union dies as his punishment (Samuel 2:11). Bal, "Reading Bathsheba," 121–122.

109. Bal, "Reading Bathsheba," 137.

110. Bal, "Reading Bathsheba," 127.

111. Bal, "Reading Bathsheba," 127.

112. Bal, "Reading Bathsheba," 140.

113. Svetlana Alpers and Margaret Carroll, "Not Bathsheba," in *Rembrandt's 'Bathsheba Reading King David's Letter*,' ed. Ann Jensen Adams (Cambridge: Cambridge University Press, 1998), 151.

114. Alpers and Carroll, "Not Bathsheba," 152–153.

115. See Richard Dyer, *White* (London: Routledge, 1997).

116. Alpers and Carroll, "Not Bathsheba," 149, 155–156.

117. The X-ray of Rembrandt's painting shows the letter was added later. Berys Gaut, *Art, Emotion and Ethics* (Oxford: Oxford University Press, 2007), 20.

118. Alpers and Carroll, "Not Bathsheba," 157.

119. Alpers and Carroll, "Not Bathsheba," 158.

120. Gaut, *Art, Emotion and Ethics*, 24–25.

121. Gaut, *Art, Emotion and Ethics*, 23.

122. Gaut, *Art, Emotion and Ethics*, 23.

123. Gaut, *Art, Emotion and Ethics*, 23.

124. Merleau-Ponty, *The Visible and the Invisible*, 138; *Le visible et l'invisible*, 180.

125. Mallin, *Art Line Thought*, 276.

126. Mallin, *Art Line Thought*, 276.

127. Mallin, *Art Line Thought*, 276.

128. Merleau-Ponty, *Phenomenology of Perception*, 137; *Phénoménologie de la perception*, 158.

129. Mallin, *Art Line Thought*, 276. Mallin develops his own understanding of these four regions of existence in *Merleau-Ponty's Philosophy* (New Haven, CT: Yale University Press, 1980).

130. Mallin, *Art Line Thought*, 276.

131. Mallin, *Art Line Thought*, 293–294.

132. Mallin, *Art Line Thought*, 339.

133. Mallin, *Art Line Thought*, 260, 275.

134. Mallin, *Art Line Thought*, 275.

135. Mallin, *Art Line Thought*, 276.

136. Mallin, *Art Line Thought*, 284.

137. Mallin, *Art Line Thought*, 282.

138. Mallin, *Art Line Thought*, 296.

139. Mallin, *Art Line Thought*, 293.

140. As Mallin points out, for Husserl these common structures were "transitional syntheses" and, for Heidegger, "temporality" (Mallin, *Art Line Thought*, 276).

141. Merleau-Ponty, "Eye and Mind," 178; *L'Œil et l'esprit*, 59.

142. Mallin, *Art Line Thought*, 283.

143. Mallin, *Art Line Thought*, 269.

144. Heidegger, "On the Essence and Concept," 184; "Vom Wesen und Begriff," 310.

145. Mallin, *Art Line Thought*, 267.

146. Mallin, *Art Line Thought*, 269.

147. Mallin, *Art Line Thought*, 261.

148. Merleau-Ponty, "Eye and Mind," 184; *L'Œil et l'esprit*, 76. Mallin, *Art Line Thought*, 270.

149. Mallin, *Art Line Thought*, 266.

150. Mallin, *Art Line Thought*, 267.

151. Mallin, *Art Line Thought*, 251.

152. Mallin, *Art Line Thought*, 269.

153. Mallin, *Art Line Thought*, 267. It's important to note here that Mallin's reading of Merleau-Ponty's "inexhaustibility" is an unusual one. It is usually taken as demonstration that the world cannot be reduced to a metaphysical plane.

154. Mallin, *Art Line Thought*, 260.

155. Mallin, *Art Line Thought*, 257.

156. Mallin, *Art Line Thought*, 269.

157. Merleau-Ponty, *The Visible and the Invisible*, 3; *Le visible et l'invisible*, 17.

158. Dolleen Tisawii'ashii Manning, "The Murmuration of Birds: An Anishinaabe Ontology of *Mnidoo*-Worlding," in *Feminist Phenomenology Futures*, edited by Helen A. Fielding and Dorothea E. Olkowski (Bloomington: Indiana University Press, 2017), 178.

159. Manning, "The Murmuration of Birds," 157.

160. Manning, *Mnidoo-Worlding*, 52.

161. Merleau-Ponty, "Eye and Mind," 187; *L'Œil et l'esprit*, 84.

162. Mallin, *Art Line Thought*, 269. Mallin references Heidegger's use of *Vorstellen*, of "representation." In German, *stellen* means "to place," and with the prefix *vor*, we have setting in place before the mind.

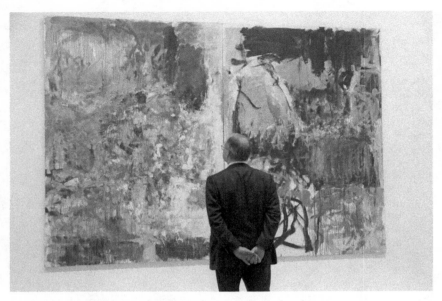

Fig. 2.1 Joan Mitchell, *Un jardin pour Audrey*, 1974. Diptych, oil on canvas, 99.5 × 141.75 in., 252.73 × 360.05 cm. Private Collection France. Photo: Leah Maghanoy © Art Gallery of Ontario.

2

THE ETHICS OF EMBODIED LOGOS
Joan Mitchell's Abstract Expressionist Paintings

> I paint out of love. Love or feeling is getting out of yourself
> and focusing instead on someone or something else.
> Joan Mitchell 1957[1]

I. JOAN MITCHELL'S COLOR ETHICS

Wet Orange (1972) is a triptych field painting with blocks of oranges, browns, greens, and purples that captures the vastness of the Midwest landscapes where Joan Mitchell grew up—cornfields, skies, water.[2] It is luminous, with blocks of color that pulsate against one another, creating an experience of depth across the flat surface of the canvas. In Mitchell's own words, it is like "a living, breathing, pulsating organism with a palpable life of its own."[3] Although the orange is at first overwhelming, overshadowing the other colors, as my eyes move into the world established by the work, other colors come into play; the purples and blues begin to stand out, throbbing against the orange. A variety of brush strokes are used. In places the paint is thick, with gobs of it dripping down. There is a dappled effect, a criss-crossing of colors that jostle up against the brilliance of the orange, which glows more deeply over time. New aspects—new modulations, mixtures, textures, and rhythms—continue to emerge. Even as *Wet Orange* captures an essence of the Midwest landscapes of Mitchell's youth, it cannot be subsumed to conceptual forms. It is the painting of an embodied identity, but it is also a thing that stands independently, allowing it to be encountered by others. At first the work seems to resist my gaze. I cannot incorporate it into familiar concepts or ideas. There is a delay between the ways I perceive and my reflection on that perception. To really see takes time and requires opening up a free space for encountering the work.

This painting provides this free space. Although her triptych unites the distinct realms of each panel, its vastness, even from a distance, requires

the viewer's gaze to move across the work. Since it cannot be seen all at once, it defies the supremacy of vision that draws mastery in the privileged moment of the glance.[4] The three panels of the painting set in motion a rhythm among them even as each functions as a separate entity. There is no "right place" to stand, which allows for the free movement of viewers. This frees space temporally by inviting viewers to move along the work without requiring them to synthesize the experience into a whole. It makes time simultaneous by drawing on and bringing together multiple experiences of nature that specify, articulate, and sediment embodied perceptual structures without fusing the experiences together. It teaches me that seeing what is there takes time, countering the illusion of a world "spread out" before me, of "being immediately present everywhere and of being situated nowhere."[5]

Mitchell's abstract expressionist paintings take my breath away, and they have done so for years.[6] In this chapter I turn to her extraordinary works of color to explore how they enact ethics and reveal encountering alterity without appropriation, domination, or fusion. Her paintings of nature resist the imposition of concepts. They reveal the way nature opens up to her and to the viewers of her paintings with its influxes, interflows, crosscurrents, mixtures, and interpenetrations, even as it withdraws and remains unknowable. Her works acknowledge the alterity of nature and how it alters her. Working with color, they give us the rhythms of the flesh before or on the other side of the cognitive-linguistic that can nonetheless be reflected upon. Her paintings cultivate the perception of nature before the imposition of forms.

Abstract expressionism, a movement that began in New York in the 1940s and 1950s, was about the expression of feelings and inner impulses.[7] But that does not describe Mitchell's works. They are not about the expression of an internal world so much as the expression of her embodied memories of her encounters with places, trees, flowers, water, and landscapes that affected her, and she did not attempt to render them either as likenesses or as sensations: "I paint from remembered landscapes that I carry with me—and remembered feelings of them, which of course become transformed. I could certainly never mirror nature. I would like more to paint what it leaves me with."[8] Her works are situated at the threshold between interiority and exteriority, between her own living identity and the world she encounters that shapes her. They open up an approach to nature that takes us beyond things, drawing on a rich perceptual world inflected by feeling, intuition, emotion, touch, movement, and other invisible metabolisms inherent to embodied perception. But Mitchell does not simply paint

her own feelings. She paints the sentiments of the things themselves. Unlike Jackson Pollock, she painted her canvases against a wall, and the paint dripped downward with the coparticipation of gravity's pull. Her method of working was not one of frenetic activity, focused around the spurt or the line. Rather, she worked slowly, focusing on the "relationships emerging on the picture plane."[9] Her method of painting required contemplation—pauses that allowed her to consider what she was doing as she was doing it: "I don't go off and slop and drip . . . I stop, look, and listen, at railroad tracks. I really want to be accurate."[10] This accuracy is not, then, about expressing her inner emotions so much as attending to that which she paints and thinking about the relations that emerge on the canvas.

Un jardin pour Audrey (1975) is a large diptych oil on canvas that solicits my gaze with its riot of oranges, greens, yellows, and pinks (see fig. 2.1).[11] I begin the encounter by allowing my attention to settle into the first panel because it draws my gaze more insistently. Settling in requires vision's interrogating movement. Perceiving eyes are in constant motion. Just as the glance is always on the move, the attentive gaze also does not sit still. The painting's colors pose to my body a kind of questioning, an "existential rhythm," that attracts or repels. My "gaze pairs off" with the colors in a chiasmic "exchange" between the sensing and the sensible, with neither one nor the other dominating the relation.[12] As a sensible work on the verge of being sensed, it poses the question of how to look at it as a "sort of confused problem." My body must adjust itself, gear into the work, and find the "attitude" that will allow it to come into being for me as "the response to a poorly formulated question."[13] Because there is no object as such for my eyes to grasp, I am more aware of the movement of my gaze across the canvas as it searches for a place to rest. This panel is a lush and complex swirling of oranges, reds, golds, greens, purples, and whites. The reds and oranges are luminous, as are the patches of turquoise and emerald green. The movement of my looking is matched by the movement in this panel. If I focus my gaze on the oranges, they seem to cascade down the left side of the canvas. If I turn to the purples, they jump to the foreground while the other colors almost recede, although the purples are subtler in hue. There is a rhythm to this piece that begins to take shape, emerging only after some time. It is evocative of the sun in the way it lights what is beneath it according to the passage of fast-moving clouds; it is a rhythm created through the relation of the movement of my gaze to the work. The orange flickers across both panels, drawing my eyes to the second panel. Whereas the first panel is lush and vibrating with movement, the second panel is quieter and more meditative, although the luminous orangey red glitters across the darker

canvas like sunlight on a stream. A dark pool begins to emerge near the center in shades of emerald green.

The movement of relationality emerges as a central theme in *Audrey*. As I dwell with one panel, it suddenly shifts from seeming flat and resistant to my gaze to opening up and inviting me in. The longer I spend with it, the more there is to see. Details that had previously gone unnoticed suddenly spring to view. In the first panel, I observe the clearing in the top-left corner along with the way the oranges seem to spill past it on their way down the canvas. The second panel now seems dark and flat. But if I shift my gaze to it and give it time, it too suddenly opens up to depth, becoming lighter, and what now is evidently a garden invites me in. Orange is reflected in the pool. This radiant color seems to carry the essences of both flowers and sunlight, which reverberate with the carnal essences I carry within me. But as my gaze settles into the second panel, the first one goes flat and again resists my gaze. Just as two hands that belong to one body can touch and feel different things at the same time, so too can artworks have incompossibles—more meanings than one that do not fit logically together in the way cognition demands.[14] But in my encounter with this painting, the incompossibles reach beyond the body of the work to intertwine with my own embodied perceptual cognition. To experience the two panels in depth at the same time, my eyes must run back and forth across them, creating a chiasmic intertwining with the two that allows each one to bend into and reflect the lines of the other, holding them both open at the same time without one being subsumed into the other.

According to Merleau-Ponty, every painting or spectacle has a "total logic" belonging to the structure that presents a world; it is the experience of a certain "coherence between colors, spatial forms, and the sense of the object."[15] When we stand close to a painting, we see "smears of paint." Taken out of the context of the whole that provides the field of vision, "the color itself changes." This is what happens when the painter gazes at a "mountainous landscape," isolating a patch of green through squinting their eyes, which is to adopt an "analytic attitude." The color no longer represents the meadow. It is no longer the same green.[16] Isolating the color "destroys" the system of the visual field, which is organized around a "dominant color," and "the precise contrasts of the lighting; no longer are there any determinate things with their own colors."[17] This is why, for Merleau-Ponty, there is a correct place to stand before an artwork.[18] In a painting the dominant color sets the lighting level for the whole work, according to which everything within the work is seen. Moreover, once it has established itself as a level, like lighting, it directs and leads the gaze, becoming neutral in the

way that electric lighting initially stands out when it is first turned on in the evening but then moves into the background.[19] Lighting is actually "prior to the distinction between colors and lights," which is why "it always tends to become 'neutral' for us."[20]

An abstract painting like *Audrey* also has a logic, level, or coherence that belongs to the work—but it is not the same as the one described previously. When I encounter this work over time, the logic seems to shift. It is in constant movement. In order to take in both panels at the same time, there is a right place to stand before the work. Nonetheless, *Audrey* encourages me to walk within the garden, as well, alongside the two panels. When I stand close to the canvas to look at the details, I am surprised to see the thickly dabbed gobs of paint, the drips, the singularity of the colors before they intertwine with others in the painting as a whole, modulating individual tufts of color. The colors do not represent, so they cannot lose their representative value when I stand close to the work. But this does not mean they are mere patches of color; these extraordinary brushstrokes of animated color still modulate one another. Attending to them is not unlike bending down to encounter a plant or flower in a garden up close. Although the colors in Mitchell's works resist a representative value, the rich details, even if taken out of the context of the ideal point of view, are astounding in their vivid presence.

In the modern age, most scientists and philosophers do not trust the phenomenal experience of perception to give us the real world. The phenomenal experience of color, in particular, poses problems since it is not clear whether color belongs to the things or to the perceiver. In his pivotal experiment, Isaac Newton found that white light could be split into its component colors when passed through a prism. Because the component colors returned to white light when passed through another prism, he concluded that colors do not belong to the things themselves but rather to the perception of light's wavelengths. Objects have colors because they are "disposed to reflect various types of light rays."[21] The sensation of red is caused by the refraction of "light from the long wave end of the spectrum." It is also generally accepted that humans have trichromatic vision—color cones sensitive to blue, green, and red—whereas other species—like bees, for example—detect ultraviolet light that is beyond human capability. But there is much that cannot be agreed on. Realists hold that color in some way belongs to the things and is represented to the perceiver: "sensory impressions or stimulations are received from the external objective world," causing "items in an internal, subjective medium," which "stand for, correspond to, or in some way re-present the properties of the external world."[22]

Subjectivists, or eliminativists, as they are also called, hold that colors are subjective qualities that are either projected onto objects or emerge out of experience.[23]

In whatever way the research is parsed, scientists working from varying theoretical assumptions seem to generally agree that phenomenal experience is merely subjective.[24] In particular, they have struggled with the question of how humans perceive the constancy of colors "whereby the perceived or apparent color of a surface remains constant despite changes in the intensity and spectral composition of the illumination."[25] For Merleau-Ponty, however, explaining color constancy is not a problem; color remains constant when it belongs to a field. This means it adheres neither solely to the viewer nor to that which is viewed. He cites an experiment where viewers look into the interior of two boxes: one painted white and dimly illuminated, the other painted black and brightly illuminated. Both boxes appear grey until a black piece of paper is introduced into the white box and a white piece into the black box. The first box now appears white and faintly illuminated and the second black and brightly illuminated. They now belong to a field: "For the lighting/object-illuminated structure to be given, there must thus be at least two surfaces with different reflecting powers."[26] Although Merleau-Ponty is responding to the science of his day, contemporary scientists still question the physical possibility of color constancy; they ask how observers judge constancy, what neural mechanisms are at work, and whether natural scenes work differently than the laboratory situation without, it seems, taking the phenomenal field into account.[27] One contemporary scientist does note that one of the biggest challenges facing research in color constancy is moving the research out of the laboratory, which provides results that are "deterministic, and relatively simple," and into natural situations with the "intrinsically variable nature of real surfaces and illuminations."[28]

But for the phenomenologist, the world, physis or nature, does not exist as an objective reality we approach only imperfectly through our sensing bodies. The body is not simply a "transmitter of messages."[29] Human bodies, like other living creatures, open onto a world to which they belong; they are also of nature and so able to expressively disclose and communicate with the natural world through the ways they take it up. A thing does not become real for vision, or for touch, but rather presents as an "absolute reality" when it is given in its "maximum articulation"—a visual field the body grasps in "richness and clarity," where all the senses confirm one another to provide a world: "it is the matter itself that takes on sense and form."[30] There is a logic to the world that bodies understand, and to have

a sensing body is to be geared into this logic. It is to possess a schema or structure of the "inter-sensory correspondences" that constitute a world that extends far beyond what one perceives in the moment. This is the logic of the world that opens itself to human bodies and their perceptual structures while, at the same time, "animal behavior aims at an animal milieu (*Umwelt*)" and the ways the world resists it. For this reason, the experimental situation does not allow for this intercorporeal communication and isolates natural stimuli by breaking down these structures; it does not allow for explanations of how bodies take up the world.[31]

Colors are perceived as constant because human perception of them leads to a world and to things. Colors belong to particular objects, and because the things remain constant, so do their colors: "the blue of a rug would not be the same blue if it were not a wooly blue."[32] And the carpet belongs to an entire perceptual context that is a field of perceptual relations including touch, hearing, seeing, and also smell. When empiricists seeking an objective explanation for color look at a white wall in shadow or a grey piece of paper under light, they conclude that the colors of the wall and the paper remain constant as white and grey because these are the colors they *remember* from "normal" lighting conditions. They artificially reconstruct the phenomenon.[33] Merleau-Ponty simply sees the piece of paper more clearly. His gaze has a better grasp on it because it "is more luminous, more clear." At the same time, the wall that is not lit recedes from his visual grasp.[34] Judgment or reflection, like empiricism, also falls short. Although he intentionally extends beyond himself to a world, it is not one he posits as a "certain identifiable quale throughout all of the experiences that [he] has of it." The constancy of color is not ideal. In "living perception" color provides "an initial approach to the thing," which cannot be recreated in the experimental situation of the laboratory, which isolates one ideal way that color appears and ignores all the others.[35] Colors belong to the things, to a world, and to an existential milieu with which the perceiving subject is "synchronized."[36]

Merleau-Ponty favored Cézanne because the painter went straight to the world of things themselves in which we are anchored; he made "*visible* how the world *touches* us," how the things appear and organize themselves "before our eyes" in a "primordial world."[37] This organization of the world relies upon all our senses working together and confirming one another. When Merleau-Ponty gazes at "the brilliant green of Cézanne's vase, it does not cause [him] to *think* of pottery, it presents it to [him], it is there, along with its thin and smooth outer surface, and its porous interior, in the particular manner in which the green is modulated."[38] If a phenomenon

"presents" itself to only one of his senses, it might seem almost a "phantom." But in the painting, it is not just the green he sees but also the way it feels, the smoothness and texture of the vase, and its fragility. The vase is not a phantom; it approaches "real existence." Because the painting opens onto a world, all the senses confirm one another; a painting includes "even the odor of the landscape."[39]

But I cannot gaze at *Un jardin pour Audrey* as one would an object in the world as such. My gaze is generally more at home in a figurative painting since it is already familiar with the things it gears into to encounter the work. It revives previously sedimented ways of perceiving. Mitchell's paintings do not so easily offer this comfort. I encounter the painting by responding to the solicitation of the vibrant colors to look at it, yet being open to the work is, in itself, not sufficient. I must dwell with the work, specifying, articulating, and sedimenting new perceptual structures. Colors are not given as "sensations" but rather as "sensibles."[40] To see the work is to see according to it, to enter into its world, and this I can do because I am *"sensitive"* to colors. Merleau-Ponty is right that perception is anonymous and prepersonal in that I cannot make my body respond to the work. I give over to the painting. I do not try to think it just as I do not think the blue of the sky, or stand over and against it as I might an object. Rather, the blue of the sky "thinks itself in me."[41] My body responds to the blue, which, in turn, invites my body to gear into its depth. This sensitivity is a corporeal capacity that precedes me as a subject that opens my body onto a world through a "kind of primordial contract" without me even trying. Because perception is this pact with a world, it belongs to a horizon and a visual field.[42] Although my body is sensitive to colors, the visual field in *Audrey* is not immediately familiar to me—certainly not through conceptual categories but also not in terms of things. The work breaks open any conceptual unity or pact between my body and a given world of forms and allows for the creation of new relations and new ways of relating. My body engages with the "'vibrations' of the whole painting, even when the details are not visible."[43]

The painting offers up an abundance of intertwinings—of tufts and thickets that belong to flesh. As I stay with the painting, my phenomenal perception is drawn into relation with it, setting to work in me without me. I run my eyes over its surface, encountering it rather than projecting onto it ideas and concepts that would only shut the work down rather than open it up. After spending a couple of hours with it, I find that when I walk away from it through the gallery, Mitchell's other works have become more intense: the colors and lines have a sharpness to them that I do not remember

from my first walk around. My embodied regions of existence have come to the fore; the cognitive-linguistic has receded. I perceive now according to the work and according to the new perceptual structures the painting has opened up for me. *Un jardin pour Audrey* has cultivated my perception, further specifying, articulating, and sedimenting my corporeal sensitivity to colors that in no way could be referred to as mere sensations.

According to the accompanying information that tells viewers how to understand the painting, *Audrey* portrays a heavenly garden. When possible, as in this case, I only read about the work at the end of my first encounter since I do not want the art historian's categories to shape the experience for me.[44] This concept of heavenly gardens united as one does not sit well with me. I have noticed, for example, how in both panels there are drips of paint moving from top to bottom that seem to become more insistent over time. They draw my vision into the ground even as the colors lift it up. I feel the downward motion. The dark strokes at the top of both panels also push the eye downward. If this is a heavenly garden, why does the pull of gravity draw the viewer so decidedly back to earth? The materiality of the work suggests to me that we cannot leave the world behind. Heaven is on earth—in our intertwinements with one another, with nature, and with the world. The painting was apparently dedicated to Mitchell's friend Audrey Hess, who had recently died. To love someone is to recognize their complexity, the incompossibles or contradictions, and to accept the bleaker moments along with the joyous ones. The essence of Audrey continues to live in the flesh of her friend—the painter—and the flesh of this painting, which is, in turn, opened up to me to reflect upon through my encounter.

Although Merleau-Ponty was a contemporary of the first abstract expressionists, he did not engage with their works.[45] They did not give him the phenomenal reality he sought. Colors are not secondary qualities. They can present us with things, "forests, storms—in short the world," because our vision knows how to understand this carnal world of colors that provides a "deeper opening upon things."[46] But in abstract expressionist painting, there are no things as such. This does not mean the colors employed do not touch on the world—but it is a material, fleshy, and conceptless world. Modern artists aim at "multiplying the systems of equivalences, toward severing their adherence to the envelope of things."[47] Nonetheless, these systems of equivalences are a further indication that there is a "logos of lines" that our bodies understand. Bodies respond to these lines, which can be transposed into any medium. Artworks speak to an embodied logos that understands the logic of lighting, color, and movement. It is not a matter of choosing between figurative and nonfigurative painting: "it is

true and uncontradictory that no grape was ever what it is in the most figurative painting and that no painting, no matter how abstract, can get away from Being, that even Caravaggio's grape is the grape itself."[48] Abstract and figurative paintings all belong to this same circuit of being that shows itself, reverberates, and modulates in things and their appearances.

But Mitchell's works do not give us things; they give us essences—carnal essences as embodied perceptual ideas. These essences emerge from her embodied perceptual experience. They are not sensations; they are the intuited essences of the landscapes around her: "If only I could feel a sunflower" and "I can feel the sunflower almost physically."[49] The colors and movement of the sunflowers echo within the painter's body, which bends into, takes up, reflects, and responds to the sunflower's lines.[50] Although orange and yellow are the predominant colors of *Sunflower III* (1969), a cascade of colors tumult down the left-hand side of the canvas, tending toward, but never finally coming to rest, in definable forms.[51] Besides yellow there are also greens, blues, reds, purples, oranges, and browns. On second glance, the white on the right-hand side of the canvas is white painted over oranges, pink, and green, gobs of white painted over dark blue. The colors flow into one another, a dancing and glittering harmony. Her paintings of sunflowers are not at all still lifes, as such; they resonate with the vibrant colors, the energy, the movement, and the vitality as well as the fading away of sunflowers. They reveal how we can bend into and respond to alterity without having to conquer, fuse with, or dominate it. They show how responding to alterity in this way does not threaten one's identity; it deepens it.

Put otherwise, she paints the "sum of the character of a subject—whether water or tree—as she has come to know it through numerous past and recent experiences that are interwoven in paint."[52] These essences, while not figurative, communicate the way of being of a sunflower. They reveal how to perceive according to sunflowers, not only in terms of color and light but also in terms of energy, emotion, and movement. These essences are not platonic. They are more a *Sosein*, a way of being, than a *Sein*, or being itself. They adhere to "a time and a space that exist by piling up, by proliferation, by encroachment, by promiscuity."[53] They bring the past with them in perceptual encounters that belong to the present against the horizon of the future. Mitchell accomplishes this piling up through building bridges among the landscapes she encounters. She articulates on canvas the ways she has been interpenetrated by them—the ways they intermix with her and within her.

Mitchell's paintings enact ethics by cultivating embodied phenomenal perception to be open to alterity, to that which alters us. As an artist,

she reveals alterity not through appropriating it into her own work without acknowledgment but rather by showing how it deepens her own identity and sense of self. Her works allow for other metabolisms and relations than our relations to things. They reveal how reality is relational and expands our understanding of what it means to be in touch with being. She describes this experience as "empathy . . . that's all my painting is about. My empathy with nature, dogs, gardens, and all that is just the way I am. It has to do with something you feel."[54] It is more difficult to encounter her works if one remains geared primarily into the cognitive-linguistic realm of existence. Since seeing is so closely tied to representation, concept, and form, the mimetic tendencies of figurative painting can potentially allow the viewer to remain conceptually engaged, inhibiting the work from fully setting to work. Nonetheless, the paintings still work in me without me. Mitchell's works draw on colors and lines that beckon to bodies to respond. Whereas Cézanne brought the logic of corporeal perception into appearance, Mitchell transposes other corporeal metabolisms onto the visual plane. Her works reveal the expansiveness of perception to the possibilities of these alternate and invisible metabolisms for opening up our relation to nature. They reveal how she bends into the lines of nature and how nature opens her up to new and generative forms of expression. It is not just a way of seeing; it is a relational practice. This is the meaning of nature in its Greek sense of physis: as generativity.

II. Luce Irigaray and Painting the Real

Luce Irigaray is also concerned about the imposition of forms on what we see. In this modern age, forms, or categories of understanding, are usually made from someone else's vision according to use value or mental constructs so that we do not actually perceive what is there in itself and do not allow it to provide its own forms: "our 'I see' is equivalent to 'I recognize': I recognize a form, I recognize a concept. I recognize something that already has a face according to a model, a paradigm, an *eidos*, that I have been taught."[55] In the previous section, I argued for an ethical enactment provided by Mitchell's paintings. In this section, I show how Irigaray makes a similar argument philosophically. Specifically, I take up her criticism of Merleau-Ponty's essay "Eye and Mind," where vision itself becomes appropriative. Although he aspires to be relational, Merleau-Ponty too often slips into the metaphysical narcissism of the singular male subject, who, in universalizing his experiences, encounters only himself, appropriating alterity without acknowledgment into his own flesh.[56]

In his late work, Merleau-Ponty rethinks the philosophical founda-
tions reflected in the concepts he introduces, like "flesh" and "chiasm." For
Irigaray, he nonetheless builds his ontology on unexamined foundations
because he still belongs to the metaphysical tradition of Western philoso-
phy that does not take alterity into account. She attributes this narcissism
as emerging with Greek philosophy and subsequently providing the gram-
matical and symbolic system of thinking in this age.[57] Expanding philo-
sophical conceptual language does not, in itself, change this system. The
move to place "man" at the center derives from his lonesome position as the
singular subject incapable of relating to other subjects different from him-
self. For the ancient Greeks, women are seen as contributing matter and
men form to the creative process in both the natural and cultural realms.
In this phallomorphic symbolic system, the creative potential of what is
variously referred to as the feminine, nature, or matter does not exist in its
own right but only in the way it is appropriated into the actuality provided
by form linked to the masculine and mind.[58]

The division created between matter and form institutes yet another
division between the seeing of Plato's forms and the sensibility of the ma-
terial, which is accessed by touch. It is to forget that seeing is only possible
because it overlaps with a world that is sensible to touch; it is to forget that
there is an "interweaving of the material and ideal strands of the field of
vision."[59] As Cathryn Vasseleu points out, "an elaboration of light in terms
of [the materiality of] texture" means sight cannot be represented as a sense
that secures independence and distance between viewer and object.[60]
With the imposition of this binary, the actual or real is articulated accord-
ing to the form or logos of the singular subject. Since there is only one
subject position, there is only one perspective on one same world. What
Irigaray calls the maternal-feminine could provide a morphology of fluid
multiplicity and potentiality that exceeds one form, eidos, or representa-
tion, but it is designated as excess or as the other side of the binary inherent
to Western thinking. In this binary logic of the one and the other, of A and
not A, the masculine is the one and the feminine its negation.

Irigaray does not suggest we return to some new origin since it is pre-
cisely a return to origins that comes out of the reliance upon one singular
perspective that she calls into question. She returns to the Greeks to show
how it is in the continual forgetting or covering over of this first differ-
ence, sexuate difference, that difference itself is not instituted in Western
thinking. But in insisting on this first difference and so making it an origin,
her work also reveals another forgetting established at the beginning of
Greek philosophy. The forgetting of sexuate difference cannot ultimately

be disarticulated from the forgetting of other differences, such as those imposed through slavery and class privilege. Irigaray fails to recognize that it is this same binary logic—separating deliberating thinking subjects as the creators of form from nonthinking laboring and reproductive bodies—that underlies both slavery and sexuate difference.[61] As well, I would argue, it is the logic of the binary that installs rigid articulation of gender identities and contributes to the policing of trans and nonbinary gender identities. This is the logic of the singular speaking subject, who, although referring to no one in particular, nonetheless excludes bodies that differ from the norm it establishes.

At first glance it would seem Irigaray's critique of Merleau-Ponty is unfounded. To recall, Merleau-Ponty explains at the beginning of "Eye and Mind" how scientists forget the embodied perception upon which their operational thinking relies, which means they do not encounter the world but rather impose their own systems on what is there. But for Irigaray, Merleau-Ponty performs the same imposition. He forgets that it is not only because he is embodied that he is able to perceive but also that primordial corporeality is not itself subject to any distinction or grasp.[62] The logic of the singular subject is retained in the phenomenological method, which requires that the philosopher/painter be able to actively reveal or bring to light what *he* perceives.[63] Phenomenological description is *"apophanesthai ta phaimonena*—to let that which shows itself be seen from itself in the very way in which it shows itself from itself."[64] For Heidegger, logos or language provides for the gathering of this showing or making manifest from within the milieu. For Merleau-Ponty, "mute Being" shows itself to the painter. Something leaps out and catches his eye.[65] But there can be no perception before the subject is able to make sense of what is there. Merleau-Ponty privileges vision because it is, for him, far more active than passive. His vision actively interrogates the world because he does not consider the deep passivity of vision that incorporates the tactile—for example, that our eyes are touched by light waves.[66] Instead, the phenomenologist/painter's vision is "voracious"; it provides "visible existence" to what everyday or "profane" vision assumes to be invisible. It allows him to "possess the volumnosity of the world"—that is, to see space—without having to touch it or move through it; it allows him to possess the world at a distance.[67] In the phenomenologist's account, vision remains active, and the passivity inherent to perception is obscured. For Irigaray, this is because he does not consider the first touch, the primordial perception that takes place in his mother's womb before he is able to actively see or touch.[68] Before there was light.

Irigaray reminds us that since Plato's cave, light has been a metaphor for philosophical enlightenment. For the phenomenologist, its shining imposes its logic on the things to which it leads his gaze. Lighting seems "neutral" because we do not perceive light itself; rather, we "perceive according to light."[69] Although he understands that lighting, like concepts, establishes a level according to which everything is seen and everything relates, he forgets that lighting, like ideas, ultimately cannot subsume the carnality of the things in themselves. In forgetting that his eyes are touched by light waves, he assumes his vision will lead him straight to the things.[70] But light is not sufficient to allow us to see the things, the world, or relations around us since things differentiate themselves through color. Colors do not submit to binary logic or conceptual forms, despite theoretical attempts to do so, such as the opponent process theory of color vision, which assumes the oppositions of red/green, blue/yellow, and black/white.[71] Colors are many hued; they belong to the textures of the flesh that are material, temporal, and symbolic. They resonate and reverberate chiasmically, as Merleau-Ponty himself observes, deepening one another as this red becomes more brilliant nestled, as it is, alongside this blue.[72] But colors also belong to the flesh, which allows one to see but cannot itself be seen; colors have rhythms that precede and cannot be subsumed to the logos of lighting, which would be the case if they were available only to vision. But they are also affective. Art accomplishes what philosophy cannot. It provides a way for the body to mediate its affections and bring them into culture and the collective imaginary.[73]

Merleau-Ponty recognizes the corporeity of color. Nonetheless, for Irigaray, if he cannot acknowledge a perception that precedes his, that took place before he could see and before he could actively be involved, he cannot be open to perceptions that are not his. Without this recognition, there is, in effect, no gap or spacing between the active and the passive in the "experience of perception."[74] Certainly Merleau-Ponty moves beyond the "classic economy of representation," whereby subjects stand over and against objects they represent to themselves and hence control. He understands his body to be a thing among things and yet, nonetheless, a thing intertwined with the world he inhabits. What ultimately distinguishes his body from a thing—and, in his terms, makes him human—is that, unlike things, he is capable of self-affection. Irigaray recounts how she was present at Merleau-Ponty's lecture at the Collège de France when he demonstrated the touching of the touch; he displayed how he was capable of self-affection by showing how he could touch his left hand with his right and how he could touch himself touching the things.[75] This reversibility

of the sensing and the sensible is also evident in how he can hear himself speaking and even see himself seeing if he catches sight of his reflection or uses a mirror. He acknowledges what is mediated through his own active perception. Actively reflecting upon things and the world in terms of self-affection, he is a subject in relation with himself. He gives up the possibility of having a perspective on things that are not tied to his own perceptual mediation of the world. He forgets the latency of the flesh that precedes the reversibility of the chiasm. This means his seeing is not open to the other's seeing as completely other or to the invisible as invisible. The other is the invisible as the other side of the visible.

What is missing is a "free space-time" that would allow for a spacing between seeing and being seen, an asymmetry that would allow the phenomenologist to reflect upon "what produces this perception—be it active or passive."[76] Without the interval required to reflect upon the difference between the active and the passive in the operation of vision—if all that is seen is simply appropriated into his own body—his imaginary actually works to cut him off from things and others because it simply "doubles the real." He encounters the world and others through his own imaginary, according to that which passes into his body, but it does not put him into relation with the world and with others.[77] In this way vision mimics categories or the imposition of forms. If he only reflects the world and the other, he secures them according to his own vision. The specular double allows things to be seen—to become completely visible. The phenomenologist/painter makes the things we encounter in our everyday world become strange so that they come into appearance to be reflected upon in the ways they appear. But instead, things become strange to themselves, and the "specular reflection" is ultimately an "illusion."[78]

The philosopher/painter is the singular subject who is not in relation with alterity. Merleau-Ponty's phenomenologist/artist appropriates what is there for his own imaginary. The artist does not simply move beyond profane vision to bring into appearance the "'light, luminosity, shadows, reflections, color' which are 'not altogether real beings'" and thus are not usually seen.[79] The painter appropriates the mountain's changing forms for his own image. Rather than making us see what most others cannot, the painter retains his own profane vision because he never questions what the things really are in themselves. His active and interrogating gaze remains at the surface because he paints only that which is available to his "vision and to his ability to be confronted with their visibility," which means that the things are cut off from their own surroundings and the things with which they co-dwell. They are "arranged before the gaze of

the painter," which is installed into the situation only through the fact that it sees and can be seen. The claim that the painter can reproduce this flesh echoes the "activist technocratic" pretensions that Merleau-Ponty himself criticizes at the beginning of "Eye and Mind." For the painter to reproduce flesh is to rely solely on the visible and its instruments—for example, the mirror.[80]

The singular subject is perhaps best explained in Merleau-Ponty's understanding that we share the same world even if we have different viewpoints or perspectives on it. In *The Visible and the Invisible*, he explains how perception is not locked inside separate and solipsistic consciousnesses. For example, if we approach the phenomenon of color perception according to an idea or representation, we cannot be sure that we see the same color as someone else since ideas and representations cut off from embodied perception belong only to mind. But to experience colors imminently, as it were, he need only look at a landscape and speak about it with his friend: "Then, through the concordant operation of his body and my own, what I see passes into him, this individual green of the meadow under my eyes invades his vision without quitting my own." Rather than it being either he or his friend who sees, they are both inhabited by "an anonymous visibility," "a vision in general" that is both particular and universal.[81]

When Irigaray looks at a landscape with someone else, and the green of the pasture she sees is confirmed in the gaze of the other, this confirmation is not because they happen to share the same world; it is rather because they see differently when they see with one another. Her gaze is instead "modified" by the gaze of the other. The chiasm is not simply between her exterior and her interior—between what she sees and that her gaze is seen—but it is also at play between two who are different who are gazing at the same landscape "because flesh circulates between the world and [her], between the other and [her]self."[82] It is not simply that humans belong to the same world, the same flesh, but that they also have the capacity to be in relation in sharing the world. When Merleau-Ponty writes about the ways humans "haunt one another," and the way he haunts with them "a single actual Being," he means these others inhabit the same subject positions and the same world.[83] This sharing is a belonging to a world that intertwines the material, ideas, and all elements of being, and because humans are both seeing and visible, they can see that others see and inhabit this same fleshy world. But for Irigaray, intertwining is not yet a relation with other humans or other beings.

For Merleau-Ponty, the mirror is visible evidence of the ways flesh folds into flesh, the ways we intertwine with one another. But, for Irigaray,

his vision is ultimately a mirror vision that reflects him back to himself. He understands the mirror as a technique of the body; as embodied, he is "seeing-visible," and "the mirror translates and reproduces that reflexivity" that belongs to the sensible.[84] His "body can assume segments derived from the body of another, just as [his] substance passes into them; man is mirror for man. The mirror itself is the instrument of a universal magic that changes things into a spectacle, spectacles into things, [himself] into another, and another into [himself]."[85] As reversible, the other's vision only gives him back to himself. He does not acknowledge the invisible interiority of the other: "through other eyes we are for ourselves fully visible."[86]

But when the look understands itself as a mirror of the universe, it misses that which is communicated in ways other than through visibility. Flesh is "made more from touch than from sight."[87] It is not merely through vision that one body takes up the body of the other. And it is not merely a relationship between exteriority and interiority. My "body can become the body of the other" because others affect me through my communication and interaction with them so that "my interior space is modified by the things, and even more by the others, whom I encounter."[88] Although Merleau-Ponty works with the intertwining of the senses—the opening of all senses onto the world—they ultimately belong to a visible world. As we saw with Mitchell's paintings, the world is given to us not only by sight but also through other senses and "metabolisms."[89] They intensify our embodied phenomenal perception, allowing us to see what is visible as well as what is not. They cultivate our perception of the world around us before the imposition of forms, even "forms [that] breathe."[90]

Cultivating perception requires not only developing an ability to reflect upon seeing as well as hearing and touching, but it also requires the coparticipation of that which is perceived. Acknowledging difference and the invisible worlds that accompany that alterity would allow Merleau-Ponty to more effectively resist appropriation—appropriation of the other's world into his own. Irigaray describes chiasmic perception in terms of our ability to interlace with both "the world of the other" and our own world, resulting in "multiple intertwinings where each one succeeds in remaining oneself and respecting the other as other."[91] Different subjectivities coming into relation with one another opens up "new spaces created by their difference."[92] This free space-time is that which allows one to be able to "welcome what is exterior to oneself without appropriating it, without reducing it to oneself."[93]

In these intertwinings, it is important that it is not a relation of appropriation but rather that each one remains themself while respecting the

other as other, even as their world is open to new perspectives through intertwining relations.[94] Merleau-Ponty describes the chiasm in terms of the figure of the Möbius strip as "the obverse and the reverse, or again, as two segments of one sole circular course, which goes above from left to right and below from right to left, but which is but one sole movement in its two phases."[95] This circular loop describes the sensorimotor feedback loop of the individual subject.[96] For Irigaray, the chiasm is a "double loop in which each one of the two can go toward the other and come back to itself."[97] In her version, the feedback loop is not a closed system; it can be opened up by our relations with others.

Irigaray suggests it is enough to live and recognize our indebtedness to "a co-belonging," to "a world from which we are never completely detached. For, how could we live without air, without light, without sun, without fruit, without earth under our feet, or sky above our heads?"[98] We are never completely isolated from a living world, which is not the same as to say we are things among things. This is why the forms never stabilize in Mitchell's paintings. Painting was her way of living and encountering the world, and her paintings were the expression of her encounters: "If I can't paint, . . . I can't breathe."[99] Language "imposes" verbal constructions that do not "coincide with the form" that living things give to themselves.[100] But living things give us to see, and in doing so provide energy, whereas the things we see that come out of our own constructions, our own forms, take energy from us—the energy required to make room for things in our world. Merleau-Ponty alludes to this when quoting Klee; he writes that the things are sometimes experienced as though they look at us.[101]

For Irigaray, this feeling emerges from the "gift of seeing" that living beings provide.[102] The tree gives because it "unceasingly creates space." If we put aside names, such as the beech tree or the maple, identifiable by the shapes of their leaves and the colors of their bark, if we really perceive the tree and its becoming, which is different from human becoming, it gives space rather than requiring us to make room for it. Humans make room for things by including them in their world.[103] Something made by humans— a table, for example—draws upon viewers' resources and the forms they must impose to create a space for it. In this age, we tend to perceive the world in terms of how things are useful, and we do not even notice them unless they break down, as did Heidegger's hammer. But our encounters with nature remind us of an "abundance" given "to be contemplated, heard, breathed, touched, felt"—an abundance that does not need to be named to be encountered.[104] Mitchell said her paintings "did not need to tell a story; . . . if a painting is good there should be nothing one can say about

it."[105] We do not have to make sense of the natural world. To have contact with nature, we must only be attentive.[106] This difference that nature provides keeps our vision open and alive because it requires us to move beyond given cultural forms that shape the ways we see. Difference requires us to look beyond imposed meanings and their utility, whereas cultural complicity compromises our ability to see.[107]

Irigaray does not give up on painting. But for her, the task of the painter/phenomenologist is not simply to make the world visible for others. Rather, it is also to let the invisible be seen as invisible. Why, she asks, is the invisible not taken up by Merleau-Ponty in his account of painting, or only in the ways it is made visible by the painter? She suggests it is because taking up the invisible would require a different approach to vision that would take touch into account: the tactile dimension of a crossing of looks, which is not only about seeing but also about the lives that support these looks, the "breaths," and the "energies." Rather than showing us how to see, for Irigaray a painting "becomes a transmission of truth, a message of love, a work that is always already common, a creation of world, a manner of saying that which words and musical notes would have been unable to express."[108]

Irigaray wants not so much to displace the importance of vision as to open it up so that it is not subject to the categories or forms that have always already been imposed in advance. She calls for cultivating our perception of what is there, which includes the invisible. Merleau-Ponty does not yet provide for a relational ontology because, in keeping with the history of Western philosophy, he begins with the singular subject who, although embodied, ultimately provides only one point of view. This ontology might speak to a corporeal logos, but it is the logos of his body, and it is the logos of a body that forgets the maternal-feminine—the life and corporeality that made it possible for him to see. For Merleau-Ponty to be in relation with himself and the things is not yet to be in relation with others. His project allows for reflection on the prereflective world of embodied perception. But awareness of the significance of embodied perception does not yet provide for an ethical account of the real. Merleau-Ponty was a philosopher of his age and culture, and the impetus toward metaphysics and its imposing of forms still shapes his thought. This impetus in thinking is powerful. Irigaray is also a philosopher of this age, and that, too, haunts her work. Along with the history of Western philosophy, it rests upon other foreclosures to difference, such as the forgetting of slavery and class differences inherent to the first beginnings of Western philosophy and still at work in contemporary racism and class oppression.

But there is another forgetting at work in the history of Western philosophy. It is not only a matter of opening it up to difference. Its singularity as a knowledge system needs to be debunked or it will merely continue to appropriate other ways of knowing into its own without recognition. Western philosophy or logos is not the only effective knowledge system—there are multiple ways of knowing that have been opened up through embodied perceptual cognition—ways of knowing that are open to being taught by the natural world. These knowledge systems or worlds have been systematically undermined through colonial oppression which assumes the superiority if not the existence of only one knowledge system—an assumption that seems to be inherent to Western philosophy itself.[109] My suggestion is that attending to what and who are actually there can contribute to breaking open this imposed system.

Cultivating perception requires acknowledging alterity and its giving. Appropriating what is other without the acknowledgment that alterity both exceeds perception and also contributes to who we are reduces human perception to a kind of sensation that forgets it belongs to a milieu. It forgets that things appear against an enabling background that in itself remains invisible. In this age, that invisibility remains unavailable to reflection. When difference is acknowledged, we move beyond the singular subject and can no longer take the human as the center of all perception and all intertwinings. Decentering humans in this way does not mean they are no longer subjects, which would mean they would not be agents and would not be responsible for what they do. Instead, it means they are responsible for how they perceive and intertwine with multiple worlds, with nature or physis, and with others. They are responsible for their practices of living. Irigaray and Mitchell both remind us of this. Like the nature her works prepare us to encounter, Mitchell's paintings resist the imposition of cognitive-linguistic forms and representations. They resist phenomenological revealing into appearance. Instead, they invite embodied perceptual cognition—a coparticipation in the creation of meaning that begins with a corporeal logos as a responding to nature's lines and a bending into them with the very language we use to describe the works. It is language that respects that which contributes to its articulation. If we stay with her paintings and take the time to encounter them, as Irigaray describes, they alter our bodies and open our thinking to other dimensions and metabolisms that generally remain concealed. Nature can never be pinned down by the forms we impose, and this is what Mitchell's paintings reveal.

Notes

1. Quoted in Robert Hobbs, "Krasner, Mitchell, and Frankenthaler: Nature as Metonym," in *Women of Abstract Expressionism*, ed. Joan M. Marter (New Haven, CT: Yale University Press), 63.

2. Joan Mitchell, *Wet Orange*, 1972, oil on canvas, triptych, 245 × 112 in., Carnegie Museum of Art, Pittsburgh. The image can be found at https://collection.cmoa.org/objects/f47a21c9 -75ab-4195-b494-e248f4dc9beb.

3. Judith E. Bernstock, *Joan Mitchell* (New York: Hudson Hills, 1988), 120.

4. For Edward Casey, the glance is also that which orients me in space and allows what I see to leap out and beckon to me. It precedes and is intermingled with the attention of the gaze. Edward S. Casey, *The World at a Glance* (Bloomington: Indiana University Press, 2007), 309, 164.

5. Merleau-Ponty, *Phenomenology of Perception*, 330; *Phénoménologie de la perception*, 365.

6. Over the past years, I have sought out and visited several major exhibitions on Mitchell's work, including *Mitchell / Riopelle: Un Couple Dans La Démesure*, Art Gallery of Ontario, Toronto (October 12, 2017–January 7, 2018); *Joan Mitchell*, Palazzo Magnani, Reggio Emilia, Italy (March 21, 2009–June 1, 2009); and *The Paintings of Joan Mitchell*, Modern Art Museum of Fort Worth, Fort Worth, Texas (September 21, 2003–January 7, 2004). I also seek out individual works in the various museums and galleries I visit.

7. Mitchell never achieved the fame and recognition of the first generation of abstract expressionists. According to Jane Livingston, this had a lot to do with the fact that she was a woman. Jane Livingston, *The Paintings of Joan Mitchell* (Berkeley: University of California Press, 2002), 10. For Arthur C. Danto, it was because she was simply continuing in an art form that the world had moved beyond. She was out of step with the times. Arthur C. Danto, "Mitchell Paints a Picture," *The Nation* 275, no. 8 (September 16, 2002): 30–33. But the recent spate of art exhibitions focused on her work is evidence against that assumption. Perhaps she was even ahead of her time.

8. Bernstock, *Joan Mitchell*, 31. Patricia Albers claims that Mitchell had synesthesia, the experience of overlap among the senses taken to a level beyond that experienced by most people. Mitchell saw colors attached to words and people; for example, she "had musical sound-color, personality-color, emotion-color, and grapheme-color synaesthesia (meaning that she saw the letters of the alphabet in color)." Patricia Albers, "Joan Mitchell: Painting as Cathedral," in *Synesthesia: Art and the Mind* (Hamilton, ON: McMaster Museum of Art, 2008), 50.

9. Bernstock, *Joan Mitchell*, 35.

10. Bernstock, *Joan Mitchell*, 35.

11. Joan Mitchell, *Un Jardin pour Audrey*, 1975, diptych, oil on canvas, 99.5 × 141.75 in., 252.73 × 360.05 cm. Private Collection France. The image can be viewed at https://ago.ca /exhibitions/mitchell-riopelle-nothing-in-moderation (Art Gallery of Ontario, "Mitchell /Riopelle: Nothing in Moderation," Feb. 18–May 6, 2018).

12. Merleau-Ponty, *Phenomenology of Perception*, 221; *Phénoménologie de la perception*, 348. Merleau-Ponty writes: "The *Rotempfindung* is part of the *Rotempfundene*—this is not a coincidence, but a dehiscence that knows itself as such." *The Visible and the Invisible*, 267; *Le visible et l'invisible*, 314.

13. Merleau-Ponty, *Phenomenology of Perception*, 222; *Phénoménologie de la perception*, 348.

14. Merleau-Ponty, *The Visible and the Invisible*, 141; *Le visible et l'invisible*, 183.

15. Merleau-Ponty, *Phenomenology of Perception*, 326; *Phénoménologie de la perception*, 361.

16. Merleau-Ponty, *Phenomenology of Perception*, 326; *Phénoménologie de la perception*, 361.

17. Merleau-Ponty, *Phenomenology of Perception*, 321; *Phénoménologie de la perception*, 355.

18. Merleau-Ponty, *Phenomenology of Perception*, 326; *Phénoménologie de la perception*, 361

19. Merleau-Ponty, *Phenomenology of Perception*, 323; *Phénoménologie de la perception*, 358.

20. Merleau-Ponty, *Phenomenology of Perception*, 324; *Phénoménologie de la perception*, 359.

21. Evan Thompson, *Colour Vision* (New York: Routledge, 1994), 22.

22. Thompson, *Colour Vision*, 26–27.

23. Barry Maund, "Color," in the *Stanford Encyclopedia of Philosophy*, April 13, 2018, https://plato.stanford.edu/entries/color/.

24. Contemporary scientists continue to pose the question of how colors remain constant in human perception under a variety of luminosities, "whether it is possible, or even sensible, to reconcile the domains of neurophysiology and phenomenology," since "progress in understanding colour vision in terms of biology has been stalled by the inability to resolve the lack of correspondence between phenomenological colour experience and the properties of [for example] LGN [lateral geniculate nucleus] neurons, the only cells offered as candidates for mediating hue experience." Jay Neitz and Maureen Neitz, "Colour Vision: The Wonder of Hue," *Current Biology* 18, no. 16 (August 26, 2008): R702. Evan Thompson, one of the founders of enactivism, argues for a relational model of perception that is much more in line with Merleau-Ponty's phenomenological approach. Thompson, *Colour Vision*, 24. This is not a topic I can deal with here.

25. David H. Foster, "Color Constancy," *Vision Research* 51 (2011): 674.

26. Merleau-Ponty, *Phenomenology of Perception*, 321; *Phénoménologie de la perception*, 355.

27. Various imaging techniques have been employed to provide "comprehensive data for modeling color constancy and so for testing and interpreting observer performance. Even so, a careful study by Arend (2001) identified fundamental problems with defining color constancy in complex natural visual environments." Foster, "Color Constancy," 675.

28. Foster, "Color Constancy," 696.

29. Merleau-Ponty, *Phenomenology of Perception*, 10; *Phénoménologie de la perception*, 17.

30. Merleau-Ponty, *Phenomenology of Perception*, 332; *Phénoménologie de la perception*, 367.

31. Merleau-Ponty, *Phenomenology of Perception*, 341; *Phénoménologie de la perception*, 377.

32. Merleau-Ponty, *Phenomenology of Perception*, 326; *Phénoménologie de la perception*, 361.

33. Merleau-Ponty, *Phenomenology of Perception*, 328; *Phénoménologie de la perception*, 363.

34. Merleau-Ponty, *Phenomenology of Perception*, 318; *Phénoméenologie de la perception*, 351.

35. Merleau-Ponty, *Phenomenology of Perception*, 319; *Phénoménologie de la perception*, 352.

36. Merleau-Ponty, *Phenomenology of Perception*, 219; *Phénoménologie de la perception*, 245.

37. Maurice Merleau-Ponty, "Cezanne's Doubt," in *Sense and Non-Sense*, trans. Hubert L. Dreyfus and Patricia Allen Dreyfus (Evanston, IL: Northwestern University Press, 1964), 19, 13–14.

38. Merleau-Ponty, *Phenomenology of Perception*, 345; *Phénoménologie de la perception*, 380.

39. Merleau-Ponty, *Phenomenology of Perception*, 332; *Phénoménologie de la perception*, 368.

40. Merleau-Ponty, *Phenomenology of Perception*, 5; *Phénoménologie de la perception*, 10.

41. Merleau-Ponty, *Phenomenology of Perception*, 222–223; *Phénoménologie de la perception*, 248–249. Italics in original.

42. Merleau-Ponty, *Phenomenology of Perception*, 224–225; *Phénoménologie de la perception*, 251.

43. Maurice Merleau-Ponty, *The Sensible World and the World of Expression: Course Notes from the Collège de France, 1953*, trans. Bryan Smyth (Evanston, IL: Northwestern University Press, 2020), 125; originally published as *Le Monde sensible et le monde de l'expression: Cours au Collège de France Notes, 1953*, ed. Emmanuel de Saint Aubert and Stefan Kristensen (Geneva: MétisPresses, 2011), 167.

44. Indeed, this curator compares one panel to a Monet and the other to a Matisse. Mitchell herself apparently resisted comparisons of her work to Monet's, which many commentators seem tempted to do since she inhabited his home in Giverney. But comparing an artist's work to another's does not actually tell us about the work itself.

45. For example, Willem de Kooning (1904–1997), Jackson Pollock (1912–1956), Mark Rothko (1903–1970), and Hans Hofmann (1880–1966).

46. Merleau-Ponty, "Eye and Mind," 172; *L'Œil et l'esprit*, 43.

47. Merleau-Ponty, "Eye and Mind," 172; *L'Œil et l'esprit*, 43. As Véronique Fóti points out, "Merleau-Ponty's tendency to privilege art's interrogation of phenomenal reality leads him to focus on its mimetic power, rather than to consider that motion, or dynamic energy, need not be mimetically presented to be conveyed by a work of art." Fóti, *Tracing Expression in Merleau-Ponty*, 53.

48. Merleau-Ponty, "Eye and Mind," 188; *L'Œil et l'esprit*, 87.

49. Bernstock, *Joan Mitchell*, 86.

50. As Véronique Fóti describes, "A carnal essence is not fixed in invariant self-identity but is open to alteration (so that, for instance, Van Gogh's powerful paintings of sunflowers do not fix-ate the essence of the flower's sensuous presencing, which is, for instance bodied forth anew and differently in the abstract *Sunflowers* canvases painted by Joan Mitchell)." Fóti, *Tracing Expres-sion in Merleau-Ponty*, 44.

51. Joan Mitchell, *Sunflower III*, 1969, oil on canvas, 112.5 × 78.5 in., Smithsonian American Art Museum. The image can be viewed at https://americanart.si.edu/artwork/sunflower -iii-17542.

52. Bernstock, *Joan Mitchell*, 67.

53. Merleau-Ponty, *The Visible and the Invisible*, 115; *Le visible et l'invisible*, 145–146.

54. Bernstock, *Joan Mitchell*, 68.

55. Irigaray, "Being Two, How Many Eyes Have We?" 142.

56. In this chapter I specifically address Irigaray's later essay, "To Paint the Invisible," trans. Helen A. Fielding, *Continental Philosophy Review* 37, no. 4 (2004): 389–405. I will not address Irigaray's critique of Merleau-Ponty in the essay on the chiasm in *Ethics of Sexual Difference*. This work has already been done by a number of scholars who variably defend Merleau-Ponty or support Irigaray's critique, including: Judith Butler, "Sexual Difference as a Question of Ethics: Alterities of the Flesh in Irigaray and Merleau-Ponty," in *Feminist Interpretations of Maurice Merleau-Ponty*, ed. Dorothea E. Olkowski and Gail Weiss (University Park: Pennsylvania State University Press, 2006), 107–125; Elizabeth Grosz, "Merleau-Ponty and Irigaray in the Flesh," *Thesis Eleven* 36, no. 1 (August 1993): 37–59; Lisa Guenther, "Merleau-Ponty and the Sense of Sexual Difference," *Angelaki* 16, no. 2 (2011): 19–33; Susan Kozel, "The Diabolical Strategy of Mimesis: Luce Irigaray's Reading of Merleau-Ponty," *Hypatia* 11, no. 3 (1996): 114–129; Ann V. Murphy, "Language in the Flesh: The Politics of Discourse in Merleau-Ponty, Levinas, and Iri-garay," in *Feminist Interpretations of Maurice Merleau-Ponty*, ed. Dorothea E. Olkowski and Gail Weiss (University Park: Pennsylvania State University Press, 2006), 257–271; and Silvia Stoller, *Phänomenologie der Geschlechtlichkeit* (Nijemgen, Netherlands: Radboud Universiteit Nijmegen, 2006), 193–228.

57. Marjorie Hass provides an excellent analysis of Irigaray's social science research in linguistics and argues that it is not supplementary but actually foundational to her philosophical claims. See Marjorie Hass, "The Style of the Speaking Subject: Irigaray's Empirical Studies of Language Production," *Hypatia* 15, no. 1 (2000): 64–89.

58. I work this argument through in detail in my article, "Questioning Nature: Irigaray, Heidegger and the Potentiality of Matter," *Continental Philosophy Review* 36, no. 1 (2003): 1–26.

59. Cathryn Vasseleu, *Textures of Light: Vision and Touch in Irigaray, Levinas and Merleau-Ponty* (London: Routledge, 1998), 12. Vasseleu's text can be added to the list of philosophers who have thought through Irigaray's earlier critique of Merleau-Ponty.

60. Vasseleu, *Textures of Light*, 12. Vasseleu does point out that it is only because Merleau-Ponty "incorporates the tactile into the visual that [he] is able to privilege the visual." Vasseleu, *Textures of Light*, 68.

61. Ewa Plonowska Ziarek, for example, points out how Irigaray's brilliant reading of Marx in "Women on the Market" is attuned to the ways "commodified women's bodies become abstrac-tions without any intrinsic value." Ewa Plonowska Ziarek, "'Women on the Market': On Sex, Race and Commodification," in *Rewriting Difference: Luce Irigaray and "the Greeks,"* ed. Elena Tzelepis and Athena Athanasiou (Albany: State University of New York Press, 2010), 206. In Ziarek's account, "Irigaray defends her analogy between the female bodies and commodities, between the sexual and economic exchanges, by arguing that it was in fact Aristotle who concep-tualized the relation between matter and form, so crucial to Marx's thinking of the commodity." In her reading of Marx, Irigaray accordingly analyzes the "consequences of the commodity form for the conceptualization of female embodiment." But she overlooks slavery even as Marx refers

to it in order to establish "the distinction between Aristotle's and his own theory of value. Marx claims that Aristotle failed to see the equality of labor in the equalization of products for the precise historical reason that "Greek society was founded on the labor of the slaves, hence had as its natural basis the inequality of men in their labor power." Ziarek, "'Women on the Market,'" 204. The problem, as Ziarek articulates it, is that both Marx and Irigaray see slavery as belonging only to antiquity and equality, although not yet realized, as belonging to modernity, which allows them both to "disregard modern forms of slavery, racism, and white supremacy in their account of the commodity form" (Ziarek, "'Women on the Market,'" 204). Tina Chanter, while agreeing with Irigaray's suggestion that the feminine and the masculine were associated with "fundamental categories of Western metaphysics, such as form and matter," nonetheless points out that "one could equally go back to Aristotle's politics to find arguments that emphasize the capacity of slaves for bodily labor, comparing their utility to that of tame animals and suggesting that slaves differ from masters to the same extent that bodies differ from souls and beasts from men. Aristotle also, of course, denies slaves the capacity to deliberate (see 1252a33–1260a12)." Tina Chanter, "Irigaray's Challenge to the Fetishistic Hegemony of the Platonic One and Many," in *Rewriting Difference: Luce Irigaray and "the Greeks,"* ed. Elena Tzelepis and Athena Athanasiou (Albany: State University of New York Press, 2010), 226.

62. Vasseleu, *Textures of Light*, 69.

63. Through this section, when I use *he* or *him*, I am referring both to Merleau-Ponty and to the singular male, able-bodied, European subject position.

64. Martin Heidegger, *Being and Time*, trans. John Macquarrie and Edward Robinson (New York: Harper & Row, 1962), 58; originally published as *Sein und Zeit* (Tübingen, Germany: Max Niemeyer, 1993 [1927]), 34.

65. Merleau-Ponty, "Eye and Mind," 188; *L'Œil et l'esprit*, 86–87.

66. Irigaray, "To Paint the Invisible," 397.

67. Merleau-Ponty, "Eye and Mind," 166; *L'Œil et l'esprit*, 27.

68. Irigaray, "To Paint the Invisible," 397.

69. Merleau-Ponty, *Phenomenology of Perception*, 323–324; *Phénoménologie de la perception*, 359.

70. Irigaray, "To Paint the Invisible," 397.

71. Charles Q. Wu, "A Neurologically-Based two Stage Model for Human Color Vision," in *Human Vision and Electronic Imaging XVII*, ed. Bernice E. Rogowitz, Thrasyvoulos N. Pappas, SPIE Conference Proceedings, vol. 8291, 2012. DOI:10.1117/12.909692.

72. Merleau-Ponty writes: "Claudel has a phrase saying that a certain blue of the sea is so blue that only blood would be more red" (*The Visible and the Invisible*, 132; *Le visible et l'invisible*, 172). See Irigaray, "Flesh Colors," in *Sexes and Genealogies*, trans. Gillian C. Gill (New York: Columbia University Press, 1993), 157; Foster, "Color Constancy," 674–700. See also my article "'Only Blood Would Be More Red': Irigaray, Merleau-Ponty and the Ethics of Sexual Difference," *Journal of the British Society for Phenomenology* 32, no. 2 (May 2001): 147–159.

73. See Fielding, "'Only Blood Would Be More Red.'"

74. Irigaray, "To Paint the Invisible," 394.

75. Irigaray, "To Paint the Invisible," 396.

76. Irigaray, "To Paint the Invisible," 397. For more on the interval, see Dorothea E. Olkowski, "The End of Phenomenology: Bergson's Interval in Irigaray," *Hypatia* 15, no. 3 (2000): 73–91.

77. Olkowski, "The End of Phenomenology," 399.

78. Olkowski, "The End of Phenomenology," 402.

79. Merleau-Ponty, "Eye and Mind," 166; *L'Œil et l'esprit*, 29. Irigaray, "To Paint the Invisible," 400.

80. Irigaray, "To Paint the Invisible," 401.

81. Merleau-Ponty, *The Visible and the Invisible*, 142; *Le visible et l'invisible*, 183.

82. Irigaray, "To Paint the Invisible," 399.

83. Irigaray, "To Paint the Invisible," 398. See also, Merleau-Ponty, "Eye and Mind," 161; *L'Œil et l'esprit*, 13.

84. Irigaray, "To Paint the Invisible," 400.

85. Merleau-Ponty, "Eye and Mind," 168; *L'Œil et l'esprit*, 33–34.

86. Merleau-Ponty, *The Visible and the Invisible*, 143; *Le visible et l'invisible*, 186.

87. Irigaray, "To Paint the Invisible," 400, 403.

88. Irigaray, "To Paint the Invisible," 403.

89. Irigaray, "To Paint the Invisible," 400.

90. Merleau-Ponty, *The Sensible World and the World of Perception*, 125; *Le Monde sensible et le monde de l'expression*, 167.

91. Irigaray, "To Paint the Invisible," 397.

92. Irigaray, "To Paint the Invisible," 391.

93. Irigaray, "To Paint the Invisible," 397.

94. Irigaray, "To Paint the Invisible," 391.

95. Merleau-Ponty, *The Visible and the Invisible*, 138; *Le visible et l'invisible*, 179–180.

96. Enactivists have referred to this as "experiencing oneself as an agent [which] depends on the existence of specific types of dynamic interactive processes between the organism and its environment. [They] call these processes 'self-specifying' because they implement a functional self/non-self distinction that implicitly specifies the self as subject and agent." They rely on sensorimotor integration and homoeostatic regulation. The first refers to the "systematic linkage of sensory and motor processes in the perception–action cycle" and the second to "the process of keeping vital organismic parameters within a given dynamical range despite external or internal perturbations." Kalina Christoff et al., "Specifying the Self for Cognitive Neuroscience," *Trends in Cognitive Science* 15, no. 3 (2011): 104–107. Thanks to John Jenkinson for directing me to this article and explaining the significance of the feedback loop.

97. Luce Irigaray, *An Ethics of Sexual Difference*, trans. Carolyn Burke and Gillian C. Gill (Ithaca, NY: Cornell University Press, 1993), 9.

98. Irigaray, "To Paint the Invisible," 401.

99. Patricia Albers, *Joan Mitchell: Lady Painter* (New York: Alfred A. Knopf, 2011), 14.

100. Irigaray, "Being Two, How Many Eyes Have We?" 144.

101. Merleau-Ponty, "Eye and Mind," 167; *L'Œil et l'esprit*, 31.

102. Irigaray, "Being Two, How Many Eyes Have We?" 144.

103. See Heidegger, *Being and Time*, 145; *Sein und Zeit*, 110–111.

104. Irigaray, *Sharing the World* (London: Continuum, 2008), 42.

105. Bernstock, *Joan Mitchell*, 41.

106. Irigaray, *Sharing the World*, 42.

107. Irigaray, "Being Two, How Many Eyes Have We?" 146.

108. Irigaray, "To Paint the Invisible," 403.

109. Potawatomi botanist Robin Wall Kimmerer beautifully describes how plants and animals are our oldest teachers if we would but attend to them and reciprocally care for them. She describes the twin trees planted by the settlers who built the home she moved into: "Such a responsibility I have to these people and these trees, left to me, an unknown come to live under the guardianship of the twins, with a bond physical, emotional, and spiritual. I have no way to pay them back. Their gift to me is far greater than I have ability to reciprocate. They're so huge as to be nearly beyond my care, although I do scatter granules of fertilizer at their feet and turn the hose on them in summer drought. Perhaps all I can do is love them. All I know to do is to leave another gift, for them and for the future, those next unknowns who will live here. I heard once that Maori people make beautiful wood sculptures that they carry long distances into the forest and leave there as a gift to the trees. And so I plant Daffodils, hundreds of them, in sunny flocks beneath the Maples, in homage to their beauty and in reciprocity for their gift. Even now, as the sap rises, so too the Daffodils rise underfoot." See Robin Wall Kimmerer, *Braiding Sweetgrass: Indigenous Wisdom, Scientific Knowledge, and the Teachings of Plants* (Minneapolis, MN: Milkweed Editions, 2013), 70–71.

II.
ENACTING
POLITICS

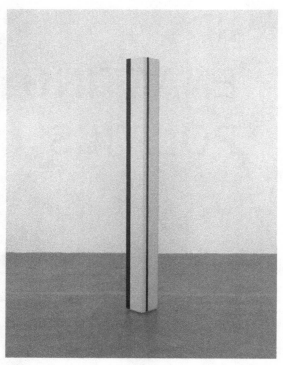

Fig. 3.1 Anne Truitt (1921–2004) © Copyright Alexandra
Truitt. *First Requiem*, 1977. Synthetic polymer paint on wood,
91 × 91 × 8 in. (231.1 × 20.3 × 20.3 cm). Gift of Robert B. and
Mercedes H. Eichholz. Digital Image © The Museum of
Modern Art/Licensed by SCALA/Art Resource, NY.

3

EXPERIENCING PUBLIC SPACE
Anne Truitt's Minimalist Sculptures

THE VIBRANTLY COLORED MINIMALIST SCULPTURES of Anne Truitt (1921–2004) exceed the flat surface of the canvas. They even transcend the materiality of each work, throbbing with life. I was taken aback by the intense presence I experienced when I first encountered them at an exhibition of her work, and I wanted to figure out why.[1] The works that specifically caught my attention were her rectangular wooden boxes made to human proportions. They stand tall, and most are relatively narrow, although they vary in width as well as height. These sculptures resist representational reduction. They are almost impossible to photograph.[2] Their intense liveliness cannot be captured by the beautiful yet flat images in the catalog. As well, they are both paintings and sculptures: they are three-dimensional, yet if one faces them, they almost appear as two-dimensional paintings. When I stand directly in front of *Return* (2004) so that its three-dimensionality disappears, the flat surface I am faced with is nonetheless one of amazing luminance and depth. Painted in extraordinary colors—among them the vibrant red of *Return*, the glowing green of *Pith* (1969), and the layering of orange, pink, blue, and green in *Morning Choice* (1968)—they seem to float.[3] Some are monochromatic, and others combine either horizontal blocks or vertical stripes of color. *First Requiem* (1977), which stands seven and a half feet tall, has varying vertical stripes of color of differing widths; one side is pink and black while another is grey, pink, black, and navy (see fig. 3.1).[4] The boxes are so lively that they vibrate and pulsate; they almost breathe.

The boxes "become human" for Truitt. In their intense presence as things, they paradoxically mirror human flesh. Indeed, they "become flesh," insisting on a response from viewers' embodied perceptual cognition.[5] Like human bodies, the sculptures are both material objects and transcend their materiality, but it is their materiality that allows them to

extend beyond themselves. Each sculpture has to be the right size and must have enough color to make it work.[6] Although they are technically made of plywood, the wood disappears beneath the paint. They are of color, which "is the least material of matter," although this immateriality is technically achieved. In order to make the color "sing from the inside, in order to give it transparency, you can't use too much white, because it will kill it."[7] The translucency of the colors is achieved by applying layer upon layer of color and sanding between each with finer and finer sandpaper. This process allows the color to be "set free into three dimensions, as independent of materiality" as is possible, even as this setting free is absolutely dependent upon the sculptures' material presence.[8]

Yet even as the sculptures are set free to float, they are also about gravity. Truitt wanted to "magnetize the line of gravity from the sky down to the ground," allowing the sculptures to move the way humans do. The effect had to be "springy" just as humans are springy when they walk. This is vertical being. Truitt moves the eye by painting a strip of a particular dark purple that few people will see at the bottom of a ten-foot monochrome sculpture, lifting it a quarter of an inch into the air.[9] A hazy strip of color at the top can have a similar effect. In sculptures with differently colored sides, colors wrap around the corners to make them move and vibrate the way "light moves." As I walk around the sculptures, the colors shift and change with the lighting in the space. They were made to respond to the shifting of the sun in the sky over the earth, marking time, allowing for an "aliveness that won't settle, that won't stay put."[10]

Individual works rely on the juxtaposition of color hues. This yellow against this green against this white allows the whole sculpture to throb with life. Each color combination is precisely intuited. When put "with another color, it just zooms into being."[11] While Truitt varies color hues, their value and saturation—that is, the darkness of the colors along with their luminosity, depth, and intensity—remain the same. She observes that the strong relation between "color and structure" is integral to her works. Although they retain their "individuality," they also "join forces . . . as independent melodies can combine into a harmonic whole."[12] Enlivening the sculptures through color combination holds not only for individual sculptures but also for the exhibition itself. The sculptures resonate with one another. Since visiting this exhibition, I have seen individual sculptures in various museum settings, and although the works remain strong, when brought together in a careful curation they resonate with one another, as in my first encounter where the placing of the boxes allowed for maximum relational interplay among the works.

These sculptures, then, reveal how material objects can actually help ground us in a shared relational reality. In Hannah Arendt's words, artworks are "tangibly present, to shine and to be seen, to sound and to be heard, to speak and to be read."[13] Truitt's sculptures are thought things that, once objectified, belong to the particularity, but also to the stability, of the experiential world of reality. But the thought behind them works to resist the imposition of ideas. Instead, they help refigure what we mean by reality in the astonishing way they anchor us to the world, reminding us of the way we generally encounter it with a grip just strong enough to allow us to navigate our surroundings without actually taking into account what and who we perceive in the here and now. The sculptures ground viewers within a situation that cannot easily be subsumed to the systematicity that belongs to this age. Although her works are labeled minimalist, Truitt resisted this category, which she associated with works that do not refer to anything or any reality; her own works were, for her, "totally referential."[14] They refer to a reality that encompasses the particularity of individual emotions, ideas, and experiences in a shared perceptual world. As artworks they belong to a public world. The "dead letter" of the artwork comes to life in encounters with viewers.[15] As with all "living things," these encounters will come into being and, along with their intensity, fade away. Nonetheless, when the artwork appears in public, as it is meant to do, it helps cultivate perception and ground humans in a stable world.[16] Thinking that engages with the world we experience helps guard against the regimenting movement of organizing systems that detach us from reality. Such systems threaten to engulf that which makes us human, this very capacity *to be* responsive in our embodied perceptual cognition and hence responsible *for* the world and others. In their intense presence as things that establish a place of appearance, Truitt's sculptures begin the work of enacting politics.

I: From the Loss of Common Sense to the
Rise of Ideological Reasoning

Arendt describes well the dangers of losing relation to reality through embodied perceptual cognition. She begins *The Human Condition* with the observation that any joy that greeted the first launching of a human-made object into space in 1957 did not arise out of pride in human accomplishment or "human power and mastery" but was rather expressed in the words of "some American reporter" as "the first 'step toward escape from men's imprisonment to the earth.'"[17] The first image of earth provided by this launch well signified the Archimedean standpoint of the "modern

astrophysical world view."[18] This image, although experientially striking, nevertheless represented how "earth-bound nature" can now be viewed "from a truly universal" standpoint. The origins of this event can be traced through the evolution of modern science, where Arendt describes a shift from reliance on common sense as grounded in situated, sensual, and relational points of view on a shared reality to its new ground as a structure of the mind. But this new ground does not provide a foundation for thought. Thinking belongs to the movement of existence, coming into being and fading away. It comes into its own when it exceeds the useful production and organization of what is needed for living. This is why artworks are thought things. But the making of artworks also relies on cognition; cognition, unlike thinking, is practical. Whereas thinking is "relentless," cognition is a process that, "like fabrication itself, [has] . . . a beginning and end, whose usefulness can be tested."[19] The mental processes of logical reasoning are of another ilk. They belong to axioms, to "self-evident statements" such as two plus two equals four, and to the "subsumption of particular occurrences under general rules." The laws of logic correspond with the cyclical processes of nature that have no beginning or end.[20]

These laws are not Platonic. Although Plato distrusted bodily senses and put his faith in the "mathematical world of ideal forms," his forms were still appearances "given to the eyes of the mind as sense data were given to the organs of the senses."[21] But Galileo's discovery of the telescope changed everything. With the universe now within reach of an "earth-bound creature and its body-bound senses," scientists shifted from Copernicus's heliocentric *idea* to the *demonstration* of the "modern astrophysical world view," which was previously unimaginable.[22] In challenging "the adequacy of the senses to reveal reality," humans find themselves in a universe they can only know through their "measuring instruments": this means "man encounters only himself."[23] Although these instruments allow for extraordinary acts, such as releasing "energy processes that ordinarily go on only in the sun," we now deal with nature from the Archimedean point that belongs to the universe and not to earth: "we have found a way to *act* on the earth and within terrestrial nature as though we dispose of it from the outside."[24]

Even though humans can now intervene in the cyclical processes of nature itself, because there is no one individual who sets these processes on their way, there is no one to take responsibility for the outcome. It is not that modern mathematics simply has a further reach in its universal ambitions but that, in exchanging reliance on appearances for reliance on the "structure of the human mind," there is a withdrawal from the shared

public realm.[25] With geometry now subjugated to algebra and "terrestrial sense data and movements" reduced to mathematical symbols, mathematics is no longer bound to lived space. The new "non-spatial symbolic language" allowed Newton to develop a law of gravity that applied to the movement of both "heavenly" and "terrestrial" bodies. It allowed human minds to overcome their limits and "reckon with entities which could not be 'seen' by the eye of the mind."[26] But in abolishing the "old dichotomy between earth and sky," "all events" become "subject to a universally valid law" that is "beyond the reach of human sense experience."[27] Rather than finding a measure for existence in the heavens or on earth—or, more specifically, between the two, as in Truitt's sculptures—modern science provides its measure in the human mind, removed from the sensual relationality of existence.

This withdrawal from the context of lived experience allowed for a new way of encountering nature: the experiment. Rather than "observing natural phenomena" as they are given, humans now set up nature according to the "conditions" of the mind—"that is, under conditions won from a universal, astrophysical viewpoint, a cosmic standpoint outside nature itself."[28] With enough distance, the multiplicity and diversity of the natural world available to the human senses at "close range" can now be brought into accord with the "patterns and symbols" provided by "the measure of the human mind." This measure is not one of "ideal forms disclosed to the eye of the mind." Even the metaphoric presence of the mind viewing the phenomena is now gone.[29] What is transformed is our relation to the real. Science becomes a mathematical projection onto the world.[30] For Newtonian physics, the motion of bodies in space is both determinable and predictable in terms of position and speed. This means nature can be "calculated in advance." With "atomic" physics, the guarantee is necessarily statistical: "a state of motion may on principle only be determined *either* as to position or as to velocity."[31] This means phenomenal particularity in time *and* space is not realizable. It is relative. Although quantum theory cannot be reduced to Newtonian physics, there is no essential difference between the two. "Modern nuclear and field physics" all participate in the shift in the way science comprehends the real whereby science now comprehends through closing off and partitioning. In Newtonian physics, what appears is the relation between the subject and the object whereby the subject stands over and against the object. In quantum physics, the object itself disappears, and the "subject-object" relation becomes a pure or "mere relation."[32] The real becomes subjected to a process imposed from without. Both subjects and objects are entrapped, secured, and set up.

Once science is no longer grounded in sensual encounters with a natural world, a shift takes place from truth to truthfulness and from reality to reliability.[33] Descartes learned from Galileo's discovery that, since human senses cannot be trusted, everything must be doubted; "doubting at least is certain and real." He could not doubt his conscious awareness of the "process of doubting"—a process that itself could become an "object of investigation in introspection."[34] Common sense undergoes a transition. It is no longer the sense that gathers all the other senses, with their "private sensations" and particular situated perspectives, together into a common and shared world. Now what is held in common is the structure of the human mind and its ability to reason—that is, to conclude that two plus two will always equal four. Although the "'truths' of the modern scientific world view . . . can be demonstrated in mathematical formulas and proved technologically," they cannot be expressed in "speech and thought." This means we can no longer "think and speak about the things which nevertheless we are able to do."[35]

And it is the unthinkable that is done in the ideal experimental process of, for instance, the Nazi death camp. In *The Origins of Totalitarianism*, Arendt describes the camp as an experiment for "total domination."[36] The camp must be completely isolated from the outside world. Its purpose is not economic but rather existence for the sake of the system that makes possible the perpetration of crimes that take "place in a phantom world" that nevertheless materializes and is apprehensible in terms of "the sensual data of reality." Phenomenologically, what is missing from the camp is the situation. The camp "lacks the structure of consequence and responsibility without which reality remains a mass of incomprehensible data."[37] There is no apparent connection between what people do and the punishments meted out. If there is any explanation to be found, it is linked to what people are rather than who they are. The "horror" of life in the camp "can never be fully embraced by the imagination for the very reason that it stands outside of life and death. It can never be fully reported for the very reason that survivor[s] return to the world of the living, which makes it impossible for [them] to believe fully in [their] own past experience."[38]

To belong to the world of the living is to belong to the experiential world of existence, which is bounded by the temporal cycle of being born and fading away and is acknowledged by others. In this world, people live within a web of relationships, and actions have consequences. But the camp destroys world and hence reality and does not replace it with another reality perceived by the senses and confirmed by others. Instead, it also provides a space that subjugates actuality to know-how, reality to

reliability. Imperialism fostered the emergence of concentration camps at the beginning of the twentieth century during the Boer War, when they were established as a utilitarian means to an end. Under totalitarianism, the camps were transformed from the instrumental "everything is permitted" to the unthinkable "everything is possible."[39] The system reveals "that the power of man is greater than they ever dared to think, and that man can realize hellish fantasies without making the sky fall or the earth open."[40]

The death camps were the logical conclusion to a premise realized through ideological reasoning. Ideological reasoning, whether it adheres to a law of history or nature, provides a system that purportedly works in favor of all humans by adhering to a law that, like a universal law, is greater than those it governs. The problem with a law that deals with individuals is the inconvenient gap between the law and the meting out of justice because "each concrete individual case" has an "unrepeatable set of circumstances."[41] Applying the law is messy and imprecise because there are always gaps and inconsistencies in lived existence. But ideological reasoning, unlike experience, is not burdened with contradictions. Like mathematical principles, it "orders facts into an absolutely logical procedure which starts from an axiomatically accepted premise" from which "everything" else is deduced.[42]

Two elements belong to ideologies: the "element of movement and of emancipation from reality and experience." But the movement that belongs to ideologies is self-generated and does not emerge from experience. Although an idea might first come from experience, when transformed into an axiomatic premise, it is subsequently unaltered by experience or reality; in fact, it provides a logic that might seem to promise a truer reality than the one perceived by the senses.[43] For the racism of the Nazis, the law of nature as understood through a certain reading of Darwin justified their actions. For the Bolsheviks, it was the law of history, for which they were indebted to Marx.[44] But the difference between these two is not so great. Darwin understood nature in terms of development with a progressive and unilinear movement—in other words, as historical. Law no longer refers to some kind of stabilizing force for "human actions and motions" and becomes, instead, "the expression of the motion itself."[45] A process of becoming, of reaching toward a future goal that will never be achieved, replaces what actually is—that is, reality.

Totalitarianism reveals the movement of ideology as mirroring that of logical reasoning, an infinite process where the end goal is the process itself. The goal of an ideology can never be achieved because the goal and the law are one and the same, and the process is for the sake of the process: "If

it is the law of nature to eliminate everything that is harmful and unfit to live, it would mean the end of nature itself if new categories of the harmful and unfit-to-live could not be found."[46] The process, as the "law of movement," is realized through terror, which is the essence of totalitarian control. Through its use, humans are stabilized in order to "liberate the forces of nature or history." Since it is the system of terror itself that "executes these judgments," only those who stand in the way of the movement are guilty. Both those who are murdered and those who murder to execute the law are innocent because individuals cannot be held responsible since they are under laws that govern individuals in their relations with one another. Laws that govern individuals provide a boundary within which people can act and be responsible, where they can think about what they do. Arendt calls this boundary "the living space of freedom."[47] For this reason, she describes "total terror" as the destruction of this space between humans— the space that allows them to appear before one another and to act. With total terror humans are pressed "against each other," as they are in the camp or—literally, I would add—in the hold of the slave ship. Totalitarian government "destroys the one essential prerequisite of all freedom which is simply the capacity of motion which cannot exist without space."[48]

This freedom to move refers not only to our relations with others in the world but also to our inner freedom of thought, which is constrained by ideology. A totalitarian ideology is not concerned with the idea itself but rather with the "logical process which could be developed from it."[49] Here, the emphasis is not on the idea of "racism or dialectical materialism" but rather on its "inherent logicality." This logic that replaces thinking as "a principle of action" has its own movement or "coercive force" that "springs from our fear of contradicting ourselves" and thus rendering our "whole life meaningless."[50] It is a logic of universal movement according to which both history and the future can be calculated and individual particularity subsumed. It is "independent of all experience" and emancipated from the reality perceived with the senses. History is understood in terms of progress. Even racism that seems to focus on nature justifies its practices by way of the progressive movement of history. Darwin explains this "one consistent process" as allowing for the elimination of the unfit. Only it can uncover the "truer" although concealed reality through "certain methods of demonstration." But unlike action that is motivated by thinking that comes out of existence, "ideologies have no power to transform reality." In taking one point derived from experience and turning it into an axiomatic premise, ideological logic can no longer be affected by other experiences or "be taught by reality."[51] Instead, when reason is emancipated from

experience, it is assumed that what appears as real signifies "something else." Reality has nothing to offer ideological deduction.[52] Contradiction, which is the home of experience, is not tolerated.

In totalitarian ideology, isolated humans are pressed together through total terror even as they are supported in "a world which has become a wilderness for them." Their only defense is the "self-coercive force of logical deduction," which turns individuals against others.[53] All relation with reality is destroyed. When contact with others and with reality has been broken, humans are no longer able to experience reality or think about what they do. An ideology succeeds when those under its reign no longer experience a "distinction between fact and fiction"—understood as the "reality of experience"—or a "distinction between true and false"—that is, "the standards of thought." With tyrannies, there is still a private sphere that allows for experience and thought, but in totalitarian regimes, even this is destroyed, along with the capacity to act.[54] Tyrannies leave people feeling isolated, cut off from others with whom they might act, but this does not make them lonely. And someone can be lonely when they feel abandoned by human companionship, but this does not make them isolated. It is the combination of isolation and loneliness characteristic of totalitarian ideology that destroys not only the public sphere where people can act but also the private sphere where they can withdraw into their own thoughts and experiences. Arendt notes that "the rule over slaves in antiquity, would automatically be a rule over lonely, not only isolated, men and tend to be totalitarian."[55]

An ideology as a system that allows for only one perspective, although perhaps originating from embodied perceptual cognition, since all new acts do, has no capacity for flexibility or openness to other points of view that contribute to the whole. It cannot partake in a common shared reality that opens up vibrant possibilities for the future. And anything, however unimaginable, becomes possible. The rhetoric of freedom and justice that belongs to the citizen does not suffice for refugees or detainees who are "placed in a situation where," unless they commit a crime recognized as such by an operative legal system, what they do or do not do, have done or have not done, has no bearing on the way they are treated by others. It is this lack of having one's reality recognized by others that is endured by the camp prisoner, the enslaved, the refugee, and the detainee.[56] Humans rely on common sense—the sense of a world shared with others to guarantee their particular experiences of a "materially and sensually given world." Those who are uprooted from their homes or become superfluous lose the experience of belonging to a shared world. Without others to confirm

what they see or hear what they hear, they cannot rely on the particularity of their own sensual experience.[57] But the certainty of logic does not need the confirmation of others or the self. It provides the "only reliable 'truth'" once common sense is lost. But it is a truth that "does not reveal anything."[58]

Under totalitarian regimes, no one takes responsibility because, under the pressure of total terror, they relinquish their agency to the logic of the idea that replaces thinking. Under the ideological reasoning that governs totalitarian governments, no one is guilty because no one acts: "Where all are guilty, nobody in the last analysis can be judged."[59] The system works to displace individual agency by detaching individuals from situated reality. People who lose touch with reality also lose touch with the responsiveness that grounds their responsibility to the world and to others. Nonetheless, although the embodied perceptual cognition that supports the human capacity to be responsive is disrupted by the logic of the system, Arendt does not argue that this disruption absolves individuals of responsibility.

It does mean, however, that ways must be found to reground agency in situated reality to displace the logic of racist ideology that replaces thinking and seems to absolve individuals of responsibility. My claim is that the movement of embodied perceptual cognition guided by encountering and gearing into a world facilitates the "passage from the apparent to the real," where the "'real' is the insurmountable plenitude" of the world.[60] Perceptual faith precedes any logical reasoning that a world exists populated by things and others because such questioning of existence comes only after the fact—after we have first perceived the world through the depth of lived experience, which allows for the gaps, fissures, and opacity denied by ideological reasoning.[61] To cultivate perception is to bring reality as perceived—as experienced—to the foreground because the ideas that emerge from embodied perceptual cognition work differently from the idea of ideology. We can only understand what it means to be earth creatures from the point of view of inhabiting the earth, not from an Archimedean point in the universe. After all, the body is "not merely one expressive space among all others"; it is "the origin of all others, it is the very movement of expression."[62]

Cultivating perception helps remind us of our individual responsibility from within a world revealed by common sense. Perception is first and foremost a making sense of what is there. It is not mere sensation, and it is not achieved through judgment and analysis. Making sense is temporal, spatially situated, and shared. It has the narrative quality missing from the camps, where it is possible to take in what is there through sense data, but

this data does not make sense to embodied perceptual cognition. Truitt's work *First Requiem* makes this point (see fig. 3.1). Each of the four sides of the sculpture is quite different, with varied colors and stripes of different widths, although, as with her other sculptures, color wraps around the corners, providing the liveliness she sought. Because there are four sides, it is impossible to take in the entire work in one glance. One must walk around it at the pace it demands, experiencing how, at each turn, it becomes something different. At each corner one can see two sides at once, but never more than that. Circumnavigating the sculpture too quickly provides a sense of disequilibrium. One cannot encounter the work in its unfolding. This is what Truitt referred to as the narrative quality of her works, and it is vital to their "emotional impact."[63] It is narrative because it unfolds in time, but the narrative it unfolds speaks first to a corporeal logos—to perception, motility, and affect. The embodied perceptual cognitive sense viewers make of the work requires them to bring their own affective experiences to the encounter. The work relies on the potentiality for the plenitude of experiential encounters viewers bring with them.

But narrative also implies an audience. We speak and act before others. An encounter with these sculptures reveals how experiencing reality requires not only perceptual data but also a space of appearance where things, beings, and relations come into appearance and fade away. Experience cannot be temporally collapsed like logic or a mathematical algorithm. As with a living body, *First Requiem* cannot be encountered all at once, and it cannot be understood through know-how; its incompossibles must be encountered over time and from different perspectives. It institutes a place of appearance that requires space for people to walk around it, which they are drawn to do. It shows how differently situated points of view are necessary to provide an understanding of the work as a whole and contribute to common sense.

In being given a material existence, Truitt's experiential world helps ground the real. Kimberley Curtis explains that, for Arendt, artworks provide for a "texture of realness [that] has the particular quality of fullness as opposed to force." Artworks belong to the public world because they ground us in the particularity of existence that comes under attack by totalitarian regimes.[64] The variation in embodied perceptual cognition they provide has political significance. Reality is not that which is reliable, a logical possibility; it is, rather, a plurality of shared meaningful perspectives on the same world that are grounded in experience. This is not yet the public sphere as such, but a public or political sphere is not possible without the possibility for shared relational existence. Truitt's sculptures provide for

this plurality of perspectives. Reality is relationally affirmed and requires the situatedness of encounters in time and space. The logic of the system requires neither a space of appearance nor confirmation by others.

II: Racism as an Ideological System

Although ideological systems do not, in themselves, provide for a grip on the world, the embodied perceptual capacity to take a hold on the world paradoxically allows bodies to gear into the singular level established by an ideology. Perceptual faith contributes to this process. When perception is "sustained by the certainty of the world," it is "animated" by an embodied logic or logos that opens onto a relational field. Any appearance that does not belong to that logos is somehow crossed "out as *unreal*" or not perceived as part of the field.[65] An ideology can work similarly, crossing out any ideas or experiences that contradict its logic. Indeed, an idea can become a level or dimension that remains in the background and yet shapes the way "every other experience will henceforth be situated" in the way lighting sets a level for the way colors appear constant.[66] For example, the concept of humanity (*Menschheit*), like the color yellow, "is capable of setting itself up as a level or a horizon."[67] An idea as such is invisible. But it nonetheless "inhabits this world, sustains it, and renders it visible, its own and interior possibility, the Being of this being."[68]

Merleau-Ponty calls ideas taken up by bodies idealities. As "experiences of the flesh," such as "the moments of the sonata [or] the fragments of the luminous field, [they] adhere to one another with a cohesion without concept."[69] In other words, hovering on the other side of language, idealities are corporeal ways of understanding, of moving into the world and taking it up. They describe the ways bodies respond to others, are shaped by them, and in turn shape them. As such, idealities are not to be understood in the way essences usually are: as an idea or eidos that remains through all variations of a thing. Such formal essences require absolute distance and remove the thing from time and history. But idealities cannot be so separated. They begin with a particular moment but are taken up as a kind of generality that extends beyond and is layered in depth behind the visible present moment.[70] In a late note, Merleau-Ponty describes such an ideality. Some sculptures he sees "remind [him] of beautiful [mineral] rocks": "One day when someone was showing me, with a sort of fervor which surprised me, some rocks, and gave me some of them, not without some hesitation. I don't specify the memory or the place and it remains in doubt: it seems to me (but rather through reasoning, that it was in the Belgian Congo. . . . It must be there. But who? I know merely that it was a

woman)."[71] He describes this memory to be more like a category, one "deposited" in the sculpture he is looking at as "a certain call" to him, but the memory is not a representation or even a singular experience but rather an existential, a "mode of sensing" solicited by the materiality of the sculpture. It is only through reason that he can speculate when and where the event took place. But his memory of the event is more like an "element" "in the sense of water, of air etc." He concludes that if there are no points of time as such, that means subjectivity is far more like a field, and "even its temporality has this structure."[72]

This means idealities are neither restricted to their spatial and temporal origins nor inaccessible, locked in an unreachable past. Rather, they are open textured and ontologically malleable when they are reactivated in the present through embodied perception. Even ideas we think of as pure originate from bodily encounters. They stream "forth along the articulations of the aesthesiological body, along the contours of the sensible things," transfiguring "horizons," and take up life in the mind because they were found at "the junctures of the visible world."[73] Since idealities can never be removed from a situation and surveyed from above, they are a way of comporting or holding ourselves in relation to others and things. Because our bodies are inherently sinuous, they are able to respond to other bodies and things in the present and move alongside them, gear into them, and incorporate gestures and movements. Idealities take up the generality of my embodiment, but this generality is corporeally specified in individual encounters and open to change.[74] As capacities, idealities are enacted as variations of a certain style or way of being that is both general but also uniquely specified—an individual "manner of being."[75] But this perceptual and motile deepening of our encounters with the world through sedimenting new structures breaks down in a world organized according to imposed ideas that do not correspond to what or who is there.

Instead, the structures sedimented are those that belong to an imposed system that actually inhibits encounters. To recall, ideological reasoning is singular and rigid. It does not allow for the gaps and fissures— the incompossibles that are the home of embodied perceptual cognition. Even though Merleau-Ponty's "two hands touch the same things," they each have their own "tactile experience" that he understands as an assemblage, as a "cluster" of "consciousnesses" that adhere to his "synergic" body's hands and eyes.[76] This is why the body is neither a thing nor an idea, neither object nor subject. Instead, it is a "measurant of the things." This measure is lived according to idealities, according to ideas that belong to "to the flesh," providing its "axes, its depth, its dimensions."[77] The body's

inherent openness to the world allows it to move into and incorporate new idealities as new beginnings, but this openness also allows it to incorporate ideological reasoning, which works to shut the openness down so cognition encounters only itself.

Arendt shows how racism as a totalizing ideology imposes a logic not inherent to reality. Although it is clear how ideology controls under totalitarian regimes, the limit situation of the camp she explores is one that defines and shapes modernity more broadly. Although there were earlier camps that did not have the distinction of being established strictly to annihilate a group of people, Alexander Weheliye, like Arendt, maintains that we cannot see the Nazi camps as an isolated or unconnected phenomenon in the history of Western colonialism: "modern concentration camps" go back to the 1830s in the United States as part of a larger genocidal campaign against Indigenous peoples.[78] As well, the Germans first used camps in their colonial campaign in German South West Africa to incarcerate the Herero and the Namaqua; the camps were "integral to the genocidal acts perpetrated by the German colonialists against these groups from 1904 to 1907."[79] These camps confirm "a thick historical relation" between the ascent of "modern concentration camps in colonial contexts and their subsequent reconstitution as industrialized killing machines in Europe during the Third Reich."[80] Kathryn T. Gines convincingly argues that Arendt, too, does not escape the racism inherent in Western philosophy in that she does not extend her compelling critique of anti-Semitism to the racism experienced by African Americans.[81] Arendt even relies on some of the same understandings of racialized progress she so convincingly critiques but also redeploys in *Origins*.[82]

My point here is that racism as ideology is taken up differently under colonialism but nonetheless is addressed to bodies within a complex ideological, but also spatial and temporal, nexus. For Weheliye, what made the Nazi camps unique at the time was not only the singularity of their purpose but also that they were established in Europe, which had previously been able to keep the worst horrors of colonialism outside its borders while perpetrating violence elsewhere.[83] The slave ships that transported Africans in their holds across the Middle Passage to be sold to plantations stored the Africans as mere cargo. The enslavers literally wrenched their victims from their home worlds without providing them with new ones. They imposed a coding and system on the enslaved that had no relation to who they were. The colonizers not only denied their victims their freedom of mobility but also their own languages and cultures, the bedrock for the freedom of thought.[84] Such a destruction of world also belonged

to and continues to be a legacy of modern slavery. The plantation has not been overcome, as can be seen, for example, in the police killing of African Americans that is regularly not recognized as murder by the judicial system.[85] As Weheliye notes, "the concentration camp, the colonial outpost, and slave plantation suggest three of many relay points in the weave of modern politics, which are neither exceptional nor comparable, but simply relational."[86] While the death camps' purpose was to reduce bodies to "bare life," or biological life, that, once cut off from lived existence, could be annihilated, the purpose of slavery was "social death" as "the purging of all citizenship rights from slaves save their mere life." But Weheliye prefers Hortense Spillers's "distinction between body and flesh" because she reminds us of the "embodiment of those banished to the zone of indistinction" and shows "how bare life is transmitted historically so as to become affixed to certain bodies."[87]

Specifically, Spillers's distinction between body and flesh helps articulate the difference between "captive and liberated subject-positions." Captive people have their bodies stolen from them. They are severed from their "motive will" and "active desire."[88] Merleau-Ponty has access to a world through the "actual body" he calls "mine."[89] Captive bodies cannot call their own bodies "mine." They cannot extend seamlessly into the world, gearing into it as they do. They cannot allow their gaze to wander where it will.[90] They are not reflected back to themselves by the world, or, if they are, it is a distorted reflection that does not speak to their embodied experiences or alternatively imposes its forms upon them, making them alien, foreign, not their own. For captive bodies there is only flesh; deprived of embodied access to the world and of a subject's point of view, their bodies are nonetheless not "bare life" if bare life is to be understood as biological life completely cut off from memory and experience.

For flesh exceeds the symbolic order ruled by the ideology of racism. In her pivotal essay, "Mama's Baby, Papa's Maybe: An American Grammar Book," Spillers describes how the enslavement of Africans installs a "primary" scene at the origins of the American symbolic order where the *not having a subject position* of the enslaved Africans belongs to the grammar of the symbolic order itself.[91] It is not only that those enslaved were desubjectified but that they were never subjects within the system. This means they were also denied gender because gender is tied to the emergence of the speaking subject within the patriarchal, patrilineal symbolic order.[92] The Middle Passage was a symbolic *"nowhere,"* a suspension in a Freudian "oceanic" that can be taken as an "analogy for [the] undifferentiated identity" of this "human-as-cargo" of those who were taken from

"the indigenous land and culture" but were "not-yet 'American' either."[93] Excluded as speaking subjects in the primary narrative of the American symbolic order even after attaining freedom, enslaved Africans and their descendants could never attain a subject position because the ruling ideology, with its accompanying symbolic, was not itself transformed.

Nonetheless, even though flesh might not be included in the grammar of the symbolic order, it still provides a "primary narrative": "Before the 'body' there is the 'flesh,' that zero degree of social conceptualization that does not escape concealment under the brush of discourse, or the reflexes of iconography."[94] As a primary narrative, flesh is this "seared, divided, ripped-apartness, riveted to the ship's hole, fallen, or 'escaped' overboard."[95] This marking of flesh that is transferred across generations is hidden beneath what Spillers calls a "hieroglyphics of the flesh," which is the subsuming of this violent history, with its "political, economic, social, and cultural disciplining," to a fictional biological basis ocularly available in terms of skin color.[96] Although flesh might exceed the discursive as the "vestibule (or 'pre-view')" of a colonized North America, it remains nonetheless temporal, not reducible to bare life. Because the past lives on in flesh, providing the relational intersections of all that is, including the symbolic, material, affective, perceptual, and ideological, it is able to disrupt any articulation of a metaphysics of presence.[97] Crimes against the flesh thus institute these gashes that cannot be sutured over, that do not disappear, that are rifts in the flesh of the world.

Whereas the essence of totalitarianism is terror, the essence of the ideology of racism under colonization is profit. It is well served by the "'atomizing' of the captive body," which takes it out of lived time and space. In this symbolic order, even with so-called "liberation," the "captive flesh/body" is still ruled by an "episteme"—an ideology that perpetuates the "originating metaphors of captivity and mutilation" that serve the economic order. The temporality and spatiality of lived existence, with its historical horizons, are collapsed into the repetition compulsion that grounds the new symbolic order; the "human subject is 'murdered' over and over again."[98] The specificity of names, kin relations, and gender is obliterated by an accounting system of salable goods.[99] There is no differentiation in quantification between men and women other than that women, with their "apparently smaller physical mass," take up "'less room' in a directly translatable money economy."[100] The problem of kinship for this profit-oriented ideology is that it would undermine "property relations . . . since the offspring would then 'belong' to a mother and a father."[101] In this new "patronymic, patrifocal, patrilineal and patriarchal order," where a

mother's relation to her child is assured through birth and a father's by the giving of his name, the Africans enslaved were denied both.[102]

But despite the imposition of this ideology, "African peoples in the New World" fostered relational ties.[103] Moreover, outside the ideology of this patriarchal symbolic order, where "'motherhood' is not perceived . . . as a legitimate procedure of cultural inheritance" and African American men are denied access to the "Father's name, the Father's law," it is "the female" who "stands *in the flesh*, both mother and mother-dispossessed." Spillers's point is not that African American women should seek gendered inclusion within this system, with its racist ideology ruled by profit. The possibility for their empowerment lies in challenging the system itself; in standing "*in the flesh*," they open up the possibilities for "the *insurgent* ground as female social subject [who claims] the monstrosity (of a female with the potential to 'name')." [104] She reveals, shows, or names from outside the system, bringing to appearance possibilities for a new relational and civic order that begins with the "pre-view" of the flesh.[105]

Disrupting racist ideology will take such a shift in the relational order of phenomenal perception with its power to name. Sylvia Wynter describes ideology as the colonial "totalizing ground" that needs to be disrupted.[106] The total visibility that supports racist vision remains in the background because we do not see the structures that support that vision, the ways of thinking, or the historical events that belong to the metaphysics of the flesh. As Al-Saji points out, "I can see objects only because I cannot see otherwise than as objects." The background of habits, horizons, and "historicity that institutes vision" cannot be seen in order to enable the perception of objects to take place.[107] It is not that Wynter wants to forego a ground altogether; rather, the ground needs to include all humans, which means upending the system of the binary principle that establishes the human in the first place as "Man" and his others, which imposes the invention of "Indians, Negroes, Natives."[108] It is a system guided by one idea "about one ethno-class conception of the human Man which represents itself as if it were the human."[109] This understanding of the human as Man also shapes the ways humans "experience" themselves to be.[110] For as we saw with Merleau-Ponty, even the idea of "Man" has its reverberations in the flesh of the world since it is always more than just an idea in the ways it can fall into the background, setting up a level against which everything else appears. To understand the world ontologically as flesh means there are no absolute binaries between ideas and things. Ideas such as "racial inferiority" can be literally inscribed in the flesh, as well as taken up as idealities in the way our bodies direct us in and toward a world.

On the other side of ideology and its representational impositions, colors, too, are nonbinary. Truitt's sculptures reveal how bodies, as material, are of color and thus resonate and respond affectively to colors. Although the boxes are the size of bodies, they do not represent bodies as such but instead capture idealities—affects, intensities, the depths of interiority—that have been turned from private feelings into artworks fit for a public world.[111] Even though they rely upon a subjective response from viewers, their strong material presence locates them fully on the side of the shared objective world. They help dislodge viewers from subjective projection onto the world, grounding them more fully in the present and opening up possibilities for simultaneous encounters with who or what is there. Although the works are not representational—to recall, for Truitt, they are referential—in their presence, they awaken my body to its hidden capacities for an emotional range from joy to wonder. They vibrate with energy to which my body responds, and I notice how rarely I have the opportunity to expand corporeally in the way these works invite in my day-to-day routines. To encounter Truitt's works is to be corporeally reminded of the richness of the given that cannot be so easily incorporated into a subjective field without remainder. Rather than confirming existing perceptual structures, they open them up to new specifications, articulations, and sedimentations.

Although Truitt's sculptures reveal how intense colors interweave with emotional memories, their presence as floating blocks of color is fully anchored in the present. Ideological reasoning sacrifices the present for a future that never arrives. As a process in motion for the sake of the process, it never actually touches on anything or anyone. But embodied perceptual cognition does. It takes place at the intersection of interiority opening onto an exterior world. When we learn to see colors, we acquire a "certain style of vision," a certain way of seeing. Colors show us the "gaping open" of a horizon between interiority and exteriority. They not only resound and intertwine with one another, allowing for perceptual modification, but also intertwine with memories and idealities we carry within us as an "ephemeral modulation of this world."[112] In describing the red of a dress, Merleau-Ponty notes that its fibers are interwoven with all the "fabric of the visible," and hence also the "fabric of invisible being," since the visible belongs to a temporal spatial sedimentation. The dress is thus a "punctuation in the field of red things, which includes the tiles of roof tops, the flags of gatekeepers and of the revolution," and so on. A color can never be simply a "chunk of absolutely hard, indivisible being, offered all naked to a vision which could be only total or null."[113] Nonetheless, the dynamic colors of Truitt's

sculptures have a stronger presence than the significations we bring with us to the encounter. They insist we encounter them as they are, as flesh.

These works provide for flesh on the other side of signification, before the imposition of ideas, before the gashes or in spite of them since they bring embodied memory, trauma, and affect with them. In their glowing presence as transcendent blocks of color, they solicit the gaze establishing "an expressive space."[114] In a letter to her sister, Truitt writes that she is after the "ultimate space, the one behind phenomenological space," and that "color is one of the attributes of that space, or one of the keys to it—I think the latter."[115] It is flesh. This does not mean her boxes are cut off from cognition. Rather, they precede and support it, soliciting embodied perceptual cognition to be open to new ways of thinking that nonetheless are anchored in and thus arise out of situations. The exhibition as a whole— the intermingling of these sculptures in one place—provides a realigning of my perceptual world according to the works. Rather than merely seeing the works, I am brought into the level of perceptual attunement with things, people, and emotions precisely because the works resist representation but have such an overwhelming yet intimate presence that invites me into their proximity with a heightened awareness.

III. Racist Idealities and the Corporeal Schema

Racist ideology embodied as ideality is impoverished; in its rigidity it works to close down the inherent sinuosity and openness of the body. Nonetheless, it cannot completely close it down since the body is an open system. This openness allows it to incorporate racist idealities in the first place, but it is also the same openness that means there is a possibility for agency and change. Idealities are assimilated into a corporeal schema that Merleau-Ponty describes as a "global awareness of my posture in the inter-sensory world."[116] This schema is one that is sedimented over time and remains in the background as a "certain structure of the perceived world," which means the "perceived world" is also "rooted" in the corporeal schema.[117] In other words, because the body is open to the world, the corporeal schema and the perceived world are coconstitutive. There could be a danger here that body and world become another closed, although coconstitutive, system. But because embodied subjects are also capable of embodied perceptual cognition, they are not merely automatons with reflexes; they do not simply react to the real. Although the corporeal schema shapes how we encounter the world and make sense of it—it "governs the details, it brings out the sense, it shows an order, an interior of process"—the schema is not static.[118] As an intersensory belonging to the real, it is also dynamic.[119]

Embodied responses are creative as an "original intentionality," an "I can" rather than an "I think that," and thus they are open to change.[120]

Nonetheless, because it is sedimented over time in response to the world, the corporeal schema is also described as a "privileged level" and an "attitude toward" the world.[121] This privileged level is accomplished through movement: "The body is [a] schema because it's [a] motor power."[122] We do not engage with the world through the translation of representations into movements: "vision and movement are specific ways of relating" to the world gathered together through the "movement of existence" oriented toward the "inter-sensory unity of a world."[123] When experienced typists are at work, they do not take up each letter, or even each word, as evoking a representation of movement. They might not even cognitively know where the letter is on the keyboard, at least not without reflecting upon the movement of their fingers. But they know where to find the letters. They have incorporated the space of the keyboard into their own bodies. Their fingers move across the keyboard not "as a spatial trajectory" but rather "as a certain modulation of motricity . . . endowed with a typical or familiar physiognomy."[124] Reading a word opens up a "motor space" beneath the typist's hands. The word itself is a "modulation of visual space," and the fingers' movement is a "modulation of manual space." The typist does not need to "translate the word into movement" since "each 'visual' structure" has a "motor essence."[125]

Learning to type relies on the inherent human capacity to be open to the world. Humans are only able to move into and toward the world—that is, to have a world—because their bodies gear into it and incorporate new ways of making sense. Corporeal meanings literally incorporated in habits are at the same time both motor and perceptual because they inhabit a place between what we explicitly perceive and the movements solicited by what is perceived. They delimit the field of what can be seen and what can be done.[126] Once the "blind man's cane" has been incorporated into his body schema, it extends his visual reach from his fingers to the end of the cane.[127] The ways we move are an extension of our existence within a world that is perceivable, and perceptual habits, in turn, provide for the "acquisition of a world." At the same time, "every perceptual habit is still a motor habit." In other words, "the grasping of a signification is accomplished by the body" and not by the mind.[128]

This means that even though the rigidity and singularity of racist ideology can be incorporated as ideality in the habitual body, as embodied, it is nonetheless still open to change. But enacting change requires a new way of making sense of the perceived world. We inhabit particular

situations in space and time that "are always surrounded by indeterminate horizons that contain other points of view." The corporeal schema is a system of equivalences that allows the body to gear into "different motor tasks" and take up the world in the way the typist is at home with the keyboard. It allows the body to "understand" the world it encounters without the mediation of "'representations,' or without being subordinated to a 'symbolic' or 'objectifying function.'"[129] It allows sedimented structures to be transposed into new situations because it is always an "experience" of one's "body in the world."[130] What is possible always exceeds a given situation. On the one hand, it can allow for the transposition of racism into ever new situations. On the other hand, it can also allow for shifting the structures themselves. Even at the level of corporeal intentionality, agency is enacted, and choices are made.[131]

How one takes up racist idealities depends on the way one's body is situated within the system. Embodied subjects are capable of taking up idealities that either impede their own ability to gear smoothly into the world or allow them to impede that of others. For racialized people, situational possibilities are too often foreclosed. Frantz Fanon explains how it is difficult for him, as a racialized man in a colonial world, to develop a corporeal schema as "a manner of expressing that [his] body is in and toward the world."[132] The corporeal schema opens the body to the world through movement. Since it is itself not perceived, it can be understood to be more like a "norm or a privileged position" that orients bodies in the world; it is "prior to explicit perception."[133] We don't perceive the norms themselves; rather, we tend to perceive *according* to them. Sitting at his desk, Fanon can reach for his cigarettes when he wants to smoke. He can "lean back slightly" so that he can open the left drawer in order to find his matches. This is, for him, an "implicit knowledge"; it is the "slow composition of [his] *self* as a body in the middle of a spatial and temporal world . . . [that] does not impose itself on [him]; it is, rather, a definitive structuring of the self and of the world."[134] But in a colonial world where his Black body is defined only in opposition to white bodies, it is reflected back to him as "distorted."[135]

While Merleau-Ponty moves freely in a world where his perception aligns with his motor intentions, allowing for the "responses" he "anticipate[s] from" it, Fanon's agency, his ability to take up the "real world," is *"fixed."*[136] Merleau-Ponty experiences his body as the "implied third term of the figure-background structure." The world is not simply what he perceives. As the third term, his body actively participates through the level established by situated and relational perception; he reaches for his pipe, and he engages with others.[137] But Fanon does not always experience his

own body as the implied third term, as a moving—that is, perceiving—subject; he occupies "space," and he moves "toward the other." But the racializing other does not recognize him in his opacity as a subject: "I move slowly in the world . . . I progress by crawling. And already I am being dissected under white eyes, the only real eyes. I am *fixed*."[138] Under white eyes, the only ones that count in the creation of colonizing culture, his corporeal schema crumbles: woven as it is through a matrix of racist myths, it becomes instead a "historico-racial" schema that is ultimately collapsed into a "racial epidermal schema."[139] He is a "slave, not [even] of an 'idea' that others have of [him], but of [his] own appearance."[140] Rather than moving freely in and toward a world that appears to him with increasing richness and clarity, reflecting him back to himself, he is blocked at every turn. It is experienced by him as "an amputation."[141] The creative possibilities of his "I can" become reworked as an "I cannot."[142] Although he refuses this loss, he is nonetheless denied agency, with its accompanying "responsibility," in a world where, as Al-Saji points out, he always already arrives too late on the scene.[143] Encounters with the "other" are foreclosed; "coexistence" is distorted by a colonial temporality that shuts down the possibilities of the present where encounters take place. Fanon does not experience feelings of "inferiority" but rather of "nonexistence."[144]

For those white bodies who racialize, the possibility for creative agency is more open. Helen Ngo explains this phenomenon in terms of racism as habit.[145] As we saw previously, habits are embodied ways of taking up and understanding the world. The typist has to cultivate the keyboard as a habitual modulation of space. Racism as habit operates on the other side of cognition, accessible to reflection but usually cultivated prereflectively through a certain corporeal understanding of the world. As Ngo points out, racist habits belong to a certain "orientation" toward the world that is accompanied by a "receptivity" to the ways the world solicits our embodied perception.[146] Habits are not automatic reflexes but must always be redeployed and creatively transposed to move into new situations.[147] Ngo finds Merleau-Ponty's concept of sedimentation not sufficient for describing an *"ongoing* activity" that is not simply "deposited" into the body.[148] Nonetheless, she describes how we can think about sedimentation as a more active concept in terms of settling into a situation and actively holding the body in each encounter with the world and others—in other words, that habits are both *"held* and *activated."*[149]

But white bodies have to actually encounter the world to enact change. In his analysis of the experience of being subjected to the racializing gaze of a white woman in the confined space of an elevator, George Yancy

observes that the woman does not actually see him. She encounters only herself, only the representations she projects onto the world and others. She "'sees' a criminal . . . something eviscerated of individuality, flattened, and rendered vacuous of genuine human feelings." And yet, he has not actually done anything. Like the prisoners in the Nazi camps, he is not held responsible for his deeds, for who he is, but for what he is, or, more to the point, for how he appears.[150] In his view "she is one of the walking dead."[151] Her feelings of "expansiveness" impede his freedom, but they also impede hers. She does not actually gear into the world since we do not gear into the "imagination."[152] We are free when we are able to move into a situation and take up the possibilities that situation allows.[153] For Yancy, however, it is a matter of survival for Black people to close down possibilities for encounters in situations like this, or, rather, to risk reading too much into them, because the consequences of not doing so can be deadly.[154] While Yancy's freedom is here curtailed, the white woman's is not. Nonetheless, because she does not actually see him and does not try to question how she sees him, she in fact gives up her freedom. To actually be open to gearing into the encounter would entail cultivating her perception, which would allow her to shift her bodily habitual response, the affective and habitual way her body responds to Yancy's presence.[155]

Although racist ideology has its own logic, it is not a logic that engages the real. Attempting to dismantle racist ideology through reason alone is not sufficient for addressing how bodies phenomenally take up racist styles of being that structure the ways they encounter the world and others. At the same time, those who do not reflect upon the ways they corporeally move into and take up the world and others will continue to gear into and take up a racist system that does not touch upon who or what is actually there. Racist habits belong to the corporeal schema and impede encounters with others. As embodied norms, they fade into the background. Nonetheless, these norms are still open to change, since it is possible for movements or gestures belonging to the corporeal schema to become integrated into new movements and new gestures and for what is given in the visual field to be incorporated into new ways of making sense.[156] These new ways of making sense are what Merleau-Ponty refers to as divergences (écarts) from the norms.[157] They arise out of and are shaped by norms but do not coincide with them. Divergent changes to norms have the possibility of becoming new norms.[158]

IV: THE NEW DIMENSIONS OF TRUITT'S SCULPTURES

Truitt's sculptures provide for such divergences, offering colors as new dimensions: the color on one sculpture can wrap around the side of the work

so that the corner seems to disappear, providing an écart—an unexpected divergence from expected perceptual norms. They open up new norms by grounding embodied perceptual cognition firmly in a situational world, in reality as relational, on the other side of imposed ideas. In this experiential world, "perceptual thinking" is rooted "in the moving subject."[159] Encountering these sculptures helps reorganize my corporeal schema, my "system of motor powers or perceptual powers."[160] The sculptures show up the centrality of movement to perception—that is, to creatively revealing being. As I walk around a cluster of five sculptures arranged with one in the center and two on each periphery, the sculptures on the periphery appear to bend and move.[161] The faster I walk, the more the colors bend and curve away from the direction of my steps. As I slow down, so do they, and then they gradually resume their upright position. We could call this an optical illusion; the tall rectangular sculptures bend across my cornea as I move. Or we could explore the phenomenological insight these works provide.

The movement of my gaze is "a march toward the real."[162] It anchors itself in the world not as an operation of consciousness but rather "through a preconscious operation" that precedes the gaze since it is "always already" anchored in a level. But instances of what Merleau-Ponty calls "ambiguous perception" reveal "the power we have of changing" the way we are perceptually anchored within the world. The church steeple begins to move across the sky when the sky is relegated to "peripheral vision." When I focus on the sculpture in the center of the ensemble, those on the periphery begin their dance: "My eye is, for me, a certain power of encountering things; it is not a screen upon which things are projected." Rather, it has a "certain hold" on the artwork.[163] As a march toward the real, my gaze works to encounter the sculptures. Rather than showing us what is logically there, the sculptures reveal how we relationally encounter the world: the ways things leap out at us, bend into one another, or recede into the background. My gaze is solicited by the artworks that require me to move around them if I am to encounter them fully. Movement relationally connects the subject to a situation; indeed, "this motor capacity is the light of perception."[164] As I move, the works reveal variation: the multiple perspectives that belong to moving because they move when I move.

Embodied subjects achieve stability in their lived existence. Although they institute an "instability" or "fluctuation" when they move, the body also moves in order to "organize the instability": "walk, lose one's balance, catch oneself."[165] It seems as though the world is stable because we can lend it the movement of our bodies, providing these variations that allow for multiple perspectives on the things. Like a Cézanne still life that

achieves a sense of reality by opening up the pictorial space to multiple perspectives, Truitt's sculptures show how variation provides "dimensions of stability."[166] This is very different than the stability achieved through the movement of an ideological system that actually denies a perceptual hold on the world that is anchored in a situation but open to creative play. I initiate, and hence reveal, a certain reality through the ways I move and the perspectives I take. This is the prereflective phenomenal reality we corporeally live but rarely consider because, in this modern age, we have learned not to trust our perception, even though it is our primary way of making sense of what is—and one that grounds us in a world in which we think and act.

As we have seen, levels belong not only to a situation but also to the ways perception anchors within that situation; that is, they belong to the body schema itself. Because perception is intertwined with movement, the ways we move affect our perception, and our perception affects the ways we move. But we cannot perceive ourselves moving since that would require an outside perspective on ourselves. This is why this chiasmic relation tends to fall into the background. Perception and movement are "synonymous"; they "emerge from one another," but this coemergence remains imperceptible in itself because we cannot perceive ourselves perceiving.[167] However, an encounter with Truitt's sculptures reveals how my perception and the ways I move are chiasmic. I see this in the ways the sculptures respond and bend into one another as I move. They also reveal how my body is in a chiasmic relation to the world. Situations are opened up by living beings, and living beings are, in turn, opened up by situations.[168] An encounter with Truitt's sculptures reveals this relation, allowing for the possibility to reflect on it. We are responsible for what we do and for our relations with others. This is why Merleau-Ponty preferred the word *praxis* to *action*; he found in praxis a sense of motivation that is embedded in the world itself—we are solicited by the things.[169]

Truitt's sculptures allow for the time and space that belong to a situation. They provide a stable place as time swirls around them; they slowly disintegrate, like bodies over time.[170] They help provide a visual field that is given to viewers through its "near-bys, its far-offs, its horizon," a field in which things and relations appear, a field that is "indispensable for there to be *transcendence*"—that is, multiple but not infinite possibilities for engagement.[171] This is what it means to encounter the world and others. To imagine that there is a singular world that can be reconstructed through some account of a physiological nervous system that denies interiority does not give us what is actually there. Similarly, to organize the world according

to the singular perspective of an ideological system that denies the world we live suppresses the relationality that belongs to our experience of reality.[172] The movement of ideology is the movement of the system for the sake of the system that does not touch on who or what is actually there. It operates outside the time and space that belong to the situation and, in so doing, curtails not only freedom of movement but also the freedom of embodied perceptual cognition. One can only encounter Truitt's sculptures through moving around them; it is movement motivated by the works themselves that allows them to be perceived from different points of view. When I walk around them, I experience movement in terms of the range of perspectives I am able to generate. Because the encounter phenomenally reveals my relationality to the world, it also provides the possibility for reflection on how I respond and hence on how I am responsible for what I do.

In the logical space of infinity, there are no limits provided by the situation; it is, as Arendt observes, not merely that everything is permitted but rather that anything is possible if it is delimited by the system and for the sake of the system. The only limit is the limitless imagination of the human mind. Rather than the space of infinity, Truitt's sculptures establish spatial situations with their inherent limits that allow for encountering the real. They reveal that there is no logical space of infinity; where I am situated and how I move affect what and how I perceive. They are in and of themselves vertical beings that, like human bodies, find their home between earth and sky. They reveal an important aspect of vertical being—that it is not reducible to one perspective, that it allows for "the possible as a claimant of existence."[173] Each situation provides a multiplicity of possibilities for movement and perspective, but these possibilities are circumscribed by the material, temporal, and spatial limitations—as well as the limitations posed by the existence of others—that make movement possible in the first place. Vertical being—being situated on the earth and beneath the sky—is interrogative: it "requires creation of us for us to experience it."[174] But this is not the same creativity that belongs to the infinite imagination of the mind. Where life is experienced as terror or nonexistence, the movement that allows for questioning, responsiveness, and taking responsibility is shut down.

A public realm that denies the coexistence of multiple perceptions of reality risks becoming an ideology, cut off from the movement of life. A situation provides for an openness that allows one to move around and see things from different perspectives because the possibilities are not infinite. When reality is created through making sense of what is there, meaning is not simply imposed on what is but is rather encountered through

embodied perceptual cognition. When systematicity threatens to engulf that which makes us human, our very capacity to be responsive is impeded along with a sense of responsibility for a shared world and for others. If we are unable to gear into and perceptually make sense of a situation that is confirmed by others, we cannot make sense of the real. We are not able to think through what needs to be done or reflect on the effects of our own responses. This retreat from the reality that emerges from encounters with who and what is there helps facilitate the kinds of violence required by racist ideology. Living in a world of imposed systems means anything is possible, for it does not have to touch on what or who is there; it does not have to make sense. If the political is a making sense of what we do according to the common sense of a shared reality that consists of multiple simultaneous points of view, then it is always contingent and changing; nevertheless, and because of this, it is grounded in reality. For reality can only be given to us through the movement of embodied perceptual cognition.

Notes

1. I first saw Truitt's sculptures at the Hirshhorn Museum and Sculpture Garden's 2009 retrospective of her work. Admission to the Hirshhorn is free, which increased its accessibility. Thanks to Kevin Rodgers for recommending the exhibition and for our conversations about Truitt and minimalist sculpture. A video exhibition of a 2010 exhibition of her work at Matthew Marks Gallery, New York, can be seen at https://matthewmarks.com/exhibitions/anne-truitt-sculpture-1962-2004-05-2010 .

2. Kristen Hileman, "Presence and Abstraction," in *Anne Truitt: Perception and Reflection*, ed. Kristen Hileman (Washington, DC: Hirshhorn Museum and Sculpture Garden, 2009), 35.

3. Anne Truitt, *Return*, 2004, acrylic on wood, 81 × 8 × 8 in., available at Matthew Marks Gallery, http://www.annetruitt.org/exhibitions/anne-truitt-sculpture-1962-2004/selected/3; *Pith*, 1969, acrylic on wood, 85.5 × 18 × 18 in., available at Dia:Beacon, http://www.annetruitt.org/exhibitions/anne-truitt-at-diabeacon/selected/6; *Morning Choice*, 1968, acrylic on wood, 72 × 14 × 14 in, available at Anne Truitt, http://www.annetruitt.org/works/selected-sculptures/17 .

4. Anne Truitt, *First Requiem*, 1977, acrylic on wood, 90 × 8 × 8 in., available at MoMA, https://www.moma.org/collection/works/174793.

5. Truitt speaking about her work in Jem Cohen, dir., *Anne Truitt: Working* (Brooklyn: Gravity Hill Farms, 2008), 16mm film, 13 min. The film can be viewed as part of a symposium, *Anne Truitt, Working—A Remembrance. In the Tower: Anne Truitt Symposium, Part III*, National Gallery of Art, Washington, DC, January 19, 2018, https://www.youtube.com/watch?v=5_02__pD578.

6. Cohen, *Anne Truitt: Working*.

7. Cohen, *Anne Truitt: Working*.

8. Truitt writes:

> In the case of the sculptures, I then make scale drawings of their dimensions and have the structures fabricated by a cabinetmaker; they are made of fine-grained 7/8″ plywood, carefully mitered and splined. They are hollow and if they are tall are weighted at the bottom so that they will not tip. The insides are sprayed with preservative, and they have holes drilled up into their hollows so that they can breathe in various temperatures. I paint these structures with a number of coats, sanding with progressively finer

sandpapers between each one, until I have layered color over them in varying proportions. By way of this process, the color is set free into three dimensions, as independent of materiality as I can make it. (Anne Truitt, *Turn: The Journal of an Artist* [New York: Viking Penguin, 1986], 56–57)

9. Cohen, *Anne Truitt: Working.*

10. Cohen, *Anne Truitt: Working.*

11. Cohen, *Anne Truitt: Working.*

12. James Meyer with Anne Truitt, "Grand Allusion," *Artforum International* 40, no. 9 (May 2002), 158.

13. Hannah Arendt, *The Human Condition* (Chicago: Chicago University Press, 1958), 168.

14. Hileman, "Presence and Abstraction," 30. Truitt is quoted from a March 1987 interview in the *Washington Post.* Although Truitt's work is understood as minimalist, and she is taken to be a contemporary of other artists in this tradition, such as Donald Judd, Robert Morris, Dan Flavin, and Sol Lewitt, her work must nevertheless be understood on its own terms. James Meyer, "The Bicycle," in *Anne Truitt: Perception and Reflection*, ed. Kristen Hileman (Washington, DC: Hirshhorn Museum and Sculpture Garden, 2009), 50–51. Taking up an artist's works primarily in relation to others can be a way of avoiding the materiality of the works themselves.

15. Arendt, *The Human Condition*, 169.

16. As Cecilia Sjöholm, drawing on Arendt, points out, "art and politics have in common their appearance in the public sphere." Cecilia Sjöholm, *Doing Aesthetics with Arendt: How to See Things* (New York: Columbia University Press, 2015), 21.

17. Arendt, *The Human Condition*, 1.

18. Arendt, *The Human Condition*, 261.

19. Arendt, *The Human Condition*, 171.

20. Arendt, *The Human Condition*, 171.

21. Arendt, *The Human Condition*, 266.

22. Arendt, *The Human Condition*, 260.

23. Arendt, *The Human Condition*, 261. Arendt is citing the physicist Werner Heisenberg.

24. Arendt, *The Human Condition*, 262. My italics.

25. Arendt, *The Human Condition*, 266.

26. Arendt, *The Human Condition*, 265.

27. Arendt, *The Human Condition*, 263.

28. Arendt, *The Human Condition*, 265.

29. Arendt, *The Human Condition*, 267. As with statistics that allow one to stand back far enough so that all particularity is obscured, there is no actual moment in time or any concrete event. Instead, there are rates of probability.

30. Martin Heidegger, "Science and Reflection," in *The Question Concerning Technology and Other Essays*, trans. William Lovitt (New York: Harper & Row, 1977), 164; originally published as "Wissenshaft und Besinnung," in *Vorträge und Aufsätze* (Frankfurt am Main: Vittorio Klostermann, 2000), 46.

31. Heidegger, "Science and Reflection," 172–173; "Wissenshaft und Besinnung," 54–55. My italics.

32. This pure relation or ordering process "takes precedence over the object and the subject," which are now "secured as standing-reserve." Heidegger, "Science and Reflection," 172–173, 165; "Wissenshaft und Besinnung," 54–55, 47.

33. Arendt, *The Human Condition*, 267, 279.

34. Arendt, *The Human Condition*, 279–280.

35. Arendt, *The Human Condition*, 3.

36. Hannah Arendt, *The Origins of Totalitarianism* (San Diego, CA: Harcourt, 1968 [1952]), 445.

37. Arendt, *The Origins of Totalitarianism*, 445.

38. Arendt, *The Origins of Totalitarianism*, 444.

39. Arendt, *The Origins of Totalitarianism*, 440.

40. Arendt, *The Origins of Totalitarianism*, 446.

41. Arendt, *The Origins of Totalitarianism*, 461–462.

42. Arendt, *The Origins of Totalitarianism*, 471.

43. Arendt, *The Origins of Totalitarianism*, 471.

44. Arendt, *The Origins of Totalitarianism*, 463.

45. Arendt, *The Origins of Totalitarianism*, 464.

46. Arendt, *The Origins of Totalitarianism*, 464.

47. Arendt, *The Origins of Totalitarianism*, 465.

48. Arendt, *The Origins of Totalitarianism*, 466.

49. Arendt, *The Origins of Totalitarianism*, 472.

50. Arendt, *The Origins of Totalitarianism*, 472–473. Arendt writes, "To the extent that the Bolshevik purge succeeds in making its victims confess to crimes they never committed, it relies chiefly on this basic fear and argues as follows: We are all agreed on the premise that history is a struggle of classes and on the role of the party in its conduct. You know therefore that, historically speaking, the party is always right. . . . The coercive force of the argument is: if you refuse, you contradict yourself and, through this contradiction, render your whole life meaningless." Arendt, *The Origins of Totalitarianism*, 473.

51. Arendt, *The Origins of Totalitarianism*, 470–471.

52. Arendt, *The Origins of Totalitarianism*, 471–472.

53. Arendt, *The Origins of Totalitarianism*, 473.

54. Arendt, *The Origins of Totalitarianism*, 473–474.

55. Arendt, *The Origins of Totalitarianism*, 475. The private sphere is also destroyed when, for example, a woman is abused in her own home and is also deprived of a place of retreat.

56. Lisa Guenther points out that "Arendt underestimates the degree to which the legal personality of criminals can be destroyed in a situation of mass incarceration, as well as the sense in which some prisoners are 'state-raised,' interpellated as criminals more because of their class and race than because of their actions or speech." Lisa Guenther, *Solitary Confinement: Social Death and Its Afterlives* (Minneapolis: University of Minnesota Press, 2013), 258. Guenther's important work on the loss of self and reality under situations of solitary confinement brilliantly clarifies the necessity of reality being confirmed by our relations with others.

57. Guenther, *Solitary Confinement*, 475–476.

58. Guenther, *Solitary Confinement*, 477.

59. Hannah Arendt, "Organized Guilt and Universal Responsibility," in *Essays in Understanding 1930–1954: Formation, Exile, and Totalitarianism*, ed. Jerome Kohn (New York: Schocken Books, 1994), 126.

60. Merleau-Ponty, *The Visible and the Invisible*, 22; *Le visible et l'invisible*, 40; *Phenomenology of Perception*, 337; *Phénoménologie de la perception*, 373.

61. See Édouard Glissant's discussion of opacity in his *Poetics of Relation*, trans. Betsy Wing (Ann Arbor: University of Michigan Press, 1997), 189–194.

62. Maurice Merleau-Ponty, "The Philosopher and His Shadow," in *Signs*, trans. Richard C. McCleary (Evanston, IL: Northwestern University Press, 1964), 147.

63. Merleau-Ponty, "The Philosopher and His Shadow," 33.

64. Kimberley Curtis, *Our Sense of the Real: Aesthetic Experience and Arendtian Politics* (Ithaca, NY: Cornell University Press, 1999), 12.

65. Merleau-Ponty, *Phenomenology of Perception*, 326; *Phénoménologie de la perception*, 361. My italics. However, I would argue this crossing out of "aberrant" givens belongs to not really perceiving what is there.

66. Merleau-Ponty, *The Visible and the Invisible*, 151; *Le visible et l'invisible*, 196.

67. Merleau-Ponty, *The Visible and the Invisible*, 237; *Le visible et l'invisible*, 286.

68. Merleau-Ponty, *The Visible and the Invisible*, 151; *Le visible et l'invisible*, 196.

69. Merleau-Ponty, *The Visible and the Invisible*, 152; *Le visible et l'invisible*, 196–197.

70. Merleau-Ponty, *The Visible and the Invisible*, 113; *Le visible et l'invisible*, 152.

71. Maurice Merleau-Ponty, "New Working Notes from the Period of *The Visible and the Invisible*," in *The Merleau-Ponty Reader*, ed. Ted Toadvine and Leonard Lawlor (Evanston, IL: Northwestern University Press, 2007), 429–430. The transcriber of this note dated December 1959 is unsure of the name of the sculptor and notes it as "Giorgio de [Gisgi?]." I wonder, and it would seem to me a possibility, if it was Giorgio de Chirac.

72. Merleau-Ponty, "New Working Notes," 429–430. I must admit to being cynical about his ability to remember the things, the rocks, but not the "woman" from the "Belgian Congo" who showed them to him. Nonetheless, her fervor as affect is taken up in his experience of the rocks and stays with him as part of their ideality or corporeal essence.

73. Merleau-Ponty, *The Visible and the Invisible*, 152; *Le visible et l'invisible*, 200.

74. Merleau-Ponty, *The Visible and the Invisible*, 114; *Le visible et l'invisible*, 154.

75. Merleau-Ponty, *The Visible and the Invisible*, 115; *Le visible et l'invisible*, 154. They are thus more *Sosein*, or ways of being, then *Sein*, or being itself.

76. Merleau-Ponty, *The Visible and the Invisible*, 141; *Le visible et l'invisible*, 186.

77. Merleau-Ponty, *The Visible and the Invisible*, 152; *Le visible et l'invisible*, 199.

78. Alexander G. Weheliye, *Habeas Viscus: Racializing Assemblages, Biopolitics, and Black Feminist Theories of the Human* (Durham, NC: Duke University Press, 2014) 35.

79. Weheliye, *Habeas Viscus*, 35.

80. Weheliye, *Habeas Viscus*, 36. Philippe Sands makes this connection in his account of Rafael Lemkin's mission to institute the legal term of *genocide* as "the destruction of groups" within the context of the post-WWII Nuremburg trials of Nazi war criminals. This quest met with resistance from both the American and British legal prosecution teams: the Americans were afraid of political backlash given their historic treatment of African Americans and Indigenous peoples, and the British were aware of the implications of this term for their colonial empire. Philippe Sands, *East West Street* (London: Weidenfeld & Nicolson, 2016), 107, 208, 336.

81. See Kathryn T. Gines, *Hannah Arendt and the Negro Question* (Bloomington: Indiana University Press, 2014).

82. Arendt makes claims such as "the danger is that a global universally interrelated civilization may produce barbarians from its own midst by forcing millions of people into conditions which, despite all appearances, are the conditions of *savages*." In redeploying this word, especially in this context, Arendt reveals how she too ultimately belongs to a Eurocentric way of thinking that relies on a binary of civilized and not civilized. It is this binary way of thinking which underlies and supports colonialism. Arendt, *The Origins of Totalitarianism*, 302. My italics.

83. Weheliye, *Habeas Viscus*, 38. Merleau-Ponty also writes, "Western humanism is a *humanism of comprehension*—a few mount guard around the treasure of Western culture; the rest are subservient.... Western humanism, like the Hegelian State, subordinates empirical humanity to a certain idea of man and its supporting institutions." Merleau-Ponty, *Humanism and Terror*, 176.

84. Sjöholm points out that even as Arendt did not recognize the rich cultural heritage of African peoples, she nonetheless understood the significance of preserving cultural heritage, including literature and artworks, for conditioning the world and allowing it to endure. Sjöholm, *Doing Aesthetics with Arendt*, 31–32.

85. As I complete the final revisions on this chapter in June 2020, protests denouncing police violence against Black people are taking place across the United States as well as in Canada and Europe. The protests have been galvanized by the killing of George Floyd, an African American man killed by a white police officer who held him in a choke hold for almost nine minutes. "I can't breathe" has become a slogan for the marches. Floyd's death can be added to a very long list of police killings of Black people in the United States, including the shootings of Mike Brown, Jonathan Ferrell, Renisha McBride, Eric Garner, Tamir Rice,

Freddie Gray, Ahmaud Arbery, Breonna Taylor, and Rayshard Brooks. See Amina Khan, "Getting Killed by Police Is a Leading Cause of Death for Young Black Men in America," *Los Angeles Times*, August 16, 2019, https://www.latimes.com/science/story/2019-08-15/police-shootings-are-a-leading-cause-of-death-for-black-men.

86. Weheliye, *Habeas Viscus*, 37.

87. Weheliye, *Habeas Viscus*, 37. Weheliye's critique of Giorgio Agamben's concept of "bare life" as the bringing of "biological life" into the political realm is one that I cannot take up here. See Giorgio Agamben, *Homo Sacer: Sovereign Power and Bare Life*, trans. Daniel Heller-Roazen (Stanford, CA: Stanford University Press, 1998). Of course, Agamben takes his reading of bare life from Arendt. See, for example, Arendt, *The Origins of Totalitarianism*, 441. Weheliye takes his definition of "social death" from Orlando Patterson, *Slavery and Social Death: A Comparative Study* (Cambridge, MA: Harvard University Press, 1982), 39.

88. Hortense J. Spillers, "Mama's Baby, Papa's Maybe: An American Grammar Book," *Diacritics* 17, no. 2 (Summer 1987): 67.

89. Merleau-Ponty, *Phenomenology of Perception*, 84; *Phénoménologie de la perception*, 97.

90. Indeed, it was accusations of the wandering gaze that were used as an excuse for lynching.

91. Spillers, "Mama's Baby, Papa's Maybe," 64–81. The symbolic order references Jacques Lacan's understanding of the cultural psyche as established through language. The imaginary, which is tied to the image, precedes language.

92. C. Riley Snorten takes this up in *Black on Both Sides: A Racial History of Trans Identity* (Minneapolis: University of Minnesota Press, 2017).

93. Spillers, "Mama's Baby, Papa's Maybe," 72. Italics in original.

94. That is, it is concealed by both the symbolic and the imaginary of American grammar. Spillers, "Mama's Baby, Papa's Maybe," 67. Weheliye, *Habeas Viscus*, 51.

95. Spillers, "Mama's Baby, Papa's Maybe," 67.

96. Spillers, "Mama's Baby, Papa's Maybe," 67. Weheliye, *Habeas Viscus*, 43.

97. Spillers, "Mama's Baby, Papa's Maybe," 67. Thanks to Zelda Blair for drawing my attention to the vestibule in the article.

98. Spillers, "Mama's Baby, Papa's Maybe," 68.

99. Spillers, "Mama's Baby, Papa's Maybe," 73.

100. Spillers, "Mama's Baby, Papa's Maybe," 72.

101. Spillers, "Mama's Baby, Papa's Maybe," 75.

102. Spillers, "Mama's Baby, Papa's Maybe," 76.

103. Spillers, "Mama's Baby, Papa's Maybe," 74. This ideology includes civil codes of "slaveholding" that "cannot *move* in the behalf of the enslaved or the free," compelling the "'master'" to "treat the enslaved as property, and not as person." Spillers, "Mama's Baby, Papa's Maybe," 78.

104. Spillers, "Mama's Baby, Papa's Maybe," 80.

105. Erica S. Lawson describes the ways Black women engage in maternal activism and leadership as social subjects on behalf of their children: "Many Black mothers and fathers quietly or publicly advocate for their children to address the social injustice that they encounter in the everyday world"; she examines "maternal subjectivity as an epistemological platform that engenders expressions of leadership and agency for some Black women." Erica S. Lawson, "Mercy for Their Children: A Feminist Reading of Black Women's Maternal Activism and Leadership Practices," in *African Canadian Leadership: Continuity, Transition and Transformation*, ed. Tamari Kitossa, Erica S. Lawson, and Philip S. S. Howard (Toronto: University of Toronto Press: 2019), 205, 192.

106. Scott, "The Re-Enchantment of Humanism," 121.

107. Al-Saji, "A Phenomenology of Critical-Ethical Vision," 379.

108. Scott, "The Re-Enchantment of Humanism," 121, 198, 183.

109. Scott, "The Re-Enchantment of Humanism," 198.

110. Scott, "The Re-Enchantment of Humanism," 205.

111. Truitt observes that as she aged, color became "more complex and harder and harder to mix": "I have all those years that I have to face and it takes a certain amount of courage. It's not a light and foolish thing.... There are more complexities in it because my own experience is much more complex." Meyer with Truitt, "Grand Allusion," 161.

112. Merleau-Ponty, *The Visible and the Invisible*, 132; *Le visible et l'invisible*, 173.

113. Merleau-Ponty, *The Visible and the Invisible*, 132; *Le visible et l'invisible*, 173.

114. Merleau-Ponty, *Phenomenology of Perception*, 147; *Phénoménologie de la perception*, 170.

115. Hileman, "Presence and Abstraction," 33.

116. Merleau-Ponty, *Phenomenology of Perception*, 102; *Phénoménologie de la perception*, 116.

117. Merleau-Ponty, *The Sensible World*, 104; *Le monde sensible*, 144.

118. Merleau-Ponty, *The Sensible World*, 93; *Le monde sensible*, 133.

119. Merleau-Ponty, *Phenomenology of Perception*, 102; *Phénoménologie de la perception*, 116.

120. Merleau-Ponty, *Phenomenology of Perception*, 139; *Phénoménologie de la perception*, 160. Merleau-Ponty also calls this, following Husserl, an "'operative' intentionality." Merleau-Ponty, *Phenomenology of Perception*, 441; *Phénoménologie de la perception*, 478.

121. Merleau-Ponty, *The Sensible World*, 90, 93; *Le monde sensible*, 131, 133.

122. Merleau-Ponty, *The Sensible World*, 90; *Le monde sensible*, 131. Note, this quote is a title in the original text and, as such, is capitalized.

123. Merleau-Ponty, *Phenomenology of Perception*, 102, 139; *Phénoménologie de la perception*, 116, 160.

124. Merleau-Ponty, *Phenomenology of Perception*, 145; *Phénoménologie de la perception*, 168–169.

125. Merleau-Ponty, *Phenomenology of Perception*, 145; *Phénoménologie de la perception*, 169.

126. Merleau-Ponty, *Phenomenology of Perception*, 153; *Phénoménologie de la perception*, 177.

127. Merleau-Ponty, *Phenomenology of Perception*, 144; *Phénoménologie de la perception*, 167.

128. Merleau-Ponty, *Phenomenology of Perception*, 154; *Phénoménologie de la perception*, 178.

129. Merleau-Ponty, *Phenomenology of Perception*, 141; *Phénoménologie de la perception*, 164.

130. Merleau-Ponty, *Phenomenology of Perception*, 142; *Phénoménologie de la perception*, 165.

131. When I first shifted to a German keyboard, where the *y* and the *z* are the reverse of an English keyboard, it took some time before my fingers adjusted to the new visual/spatial situation, but they did.

132. Merleau-Ponty, *Phenomenology of Perception*, 103; *Phénoménologie de la perception*, 117.

133. Merleau-Ponty, *The Sensible World*, 103; *Le monde sensible*, 143.

134. Fanon, *Black Skin, White Masks*, 111; *Peau noir masques blancs*, 89. Italics in original.

135. Fanon, *Black Skin, White Masks*, 113; *Peau noir masques blancs*, 91.

136. Merleau-Ponty, *Phenomenology of Perception*, 261; *Phénoménologie de la perception*, 290. Fanon, *Black Skin, White Masks*, 110 [*le véritable monde*], 116; *Peau noir masques blancs*, 89, 93. Italics in original.

137. Merleau-Ponty, *Phenomenology of Perception*, 102–103; *Phénoménologie de la perception*, 117.

138. Fanon, *Black Skin, White Masks*, 112, 116; *Peau noir masques blancs*, 90, 93. Italics in original.

139. Fanon, *Black Skin, White Masks*, 112; *Peau noir masques blancs*, 90.

140. Fanon, *Black Skin, White Masks*, 116; *Peau noir masques blancs*, 93.

141. Fanon, *Black Skin, White Masks*, 112; *Peau noir masques blancs*, 91.

142. Al-Saji, "A Phenomenology of Critical-Ethical Vision," 377. I will add here that others have pointed out the ableist assumptions in both Merleau-Ponty's and Fanon's texts. Robert McRuer, for example, draws on Adrienne Rich's description of "compulsory heterosexuality" to describe how able-bodiedness is naturalized so that the world is established under the assumption that natural and hence healthy bodies are "able-bodied." Robert McRuer, "Compulsory Able-Bodiedness," in *50 Concepts for a Critical Phenomenology*, ed. Gail Weiss, Ann V. Murphy, and Gayle Salamon (Evanston, IL: Northwestern University Press, 2019), 61–62.

143. Fanon, *Black Skin, White Masks*, 140; *Peau noir masques blancs*, 114. Alia Al-Saji, "Too Late: Racialized Time and the Closure of the Past," *Insights: Institute of Advanced Study* 6, no. 5 (2013): 5. In this essay, Al-Saji provides a brilliant analysis of temporality in Fanon's work.

144. Al-Saji, "Too Late," 8.

145. Helen Ngo, "Racist Habits: A Phenomenological Analysis of Racism and the Habitual Body," *Philosophy and Social Criticism* 42, no. 9 (2016): 848.

146. Ngo, "Racist Habits," 863–865.

147. Ngo, "Racist Habits," 849–850.

148. Ngo, "Racist Habits," 862–863.

149. Ngo, "Racist Habits," 863, 865. Italics in original.

150. George Yancy, "The Elevator Effect," in *Black Bodies, White Gazes: The Continuing Significance of Race* (Lanham, MD: Rowman & Littlefield, 2008), 4. Ngo also turns to Yancy's essay to explore racism as habit.

151. Yancy, "The Elevator Effect," 4.

152. Merleau-Ponty, *Phenomenology of Perception*, 338; *Phénoménologie de la perception*, 374.

153. Merleau-Ponty, *Phenomenology of Perception*, 467; *Phénoménologie de la perception*, 505.

154. Yancy, "The Elevator Effect," 10.

155. Yancy, "The Elevator Effect," 5.

156. Merleau-Ponty, *Phenomenology of Perception*, 154–155; *Phénoménologie de la perception*, 179.

157. Merleau-Ponty, *The Sensible World*, 98; *Le monde sensible*, 139.

158. Stefan Kristensen, "Le mouvement de la création: Merleau-Ponty et le corps de l'artiste," *Alter: Revue de la Phénoménologie* (2008): 245.

159. Merleau-Ponty, *The Sensible World*, 86; *Le monde sensible*, 125.

160. Merleau-Ponty, *Phenomenology of Perception*, 155; *Phénoménologie de la perception*, 179.

161. These works are *Elixir*, 1997, acrylic on wood, 82 × 8 × 8 in.; *View*, 1999, acrylic on wood, 82 × 8 × 8 in.; *Viking*, 2002, acrylic on wood, 82 × 8 × 8 in.; *Evensong*, 2004, acrylic on wood, 82 × 8 × 8 in.; and *Return*, 2004, acrylic on wood, 81 × 8 × 8 in.

162. Merleau-Ponty, *Phenomenology of Perception*, 291; *Phénoménologie de la perception*, 323.

163. Merleau-Ponty, *Phenomenology of Perception*, 291–293; *Phénoménologie de la perception*, 323–324.

164. Merleau-Ponty, *The Sensible World*, 85; *Le monde sensible*, 125.

165. Merleau-Ponty, *The Visible and the Invisible*, 230; *Le visible et l'invisible*, 284; Merleau-Ponty, "New Working Notes," 435.

166. Merleau-Ponty, "New Working Notes," 434.

167. Merleau-Ponty, *The Visible and the Invisible*, 255; *Le visible et l'invisible*, 303.

168. Kristensen, "Le mouvement de la création," 247.

169. Merleau-Ponty, *The Sensible World*, 100; *Le monde sensible*, 140.

170. Anne Truitt, *Daybook: The Journal of an Artist* (New York: Penguin Books, 1982), 51.

171. Merleau-Ponty, *The Visible and the Invisible*, 231; *Le visible et l'invisible*, 280. Italics in original.

172. Merleau-Ponty, *The Visible and the Invisible*, 231; *Le visible et l'invisible*, 280.

173. Merleau-Ponty, *The Visible and the Invisible*, 228; *Le visible et l'invisible*, 277.

174. Merleau-Ponty, The Visible and the Invisible, 197; Le visible et l'invisible, 248.

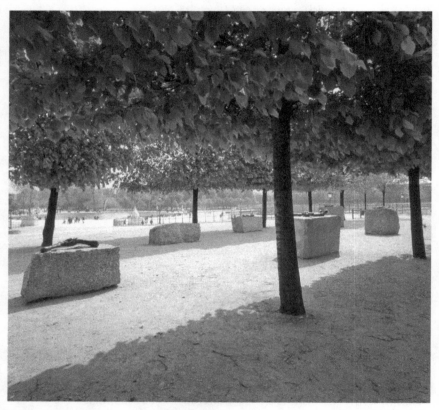

Fig. 4.1 Louise Bourgeois, *The Welcoming Hands*, 1996 © The Easton Foundation/VAGA at Artists Rights Society (ARS), New York/SOCAN, Montreal (2021). Photo: Jean-François Jaussaud.

4

BUILDING DIFFERENT WORLDS

Louise Bourgeois's *The Welcoming Hands*

I WAS IMMEDIATELY DRAWN TO the configuration of six sculptures of intertwining bronze hands supported by granite blocks of divergent heights, shapes, colors, and textures the first time I stumbled across them in the Jardin de Tuileries in Paris (see fig. 4.1). Louise Bourgeois's (1911–2010) *The Welcoming Hands* (1996) beckoned me to approach and encounter them, to walk around them and touch them; I was at once both disturbed and captivated by these precisely rendered sculptures (see fig. 4.2).[1] The bronze hands that rest upon the granite stones are at once beautiful and uncanny in their lifelike mimesis of hands that hold, support, and intertwine with other hands. They reveal hands, which usually disappear in everyday tasks, as strange. And they reveal their strange appearance as seemingly amputated limbs that are also quite lively. The sculptures were originally created for Battery Park in New York City.[2] They were installed across the water from the Statue of Liberty and were meant to welcome "newcomers"—new immigrants—as Bourgeois herself once was. But some officials from the adjacent and newly built Holocaust museum and the Battery Park City Authority worried the hands were suggestive of "severed body parts" and a reminder of death camps.[3] The hands were moved away from the museum, to the artist's dismay. They were eventually sold and installed in the Jardin de Tuileries in a site within the garden chosen by Bourgeois, who oversaw the installation.

The sculptures cannot be seen from a distance. The granite blocks seem to arise from the earth, and the hands are only visible once one has entered into the clearing where they are installed. Passersby stumble upon them as I did, and few seem completely indifferent to their solicitation. The hands call on these passersby to encounter them—to move around them, bend over them, and touch or even caress them—as those who respond to the sculptures reflect on them with one another. The

varying stone sizes and shapes lend themselves to bodies of different heights and capacities. Children are immediately attracted to the singular tiny child's hand resting on a low-standing stone they can easily reach. They measure their own hands against it and discuss the sculpture with their adult companions.

As I stay awhile with the hands, they no longer look like severed limbs. Set on a granite block just below my chest height, two sets of arms and hands form a chiasmus—the crisscrossing arms of two people facing one another and holding on to each other's hands. These lively and engaged hands bring their invisible bodies with them similarly to the way Merleau-Ponty describes the phenomenal experience of leaning on his desk with both hands oriented toward a task, his body trailing "behind them like a comet's tail," his "entire stance" visible in the gesture of his hands.[4] But Bourgeois's bronze hands are not engaged in a task; they are engaged with one another. In another sculpture, one set of arms encircle another's invisible body and visible arms as though standing behind them. The hands are tender, gentle, and supportive. In yet another, two strong hands grasp and support two old and frail hands.

Already there is something different about a permanent work installed outdoors. Because these sculptures are not located in a museum, they are encountered by passersby rather than gallery visitors. They are not aesthetic objects to be looked at from a distance. Only some of those who encounter the works seek out the plaque bearing the artist's name. In a museum, sculptures cannot be touched—outdoors, they can. These works openly invite touch in a way even the other outdoor sculptures in the park generally do not. Bourgeois's sculptures are encountered by those who do not already know her work and who have perhaps not sought out an artwork but are merely passing through. The sculptures alter the rhythms and movements of those who pass by, gathering them together in varying and shifting configurations and inviting them to stay a while.

Placed just off the grid of the royal road that links the grand monuments of the French Republic, the six individual sculptures question what it means to build a public and communal space. *The Welcoming Hands* are nestled under two parallel lines of trees on the far northwest corner of the gardens near the Galerie Jeu de Paume, which was once a handball court. At least three paths meet and cross at this place created by the sculptures. Two of the paths are, in turn, divided by rows of trees, creating the sense of multiple paths. These paths are not visible if one follows the main route from the Musée du Louvre going west through the gardens past the Place de la Concorde, connecting the Champs Élysées and the Grand Palais to

the Arc de Triomphe, and ending at La Grande Arche de La Défense. The sculptures are situated on a hill off this main path, but the granite stones are not indifferent to the materials of the nearby monuments. There is the three-thousand-year-old obelisk made of yellow granite around which traffic swirls in the adjacent Place de la Concorde, where the guillotine stood during the revolution. There are the statues—contemporary, modern, and classical—that populate the Jardin des Tuileries, as well as the Tour Eiffel, which can be seen in the distance, yet there is a difference. Set within this imposing institutional layout that begins with the highly planned gardens and extends out into the grand boulevards of Paris, Bourgeois's sculptures are modest, quiet, and easily missed.

My argument is that these sculptures establish a public site where people who dwell in different worlds have the possibility to encounter one another. The site interrupts the Eurocentric idea of public space that insists on reducing the visual field to representations of civic equality whereby citizens identify with one another within the same culture.[5] The monuments support the singular narrative that covers over the violence of European colonization and domination as well as the alternative histories of those colonized. The relatively recent laws against the headscarf, or "veiling," in France are an example of this phenomenon. In this public debate, the veil is seen as uniformly oppressive to women, as defying France's principle of secularism, or *laïcité*, and as symbolic of nonintegration.[6] But these laws do not take into account the actual lives of the women whose bodies they control since they also impede their participation in civic life. If the women concerned had actually been consulted, another story would have emerged.[7] But that would have required seeing them as subjects. Michela Ardizzoni points out that the terms *veil* and *headscarf* (*le foulard*) are European words that emerged out of the Orientalist imaginary of "women's subjugation," along with a "mysterious and secretive—almost dangerous—erotic nature of that which is covered and concealed from the casual gaze."[8] This erotic "symbol" shifted to one of "political danger" during the Algerian war, in which Algerian women were active participants in resistance.[9] For Ardizzoni, "the question of the veil" is "couched in terms of restricting binaries: secularism-Islam, Us-Them, East-West"; this covers over the complexity and "hybridity" that belong to the "contestation" and "re-negotiation" of social identities.[10] It is telling that Muslim terms such as *hijab* and *haik* were not generally used in the French press.[11]

As Arendt explains, a polis is protected by laws that provide the stability and limits within which people can act and speak—that is, disclose

themselves.[12] Like the territory opened up by Bourgeois's sculptures, laws provide the limits for a place of appearance. Laws that shut down public participation based on representational appearance do not provide a space where uniqueness can appear and where people can be touched by what is said and done. Instead, they provide limits that wall in.[13] What remains is not political power in Arendt's sense of the potentiality of action when people live together, but rather force.[14] Banning the veil is an example of such representational closure that echoes the divisive exclusion arising out of unequal access to economic opportunities as well as to political power. The concern I pose is how embodied perception can be reflectively cultivated to open up possibilities for sharing the same world with others who dwell in different worlds—a sharing that does not rely only on the representational level of existence.[15]

The sculptures, in inviting encounters, allow passersby to actually touch upon who and what is there as the relational within a place created by the works. If we encounter others only through the overdetermined representations we project onto who is there, we encounter only what we have made ourselves. A political system that reduces equality to a fixed representational identity does not recognize that the relations implied by this equation result in a nonrelational conformity articulated as the "unitedness of many into one." Such a unity is, as Arendt argues, "antipolitical; it is the very opposite of the togetherness prevailing in political or commercial communities."[16] But space that is truly public offers a place where unique individuals can disclose themselves through acting and speaking together. And, as Sjöholm points out, artworks contribute to such space since, as they are made to appear in public, they help condition public perception.[17] *The Welcoming Hands* installs a public place as a place of disclosure where appearing the same is not required for being equal. Bourgeois comments that the hands are "those of people of different ages, from babies to the very old and of many different colors." Moreover, the hands are not obviously sexed, although Bourgeois claimed her own hands served as a model, as did the hands of her assistant.[18] But the differences the sculptures disclose do not rest on the reduction of skin color or clothing to the representational we tend to rely on in this age. Instead, they open up a relational space of disclosure.

To return to the example of veiling, a French company even withdrew its plan to market a sports hijab due to public pressure. The idea behind this withdrawal is that the hijab represents loss of freedom for women when, in fact, for many Muslim women it means the opposite: it is a chance for them to be active in the world.[19] But Bourgeois's hands challenge the

belief, reinforced by the surrounding grand monuments, that to be equal is not to be different. They bring into appearance the diversity, alterity, particularity, and mutual interdependence of those belonging to the public realm. This is diversity that is often actively suppressed and realities that are prevented from appearing within the public space of appearance. But to be deprived of this space of appearance is to be "deprived of the reality that comes from being seen and heard by others, to be deprived of an 'objective' relationship with them that comes from being related to and separated from them through the intermediary of a common world of things."[20] To be clear, being seen is not to be confused with "self-presentation," the "active and conscious choice of the image shown." Instead, to be seen by others comes from "the urge toward self-display by which living things fit themselves into a world of appearances," in other words, from the urge to participate in creating a world with others.[21] The focus on the self-presentation provided by the laws hinders the need for self-display or for participating in a world with others.

The sculptures enact the political by making manifest that which usually remains invisible and that which does not usually come into appearance: the relational web enacted by individuals whose uniqueness only appears through what they say and do. These sculptures extend Arendt's public world to include the caring and interdependence that also belong to a public world attuned to relations with others, which allows for welcoming relations with strangers. It is not the insistence on abstract identity we need: "The end of the common world has come when it is seen only under one aspect and is permitted to present itself in only one perspective."[22] As we saw in the last chapter, it is this lack of having one's reality recognized by others that must be endured by those whose subjectivity is publicly denied, including the women in France whom the veiling laws address. To be denied this space is to be "deprived of reality"—that is, "guaranteed by the presence of others, by its appearing to all."[23]

I. HOLDING OF THE HELD

Bourgeois's sculptures install public space by providing an alternate level to the dominant one of the Parisian imperial and postrevolutionary architecture; the straight lines that connect the triumphant markers of a city's past also mark the intersection of paths where this work is placed. They disturb the organization of the larger field. To recall, spatial levels provide the dimension or field against which objects, beings, and world are relationally revealed. They establish a kind of perceptual logic within which the relations among things make sense. Anything that does not make

sense within the logic is crossed out as "unreal." It remains imperceptible. How could Merleau-Ponty know his pen was not constantly shifting color, from black to blue to grey, unless perception could take account of shifting lighting levels within a field? He does not see the color of his pen changing. He sees his pen in shadow or in direct sun. The varying colors of his pen remain unreal, if they are even seen at all. To maintain "certainty of the world," he skips over details that do not belong to the logic of the dominant level that establishes the field.[24] They do not even appear in their absence. I think this is one reason it is difficult to notice Bourgeois's sculptures until one is actually there at the site; they do not belong to the dominant architectural level.

Another reason one could miss them is that they only set to work when one is near them. When one does stumble upon them, they establish a new local spatial level of being touched and of touching upon. As proximal, touch resists the distant unfolding that vision provides. What is touched can "never quite become an object" or a representation in the way it can for vision. Perhaps this is why it would not work for the sculptures to be seen from a distance. The subject of touch cannot have the experience of being "everywhere and nowhere," which is the illusion of a disincarnated mind.[25] There is no one perspective from which to take in all the works at once. In fact, each granite and bronze sculpture establishes its own level that interlaces with the level of the works as a whole. Encounters with them take time. Each sculpture beckons differently to individual bodies. They are set at divergent heights, and people sit down, lean over, or extend their reach to touch them. The various configurations have distinctive affects, from the singular child's hand that calls out for protection to the varying configurations of interlaced pairs. These incompossible affects bring to appearance diverse ways we can be moved and touched when we are near to others. Proximity is to be immersed in a world, to inhabit or dwell within it. It precedes any articulation or conceptualization of difference as such, but it is also not coincidence or fusion. There can only be proximity when there is also distance.[26] It is the primordial openness at the heart of being that precedes the inscription of difference that belongs to perception.

Perception can, of course, be unmoored from the relational level that provides us with a world, allowing us to see more clearly how vision takes place in a relational field. Merleau-Ponty describes how he is always capable of engaging in analytical perception, disengaging his gaze from its spatial home: "As I cross Place de la Concorde and believe myself to be entirely caught up within Paris, I can focus my eyes on a stone in the

Tuileries garden—the Concorde disappears and all that remains is this stone without any history; again, I can lose my gaze within this coarse and yellowish surface, and then there is no longer even a stone, and all that remains is a play of light upon an indefinite matter."[27] This "natural world," which we can intentionally bring to view, underlies the existential one in which we dwell—the one in which things and relations become meaningful for us.[28]

Moving into new levels engages passive touch. Strictly speaking, this transition is not, in itself, actively achieved since it is the capacity of the body as an "organism—as a pre-personal adhesion to the general form of the world, as an anonymous and general existence" that plays out "beneath the level" of "personal life."[29] Our anonymous bodies gear into and take up new levels, although this transition is achieved more quickly when we engage with what is there. Our bodies provide the capacity to move into and be shaped by the generality of public spaces; it is our bodies that allow us to encounter the world at all. I can see the blue of the sky "because I am *sensitive* to colors."[30] This sensitivity is an exchange between the sensing and the sensible, with neither taking priority. My perceptive body responds to the solicitation of the work, the questions it poses, and adjusts itself, finding a fitting comportment that will allow what is sensed to become perceived.[31] If I do not adjust my sensing to what is there, what is there will remain indeterminate or overlooked. Nevertheless, the anonymous body is not merely a set of corporeal capacities because both the sensing and the sensed have a "historical thickness" and a "perceptual tradition" they bring with them, one that settles round like an "atmosphere of generality."[32] We take up a perceptual tradition that underlies our personal choices and experiences and is given to us because we are always already in a world that precedes us with a certain shared corporeal logic or way of understanding space and movement.[33]

Those passersby who are drawn to encounter the hands engage not only the passive sense of touch, which accompanies the shift in levels already at work, but also the intentional touching of the things, which helps cultivate their perception. Even as each touch touches something or someone, this touching is simultaneously itself touched and shaped by that which it touches. Through touching these sculptures, my hand is in touch with the touch of the artist. Every gesture in some way belongs to and carves out a place in being, and the body itself is a variant of the depth, layers, and absences that belong to being itself. Similarly, vision and touch work together synesthetically because they open onto the same world. When I encounter the sculptures, I can see the roughness of the

stone and the smoothness of the bronze because all my senses have previously sedimented structures that open onto this world of smoothness and roughness. Although the two senses cannot be collapsed one to the other, they can be mutually deepening.[34] When I touch the sculpture of two young adult hands tenderly supporting a frail hand, I can feel the little dips and ridges in the aging flesh, the lines of veins that become more visible to me as I sketch them out with my fingers. Touching, like the other senses of perception, opens on to the "common structures" that typify "existence as a whole," entailing "specification, articulation and sedimentation." This perceptual process can also more generally be understood as differentiating and making visible.[35]

The "knowing touch" allows us to encounter the world. It is effective if it synchronizes with what is touched through exerting the right amount of pressure—the appropriate movement at the right speed—to provide the maximum perceptual understanding of the thing touched: "It is not Me who touches, but rather my body."[36] When Merleau-Ponty moves his hand across a table, he can distinguish between the natural grain of the wood and the structure given to it by the carpenter. Similarly, my hand knows the difference between the natural roughness of the granite and the straight line of the cut determined by the artist. I discover that the surface of each stone has a different degree of roughness and that the flesh of each hand has a somewhat different texture. None of these tactile ways of appearing can be reduced one to the other. Nor can they be detected by static pressure, which blurs the boundaries between what is touched and the touching hand. Without movement there is no background against which the tactile can emerge.[37] Without a field, the touch remains only a vague pressure or sensation. Knowing perception belongs to this field and brings with it a certain sedimented motile style that also shapes the tactile encounter.

These hands call on passersby to reflect upon what it means to touch. They are mimetic, uncannily close representations of human hands that reveal the strangeness of hands, which are both familiar and unsettling. Hands are not usually taken up consciously as objects of thought and contemplation. They concretely grasp things, conforming to what they touch. They abstractly point to things, opening up possibilities by bringing them into appearance. Setting hands apart to be contemplated allows us to contemplate the strangeness of the self that monstrates.[38] In his earlier work, Merleau-Ponty observes he cannot simultaneously perceive the world and perceive himself perceiving. His left hand can touch his

right hand "when it is inert," but it cannot touch his right hand in the act of exploring the world.[39] In the moment the left tries to touch the right hand as it touches, the right hand crosses over to the one being touched. In his later work, he expands his understanding of phenomenological description to include being aware of himself describing the world even as he cannot coincide with that self. When his left hand touches the right while it is "palpating the things," even though the right hand as the "'touching subject' passes over to the rank of the touched," it nonetheless does so as it is descending "into the things, such that the touch is formed in the midst of the world and as it were in the things."[40] This sense of touch is what makes it possible to do phenomenology since phenomenological description takes place in the midst of the world and yet never actually coincides either with itself or with world. Perception requires this écart, gap, or dehiscence in the perception of self-touching: even though we cannot simultaneously perceive the world and perceive ourselves perceiving it, we can still become aware of how perception is shaped by that which it touches and which touches it. This is the dispossession at the heart of being and means that philosophy—specifically, phenomenology—cannot be *above* life, overhanging. It is beneath."[41]

My suggestion is that the sculptures set to work by engaging all three experiences of touch: the passive experience of the body being touched; the intentional experience of touching the things themselves, whereby the mind is not leading the touch but rather the touch is solicited by that which is touched; and finally, the touching of the touch.[42] Passersby might passively move into the new level established by the site if they stay awhile with the sculptures. Moving into this new level, or even levels, encourages passersby to encounter the sculptures with a knowing touch that is open to new sedimentations. Ultimately, they are called to reflect upon what it means to touch and be touched, to phenomenally take account of their own worlds. If the tendency in this age is to exist predominantly within the cognitive-linguistic region of existence that, if tied to any perceptual sense, is more closely tied to an impoverished sense of vision, then already, by reflectively engaging another sense, passersby are, if only briefly, brought into another level, another way of encountering what is there. They are invited to perceive according to the works and to reflect on what this means. Touch is the sense of proximity, not distance. But we usually forget that which is most proximal. In this age, most of us are more likely to notice what we see rather than the air that swirls around our bodies or the

ground beneath our feet.[43] Passersby are visually drawn to the sculptures. Nonetheless, it is primarily through touch as synesthetically overlapping with vision that the sculptures cultivate embodied perceptual cognition; I see compassion in the gentle touch of these intertwining hands. Bourgeois's sculptures help anchor us in the world as embodied, situated, and in relation with others.

II. Dwelling

If we turn to Heidegger, we could say the sculptures are relational "things" that belong to dwelling, which means encountering what is near—that which is other than oneself. Mortals belong to a fourfold of alterity. They dwell on the earth under the sky before the divinities. They can only build a place to dwell if they are able to make room for this alterity, which includes both constructing buildings and structures as well as cultivating and caring for things that grow.[44] Mortals dwell when they provide a space of appearance that lets the earth come to presence, which means not to "exploit," "master," or "subjugate" it.[45] Dwelling is a staying with things, things that gather together into a space of appearance that which is around them.

Although humans make things, they are also conditioned and transformed by them.[46] In this age, this means humans are shaped not so much by things as by subjective representations of that which is there. Subject to systems of human making, wares are produced anywhere anytime in assembly-line factories situated anywhere workers can be underpaid and overworked and too often forced to endure squalid and unsafe living and working conditions. At the same time, the digital economy requires workers who can also work anywhere anytime.[47] Nothing and no one is touched upon according to what or who they are. Alterity cannot appear where production into appearance is collapsed into a kind of making appear according to instrumental planning guided by preconceived forms. If we take up the world according to our own representations, we will only ever encounter the forms we impose on the world. We can travel great distances in no time, but this does not mean distance has been collapsed. Rather, the tendency toward placelessness makes nearness and distance all the more unattainable. In a technological and digital culture that promotes mobile and docile workforces that can be efficiently switched around or rehired when needed, all for the sake of the system, everything is "uniformly distanceless."[48]

But art sets to work differently.[49] Artworks are things that can install a space in which we might dwell. Phenomenally, nearness has nothing to

do with distance as we generally conceive it.[50] We do not draw near to representations or objects we stand over and against.[51] But an artwork that sets to work brings us near when it reveals the way things relate to one another and the ways they come into appearance within a world. Art understood in terms of aesthetics is caught up in a system of production for the sake of the process. But artworks encountered as artworks provide a site where the real is revealed. They provide an opening, a clearing within which mortals are thrown beyond the familiar.[52] While the Greek temple provides the site or opening in Heidegger's writing on art, he turns to an earthenware jug to reveal the thing. The jug, as a thing, is a vessel that, once made, stands on its own—like Bourgeois's sculptures. As a material object, it stands as a vessel whether Heidegger represents it to himself or not. But even thinking about the jug in this way is still to think about it in terms of how it is made, which is the tendency of our age, rather than to reveal its essence as a jug, as a "holding vessel."[53] The thingness of the jug is not something representable as such because it is the jug's void that holds the wine and not its impermeable bottom and sides made by the artisan.[54] The potter shapes the void that is itself "impalpable." The thingness of the vessel lies, then, not in the material itself but rather "in the void that holds."[55]

The artisan does not so much make the jug as reveal it into presence. What is concealed and withdraws in the presencing of the jug is the void. The jug's void holds in a twofold manner of "keeping and retaining" what it takes in.[56] Taking and keeping belong together, but their relational "unity is determined" by the pouring from the jug for which the jug is shaped as a jug. The shape itself lends itself to holding and pouring. And it is in the relational bringing together of pouring wine from the jug to those gathered to drink together that the thing is revealed as a thing. In German, the word for "to pour" is *schenken*, and, for "gift," *Geschenk*. The pouring, then, is the presencing of the giving.[57] The pouring of wine from the jug gathers earth, sky, mortals, and the divinities—that is, the fourfold—in its taking and keeping. The water for the vines comes from the spring that carries the rock from the earth with it as well as the rain from the sky. The grapes are nourished by the rain and the sun, the roots of the vines by the minerals found in the earth. It is drunk by mortals who are mortal not because they will die and hence have a limited time on earth but rather because they approach death as death; they feel anxiety in the face of their own finitude. The pouring from the jug becomes a gift because it "stays earth and sky, divinities and mortals." This staying is not simply a persisting but rather an appropriating that "brings the four into the light of their mutual

belonging." This event of appropriation (*Ereignis*) is the coming to light of a mutual belonging that is, in itself, transformative. Mortals dwell in the fourfold insofar as they receive the sky, await the divinities, and save and preserve the earth. The fourfold finds its fulfillment in the pouring from the jug as a giving thanks to the divinities—or that which is other than human making and control.[58] The jug presences as a thing whereby the thing becomes a verb; it "things" in the relational appropriating gathering of the fourfold. Heidegger calls it a mirror play, a round dance that brings the four into their own revealing as what they are.

The Welcoming Hands are things that install the fourfold as a relational location. Out in the open, they reveal the sky as sky; the dappled sunlight that comes and goes shimmers along the polished bronze. As I walk around the sculptures on a sunny afternoon, they seem to move as the light dances through the branches gently rocking with the wind. The light refracts differently upon the multiple surfaces. The hands seem livelier in the light, the polished limbs more vibrant. The rain from the day before has washed them and is pooled in cupped hands. The trees that line the pathways also come into appearance as trees. They are planted in parallel lines and have a kind of architectural presence that reveals both the highly structured gardens that are here brought into view and the constrained growing that belongs to the trees themselves. The straight lines of the trees mirror those of the granite stones, a material often used in building. The stones set up the hands, holding them steady under the sky and on the ground. Granite is from the earth. These stones bear both the straight lines of the architectural cut and the rough surfaces and varying colors of natural stone. They reveal the cut between world and earth, between that which is revealed and that which withdraws.[59]

There is something restful about these sculptures that hold steady under the sky and on the ground even as there is a constant swirl of movement around them: the noise of traffic from the six roads that converge at the nearby Place de la Concorde as well as the passing by of people as they walk through the garden. The architecture in these surroundings allows for one kind of presencing, and Bourgeois's sculptures, for another. The shared root *tec* can be found in both *architecture* and *technē*. *Technē* is a letting "something appear within what is present."[60] Here the granite blocks come into appearance in the way they preserve the earth as earth by showing up as granite stones in their unyielding holding and supporting of the hands in the way the earth supports mortals. The hands themselves parallel or echo the paths that intersect at various points at this place of crossroads bringing the paths into appearance. Mortals are revealed in the

aging hands, in the polished surfaces where human hands have touched the bronze, as well as in the uncanny presence of the hands that reveal the self that monstrates.

It is easy to get caught up in their uncanny likeness to human hands and assume this is what the hands are actually about. But like the jug, the hands hold. The German root word *halten*, "to hold," also means to bear, keep, preserve, and sustain. It resounds with *sich aufenthalten*, "to stay awhile," and with *Verhältnis*, or "relation." The sculptures invite passersby to stay awhile with the works. The holding that is the essence of the work is not what is literally represented in the hands but is rather the holding provided by the site the works install. It is found in the spaces between, the relations among those who stay awhile with the works and with each other. Humans can only represent that which has already shown itself "of its own accord" in light of being. They do not substitute distant things with "mental representations [*Vorstellungen*]."[61] When I think about Bourgeois's sculptures, I am already there among them. Providing representations of these hands is secondary to that experience. And this is what the sculptures reveal—that holding is not what is mimetically revealed but rather is the relationality that does not come so readily to appearance in this age. They reveal both the holding and the held as well as the essence of this age that governs the ways things and people come into appearance. The precise replication of hands can fascinate and distract passersby from the essential presencing of the sculptures in their relational holding. But then again, this fascination with representation that obscures the relations we have with one another belongs to the being of this age. The mimetic hands might visually draw passersby into the site, but in staying awhile with the hands, this fascination with representation comes into appearance for what it is even as the sculptures reveal existence as relational.

In a late speech on sculpture, Heidegger remarks on how difficult it is for a sculpture to be encountered in the modern epoch; sculptures are mostly designed for industrial landscapes and set up as aesthetic objects.[62] Nonetheless, sculptors must confront space. As Andrew Mitchell observes, "the sculptor's confrontation (*Auseinandersetzung*) is capable of interrupting the smooth functioning of the plan, of setting (*setzen*) apart (*auseinander*) a place that will disturb the seamless field" of commodified space.[63] Sculptors do not confront space in terms of extension, the place taken up by a body. Instead, sculpture can allow us to think space and body together: "I can be touched from a distance only because my body is already at that distance from me. My body is the abode and my abode is the

world."[64] When Heidegger stands by the window, he is also there on the street and in the city. When he goes through the door, he doesn't "transport" his body; he shifts his relations to the things in terms of nearness and distance.[65] Sculptors, however, in confronting space, seek to reveal the invisible essence of what is and bring it to appearance. They seek to open up space or world in new ways.[66] Sculpture itself is a body, and artists cannot separate their own lived bodies from their works: "what happens to [Bourgeois's] body is repeated in the stone."[67] This means they cannot engage space as spatium, the quantifiably measurable space in which the sculpture is placed. Sculpture reveals how space can be understood neither as subjective in terms of representation, a Kantian subjective form imposed on what is there, nor as objective in the sense of an object we stand over and against.[68] Instead, the place taken up by the body of the sculpture provides its limits: not limits in the sense of where it ends but rather where it begins to presence.[69] Humans do not make space; instead, they make room for things they set up and for which they take care. They free space "for regions, places and ways."[70] They do not *have* bodies and so are not limited by their bodies' boundaries; they *live* their bodies in relation (*im Verhältnis*) to other humans, and they stay (*aufhalten*) with things.[71] All sculpture is public (*veröffentlich*) because, in confronting space, it is always already "exposed and relational."[72]

Bourgeois's sculptures can be encountered because they establish a place where the relational, including the fourfold, begins to presence. When I move into the realm they've created, it is not so much that my body is transported into a new space but rather that the sculptures alter what concerns me and the way the world touches me.[73] They reveal the limits of the representational, as well as that which is usually concealed—the relations that sustain me in my everyday public world. The uncanniness of the hands calls on me to question what it means to be in relation to others. For Heidegger, to think we are at home is to miss the essence of what it is to be human, which is to be *unheimlich* or unhomely. In his earlier work, he understood the *unheimlich* to be the human capacity to violently make appear—that is, to create.[74] In later work, the *unheimlich* as the alien in the familiar is thought as the human capacity to question being. To think we are at home is to stop questioning what is.[75] To stop questioning belongs to the essence of this age of Gestell where humans believe they can control what is. The conquering of space and time through technology provides the illusion that there are no limits to what humans can make; they need only expand or speed up the process. But they learn how to dwell when they, as mortals, encounter not objects or representations but things in

relation on the earth and under the sky, when they think about what they build to allow for such near relations.[76]

III. Dwelling in Different Worlds

Irigaray provides another perspective on dwelling. Humans share the same world, but they dwell in different worlds that belong to their individual psychic and cultural experiences.[77] The framework Heidegger describes as imposed on the way everything is revealed in this age is also a framework that belongs to a singular subject position, a singular culture, or a subject who is only in relation to himself. For Irigaray, the measure for humans is not only the vertical dimension between earth and sky, but it is also the horizontal dimension of cultivating relations between one and an other. Mortals do not need to project that which is other to themselves onto a celestial god. Alterity as the divine can be found in others who are different from one another. Humans are not only called to safeguard the earth as earth, letting earth be; they are also called to shelter the presencing of the other—to cultivate a free space in which they might not only allow things to presence but also the other as other. This requires that each one cultivate an interior space that allows them to become who they are in relation to others. Otherwise, they offer to the other only an "enclosed," and even "empty, territory" that might shelter the other, but in "a place already defined by our norms, our rules, our lacks and our voids."[78] The other is invited to dwell in the closed "loop of the interlacing of relations where we ourselves are situated by our culture, our language, our surroundings," ignoring "our lack of freedom." In fact, the invitation to the other is too often a gesture meant only to open up—that is, to "create a draught of air in our enclosed and saturated world."[79]

For Irigaray, it is not enough to build structures; we must also build our own identities. Stepping back into "one's own horizon" allows for one to "welcome" the other thoughtfully without the "appropriation [that] has dominated" building in a "monosubjective culture," so as to allow the other to be.[80] It requires "recognizing one's own limits" and that the other cannot be reduced to "one's own existence."[81] An exchange thus requires that "the other touch us, particularly through words."[82] This requires listening to the linguistic and cultural context of what is said. Touching oneself as well as touching the other requires proximity. Proximity is achieved through responding not to things or even to being but rather to another being whom we can never know.[83] Because we do not share the same territory, proximity begins with the acknowledgment that the "other as other remains remote from us."[84] Proximity precedes difference and differentiation, but it

needs the distance that protects from fusion or confusion. Otherwise, the touch is no longer proximal; it becomes "seizure, capture, comprehension, all gestures of incorporation, introjection, apprehension in which the other as such vanishes."[85] In this age, we tend to approach each other with words that lead to "confusion" or "fusion." But to be near, "touching must remain sensuous"; it must not fuse with its "surroundings."[86] Nor can it be made to appear. Intimacy is not visible. It resists the manifestation that belongs to language as showing, describing, or grasping.[87] This "makes perception an act other than seizing, naming, reproducing," and building an identity requires more than the construction of structures or the demonstration of language. It also calls for the cultivation of relations as a perpetual movement toward the other and back to the self, opening up a territory or interval in the space between.[88]

Hands that only demonstrate are subject to the privileging of vision. But hands that belong to the self that cultivates relations alternate between caring for the self and caring for others. The "duration" woven through this movement allows for cultivating an identity that permits one to stay with the other as well as with things.[89] It allows for the temporality that belongs to dwelling. My world is formed by the relational intertwining of things and others: "They compose my flesh." When I look or touch, I bring this world with me. Perception is rarely "virginal"; our flesh is a "place of exchanges with other living beings."[90] These intertwinings provide "the expanse that man must measure"—one that is not "linear, nor uniform, nor homogeneous."[91] To denominate the other as an equal subjected "to a calculating valuation . . . makes the other's approach impossible."[92] The near cannot be reduced to a calculative measure or it loses its measure altogether.[93] We lose the ability to differentiate one from the other, to become ourselves in relation to others.

Although they are mimetic, Bourgeois's sculptures could never be reduced to the representation of hands or to mere objects; relational holding cannot be represented as such. As a child Bourgeois was apparently deeply affected by the sight of soldiers returning from the First World War with amputated limbs. The Welcoming Hands seem to provide the missing limbs. But just as we would be mistaken to equate the trauma of war and violence with amputated limbs, since trauma is that which cannot be represented, so too would we miss what these hands reveal if we focus on them either as objects or representations. Like phantom limbs that haunt, it is the relations engendered between and around the hands that allow passersby to draw near. They are things in that they gather together passersby into an open space where they stay awhile, but they also reveal that which, like the

emptiness of the jug, is ungraspable in the touching of the other. What is essential about these hands is not the hands themselves. As a meditation on touch, they show me how touching exceeds material boundaries. Hands make and demonstrate; these works themselves were made, yet they also create a site where people touch and are touched. Touching is reflexive. When I touch an other, I also touch myself. Passersby touch the sculptures, measuring their hands against them, talking about them together, and reflecting upon these gestures.

Bourgeois's sculptures allow for both the vertical and horizontal dimensions of human measure. The sculptures are drawn into the earth—one can feel and see the gravitational downward pull—and they bask under the sky, only slightly sheltered by trees. Not aligned precisely with the straight lines of the garden or city, this loosely formed circle of granite blocks permits passersby to stop, walk around, walk back, engage with the sculptures and with others with whom they are walking, or contemplate the hands on their own. The sculptures delineate a territory, a place that invites passersby to stay awhile. They walk around the sculptures, encountering them as well as their companions. They stop here to have picnics and stretch, play, and embrace. As well, I would suggest that the sculpture of the small and singular child's hand is provided a shelter that protects it from the abandonment we have all experienced at some time: people stop to touch the hand and be with it. The sculptures open relations between and among mortals, and the divine is revealed not only as the "celestial [that] lies above our head" but also as that "between us."[94] The aged frail hands as well as the child's hand remind us not only of our mortality and our interdependence but also that an identity is built over time and in relation to others.[95] It is not only a thing that can be a work of art; identity also needs to be created.

The Welcoming Hands quietly disrupt the French Republic's measure of equality as being the same by reminding passersby of the particular caring relations and mutual interdependence that might ostensibly belong to the private rather than the public sphere. As Irigaray frames it, we live in the same world, but we dwell in different worlds. The question becomes how we are to relate to others who dwell in other worlds, which is the challenge the sculptures pose for public space. It is not enough to perceive the things or the other through letting be. To understand perception as always entailing the active and the passive—the reversibility that is inherent to the chiasm—is to forget the time of the first proximal relation when the fetus was actively touched by a touch that could not be actively returned.[96] For Irigaray, this is a forgetting of the maternal-feminine

at the heart of Western culture. I would argue it is also a forgetting of the slaves excluded from the public sphere of the ancient Greeks along with the contemporary Eurocentric forgetting of the stolen labor and the murdered bodies through which colonizing cultures were built and continue to be built.[97]

Becoming oneself is to corporeally recognize both this first touch—this proximity that precedes the difference and differentiating inherent to the chiasm—and the false unity of an imposed monocultural logos or logic. To not recognize this first touch is to remain embedded in a unity, a public that does not individuate—that asserts one perspective rather than recognizing multiple worlds and multiple dwellings. This means that the one cannot recognize themselves as the center of a "unique world, even if this world has been inhabited before" them as a shared world of perceptions and levels into which they move.[98] To reflect upon perception, upon what affects me, and upon how I affect others is to create an interiority; it is to not rely simply upon an engagement with that which is beyond me, an engagement in the world. This means there is not simply one orientation to the world but that orientations are multiple. To claim that "we are with one another in the same way" and that we share a "common" world is to annul "this first existence" that has shaped the ways we perceive and situate ourselves within the world.[99]

I want to suggest the primordial level that comes before all subsequent levels is one provided first by the birth parent's body during gestation, then from birth by the parent's or parents' introduction of the baby to the world, and finally by the culture that precedes us.[100] There is now evidence that the fetus perceives at both the "proprioceptive" and "auditory levels."[101] After birth, it is usually parents and other family members who introduce the baby to the world.[102] They provide the infant with the orientation toward objects and world. I see this phenomenon as children discuss the sculptures with their adult companions, touching them together. Introducing children to objects in this way can relationally integrate the objects into the self unless they are traumatic objects that defy integration.[103] The first public, the first world into which we enter into existence as a "we," is thus not that of Merleau-Ponty's anonymous body or Heidegger's *das Man*. It is the world of the birth parent, a "'who' irreducible to another."[104] This first relation is the one that shows and brings the infant into the surrounding world.[105] It is this first relation that is internalized as the other within. In order to discover one's own sense of self that is not absorbed into the general anonymous public described by existential phenomenologists, it is necessary to recognize

this first public relation, which was not anonymous but was also not yet differentiated. Differentiation can only occur after the fact through a recognition of this first proximal relation that precedes difference, that takes place before the child can actively respond, and that provides for the possibility of subsequent relations, difference, and an insertion into the world. Similarly, at a cultural level, what is needed is the recognition and working through of the traumas of a history of colonialist violence that also shape the ways we relate. Recognition, Irigaray reminds, needs to extend beyond the cognitive scope of acknowledgment. It is relational and must also include praxis.[106] Only then can the "public 'one'" become a "we" where a recognition of difference can inhere in average everydayness.[107]

The Welcoming Hands draw attention to this first public relation. These sculptures install a public place that reminds viewers on a relational level of the multiple interdependent relations we engage. The sculptures remind us that we are unique and not merely anonymous and neutral. They reconnect passersby in this public space to embodied and interior psychic memories they bring with them into the public sphere: their first relations, the incorporation of embodied gestures, their primordial relations with their parents, and the inherence of the other within in their average everyday perception, which, like levels themselves, cannot be represented as such. The point is not to return to a past but rather to creatively cultivate the self and relations with others. Bourgeois draws on pivotal images and objects from her early life to build and create new works— the works that stand before us in the present.[108] This does not mean she is caught up in the past but rather that she recognizes the ways the past can creatively structure and shape what we build in the present.[109] The sculptures work to connect passersby who encounter them to their primordial psychic past. Rather than seeing this past as something to overcome, Bourgeois's works encourage those who encounter them to work creatively, to reinvent and cultivate new relations and perceptions. The level these sculptures evoke is at once particular and shared: it concerns the back-and-forth passage between interiority and exteriority that is specific to each individual. It works to reconnect an individual primordial archaic time with a shared present—the encounter with the sculptures. The sculptures encourage passersby to bring their psychic past with them, not as one they must overcome or leave behind but rather one to which they return with a difference—with the gap or interval of the active and passive. We create by weaving the past into the present to cultivate ourselves by going back to the self, affecting the self before returning to the other.

In the sculptures, this personal psychic creativity is also reconnected to a generational and a cultural creativity.

The public world relies on a measure of objective reality. Problems arise when it is assumed either that objectivity relies upon one single perspective—the god's eye view—or that objectivity is not possible at all. We share the same world; different people who dwell in different worlds can be beckoned by these sculptures and can experience them through embodied perceptual cognition. While this sharing is temporal and spatial, both the god's eye perspective from nowhere and the infinite views from everywhere collapse time and space. Bourgeois's sculptures require space and time to be encountered. They install a kind of dwelling that relies on the proximity of being situated, of perceiving according to the sculpture, along with a certain distance created by the uncanniness of the hands. This proximity cannot itself be perceived because it is that which allows us to experience the sculpture. It is a proximity largely denied in the level of this age.

These sculptures also address another aspect of the relational space-time that belongs to the proximity of dwelling. They reveal how objectivity is not merely external but also requires a recognition of the other within. Parents provide the first public world, giving to their children the first objective world that is the one they internalize. Recognizing the other within at a cultural level begins with its recognition as a structure of the self. An acceptance of the objectivity of the public world requires first recognizing that we dwell in different worlds. If the first objective relationship between infant and parents is not taken into account, the difference inherent to objectivity in public space will also not be recognized; the danger remains that one world will be established as the only world. Or, equally problematic, a shared and communal world remains out of reach. A shared world grounded in embodied perceptual cognition also requires recognizing this first relation or relations and thereby acknowledging the proximity that precedes difference and allows us to recognize difference at all. Cultivating the self suggests that in our average everydayness, we will be more likely to recognize difference. This means the public world need not be a reduction or a leveling down. It can be a place of coexistence, a public world that takes difference into account.

I want to return here to the example of the French law banning the headscarf in public and the cultural censoring of the veil as being uniformly oppressive to women. Irigaray describes how women cannot be subjects within a Western metaphysics that cannot recognize the maternal-feminine as an active gaze or subject position. The

maternal-feminine offers a different subject position not based on a binary opposition that is ultimately reducible to the one. It offers a perception that cannot be actively seen or appropriated by the fetus in the womb. It provides a perception that cannot be assimilated into the perspective of the singular subject understood to be independent and active in the world from the start. Al-Saji similarly argues that Islamic women cannot be seen as subjects in part because their gaze cannot be actively perceived by a racializing vision.[110] The laws against veiling were introduced in France in the name of advocating gender equality. But equality is not what they actually achieve. The laws claim to address the ostensible proselytizing of the Islamic religion by the wearing of overt religious symbols that could subvert public secularism, or *laïcité*. Within this framework, veiling seems to symbolize the inequality and oppression of women.[111] Drawing on Fanon's essay "Algeria Unveiled," Al-Saji points out that French colonizers equated the veil not only with Algerian women but with Algerian culture as a whole. In insisting on the unveiling of Algerian women, they sought to destroy a culture. But the homogeneity was, in fact, on the side of the perceiving French culture. Algerian women had heterogeneous practices of wearing the veil, including wearing hijabs, niqabs, or no head covering at all.[112] These differences are covered over by the violence of forced unveiling.

The question of veiling is complicated, and it does have a complex history and particular cultural formations that need to be individually interrogated by the women whom the practices affect, as Al-Saji points out.[113] But, as she further explains, the contemporary laws are made under the assumption that white French women belong to a gender-equal society and are not subject to sexism. At the same time, "gender oppression" is projected "onto the veils of Muslim women, officially no less French but 'from the suburbs.'"[114] This projection establishes a binary and oppositional relation between "Western" and "Muslim" women and between center and periphery. In defining their identities according to the ways they are supposed to differ from one another, it is what they have in common that is covered over. Muslim women are effectively excluded from a feminist subject position and thus are not included in the debate over what happens to their own bodies.[115] What is actually obscured is the "invisible structure of secular space"—the "cultural racism," which, for example, recognizes Christian holidays, including Sundays as the day of rest.[116] This structure, level, or field that cannot be seen because everything appears according to it renders it impossible for the dominating vision to imagine veiled women as able to see and "actively make meaning" within this

field: Muslim women are rendered so passive by the veil they cannot be seen as subjects. They become "hypervisible as oppressed" even as they are "invisible as subject[s]."[117] They can neither recede into "anonymity" nor appear as subjects.[118] This means unveiling becomes the only way for Muslim women to achieve freedom in this racist field of vision, and so a sports hijab, for example, is not seen as contributing to this goal.[119]

But as Arendt points out, the "true space" of appearance "lies between people." Acting and speaking before others creates a public space "almost any time and anywhere."[120] Laws can provide a space or limit within which action and speech can occur, but they cannot make us act. If we focus on the artwork, we miss the place of public action and speech, which is in the spaces in between and around the hands where people disclose themselves. It is in the web of relations. This is what makes public space, not the focus on the hands as object or on what the hands or veils represent. If we focus on representations, we do not encounter alterity. I would suggest that the anxiety or uncanniness the hands can engender resonates with the anxiety initially produced by not seeing the bodies that belong to the hands. Although this anxiety also opens up possibilities for questioning, for not being at home, it quickly dissipates for those who stay with the hands, making way for a perceptual attentiveness that can transform what it means to be at home.[121] Our flesh is made up of these mutual relations, these interactions, these interdependencies that surprise us and that we cannot control in the way we control what we make. The public world is the world we share, but we dwell in our own worlds and between these worlds.[122]

Participating publicly in the same world requires recognizing that we dwell in different worlds, otherwise we fall back on "cultural complicity," which obscures the real.[123] This recognition of that which we perhaps cannot see should not make us anxious. Bourgeois's hands reveal that the real cannot be represented as such. It is the situated relational that modulates between things and people. Representations are mere shadows of the real, its mere effects.[124] An artwork that reminds viewers that they touch, that puts them in touch with this aspect of corporeal being that tends to recede from view, also has the potential to shift us away from the cognitive and even calculative level of existence. Bourgeois's modest sculptures reveal a possibility of relating in public space according to another way of being than technical systematicity. Cultivating touching puts us in touch with that aspect of human being, our uncanny ability to be in relation to being, as well as to others; this relational potential manifests itself in a questioning through creating things, creating identity, and making room for relations with others.

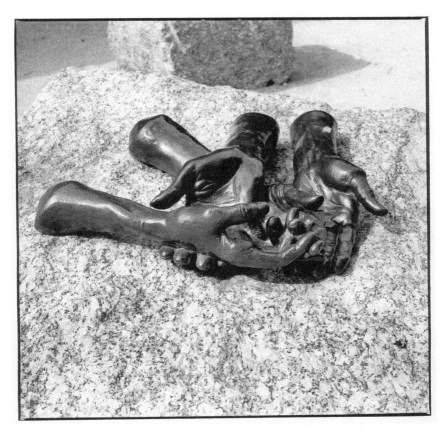

Fig. 4.2 Louise Bourgeois, *The Welcoming Hands*, 1996 © The Easton Foundation/VAGA at Artists Rights Society (ARS), New York/SOCAN, Montreal (2021). Photo: Jean-François Jaussaud.

Notes

1. Louise Bourgeois, *The Welcoming Hands*, 1996, granite and bronze; since 2000 at the Jardin des Tuileries. The image can be viewed at https://www.sculpturenature.com/en /louise-bourgeois-at-the-jardin-tuileries/.

2. Specifically, Bourgeois was "commissioned by the Battery Park City Authority of New York City to create an outdoors sculpture for the new Robert F. Wagner Jr. Park in lower Manhattan. The Park faces the Statue of Liberty and Ellis Island." Mieke Bal, *Louise Bourgeois: Memory and Architecture* (Madrid: Museo Nacional Centro de Arte Reina Sofía, 1999), 363.

3. Amei Wallach, "To an Artist, a Tender Image; to Others, a Grim Reminder," *New York Times*, August 25, 1997, https://www.nytimes.com/1997/08/25/arts/to-an-artist-a-tender-image -to-others-a-grim-reminder.html. The museum is called the Museum of Jewish Heritage—A living Memorial to the Holocaust.

4. Merleau-Ponty, *Phenomenology of Perception*, 102; *Phénoménologie de la perception*, 116. He adds, "I know where my hand is and where my body is, just as the *primitive* person in the desert is always immediately oriented without having to recall or calculate the distances traveled and the

deviations since his departure." Merleau-Ponty, *Phenomenology of Perception*, 102; *Phénoménologie de la perception*, 116. My italics. I wanted to highlight here Merleau-Ponty's own colonialist stance.

5. Identity implies difference. For two terms to be the same, they also have to be different. One is relationally implied in the other. The absolute difference assumed by a binary relation is not actually a difference at all since the difference is relational. But this relation is generally overlooked. Martin Heidegger, *Identity and Difference*, trans. Joan Stambauch (New York: Harper & Row Publishers, 1969), 23–26.

6. Since 2004 it has been illegal in France for students to wear any visible signs of religious affiliation. Since 2011 it has been illegal to wear a face-covering veil in public. In 2016 the burkini, a full-body-covering bathing suit, was briefly banned in some of the towns on the French coast. See Amanda Taub, "France's 'Burkini' Bans Are About More than Religion or Clothing," *New York Times*, August 18, 2016, https://www.nytimes.com/2016/08/19/world /europe/frances-burkini-bans-are-about-more-than-religion-or-clothing.html?action= click&module=RelatedLinks&pgtype=Article. Laïcité is described as "an uncompromising version of secularism with roots in the French revolution. This seeks to prevent the state from interfering in citizens' religious lives, and to free the state itself from religious influence. It obliges citizens to put their faith to one side in their dealings with it." This understanding of laïcité is also being taken up in Québec. "Liberté against laïcité," *Economist*, April 20, 2019, The Americas, https://www.economist.com/the-americas/2019/04/17/quebec-wants-to-ban -public-servants-from-wearing-religious-clothing.

7. For an excellent discussion of this theme, see Alia Al-Saji, "The Racialization of Muslim Veils." Ardizzoni also describes how Muslim women were not consulted. Michela Ardizzoni, "Unveiling the Veil: Gendered Discourses and the (In)Visibility of the Female Body in France," *Women's Studies* 33 (2004): 634. To be clear, I am not weighing in on the complex discussions surrounding practices of wearing the hijab. As a non-Muslim woman, this is not my place, and it is not relevant to the point I am making. Rather, I am addressing the European practices of representative exclusion.

8. Ardizzoni, "Unveiling the Veil," 629–631.

9. Ardizzoni, "Unveiling the Veil," 631.

10. Ardizzoni, "Unveiling the Veil," 629.

11. Tabassum F. Ruby explains that the term *hijab* has several meanings, including "a thing that prevents, hinders, debars" and "a thing that "prevents seeing, or beholding." Tabassum F. Ruby "Listening to the Voices of Hijab," *Women's Studies International Forum* 29 (2006): 55.

12. Arendt, *The Human Condition*, 191.

13. Fanon, *Black Skin, White Masks*, 117; *Peau noir masques blancs*, 125. See Al-Saji, "Too Late," 11.

14. Arendt, *The Human Condition*, 201.

15. Although, to be clear, shifting perception alone is not enough to change the socioeconomic and political relations that actively promote racist power relations.

16. Arendt, *The Human Condition*, 214.

17. Sjöholm, *Doing Aesthetics with Arendt*, 12.

18. Nadine Brozan, "Chronicle," *New York Times*, October 3, 1996, https://www.nytimes .com/1996/10/03/style/chronicle-631043.html. See also Allan Madden, "Louise Bourgeois, *Give or Take* 2002," Tate Modern, November 2014, https://www.tate.org.uk/art/artworks/bourgeois -give-or-take-al00343. Madden claims the hands were cast from Bourgeois's own hands and from those of her longtime assistant, Jerry Gorovoy.

19. The French company was Decathalon. A government spokeswoman is reported as saying: "Those who tolerate women in the public space only when they are hiding are not lovers of freedom." Elian Peltier and Aurelien Breeden, "A Sports Hijab Has France Debating the Muslim Veil, Again," *New York Times*, February 28, 2019, https://www.nytimes.com/2019/02/28/world /europe/france-sports-hijab-decathlon.html.

20. Arendt, *The Human Condition*, 58.

21. Hannah Arendt, *The Life of the Mind*, vol. 1 (San Diego: Harcourt Brace, 1978 [1971]), 36, 34.

22. Arendt, *The Human Condition*, 58.

23. Arendt, *The Human Condition*, 199. Lisa Guenther's work on solitary confinement well captures the way the deprivation of a space of appearance with others in its most extreme form can sever inmates from a sense of reality. Guenther, *Solitary Confinement*.

24. Merleau-Ponty, *Phenomenology of Perception*, 326; *Phénoménologie de la perception*, 361.

25. Merleau-Ponty, *Phenomenology of Perception*, 330; *Phénoménologie de la perception*, 366.

26. Merleau-Ponty, *The Visible and the Invisible*, 135; *Le visible et l'invisible*, 176.

27. Merleau-Ponty, *Phenomenology of Perception*, 307; *Phénoménologie de la perception*, 339.

28. For Merleau-Ponty, "we do not have the right to level out all experiences into a single world, nor all modalities of existence into a single consciousness." Such leveling would mean relying, as Descartes did, upon an external measure, a god, but there is no access to a world outside perception, and perception serves as the only measure. Merleau-Ponty, *Phenomenology of Perception*, 303; *Phénoménologie de la perception*, 335.

29. Merleau-Ponty, *Phenomenology of Perception*, 87; *Phénoménologie de la perception*, 100.

30. Merleau-Ponty, *Phenomenology of Perception*, 223; *Phénoménologie de la perception*, 249. Italics in the original.

31. Merleau-Ponty, *Phenomenology of Perception*, 222; *Phénoménologie de la perception*, 248.

32. Merleau-Ponty, *Phenomenology of Perception*, 248, 223; *Phénoménologie de la perception*, 275, 249.

33. We are "gathered together in a single world in which we all participate as anonymous subjects of perception" (Merleau-Ponty, *Phenomenology of Perception*, 369; *Phénoménologie de la perception*, 406).

34. Merleau-Ponty, *The Visible and the Invisible*, 133–134: *Le visible et l'invisible*, 174–175.

35. He called these, after Husserl, "transitional syntheses" and, after Heidegger, "temporality." Mallin, *Art Line Thought*, 276.

36. Merleau-Ponty, *Phenomenology of Perception*, 329–330; *Phénoménologie de la perception*, 364–365.

37. Merleau-Ponty, *Phenomenology of Perception*, 329; *Phénoménologie de la perception*, 364.

38. Jean-Luc Nancy, *The Muses*, trans. Peggy Kamuf (Stanford, CA: Stanford University Press, 1996), 70; originally published as *Les Muses* (Paris: Galilée, 1994), 122–123.

39. Merleau-Ponty, *Phenomenology of Perception*, 95; *Phénoménologie de la perception*, 109.

40. Merleau-Ponty, *The Visible and the Invisible*, 133–134: *Le visible et l'invisible*, 174–175.

41. "Every relation with being is *simultaneously* a taking and a being taken, the hold is held, it is *inscribed* and inscribed in the same being that it takes hold of. . . . What there is to be grasped is a dispossession." Merleau-Ponty, *The Visible and the Invisible*, 266: *Le visible et l'invisible*, 319. Italics in original.

42. Merleau-Ponty, *The Visible and the Invisible*, 133; *Le visible et l'invisible*, 174.

43. Of course, there are exceptions, for example, those who are blind, or musicians who have deeply sedimented their listening.

44. Heidegger, "Building Dwelling Thinking," 147; "Bauen Wohnen Denken," 149.

45. Heidegger, "Building Dwelling Thinking," 149–150; "Bauen Wohnen Denken," 151–152.

46. "We are the be-thinged, the conditioned [*die Be-Dingten*] ones." Martin Heidegger, "The Thing," in *Poetry, Language, Thought*, trans. Albert Hofstadter (New York: Harper & Row, 1971), 178–179; originally published as "Das Ding," in *Vorträge und Aufsätze*, GA, vol. 7 (Frankfurt am Main: Vittorio Klostermann, 2000 [1954]), 182.

47. See, for example, Ursula Huws, *Labour in Contemporary Capitalism: What Next?* (London: Palgrave Macmillan, 2019).

48. Heidegger, "The Thing," 164; 167.

49. Martin Heidegger, "The Origin of the Work of Art," *Poetry, Language, Thought*, trans. Albert Hofstadter (New York: Harper & Row, 1971), 61–62; originally published as *Der Ursprung des Kunstwerkes* (Frankfurt am Main: Vittorio Klostermann, 2012 [1950]), 51–52.

50. Heidegger, "The Thing," 163; "Das Ding," 167.

51. In German, the word for "object" is *Gegenstand*, something we literally stand against. Heidegger, "The Thing," 165; "Das Ding," 168.

52. Heidegger, The Origin of the Work of Art," 50; *Der Ursprung des Kunstwerkes*, 38.

53. Heidegger, "The Thing," 165–166; "Das Ding," 169.

54. Heidegger, "The Thing," 167; "Das Ding," 171.

55. Heidegger, "The Thing," 168; "Das Ding," 171.

56. Heidegger, "The Thing," 169; "Das Ding," 173.

57. Heidegger, "The Thing," 170; "Das Ding," 174.

58. Heidegger, "The Thing," 170–171; "Das Ding," 174–175.

59. Heidegger, "The Origin of the Work of Art," 61; *Der Ursprung des Kunstwerkes*, 51.

60. Heidegger, "Building Dwelling Thinking," 159; "Bauen Wohnen Denken," 161–162.

61. Heidegger, "Building Dwelling Thinking," 156; "Bauen Wohnen Denken," 159.

62. Martin Heidegger, *Bemerkungen zu Kunst—Plastik—Raum* (St. Gallen, Switzerland: Erker-Verlag, 1996), 6. My translations. The speech was given on October 3, 1964, at the opening of an exhibition of Bernhard Heiliger's works at the Erker Gallery in St. Gallen, Switzerland, Heidegger, *Berkungen zu Kunst*, 21.

63. Andrew J. Mitchell, *Heidegger among the Sculptors: Body, Space and the Art of Dwelling* (Stanford, CA: Stanford University Press, 2010), 39.

64. Mitchell, *Heidegger among the Sculptors*, 43.

65. Heidegger, *Bemerkungen zu Kunst*, 13–14. Also cited in Mitchell, *Heidegger among the Sculptors*, 43.

66. Heidegger, *Bemerkungen zu Kunst*, 14.

67. As Marie-Laure Bernadac suggests. Marie-Laure Bernadac, *Louise Bourgeois*, trans. Deke Dusinberre (Paris: Flammarion, 1996), 88.

68. Heidegger, *Bemerkungen zu Kunst*, 15.

69. Heidegger, *Bemerkungen zu Kunst*, 10; Heidegger, "Building Dwelling Thinking," 156; "Bauen Wohnen Denken," 159.

70. Heidegger, *Bemerkungen zu Kunst*, 14.

71. Heidegger, *Bemerkungen zu Kunst*, 13.

72. Mitchell, *Heidegger among the Sculptors*, 39.

73. Heidegger, *Bemerkungen zu Kunst*, 14.

74. See Martin Heidegger, *Introduction to Metaphysics*, trans. Gregory Fried and Richard Polt (New Haven, CT: Yale University Press, 2000), 160. In his essay "The Uncanny," Sigmund Freud shows how the *unheimlich* is closely related to the *heimlich* in that the familiar is revealed as strange. See Sigmund Freud, "The Uncanny," in *The Penguin Freud Library*, vol. 14, *Art and Literature* (London: Penguin, 1990), 339–376.

75. Heidegger, "Building Dwelling Thinking," 159; "Bauen Wohnen Denken," 163.

76. Heidegger, "The Thing," 175; "Das Ding," 179.

77. Irigaray, *Sharing the World*, 7.

78. Irigaray, *Sharing the World*, 24.

79. Irigaray, *Sharing the World*, 24.

80. Luce Irigaray, *The Way of Love*, trans. Heidi Bostic and Stephen Pluháek (London: Continuum, 2002), 177; Irigaray, *Sharing the World*, 2.

81. Irigaray, *Sharing the World*, 2.

82. Irigaray, *The Way of Love*, 18.

83. In her beautiful essay on touch, Kym Maclaren points out that touch is an "affective transgression and differentiation and, in its healthiest form, such intercorporeal intimacy enables selfhood and makes possible the development of true *intersubjectivity*—a relation between two subjects who recognize each other's alterity." But touch does not always enable selfhood. It depends upon the preparing of space in which the touching occurs. She writes further: "The enlivening touch, let me propose, is one for which a space has been prepared in both in the development of the person being touched and in the history of relations between the toucher

and touched. The touch felt as transgressive is one for which no such space has been prepared. Sexual abuse of a child involves a touch that calls for a bodily intentionality that the child cannot yet inhabit." Kym Maclaren, "Touching Matters: Embodiments of Intimacy," *Emotion, Space and Society* 13 (2014): 96, 101.

84. Irigaray, *Sharing the World*, 7.

85. Irigaray, *The Way of Love*, 150.

86. Irigaray, *The Way of Love*, 17–18.

87. Irigaray, *Sharing the World*, 19–20.

88. Irigaray, *The Way of Love*, 162–163.

89. Irigaray, *The Way of Love*, 148.

90. Irigaray, "To Paint the Invisible," 394–395.

91. Irigaray, *The Way of Love*, 149–150.

92. Irigaray, *The Way of Love*, 19.

93. Irigaray, *The Way of Love*, 20.

94. Irigaray, *The Way of Love*, 147.

95. As I make the final revisions to this chapter in June 2020, people are observing the harms that come from the deprivation of touch enforced by social distancing. The private nature of touch also supports a public and social world. We need to be touched in order to be part of a community. See, for example, Tanmoy Goswani, "Why We Need Hugs and Handshakes to Stay Healthy," *Correspondent*, June 12, 2020, https://thecorrespondent.com/526/why-we-need-hugs-and-handshakes-to-stay-healthy/69636720252-d995882a. This article provides links to reports that document scientific research.

96. Irigaray, "To Paint the Invisible," 396–397.

97. Even as I work on the revisions, statues of colonial leaders are coming down in the wake of the protests against colonial violence, particularly around police murders of racialized Black people, in particular. For example, Georgina Rannard reports that under Leopold II's reign as many as 10 million Africans were killed: "Leopold II's rule in what is now Democratic Republic of Congo was so bloody it was eventually condemned by other European colonialists in 1908—but it has taken far longer to come under scrutiny at home." Georgina Rannard, "Leopold II: Belgium 'Wakes Up' to Its Bloody Colonial Past," *BBC News*, June 13, 2020, https://www.bbc.com/news/world-europe-53017188.

98. Irigaray, *Sharing the World*, 100.

99. Irigaray, *Sharing the World*, 107.

100. I have also made this argument elsewhere. See Helen Fielding, "Dwelling and Public Art: Serra and Bourgeois," in *Merleau-Ponty: Space, Place, Architecture*, ed. Rachel McCann and Patricia Locke (Athens: Ohio University Press, 2016), 258–281.

101. Irigaray, *Sharing the World*, 106. See also Michael Cole, Sheila Cole, and Cynthia Lightfoot, *The Development of Children* (New York: Worth, 2005).

102. Susan Bredlau describes the ways parents show the child how to perceive the world and how to incorporate the world that is there. Susan Bredlau, *The Other in Perception: A Phenomenological Account of Our Experience of Other Persons* (Albany: State University of New York Press, 2018), 58–62.

103. Mieke Bal, "Narrative Inside Out: Louise Bourgeois' 'Spider' as Theoretical Object," *Oxford Art Journal* 22, no. 2 (1999): 110.

104. Irigaray, *Sharing the World*, 111. For Irigaray it is important that this first parent is the mother, but that is no longer always the case. Some trans men also give birth.

105. Irigaray refers to Heidegger's discussion of the "surrounding world [*umwelt*]." Heidegger writes: "The actual place is defined as the place of this useful thing for . . . in terms of a totality of the interconnected places of the context of useful things at hand in surrounding world." Heidegger, *Being and Time*, 95; *Sein und Zeit*, 102.

106. Irigaray, "To Paint the Invisible," 391. I understand praxis in this context to include economic, political, social, and cultural relations. For example, it is not enough for settlers to

recognize the violence of colonialism inflicted on Indigenous peoples if that recognition does not lead to a shift in praxis that includes transforming the economic, political, and material structures that perpetuate inequalities.

107. Irigaray, *Sharing the World*, 112. Irigaray draws on Heidegger's analysis of "das man" in her discussion of everydayness. Heidegger writes: "It could be the case that the who of every Da-sein is precisely not I myself." Heidegger, *Being and Time*, 108; *Sein und Zeit*, 115.

108. Bal, "Narrative Inside Out," 121.

109. Psychoanalytic interpretations of Bourgeois's childhood provide a common analytic perspective for accounting for her artworks. We know that Bourgeois's mother mended tapestries; she was, like the spider, a weaver. We are told that Bourgeois experienced her childhood as psychically difficult—her father had a series of lovers (her nurses), and she felt that her mother was both betrayed by her father and in turn betrayed her children by allowing these affairs to continue. My position is that these biographical details have little leverage in the encounter of a work of art set up in a public space where most passersby will have little or no knowledge about the artist but nonetheless encounter the work in their phenomenal average everydayness. While these details might later deepen one's understanding or provide background information about the artist's life, they do not account for the work's phenomenal impact or the way it sets up space.

110. Al-Saji, "The Racialization of Muslim Veils," 875–902.

111. Al-Saji, "The Racialization of Muslim Veils," 882.

112. Al-Saji, "The Racialization of Muslim Veils," 882–883.

113. Al-Saji, "The Racialization of Muslim Veils," 876–877.

114. Al-Saji, "The Racialization of Muslim Veils," 889.

115. Al-Saji, "The Racialization of Muslim Veils," 889.

116. Al-Saji, "The Racialization of Muslim Veils," 881, 887.

117. Al-Saji, "The Racialization of Muslim Veils," 890.

118. Fanon, *Black Skins, White Masks*, 116; *Peau noir masques blancs*, 116.

119. Al-Saji, "The Racialization of Muslim Veils," 892.

120. Arendt, *The Human Condition*, 198.

121. Mariana Ortega points out that for those marginalized in a dominant culture, or who exist in-between cultures, there can be an ongoing anxiety with "an end result in this self's constant awareness of not-being-at-home, not dwelling, a marked sense of not feeling at ease or having a sense of familiarity in many of the worlds she inhabits." Mariana Ortega, "Hometactics," in *50 Concepts for a Critical Phenomenology*, ed. Gail Weiss, Ann V. Murphy, and Gayle Salamon (Evanston, IL: Northwestern University Press, 2019), 171.

122. Ortega complicates this further with her concept of "multiplicitous identities"—of having to negotiate multiple worlds in the building of an identity and being between worlds. Ortega, *In-Between*.

123. Irigaray, "Being Two, How Many Eyes Have We?" 146.

124. Irigaray, *The Way of Love*, 131–132.

III.
ENACTING
CULTURE

Fig. 5.1 Janet Cardiff, *Forty-Part Motet* (a reworking of *Spem in Alium* by Thomas Tallis, 1556/1557), 2001. Materials: 40 loudspeakers mounted on stands, placed in an oval, amplifiers, playback computer. Duration: 14 min. loop with 11 min. of music and 3 min. of intermission. Dimensions: variable. Sung by Salisbury Cathedral Choir. Recording and postproduction by SoundMoves, edited by George Bures Miller, produced by Field Art Projects.

The *Forty-Part Motet* by Janet Cardiff was originally produced by Field Art Projects with the Arts Council of England, Canada House, the Salisbury Festival and Salisbury Cathedral Choir, BALTIC Gateshead, The New Art Gallery Walsall, and the NOW Festival Nottingham. © Janet Cardiff. Courtesy of the artist and Luhring Augustine, New York. Photo: Ian Lefebvre © Art Gallery of Ontario. Works by Henry Moore at the AGO Henry Moore Sculpture Centre © The Henry Moore Foundation. All Rights Reserved, DACS/SOCAN (2020).

5

POLYPHONIC ATTUNEMENT
Janet Cardiff's *Forty-Part Motet*

As I walk up the long hallway approaching the museum gallery, ethereal voices singing Thomas Tallis's late sixteenth-century Renaissance motet, *Spem in Alium*, grow in volume, expanding the space.[1] They soar through me and draw me toward them. Sound extends beyond visual boundaries, allowing the music to set to work before I even enter the space. As I turn a corner and walk into the airy room, the full effect of the voices hits me at once. As overwhelming as the voices are, the artwork that produces them, Janet Cardiff's audio installation *Forty-Part Motet* (2001), is visually sparse in presence (see fig. 5.1).[2] It consists of forty speakers set up in an elliptical pattern in eight groupings of five. The transcendent voices provide for an intensely immersive experience. The effect of the music on visitors is evident. People sit quietly on centrally located benches. Some have their eyes closed. Others walk slowly around the circumference of the speakers as the sound resonates with their bodies. As I enter the room, I can feel the sound waves hitting my body from the forty individual speakers.

The *Forty-Part Motet* is hauntingly beautiful, affectively drawing people into its open region and transforming, for a short while, the ways visitors experience time and space and encounter themselves and others. Out of each of the forty individually mounted speakers set at the head height of a standing adult comes an individually recorded voice from the Salisbury Cathedral Choir in England singing one of the forty different parts of Thomas Tallis's polyphonic choral work. The speakers provide for eight small choirs: eight groupings of bass, baritone, alto, and tenor, with children singing soprano. The artwork has been installed in over fifty galleries internationally, including the Tate Modern, the Museum of Modern Art in New York, and the San Francisco Museum of Modern Art. It transforms each gallery space in a different way since it is, in itself,

about space and time. I first worked with this piece at the Art Gallery of Ontario (AGO) in Toronto, where Henry Moore's large casts of reclining figures and abstract forms spanned the edges of the room in which it was installed (see fig. 5.2).[3] Light from the sky streamed in through the windows. The transcendent soaring of the voices was juxtaposed against the monumental time-defying weight of the sculptures that anchored visitors into the ground.

The eleven minutes of choral music are interspersed with three minutes of intermission. As well, recorded sound is overlaid with ambient sound.[4] Not only can visitors hear each individual voice, but they also hear the sounds the bodies make, the breathing, the vocal imperfections— particular sounds that disappear in the harmony. Although technologically recorded, these are human voices—warm, particular, and flawed. The intermission provides the space between the end of the performance and its beginning again. The silence that follows the final climax gradually gives way to the light banter of the singers' voices gossiping, humming, chattering, and coughing. The everyday noises people make evoke their presence. Although I cannot see them, they are nevertheless synesthetically there for me. I hear someone cough behind me. I turn my head, and even though I know the cough is disembodied, I still feel surprised to find no one standing there.[5] The work calls into question what we experience as real.[6] The real extends beyond what is objectively present.

This extraordinary artwork helps us explore how a secular site can become transformed into a kind of sacred one that allows for a different attunement to being. The site seems sacred because it allows for that which exceeds human making, although it depends on humans for its material presence. Even the text sung in Latin refers to a sacred power beyond human control in a language that is not a part of everyday speech, although its history ties it to colonial conquer.[7] The time-space here gathers people together through the participatory movement of differentiation rather than through the imposed institution of the same. This artwork creates the possibility for opening up a time-space that allows for an intimate yet public presencing that could contribute to collective being together in this age of technology characterized by efficiency, calculation, and switching about. The answer is not to be found in a nostalgic turning away from technology, which is not even possible.[8] Instead, I encounter an artwork that is inherently technological but nonetheless allows for a different attunement to being in this age, which tends to be profoundly out of tune with embodied existence. The Forty-Part Motet sets to work at the intersections of the aural, the visual, the affective, and the experience of space and time. This

piece works to transform space-time and the relations within it, revealing other possibilities for being together in our everyday practices. Allowing people to experience the ways affective pleasure can arise by being attuned together through participation and difference opens up new possibilities for collective transformation.[9] In allowing for such attunement, the artwork enacts a new cultural formation.

I. SONIC SPACE

When we listen to a choir sing, the performers are usually arranged on a stage before us—a perspective based more on a visual sense of space that allows for the performers to be seen and the voices to merge together. Alternatively, gallery visitors walk into a "three-dimensional" space, as though they are "walking into a piece of music" or have the experience of being in the choir. The effect is not completely parallel, however, since choir members are not usually free to wander around the space the way gallery visitors are encouraged to do.[10] Unlike with most paintings, there is no right place to stand; there is no place that provides a perspective on the whole. But being immersed in the sonic space dissolves Renaissance perspectival distance. There is no vanishing point as with single-point perspective painting. But neither are there several ways into the work that a Cézanne landscape provides, where one can stand on either side of the painting and the path shifts sides accordingly. Cardiff arranges the speakers in an oval so listeners are "able to really feel the sculptural construction of the piece." Tallis's music itself spatializes sound. It makes "the space 'live,' and make[s] the space 'sing.'"[11] Visitors "can hear the sound move from one choir to another, jumping back and forth, echoing each other." They can "experience the overwhelming feeling as the sound waves hit."[12]

Although the piece does not allow for one privileged perspective on the whole, neither does it provide for phenomenological points of view that still privilege the visual. Merleau-Ponty describes how the distance provided by vision is necessary to see things lined up one behind the other in relation to a situated point of view. Other senses, such as touch, are too immediate to give us depth in this way. Vision even allows us to "come in contact with the sun and the stars." It allows for this experience of ubiquity, "that we are everywhere all at once," because we can "imagine ourselves elsewhere."[13] But sounds are not encountered in spatial depth in the same way as for vision. They do not so easily hide one behind the other in relation to where I stand. They are nonetheless deeply interrelated and can transform situations, lending themselves to displacing the listener from the center.[14] Hearing people might move their heads to attune more

carefully to certain sounds, but they cannot simply close their ears to avoid the sounds.[15] Even people who are deaf cannot shut out sound vibrations.

But in the *Forty-Part Motet*, vision does not assist in locating sound direction except in the ways we see people responding to the work, turning toward a voice that beckons. Brian Kane explains how, in acousmatic sound, not only is hearing privileged over seeing, but the visual separation of sound from its source contributes to intersubjective relations—the imaginative sharing with others over the possibilities of where the sounds originate. These imaginative possibilities can lend an air of the transcendent to acousmatic sounds, the spiritual feeling of being transported elsewhere.[16] They also invite response. Visitors are invited to move around the space, and the piece itself is in constant motion, which contributes to its affect. I stand next to one speaker, which emits no sound, but in the next moment, a wave of music sweeps across the room, and a voice begins to sing beside me. I am moved. As I listen, the specificity of each voice becomes more marked. I begin to experience the interplay of the imperfect uniqueness of each voice that is not provided by points of view that offer a perspective on the whole. Instead, the voices encounter one another simultaneously because they are near one another, in the same place at the same time. They belong to the present with an immediate sensibility that vision rarely provides in this age. Nonetheless, these encounters bring the past with them as past and anticipate the future as future. Listening to music relies on memory—on retention of the past notes and phrases and anticipation of where the music will go—as well as an individual's sedimented experiences of music and musicality that shape how they gear into the sounds. But even more than that, this work allows for the experience of differentiation that is the structure of space and time for Merleau-Ponty.

The work encourages difference through the simultaneous encounters with the individually recorded voices. This polyphonic intertwining is not the same as that provided by viewpoints belonging to situations. For the Merleau-Ponty of the *Phenomenology*, "being is synonymous with being situated," and being situated is given to us primordially through spatial levels provided by vision.[17] But the time-space opening offered by Cardiff's work provides far more for participation than the situated viewpoint and is better described in Merleau-Ponty's later work in terms of flesh. The time-space of flesh is "a relief of the simultaneous and of the successive, a spatial and temporal pulp where the individuals are formed by differentiation."[18] As he describes it, he belongs to the visible present because he himself is visible; he sees "from the midst" of it. This means that when he is able to grasp a color, a sound, or a "tactile texture," it is because

he "feels himself emerge from them by a sort of coiling up or redoubling ... he feels that he is the sensible itself coming to itself ... an extension of his own flesh ... shreds of himself."[19] His past sentient experiences are reopened through the present encounter, which both keeps them alive and reshapes them in the sensing. Because he is a sentient being, the things "communicate through" him. This is not difference as a "multiplicity of spatio-temporal atoms." Nor is it the coherence provided by one spatial level. Instead, "there is a whole architecture, a whole complex of phenomena 'in tiers,' a whole series of 'levels of being,' which are differentiated by the coiling up of the visible and the universal over a certain visible wherein it is redoubled and inscribed."[20] In other words, universal being can only be expressed through the ways it is taken up in this very particular being with his own spatial and temporal history of sensible-sentient experiences at this particular time and place. In each encounter, "every relation with being is *simultaneously* a taking and a being taken."[21]

Merleau-Ponty even begins to sense that dwelling on vision alone does not fully open up all the possibilities of flesh: "this flesh that one sees and touches is not all there is to flesh, nor this massive corporeity all there is to the body."[22] He senses that "in other fields," the reversibility of the flesh might even be "incomparably more agile there and capable of weaving relations between bodies that this time will not only enlarge, but will pass definitively beyond the circle of the visible." His voice, he notes, is more closely tied to the whole of his life, and if he is "close enough to the other who speaks to hear his breath and feel his effervescence and his fatigue, [he] almost witness[es], in him as in [himself], the awesome birth of vociferation." He experiences a reversibility between "the movements of phonation and hearing" because the movements of the other's voice have a "motor echo" in him.[23] While encounters might be simultaneous, they bring with them sentient and past experiences that differentiate those encountering even as they intertwine. We see this in the way visitors encounter one another, whether through smiles of acknowledgment as they walk through the work or simply through the recognition that they are sharing an experience, even as it is not exactly the same one.

The structure of *Spem in Alium* itself contributes to simultaneous encounters. In total, it has an astounding forty different parts, although they mirror, interweave, and imitate one another. Polyphony contains several independent lines sung at the same time that intertwine and overlap. It is the simultaneous encounter of multiple voices that have independent parts. Tallis's piece also employs homophony, where two or more voices are synchronized. Although homophony is like polyphony in that the

voices have different melodic motion, unlike polyphony, which has distinctive rhythms, in homophony they have the same rhythms.[24] Tallis begins his piece with polyphony, moves to homophony, and then weaves the forty voices together in imitative counterpoint for the climax.[25] Both beautiful and mathematically complex, as Robert Jourdain explains, "to medieval ears this new music sounded revolutionary, and rightly so."[26] Polyphonic music like *Spem in Alium* is composed for many voices singing simultaneously in counterpoint, or "note against note."[27] With counterpoint, the succession of notes must be balanced with the simultaneity of notes—the notes sounding at the same time; like seeing and hearing, mind and body, succession and simultaneity are mutually intertwined but cannot be reduced one to the other.[28] The voices encounter, mirror, and respond to one another. The idea behind polyphonic music was to allow each voice to move freely, providing for "diverse combinations of sound."[29] Nonetheless, when drawing on polyphony, composers attempted to avoid "the disharmonies" that emerge when the voices are layered. Some church agents were concerned that polyphony made the sung prayers incomprehensible and, more seriously, that "it threatened to incite church congregations to emotionalism and pleasure."[30]

In Cardiff's work, Tallis's music, along with the technology that provides for a virtual choir, allows for a different spatial structure to emerge than the one given visually. Rather than seeing the things lined up one behind the other, depth is provided as an aural structure that is both spatial and temporal. Jessica Wiskus describes the temporal aspect of depth as being similar to "the two offset images of the stereoscope that initiate a vision of depth," but in music, depth is initiated through "repetition." In Tallis's work, the repeated phrases of the imitative counterpoint do not coincide "because of the flow of time." As a "great musical piece . . . this depth [is shaped] in multiple layers."[31] But in Cardiff's work, depth is also provided through space. Like the music itself, the artwork encourages freedom of movement among the visitors, who experience the immediacy of this sonic encounter of note against note. The artwork sets to work in this simultaneous encounter of a multitude of different voices that are nonetheless together and belong together. When I stand within the spherical space provided by the speakers, I am also held by these encounters. But I also bring my own past experiential world with me, affective aspects of which are intensified in this space.[32] Cardiff describes how the piece was installed in a gallery in New York shortly after the 9/11 terrorist attacks on the World Trade Center in 2001. People sat in the gallery and wept while listening to the music. The voices gathered them together in an intimate

yet collective mourning.[33] As Salomé Voegelin points out, sound "is not linear or intentional, but extensive and intersubjective."[34] Listening allows for a "deeper entanglement with the world"—a world that cannot be organized by a transcendental subject. It can only be experienced.[35]

One commentator, Joseph Crematori, observes that visitors miss the point of the work. In relocating the motet from a sacred architectural space to a nonsacred one, it is no longer possible to "listen romantically, without distance, as though one were hearing the piece performed in the distant chancel of a medieval cathedral."[36] But phenomenologically, Cermatori's argument does not make sense. His intellectual argument contradicts the embodied responses of visitors. Rather than being alienated by this reframing of space, visitors are drawn into the affective space of the sacred that has been relocated from the cathedral to the everyday space of the museum. As with a sacred space, the space of the work facilitates standing back from the everyday and being fully present. It allows for acknowledging that which falls outside of human control, even as it is technology that allows for this experience.[37] Deborah Kapchan, in her discussion of Sufi dhikr, or chanting, in secular France, explains that when sacred music is played in secular places, it can restructure how individuals experience themselves as well as their relations with one another in a communal space. Performing listening as an event can shift how walls are understood along with the spaces they delineate: public spaces can become collectively intimate.[38] Cardiff observes that "people need this emotional release to be in the moment, to feel this sense of presence and spirituality the music brings to them."[39] Similarly, for Merleau-Ponty, music is an "art which sings the divine without having to believe in God, or to belong to a religion, or to give way to dogmas, without even knowing if what is composed is really a hymn or simply a way of wanting the divine to take place."[40]

This is why thinking about space sonically is a challenge. Concerts in many ways reproduce the experience of space offered by vision. Dynamics provide the perspectival experience of being closer or further away, whereas wraparound sound provides for immersion, or the experience of presence.[41] As R. Murray Schafer describes it, "the classical Western composer places sounds in high definition before the eye of the ear."[42] Schafer, one of the early and pivotal writers on sonic environments, points out that the language usually used to talk about sounds tends to come out of visual references—in particular, references that privilege the rank ordering of perspective.[43] For example, the terms *figure*, *ground*, and *field*—which correspond respectively to the signal or soundmark, the ambient or background sounds around it, and the field where the sounds occur—are

drawn from a visual framework that works similarly to the way Merleau-Ponty describes spatial levels, which, in his account, rely primarily on vision. A spatial level provides the background against which things, people, and relations appear. All movement is relative unless one is anchored in a situation. Merleau-Ponty can alter the figure and ground through switching the intentional grip of his gaze. If he is looking at those in the train beside his, it seems to be his own train that is pulling away. If he is engaged in his own compartment, it is the other train that appears to be moving. Similarly, when he looks at the clouds, they sail through the sky. When he stares at the steeple, it charges across the sky. What changes is where his gaze is anchored. Because "the relation between the moving object and its background passes through" his body, he achieves this anchoring by engaging visually in a "milieu" that reciprocally allows the movement to seem "absolute."[44] We tend only to notice this spatial anchoring as an "explicit" act in these situations of "ambiguous perception, where we can choose our anchorage as we please." The ways we perceive, then, emerge as responses "to questions that we pose."[45] Keynotes work similarly, providing the key of a musical composition or its tonality.[46] In sonic soundscapes the keynotes refer to sounds that hover in the background against which soundmarks appear. Different places have different keynotes: the sea, the wind across the prairies, the vibration of the tramlines.

But Schafer also relies on these visually infused terms, as is evident in his discussion of how technology plays a pivotal role in the increased decibel level of noise in urban landscapes. As he explains, there has been a shift from a high-fidelity soundscape, where individual sounds stand out against any background of noise, to a low-fidelity soundscape, which describes the contemporary urban landscape, where there is a constant hum of sounds and "there is no distance; there is only presence." In the hi-fi soundscape of preurban, preindustrial cultures, humans were attuned to the slightest shifts in their environment through sound.[47] In contrast, in a lo-fi soundscape, signals are overcrowded, and there is a lack of clarity.[48] As noted previously, in visual perception, ground and figure can shift. The cloudy sky as ground to the figure of the steeple can itself become figure when we attend to the sky. Sound, too, is described in this way. The soundmark or figure of the plane against the keynote sound or ground of the sea can reverse, and the sounds of the waves can become the soundmark. What determines which sounds will be keynotes, and which sounds will recede into the background, is culturally determined. For example, the extraordinary hums of machines, what Schafer terms "noise," remained "inconspicuous" until relatively recently.[49]

But, as Andrew Eisenberg points out, Schafer does not recognize how his soundscape is "grounded in normative ideas of which sounds 'matter' and which do not."[50] For example, colonizers considered the music and speech of African slaves to be noise. Even when their music was allowed to "circulate as authentic cultural material," it was not understood to be commensurable with "European civilization." It remained in the background. But "in contemporary projects of resistance, noise is the 'voice' of subaltern identity on the margins." Making noise becomes an "expressive practice and a deliberate act of subversion" that can help shift levels through a difference in attunement to what is heard.[51] The *Forty-Part Motet* challenges Schafer's nostalgic binary understanding of a pretechnological time. It draws on technology to reveal living bodies and living relations even as it is, as a technological work, endlessly repeatable, although always with a difference since it relies on human participation for it to set to work as an artwork.[52]

Participation is, in fact, inherent to the spatial level the work establishes, perhaps because there is not much of the work for vision to grasp. In a visually established spatial level, a "pact is established" when the body as "the power of certain gestures" corresponds with "the perceived spectacle" to constitute or actualize an "integrated world."[53] But my body moves into the sonic level provided by the work by moving into the rhythms of the music, which slow me down, adjusting my body to its active stillness. Rather than moving more quickly into the level of the work by engaging in practical activities, I actively attune my corporeal listening, which includes walking around it or simply sitting among the speakers and allowing the voices to overlap in waves around me. Merleau-Ponty believes "it is very difficult to bring about a change of level for sonorous phenomena" largely because he thinks humans are not able to place sounds solely through hearing: they only correctly locate them when they rely on vision as well.[54] But I would argue that he comes to this conclusion because he is firmly anchored in the visual world that belongs to the spatial level of his age, which provides his white, educated, European male body with "clear perception and confident action," where his motor intentions "receive the responses they anticipate from the world."[55] But this gearing into the world through motor intention is different than attuning to the world through participation, as Cardiff's work calls on us to do.

II. A Sonic Epoch

An encounter with the work shifts my understanding of historical time by relying technologically on English music from the sixteenth century, but it

also reworks my phenomenal understanding of time by dramatically slowing it down. For the eleven minutes the voices sound, time and space are intensely experienced. Time seems to literally stop or stretch out so that each moment is sounded through the voices that imitate, mirror, and encounter one another. Since perception can only happen in the present moment, this slowing down of time also deepens my perception, allowing for a fuller awareness of how the past and future intertwine with the present. Because the piece is a repetitive loop, the way I experience it each time will differ. Wiskus observes that the beginning is given only through the middle of the music in "retrospect."[56] Merleau-Ponty writes: "While listening to beautiful music: the impression that this movement that starts up is already at its endpoint, which it is going to have been, or [that it is] sinking into the future that we have ahold of as well as the past—although we cannot say exactly what it will be."[57]

The work establishes an alternate space-time from the everyday one we live that dissolves when the music stops. Gallery visitors are temporally slowed down and held for a while that extends into the silence that follows. But the silence is gradually interrupted by voices being cleared and the coughing and chattering of the recorded voices of the choir members during the three-minute intermission and the holding of the visitors in the space releases. The visitors' voices begin to interweave with the recording as they slowly disperse. As the recorded chattering tapers off, the room becomes silent, and the voices of the choir members, with "one collective breath," begin again to soar; one can feel, see, and hear as visitors are drawn back into the space.[58] The silence calls on visitors to listen, and they instantly become quiet as the piece again sets to work. Normally we do not hear the banter of voices around us, but in this space, we do. The intermission plays a role in preparing our hearing for both listening to the motet and being attuned to the world around us.

The work institutes a collective, individual, spiritual, and sensory intensity. It provides visitors with the opportunity to feel deeply present in the moment, bringing embodied perceptual cognition to the fore, which is more rarely experienced in our modern age where the emphasis on vision is tied to imposing concepts rather than on actually perceiving what is there. Instead, it reminds viewers of their capacity to be held together by something beyond their own power, which nevertheless is dependent upon human-made technology and creation. As Wiskus suggests in her discussion of Proust, "it is not possession of the eternal that inspires the joy, but attunement with the rhythm of Being." Rhythm is not realized through the senses apprehending an external object or from turning

inward to a remembered image. Rather, it is "a structure that binds the past and present, subject and object, ideal and sensible."[59] This structure holds humans. It interrupts the common understanding of time as a linear flow of now moments. We see this with music where rhythm introduces a "split and a stop" "into this eternal flow."[60]

As Giorgio Agamben explains, the artwork, too, can allow for this "stop in time as though we were suddenly thrown into a more original time," one that opens up and holds us as though "arrested before something, but this being arrested is also a being-outside, an *ek-stasis* in a more original dimension."[61] Experiencing the artwork can provide for this more "original dimension of time" even as it "conceals it in the one-dimensional flight of instants."[62] This temporal structure is the epoch. The epoch is not a span of time as such but rather the giving that holds back itself in "favor of the discernibility of the gift." Said otherwise, being does not show itself but in its withdrawal provides the ground that allows for beings such as artworks to become manifest.[63] As well, the epoch gathers near that which belongs together. The German root of belonging, *hören*, means "to listen." For Heidegger, to listen is to be attuned to the epoch to which one belongs (*gehört*) and to which one responds. "To attune" (*stimmen*) is also the root of *Stimme*, or "voice," and *bestimmen*, "to define."[64] Words sharing the same root resound, respond, and mirror one another from within the same epoch, shaping the ways the world is understood.

In the modern age, this structural rhythm of epochal being is completely obscured. Being in its temporal aspect of giving, and holding back, is covered over, and only the artwork as object remains.[65] This is the understanding of time and space that Heidegger characterizes as belonging to the calculative efficiency of Gestell, which is used as measurement for all representation (*Vorstellen*), production (*Herstellen*), and the ordering (*Bestellen*) of things and even humans to be available on demand anywhere at any time. Time is understood as a series of nows because it is reduced to a "representation of three-dimensional space." Where time and space are mobilized in this way as parameters, there is no encounter; now moments will never encounter one another face-to-face. There can be a succession of moments in time, but time as the "opening up of future, past and present" is not possible.[66] Similarly, if space is measured in terms of the "side-by-side" continuum of consecutive sequences, then face-to-face encounters among the elements are excluded.[67] Calculating space as measurable means there is no actual distance; "everything becomes equal [*gleich*] and indifferent [*gleich-gültig*]," and the nearness of the encounter is foreclosed.[68] As we saw in the last chapter, nearness is

the relational as coconstitutive. It is a relation that cannot be quantitatively measured.

But in the encounter with the work of art, time-space is opened up. "True time is four-dimensional" because "the self-extending, the opening up, of future, past and present is itself prespatial."[69] The three temporal dimensions are near to one another but nonetheless held apart by this "nearing nearness" given as "denial and withholding."[70] There can be no collapse of time into space. There can be no account of the real in terms of absolute presence. Giorgio Agamben, drawing on Heidegger, explains that artists are in touch with the temporality of being and reveal it in the artworks they produce. To encounter a work of art is to experience this ecstatic, epochal opening of rhythm that "gives and holds back."[71] Because humans are "capable of the most uncanny power, the power of pro-duction into presence, [they are] also capable of praxis, of willed and free activity." In the "poetic" or creative act, humans are able to attain a "more original temporal dimension." This is why they are historical beings, "for whom, that is, at every instant [their] past and future are at stake."[72] This is the ek-static essence of historical being that does not take time as a flow of now moments but rather understands the present as extending beyond itself into the past as past and future as future. Artworks install an original site for belonging to the world within which humans can take their "original measure" for their "dwelling on earth." They are the architectonics—that is, the *arche*, or the beginning of the tectonic or structure that allows for the revealing of what is there. It reveals "present truth" within the "unstoppable flow of linear time."[73]

If we do not fixate on the artwork as aesthetic object and remain open to experiencing the work in the site it opens up for us, we can begin to understand the ways the work institutes a structure that holds open a time-space that allows for nearness. The artwork, as the gift that is given, can provide an original time-space—the *es gibt* (there is) or epoch—that provides a structure within which things, people, and relations appear according to its essential hold or way of being.[74] The *Forty-Part Motet* allows visitors to reflect upon the holding-giving of being through the holding-gathering of the work that is both temporal and spatial in that it happens in time and in a certain space. Yet when the music stops, the holding and gathering are released, and the visitors are no longer held within its essential time-space structure.[75]

Cardiff works with this time-space structure. The *Forty-Part Motet* itself establishes a poetic epoch within the larger epoch of this age of technology. It infuses relations and ways of appearing within its own space-time

structure for the time visitors are held in its rhythmic arc.[76] But unlike the work of art Agamben describes, the structure the *Forty-Part Motet* provides relies upon the individual voices of the singers as well as the participation of the individual visitors and what they bring with them to their encounters. It is this participation that makes the structure possible in the first place. Without it there it is nothing but the material technology of the speakers themselves. There is little to apprehend when the work is not setting to work. Visitors cannot stand over and against the work as they might a visual art object. But neither can they simply experience the truth the artwork actualizes in its setting to work. For Agamben, the artwork that sets to work is not mere potentiality available for the disposal of the art market or aesthetic enjoyment. The work is not subject to the relations of exchange but is rather potential actualized only in the setting to work of the relations it institutes through the engagement of the viewer with the work. In setting to work, it reveals the world to presence.

I have been generous in my reading of Agamben's work to this point in addressing human epochal belonging. But ultimately for him, "the gift of art is the most original gift, because it is the gift of the original site of *man*."[77] As Claire Colebrook points out, Agamben's "talk about human potentiality concerns European 'man'" and his actualization.[78] To recall from chapter 2, Irigaray shows how the privileging of the actualization or coming to completion in *morphë* or form in ancient Greek philosophy was accomplished through the suppression of potentiality, which was tied to the feminine as mere *hylë* or matter. In preserving potentiality as potentiality and not subsuming it to the completion of actualization, which is the original act of the forgetting of sexuate difference, there can no longer be a site that reveals the truth of man as the same while foreclosing the potentiality of difference.[79] In this reading the work of art "cannot master its own scene, cannot command what it wants to say."[80]

And this is what Cardiff's work accomplishes. It both installs difference and discloses it. Within the broader structure of this opening, the insights revealed also shift depending upon where the work is installed; what individual visitors bring with them to the encounter, including their affective experiences; and how they move with and through the work. Nonetheless, this does not imply that the meaning of the work is completely relative or even indifferent. Because the work touches upon something as well as someone, its meaning cannot be reduced to the subjectivism dismissed by Agamben and Heidegger. Subjectivism belongs to the disengaged will that assumes it has control but is all along held in the sway of the calculative measure of Gestell. But Cardiff's artwork draws on the experiential past,

the affect, and the intuition of the individual visitors in their encounters with the artwork. For Agamben, in encountering an artwork, "spectators recover their essential solidarity and their common ground," which they cannot experience if they stand over and against the work as an aesthetic object.[81] The artwork is the most original gift because it is the site of the original production of world. Cardiff's artwork alternatively provides a site for the creation of the self in relation to self, to others, to world, and to that which is beyond one's control.

In this work, the music ultimately only comes together in the embodied listening of gallery visitors. Because the work is technically produced, there is no original as such.[82] Even the singers' voices were individually recorded, which means the resonating of the voices takes place after the fact of the singing, in the gallery hall. The object side of the *Forty-Part Motet* is not that which grounds the work; it is the sensual aspect of the music that cannot be seen or touched as such—that is, the "autonomous sound effect."[83] Visitors encounter the work by participating with it in space and time. The communal sharing is shifted from the choir itself to the visitors, who become aware of one another, even encounter each other, in this suddenly very intimate yet communal space. The work that sets to work provides for an epoch, but it is an epoch that allows for individual attunement to the gathering in time and space that brings visitors to a halt. It assembles for a time those present in its midst before they are once again released as the structure breaks apart, only to start up again. Technology makes possible the repetition of gathering and dispersing that is never precisely the same. In this differing, as Merleau-Ponty writes of music, it "transforms."[84]

Agamben concludes that if humans have lost their poetic, creative, or expressive status in this age, they cannot simply "reconstruct" this "measure elsewhere."[85] It belongs to an attunement to being that, like perception itself, belongs to the here and now. I would argue that to lose this poetic or expressive status means losing one's embodied attunement to world. It would not be possible to reconstruct this measure elsewhere because the measure begins with a perceiving body in a world. Our embodied perceptual cognition allows us to gear into a spatial and temporal level in the first place, even if it is the calculative being of this age. Cardiff works with this understanding. The *Forty-Part Motet* reveals that listening belongs not simply to individual attentiveness but is also epochal. Attentiveness is corporeally solicited by the sonic level of the work. This does not mean those experiencing this epochal listening respond in the same way. The attunement it installs locates visitors in the here and now of embodied simultaneous encounters. I not only hear more intensely and feel more intensely during

my gallery visit, but visually, the Henry Moore casts seem to be more luminous than ever. Their weighty presence invades my own body, grounding it in the earth even as the voices take me with them in transcending the space. One perceptual sense can be brought to the forefront, yet to really listen means becoming phenomenally more attuned overall. It is to "echo the vibration of the sound" with one's "entire sensory being."[86] This attentiveness to the perceptual world the work establishes lasts for a short while after I leave the space. Other artworks in the museum beckon more intensely than previously. I feel more alive and more in touch not only with the artworks but also with the people around me. Inevitably, my body reverts to the prevailing epochal level, which tends to distance us from corporeal attunement to ourselves and the world we daily inhabit. Nonetheless, the work has opened up other possibilities in cultivating my perception.

III. FROM MONSTRATION TO RESONANCE

Merleau-Ponty fully describes the ways perception is expressive and how we must create in order to experience being.[87] But he does not really attend to what it means to listen without creatively revealing meaning. Rather than drawing on words as "so many ways of singing the world," expressing the world in the ways we make sense of or grasp it, how can we be openly attuned to what is there without having to immediately translate, name, or monstrate?[88] How, in other words, can the phenomenologist become responsive to other voices and other worlds, allowing at least an interval or gap before turning to signification? How can new enactments of cultural practices come from cultivating a perceptual attunement to the world and to the reverberation of the living world in which many of us, especially philosophers, tend to participate with passive and unthinking appropriation?

Jean-Luc Nancy doubts philosophers are even able to listen because they bring with them a sedimentation of categories, concepts, and ideas aligned with the visual that they impose on what is there.[89] Philosophers hear (*entendre*) and understand truths, but they do not listen (*écouter*) in terms of the sonorous, the sensual aspect of sense that exceeds meaningful forms and provides "an amplitude, a density, and a vibration or an undulation whose outline never does anything but approach."[90] When they listen for good forms (*Gestalten*), for figures against a ground, they listen in the register of the visible that collapses time in the blink of an instant.[91] They listen for forms they recognize, which allows them to objectify at a distance. But the audible takes time and belongs to the same time. While the visual tends to be mimetic, the sonorous inclines toward

the methexic—toward "participation, sharing, or contagion."[92] The temporality of the visible might best be described as "*simultaneity*" while that of the audible as "*contemporaneity*."[93] Until now I have written about the encounter as taking place simultaneously, at the same time.[94] But here, Nancy deepens this discussion of the temporality of the encounter. Where the temporal dimension of listening is taken into account, contemporaneity is a more accurate description. When I listen to Cardiff's piece, there is an aural mixing of the sound waves as they collide and resonate with my body. Sound is more a coming and going, a presencing "rather than a pure presence."[95] But monstration requires the distance that meaning making presumes. It relies on the visible that allows for such distance, summoning "presence to light." Listening, alternatively, is evocative and summons "presence to itself."[96] It neither establishes presence nor assumes it is already there. It is a resonance, a relation between listening and the self that resounds to sounds. This referral given in the resounding provides for a self that is an opening up to being.[97] The self does not exist in itself but is given to itself over and over again through this constant referral and responsiveness. This is why sense is absolutely sensuous.

Merleau-Ponty recognizes he is a sonorous being; he hears his own voice as a "vibration from within."[98] To recall, when he stands close to someone else who speaks, he can hear the other's breath and feel their "effervescence" and "fatigue." Both hearing and feeling are almost enough for him to "witness" in the other as he does in himself "the awesome birth of vociferation."[99] But what is ultimately significant about the voice, for him, is "the emergence of the flesh as expression [as] the point of insertion of speaking and thinking in the world of silence."[100] While the voice is a modulation of its relations with the world, "the flesh is a *mirror phenomenon* and the mirror is an extension of [his] relation with [his] body." It is Narcissus's "profound adhesion to Self" that this fission of appearance and Being provides.[101] Merleau-Ponty recognizes the other as subject since, in seeing the visible that is his own landscape, he concludes there must be "other landscapes besides [his] own."[102] But more than that, what he sees "passes" into the other: "this individual green of the meadow under [his] eyes invades [the other's] vision without quitting [his] own." And the other's green similarly pervades his own.[103] Ovid's Narcissus begins with himself, and his inevitable death is his punishment for this self-knowledge; he can desire only himself.[104] It is true that for Merleau-Ponty, vision as a mirroring concerns a living mirror and not one that is simply mimetic: the tree is reflected in the water, and colors subtly adjust in shade.[105] Nevertheless, although his body moves into and takes up its landscape, is even shaped by

it, and incorporates it into its fissures, style, and movements, incorporation is not yet a relation or response.

But Ovid's Echo is "an effect of resonance."[106] She can neither speak first nor remain silent. She is dependent upon others' voices, and her words are taken out of context: "They are a forced and unintentional repetition, but they can appear like a response."[107] Echo's voice is pure voice without semanticization, without intentional meaning, and yet it is a resonance and a responsiveness. Although the first sounds made by the newborn infant do not have any content or semantic meaning, and they are not uttered by a subject as such, the first cry nonetheless is addressed to particular ears that hear and respond.[108]

Even in his late lectures on Husserl, Merleau-Ponty continues to grapple with the paradox of the philosopher phenomenologist, there defined as the "paradox of the horizon": so long as he is engaged with the world in terms of his own interests and with others in terms of companionship— that is, unreflectively—he participates in a "_Mit-menschheit_," a "lateral relation by means of reference to the same world."[109] This coexistence with others centered around his own interests means he is what André Malraux terms the "incomparable monster"; he is "not one of them."[110] Yet, as soon as he reflectively considers his relation with other humans in a more general sense, in terms of humanity in general, he is no longer engaged in the world; he is the disinterested onlooker.[111] Even though he can never entirely lose his organic bonds with the world, to be a philosopher seems to require he step back from the world, reflect on it, conceive it, and posit himself within it in a kind of "antihumanistic humanism."[112] Merleau-Ponty concludes that language or meaning making mediates this paradox; humanity belongs (_gehört_) to this horizon that "depends on language," that is drawn upon at the service of expression.[113] Although, in language as expression, voice has a presence as style and particularity, the way Merleau-Ponty's friend is wholly present to him when he phones, there is little allusion to sound or voice in and of itself outside of meaning.[114] Monstration, however, reveals the world and thus brings it into existence. And for being that remains silent and is not expressed in language, there are the gestures of painting. The artist also monstrates, demonstrating the world as visible.[115] The "flexuous line" of the painter evokes an embodied response but does so silently. It preempts other possibilities for responding by "signifying" in its own "manner," providing an idea we can only understand through our "carnal participation in its sense."[116]

While painting presents us with a world, for Merleau-Ponty, music is "at the other extreme." It "is too far beyond the world and the

designatable to depict anything but certain outlines of Being—its ebb and flow, its growth, its upheavals, its turbulence."[117] However, the philosopher concedes, "a medley of sound sensations" can lead to the "appearance of a phrase" and, ultimately, "a world."[118] If the purpose of music is to reveal being, it is far less effective than painting. Music "does not speak" to Merleau-Ponty because it does not provide him with the saying of a world.[119] Without language there would be no "inscription" in the world.[120] Language opens up the boundless horizon of humanity.[121] Language, humans, and world are interlaced; they belong to the same world. This belonging is to "be understood as "'whirlwind,' as 'hollow'— therefore neither as passive nor as active."[122] It is our "'mute' experience," nonetheless, that "calls from itself for its 'expression'" as the prediscursive, or the origin of language.[123]

But what happens if, rather than making the world manifest, I participate in it and with it; if, rather than bringing presence to light, presence is summoned to itself?[124] What does it mean to move phenomenal perception to the foreground—in particular, perception of the sonorous? And how might this cultivation of sonorous perception expand my own thinking, which is so dependent upon my phenomenal body? Could it not be that to give oneself over to sonorous living rhythms is already to move away from calculative order and efficiency, if only for a while? Listening takes time; it responds to a rhythm of coming and going—like a kind of breathing—that cannot be absorbed in the glance of the eye. This is not to detach phenomenal perception from cognition, but rather to allow my thinking to be guided by the pulsating movement of life—in other words, by what is actually there rather than according to the forms of my interests and the plans I impose from outside. It is to allow my philosophical interrogative capacities to be responsive not only to my own world but also to those of others.

To be open to the movement of life is not to appropriate what is encountered into sedimented categories of perception or even to simply move into the world and unthinkingly take it up, which we can hardly prevent our phenomenal bodies from doing. In that moment of first encounter that precedes corporeal appropriation, there is a solicitation by and an interrogation of surfaces and surroundings that is a dialogue without words. My feet question the rough landscape and find its style or rhythm, so different from that of the city's sidewalks. My vision quickly takes in the lay of the land and identifies the path between the trees I am meant to follow, even as I am lost in conversation with my companion and do not really notice a phenomenally useful choice has been made.[125] If I am really attuned to

the wind's movement through the leaves and to the sounds of birdsong, I might even lose the path, becoming fully immersed. We navigate the world according to usefulness because we are embodied and move into and take up this epochal level of efficiency and systematicity. But there is another kind of attunement that belongs to our carnal being as sinuous, open, and relational. It allows me to respond to the sounds of the forest as I move into and take up its rhythms.[126] As Merleau-Ponty describes it: "All I have to do here is listen without soul-searching, ignoring my memories and feelings and indeed the composer of the work."[127] But there is, in addition, a kind of listening that is a receptiveness not limited to a simple passivity.[128] It is this deeper aspect of the phenomenal body that can attune our embodied thinking to something more than efficiency and can cultivate our embodied perceptual cognition. Rather than focusing on expression as the speaking of mute experience, retuning or cultivating embodied perceptual cognition might allow us to be more open to who or what is actually there. This is what the *Forty-Part Motet* allows me to do.

IV. ECHOES

Cardiff's work sets to work in another register than cognitive signification. My encounter with the *Forty-Part Motet* is at once both profoundly intimate and personal and also communal and shared because the work is experienced contemporaneously with others. The intimacy is experienced as profound presence and as a possibility of connection that does not have to be actualized. The work seems to connect visitors to each other because they belong to the same epochal opening even though they dwell in different worlds. It activates embodied perceptual cognition, which does not rely on individual points of view so much as a polyphony of differing voices responding to one another within a particular place. The experience, while belonging to the same epoch, nonetheless installs difference. Visitors have somewhat distinctive experiences of the work depending on where they stand or sit or how they move through the piece, as well as the affective experiences and particular histories they bring with them to the encounter. In opening up presence and difference simultaneously, it also allows for the possibility of encounter.

The artwork reveals what it means to experience oneself as corporeally attuned and as gathered together with others in the same time-space. It allows visitors to experience a different epochal way of relating to one another and the world by drawing them into a level of attentive perceptual attunement that allows for difference within the same. It accomplishes this attunement because it speaks to embodied subjects who

Fig. 5.2 *Forty-Part Motet* (a reworking of *Spem in Alium* by Thomas Tallis, 1556/1557), 2001. Materials: 40 loudspeakers mounted on stands, placed in an oval, amplifiers, playback computer. Duration: 14 min. loop with 11 min. of music and 3 min. of intermission. Dimensions: variable. Sung by Salisbury Cathedral Choir. Recording and postproduction by SoundMoves, edited by George Bures Miller, produced by Field Art Projects. The *Forty-Part Motet* by Janet Cardiff was originally produced by Field Art Projects with the Arts Council of England, Canada House, the Salisbury Festival and Salisbury Cathedral Choir, BALTIC Gateshead, The New Art Gallery Walsall, and the NOW Festival Nottingham. © Janet Cardiff. Courtesy of the artist and Luhring Augustine, New York. Photo: Ian Lefebvre © Art Gallery of Ontario. Works by Henry Moore at the AGO Henry Moore Sculpture Centre © The Henry Moore Foundation. All Rights Reserved, DACS/SOCAN (2020).

are capable of moving into new epochal levels, bringing with them their own particular experiences and relations. This attunement is not one that can be orchestrated through human control, even as it relies on technology. Because humans have this ability to make things technologically, to bring them to presence, they also have the capacity to shift the realm of presencing. They have the freedom to change their everyday practices. In allowing for that which is other to human making to come into appearance—the experience of the sacred—it provides for the experience of a different way of being in this age. The work establishes a poetic epoch within the larger epoch of this age of technology. It infuses relations and ways of appearing within its own space-time structure for the time visitors are held in its rhythmic arc. It allows them to meditate on the epoch that shapes them, as well as on the ways they individually and collectively

inhabit space-time as embodied. Corporeally understanding how epochs can shift if we are differently attuned, and how that shifts the ways we monstrate and reveal in language, is the beginning of a different, and more open, enactment of culture.

Notes

1. Thomas Tallis, *Spem in Alium* (c. 1570).
2. Janet Cardiff, *Forty-Part Motet*, 2001, dimensions: 5.1 m × 11 m × 3 m; duration: 14 min. loop with 11 min. of music and 3 min. of intermission; materials: 40 loudspeakers mounted on stands placed in an oval, amplifiers, playback computer. Sung by the Salisbury Cathedral Choir; recording and postproduction by SoundMoves, ed. George Bures Miller, produced by Field Art Projects.
3. The 2013 AGO exhibition can be viewed at https://www.youtube.com/watch?v=hL3U0GN7C1I or https://www.youtube.com/watch?v=Hj83cYfGtZw.
4. Corina MacDonald, "Scoring the Work: Documenting Practice and Performance in Variable Media Art," *Leonardo* 42, no. 1 (2009): 61.
5. As Jonathan De Souza points out, "for ecological acoustics, sounds are rich in information about the material forces that create them. Of course, such information does not determine perception. Attending to sources represents only one possible mode of listening, and the source of a given sound may be ambiguous, unfamiliar, or misidentified. Jonathan De Souza, *Music at Hand: Instruments, Bodies, and Cognition* (New York: Oxford University Press, 2017).
6. Sound, as George Bures Miller, Cardiff's cocreator, observes, "bypasses our intellectual filters and gets right into the soul of somebody. . . . Even the grouchiest, grumpiest people go in there and you can see how affected they are." James Adams, "Janet Cardiff and George Bures Miller: Art That 'Gets Right into the Soul,'" *Globe and Mail*, April 3, 2013, https://www.theglobeandmail.com/arts/art-and-architecture/janet-cardiff-and-george-bures-miller-art-that-gets-right-into-the-soul/article10752440/.
7. Although the biblical text of Tallis's music refers to that which lies beyond human control, Latin is not largely understood in contemporary secular culture and so the meaning of the words is largely lost. Nonetheless, it does refer to this transcendence. The translation from the original Latin text reads: "I have never put my hope in any other but in You / O God of Israel / who can show both anger / and graciousness / and who absolves all the sins of suffering man / Lord God / Creator of Heaven and Earth / be mindful of our lowliness." Alex Eddington and the Toronto Consort, *Janet Cardiff: Forty-Part Motet, Teacher's Guide*, National Art Gallery of Canada, Ottawa, 2015, https://torontoconsort.org/wp-content/uploads/2015/04/TeachersGuide-Forty-Part_Motet.pdf.
8. Heidegger, "The Question Concerning Technology," 16; "Die Frage Nach der Tecknik," 24.
9. See Michele Tanaka et al., "Transforming Pedagogies: Pre-Service Reflections on Learning and Teaching in an Indigenous World," *Teacher Development* 11, no. 1 (2007): 99–109. DOI: 10.1080/13664530701194728.
10. KQED Arts, "One Collective Breath: Janet Cardiff's 'The Forty Part Motet,'" December 4, 2015, YouTube video, 5:26, https://www.youtube.com/watch?v=rZXBia5kuqY; Janet Cardiff, "The Forty Part Motet," in *Janet Cardiff and George Bures Miller: The Killing Machine and Other Stories 1995–2007*, ed. Ralf Beil and Bartomeu Mari (Ostfildern, Germany: Hatje Cantz, 2007), 119.
11. Gerald Pape, "Luigi Nono and His Fellow Travellers," *Contemporary Music Review* 18, no. 1 (1999): 58.
12. Cardiff, "The Forty Part Motet," 119.

13. Merleau-Ponty, "Eye and Mind," 187; *L'Œil et l'esprit*, 83.

14. Bernie Krause describes how the sonic aspect of habitats is deeply relational; as well, one can hear how habitats have become compromised much more quickly than can be seen as animal sounds fall away or are disrupted, although he also maintains humans can learn to listen more actively and be more attuned to what is there. Bernie Krause, *The Great Animal Orchestra* (New York: Little, Brown, 2012).

15. See Ewan A. Macpherson and Andrew T. Sabin, "Vertical-Plane Sound Localization with Distorted Spectral Cues," *Hearing Research* 306 (2013): 76–92.

16. Brian Kane, *Sound Unseen: Acousmatic Sound in Theory and Practice* (New York: Oxford University Press, 2014), 7–9.

17. Merleau-Ponty, *Phenomenology of Perception*, 263; *Phénoménologie de la perception*, 291.

18. Merleau-Ponty, *The Visible and the Invisible*, 114; *Le visible et l'invisible*, 151.

19. Merleau-Ponty, *The Visible and the Invisible*, 113–114; *Le visible et l'invisible*, 151.

20. Merleau-Ponty, *The Visible and the Invisible*, 114; *Le visible et l'invisible*, 151.

21. Merleau-Ponty, *The Visible and the Invisible*, 266; *Le visible et l'invisible*, 313.

22. Merleau-Ponty, *The Visible and the Invisible*, 144; *Le visible et l'invisible*, 187.

23. Merleau-Ponty, *The Visible and the Invisible*, 144; *Le visible et l'invisible*, 187. If we understand sound as traveling in waves as "endorsed by modern acoustics [then] sounds are construed as mechanical vibrations transmitted by an elastic medium. They are thus described as longitudinal waves, defined by their frequency and amplitude. A vibrating object (the sound source, such as a moving vocal chord or a vibrating tuning fork) creates a disturbance in the surrounding medium (say, air, or water). Each particle of the medium is set in back-and-forth motion at a given frequency and with a given amplitude, and the motion propagates to neighboring particles at the same frequency, undergoing an energy loss that entails a decrease in amplitude." Roberto Casati, Jerome Dokic, and Elivra De Bona, "Sounds," in *Stanford Encyclopedia of Philosophy*, April 10, 2020, https://plato.stanford.edu/entries/sounds/#SoundWave.

24. My thanks to my colleague Jonathan De Souza for this description and explanation, as well as for his careful reading of this chapter. De Souza, email message to author, May 8, 2019. Also, note: "The full ensemble only sings together in 35 out of 183 bars (about one-fifth of the piece) and these tutti sections sometimes only last for a couple of bars at a time." Eddington, *Janet Cardiff: Forty-Part Motet, Teacher's Guide*.

25. James Murray, "Citation Notes," *Thomas Tallis Spem in Alium: Lamentations of Jeremiah*, directed by Mark Brown, Pro Cantione Antiques, 2010. Keith Anderson writes, "It is unlikely that early audiences were either aware that all forty voices enter together for the first time at the fortieth semi-breve, or that the piece lasts 69 longs (in the Latin alphabet, where I and J are the same letter, T=19, A=1, L=11, L=11, I=9, S=18, so TALLIS=69). But those fortunate listeners surely shared the most impressive aural experience of their lives, and the number symbolism is a mark of the fact that when Tallis attempted something that must have seemed impossible to the average musician of his day, he still had technique in reserve." Keith Anderson, "Notes," *The Best of Tallis*, Naxos, 2009.

26. Robert Jourdain, "The Birth of Harmony," in *Janet Cardiff and George Bures Miller: The Killing Machine and Other Stories 1995–2007*, ed. Ralf Beil and Bartomeu Mari (Ostfildern, Germany: Hatje Cantz, 2007), 121.

27. From the Latin *punctus contra punctum*.

28. De Souza, email message to author, May 8, 2019.

29. Jourdain, "The Birth of Harmony," 121.

30. Jourdain, "The Birth of Harmony," 121.

31. Jessica Wiskus, *The Rhythm of Thought* (Chicago: University of Chicago Press, 2013), 41.

32. I first visited the gallery a month after my father's death and as Sam Mallin was dying. The work allowed me to dwell with this sadness, to stay with it awhile.

33. KQED Arts, "One Collective Breath."

34. Salomé Voegelin, *Listening to Noise and Silence* (New York: Continuum, 2010), 170.

35. Salomé Voegelin, *Sonic Possible Worlds* (New York: Bloomsbury, 2014), 105; Voegelin, *Listening to Noise and Silence*, 133.

36. Joseph Cermatori, "On Matters of the Spirit," *A Journal of Performance and Art* 33, no. 3 (2011): 29.

37. I would also argue Cardiff's work installs the four-fold in the Museum—the divine that the music calls forth, the sky with the light shining in from the windows, the earth provided by Moore's grounded sculptures and mortals—the visitors gathered together by the work in this space. See Heidegger, "Building Dwelling Thinking."

38. Deborah Kapchan. "The Aesthetics of the Invisible: Sacred Music in Secular (French) Places," *Drama Review* 57, no. 3 (2013): 145.

39. KQED Arts, "One Collective Breath."

40. Maurice Merleau-Ponty, *Notes des cours au Collège de France 1958–1959 et 1960–1961*, ed. Stéphanie Ménasé (Paris: Gallimard, 1996), 63. My translation of "art qui chante le divine sans avoir à croire en Dieu, ni à faire partie d'une religion, ni à se retenir à des dogmes, sans même savoir si ce qu'il compose est réellement un hymne ou simplement une façon de vouloir dans 'divinement' prendre place."

41. R. Murray Schafer, *The Soundscape: Our Sonic Environment and the Tuning of the World* (Rochester, VT: Destiny Books, 1977), 118.

42. Schafer, *The Soundscape*, 156.

43. Schafer, *The Soundscape*, 152.

44. Merleau-Ponty, *Phenomenology of Perception*, 290–293; *Phénoménologie de la perception*, 321–324.

45. Merleau-Ponty, *Phenomenology of Perception*, 292–294; *Phénoménologie de la perception*, 324–325.

46. Schafer, *The Soundscape*, 272.

47. Schafer, *The Soundscape*, 43–44.

48. Schafer, *The Soundscape*, 272.

49. Schafer, *The Soundscape*, 152.

50. Andrew J. Eisenberg, "Space," in *Keywords in Sound*, ed. David Novak and Matt Sakakeeny (Durham, NC: Duke University Press, 2015), 198.

51. David Novak, "Noise," in *Keywords in Sound*, ed. David Novak and Matt Sakakeeny (Durham, NC: Duke University Press, 2015), 130–131.

52. However, it should be pointed out that Schafer's body of work is vast and includes collaborations with artists like Canadian Tanya Tagaq, who is an Inuit musician. Thanks to De Souza for pointing this out (email to author May 8, 2019). See also Shaun Pett, "Apocalypsis: Welcome to the Epic End of World Show at Luminato," *Guardian*, June 26, 2015, https://www.theguardian.com/music/2015/jun/26/apocalypsis-epic-show-lemi-ponifasio-luminato-festival.

53. Merleau-Ponty, *Phenomenology of Perception*, 261; *Phénoménologie de la perception*, 289.

54. Merleau-Ponty, *Phenomenology of Perception*, 540n23; *Phénoménologie de la perception*, 290n1.

55. Merleau-Ponty, *Phenomenology of Perception*, 261–262; *Phénoménologie de la perception*, 289–290.

56. To be clear, Wiskus is writing about Debussy's *Prélude à l'après-midi d'un faune* and not Tallis's work. Wiskus, *The Rhythm of Thought*, 51.

57. Maurice Merleau-Ponty, "Two Unpublished Notes on Music," *Chiasmi International* 3 (2001): 18. Also cited in Wiskus, *The Rhythm of Thought*, 51.

58. KQED Arts, "One Collective Breath."

59. Wiskus, *The Rhythm of Thought*, 120–121.

60. Giorgio Agamben, *The Man without Content* (Stanford, CA: Stanford University Press, 1999), 99.

61. Agamben, *The Man without Content*, 99.

62. Agamben, *The Man without Content*, 100.

63. Martin Heidegger, *On Time and Being*, trans. Joan Stambaugh (Chicago: Chicago University Press, 2002 [1972]), 9; originally published as *Zur Sache des Denkens* (Frankfurt am Main: Vittorio Klostermann, 2007 [1969]), 13.

64. Martin Heidegger, *Unterwegs zur Sprache* (Frankfurt am Main: Vittorio Klostermann, 1985 [1959], 169), 243.

65. Agamben, *The Man without Content*, 101; Heidegger, *On Time and Being*, 8–9; *Zur Sache des Denkens*, 12–13.

66. Heidegger, *On Time and Being*, 14; *Zur Sache des Denkens*, 18.

67. Heidegger writes: "The same is true of the elements of space; it is true of numbers of every kind, true of movements in the sense of mathematically calculated spatiotemporal intervals. We conceive of the unbroken and consecutive sequence of parameters, of what is measured by them, as the continuum. It excludes a face-to-face encounter of its elements so resolutely that even were we meet with interruptions, the fractions can never come face-to-face with each other." Martin Heidegger, *On the Way to Language* (New York: Harper & Row, 1971), 104–105; originally published as Heidegger, *Unterwegs zur Sprache*, 200.

68. Heidegger, *On the Way to Language*, 105; Heidegger, *Unterwegs zur Sprache*, 200–201.

69. Heidegger, *On Time and Being*, 15, 14; *Zur Sache des Denkens*, 20, 19.

70. Heidegger, *On Time and Being*, 15; *Zur Sache des Denkens*, 20.

71. Agamben, *Man without Content*, 100.

72. Agamben, *Man without Content*, 101.

73. Agamben, *Man without Content*, 101.

74. The German for "to hold," *halten*, is the root of *Verhältnis*, or "relation." Heidegger explains how the temporal aspect of the structural rhythm of being is obscured. The grammatical structure of the *es gibt*, the "there is" of being, literally translated as "it gives," obscures our understanding of being because it seemingly provides it with an agency we usually understand as attributed to subjects or even phenomenon. Instead, being, as the it that gives, withdraws in favor of the gift that is given, beings. Being in its temporal aspect is forgotten. Heidegger, *On Time and Being*, 8; *Zur Sache des Denkens*, 12.

75. Heidegger, *On Time and Being*, 4; *Zur Sache des Denkens*, 8.

76. Merleau-Ponty addresses this phenomenon in his discussion of film. The film's structure contributes to the overall meaning of the work, and this structure is held together by the material elements: cinematography, editing, sound, music, and acting. If one aspect of the filmic structure breaks down—for example, dubbing voices—so too does the meaning of the film as a whole. Merleau-Ponty, *Phenomenology of Perception*, 243; *Phénoménologie de la perception*, 271.

77. Agamben, *Man without Content*, 101. Italics added.

78. Claire Colebrook, "Dynamic Potentiality: The Body That Stands Alone," in *Rewriting Difference: Luce Irigaray and "the Greeks*," ed. Elena Tzelepis and Athena Athanasiou (Albany: State University of New York Press, 2010), 188.

79. See Fielding, "Questioning Nature."

80. Colebrook, "Dynamic Potentiality," 190.

81. Agamben, *The Man without Content*, 102.

82. There are two copies, one that is owned by and permanently installed in the National Art Gallery in Ottawa and one that circulates among museums and galleries, but presumably the work could be multiply copied and still be the work.

83. Kane calls this "autonomous sound effect" a "sound object." Kane, *Sound Unseen*, 8.

84. Merleau-Ponty, *Notes des cours au Collège de France 1958–1959 et 1960–1961*, 62.

85. Agamben, *The Man without Content*, 102.

86. Merleau-Ponty, *Phenomenology of Perception*, 243; *Phénoménologie de la perception*, 271.

87. Merleau-Ponty, *The Visible and the Invisible*, 197; *Le visible et l'invisible*, 248. Landes develops this theme of Merleau-Ponty and perception as expression beautifully in his work *Merleau-Ponty and the Paradoxes of Expression*.

88. Merleau-Ponty, *Phenomenology of Perception*, 193; *Phénoménologie de la perception*, 218.

89. Jean-Luc Nancy, *Listening*, trans. Charlotte Mandell (New York: Fordham University Press, 2007), 2; originally published as *Á l'écoute* (Paris: Galilée, 2002), 14.

90. Nancy, *Listening*, 2; *Á l'écoute* 14.

91. Nancy, *Listening*, 16; *Á l'écoute* 37.

92. Nancy, *Listening*, 10; *Á l'écoute* 27.

93. Nancy, *Listening*, 16; *Á l'écoute* 36. Italics in original.

94. Certainly Merleau-Ponty understands vision as being the sense that shows us "that beings that are different, 'exterior,' foreign to one another, are yet absolutely *together*, are 'simultaneity.'" Merleau-Ponty, "Eye and Mind," 187; *L'Œil et l'esprit*, 84.

95. Merleau-Ponty, "Eye and Mind," 16; *L'Œil et l'esprit*, 36.

96. Merleau-Ponty, "Eye and Mind," 20; *L'Œil et l'esprit*, 42.

97. Merleau-Ponty, "Eye and Mind," 21; *L'Œil et l'esprit*, 44.

98. Merleau-Ponty, *The Visible and the Invisible*, 144; *Le visible et l'invisible*, 190.

99. Merleau-Ponty, *The Visible and the Invisible*, 144; *Le visible et l'invisible*, 190.

100. Merleau-Ponty, *The Visible and the Invisible*, 144–145; *Le visible et l'invisible*, 190.

101. Merleau-Ponty, *The Visible and the Invisible*, 255–256; *Le visible et l'invisible*, 309.

102. Merleau-Ponty, *The Visible and the Invisible*, 141; *Le visible et l'invisible*, 185.

103. Merleau-Ponty, *The Visible and the Invisible*, 142; *Le visible et l'invisible*, 187.

104. Gayatri Chakravorty Spivak comments on how narcissism, although usually associated with the feminine, belongs to the masculine in Ovid's story. See Gayatri Chakravorty Spivak, "Echo," *New Literary History* 24, no. 1 (1993): 17–43. Irigaray suggests this myth points to the relation of sight to the masculine and hearing to the feminine. Irigaray, "Flesh Colors," 164.

105. Isabel Matos Dias, "Merleau-Ponty: Une Esthésiologie Ontologique," in *Notes de cours sur L'orgine de la géométrie de Husserl*, ed. Renaud Barbaras (Paris: Presses Universitaires de France, 1998), 284.

106. Adriana Cavarero, *For More than One Voice: Toward a Philosophy of Vocal Expression*, trans. Paul A. Kottman (Stanford, CA: Stanford University Press, 2005), 166.

107. Cavarero, *For More than One Voice*, 166.

108. Cavarero, *For More than One Voice*, 169.

109. Maurice Merleau-Ponty, *Husserl at the Limits of Phenomenology*, ed. Leonard Lawlor with Bettina Bergo (Evanston, IL: Northwestern University Press, 2002), 37, 36; originally published as Maurice Merleau-Ponty, *Notes de cours sur L'origine de la géométrie de Husserl*, ed. Renaud Barbaras (Paris: Presses Universitaires de France, 1998), 43. Italics and underlining in the original.

110. Merleau-Ponty, *Husserl at the Limits of Phenomenology*, 36; *Notes de cours sur L'origine de la géométrie de Husserl*, 43; André Malraux, *Man's Fate*, trans. Haakon M. Chevalier (New York: Random, 1961), 49–50. Merleau-Ponty refers to Malraux's usage of this term.

111. Merleau-Ponty, *Husserl at the Limits of Phenomenology*, 36; *Notes de cours sur L'origine de la géométrie de Husserl*, 43.

112. Merleau-Ponty, *Husserl at the Limits of Phenomenology*, 37; *Notes de cours sur L'origine de la géométrie de Husserl*, 44. See also Leonard Lawlor's introduction to these lectures, "*Verflechtung*," for a discussion of this paradox; Merleau-Ponty, *Husserl at the Limits of Phenomenology*, xx.

113. Merleau-Ponty, *Husserl at the Limits of Phenomenology*, 37; *Notes de cours sur L'origine de la géométrie de Husserl*, 44. Maurice Merleau-Ponty, "Indirect Language and the Voices of Silence," in *Signs*, trans. Richard C. McCleary (Evanston, IL: Northwestern University Press, 1964), 44.

114. Merleau-Ponty, "Indirect Language and the Voices of Silence," 43.

115. Merleau-Ponty, "Eye and Mind," 166; *L'Œil et l'esprit*, 26.

116. Merleau-Ponty, *The Visible and the Invisible*, 207–208; *Le visible et l'invisible*, 261.

117. Merleau-Ponty, "Eye and Mind," 161; *L'Œil et l'esprit*, 14. Merleau-Ponty also claims "music, like painting, is to the sensible world what philosophy is to the entire world." Merleau-Ponty, "Two Unpublished Notes on Music," 18.

118. Maurice Merleau-Ponty, *The World of Perception*, trans. Oliver Davis (London/New York: Routledge, 2002), 99.

119. Merleau-Ponty, *The World of Perception*, 99.

120. Merleau-Ponty, *Husserl at the Limits of Phenomenology*, 39; *Notes de cours sur L'origine de la géométrie de Husserl*, 46.

121. Merleau-Ponty, *Husserl at the Limits of Phenomenology*, 37; *Notes de cours sur L'origine de la géométrie de Husserl*, 44.

122. Merleau-Ponty, *Husserl at the Limits of Phenomenology*, 42; *Notes de cours sur L'origine de la géométrie de Husserl*, 51.

123. Merleau-Ponty, *Husserl at the Limits of Phenomenology*, 43; *Notes de cours sur L'origine de la géométrie de Husserl*, 53.

124. Nancy, *Listening*, 20; *À L'écoute*, 42.

125. See Dorothea E. Olkowski's discussion of phenomenology and usefulness in *Gilles Deleuze and the Ruin of Representation* (Berkeley: University of California Press, 1999), 59–88.

126. Bernie Krause's project is to encourage attunement to the sonic world of nature. To hear how he does this, go to Bernie Krause, *The Great Animal Orchestra*, Foundation Carter pour l'art contemporain, http://www.legrandorchestredesanimaux.com/en.

127. Merleau-Ponty, *The World of Perception*, 99.

128. Luce Irigaray, "Before and Beyond Any Word," in *Luce Irigaray: Key Writings*, ed. Luce Irigaray (London: Continuum, 2004), 135.

not his
 eyes a
his eyes secret
rage race
 adzo with
 asha a for taste
 esi for the she
 negro & port pus
 & ague they
 faint sam has a dose
 of the clap too
 and fine lace
 for his
 lady flip her over & over
 board was
 a red dawn
 they
 were drawn
 down
 ward
 a re
 ed for air
 d
 own
 do
 wn dow
 n down
 water
 drag s
 against
 the grain
 no air
 in vain
 then they
 were
 ever
 gone
 divers pour
 les âmes
 nig les souls
 nig
 nog
 nag
 nag
 pleas
 air

Fig. 6.1 Page 91 and select excerpts from *Zong!* © 2008 by M. NourbeSe Philip. Published by Wesleyan University Press and reprinted by permission.

6

DECOLONIZING REASON
M. NourbeSe Philip's *Zong!*

WE SIT IN VIRTUAL DARKNESS, flashlights in hand providing pin-points of lights, under a hovering silence. We begin to read M. NourbeSe Philip's poetry cycle *Zong!* out loud, each at our own pace.[1] Philip has organized this reading in an arts and cultural community space where people come together to read through the cycle from start to finish.[2] There are perhaps forty of us. We have been asked to wear white. People come and go; they move around. The chanting begins. Www w a wa w a wa t er, a whisper, a fluid murmur fills the room with a muttering of words and syllables that bob at the surface before disappearing. We read at the same time but not the same words. I begin to hear the particularity of the individual voices. There are no sentences, but each collection of sounds slips in and out of meaning. They drift across the room, meaning breaking up just as I think I am about to grasp it, moments of lucidity that quickly slip away. My voice floats among the others gathered in the space. I feel the intimacy of the words in my voice box even as they immediately disperse among those spoken by others I can barely see. I pace these words, these word fragments, these phonemes, these moans that are not mine but nonetheless become mine in the saying, linking me to the ones who have said them before, who will say them after, who are around me saying them now. Our voices slide around, among, and over one another's, a polyphony of voices, note against note, word against word. Taking place through the night, it is a mourning for the dead, an acknowledgment of the ancestors, as Philip also does by noting on the volume's cover that the poems were told to her by Setaey Adamu Boateng. As I learned afterward, the reading took hours; only some stayed until the end.

The poems in *Zong!* think through something unthinkable. In 1781, Luke Collingwood, the captain of the slave ship *Zong*, set sail from the west coast of Africa heading for Jamaica with "a cargo of 470 slaves." The

ship went badly astray and was weeks over its scheduled voyage. There were severe shortages of food and water. Africans were dying from "want of water." Eventually Collingwood gave the order for 150 Africans to be thrown overboard, "destroyed."[3] In his reading of British insurance law, if the enslaved Africans were to die what he considered a "natural death" from starvation, dehydration, or disease, "the owners of the ship [would] have to bear the cost, but if they were 'thrown alive into the sea, it would be the loss of the underwriters.'"[4] Subsequently, the ship's owners initiated legal action against the insurance company to recover their financial loss, and the court found in their favor. But the insurers appealed the decision to the Court of King's Bench. The three justices agreed to hold a new trial, the result of which is not known. All that remains is the initial decision, *Gregson v. Gilbert*. Philip draws from this decision for her collection of poems titled *Zong!*.[5] She restricts her palette to the words and phrases provided by this legal judgment, the only "tombstone" for those murdered.[6] She locks herself in the text "in the same way men, women, and children were locked in the holds of the slave ship."[7] Even though the Africans sent in ships to Jamaica are listed in account books as cargo without names—one "negro girl meager"—in her "footnotes," or "*footprints*," Philip names them.[8] The poems provide "a wake of sorts."[9]

Zong! is not a conventional text. It is composed of six chapters of poems; a glossary of words and phrases; a "Manifest"; a "Notanda," which takes much from Philip's diaries and provides an overview of the writing process for these poems; and the actual judgment, *Gregson v. Gilbert*. The poems have no punctuation, no traditional grammar, no linearity on the page that requires them to be read systematically from left to right or from up to down. The horizontal and vertical gaps between letters and words provide a visual spatiality to the text. The "governing principle" is the relational—the relations among every "word or word cluster" that can be seen on the page.[10] Although one can see the patterns, the poems come to life when they are read out loud. Rather than providing the singular voice of reason, speaking the text allows for a polyphonic chorus to emerge in counterpoint with voice against voice, word against word. The text of the judgment breaks apart into multiple fragments of "themes, phrases and voices" that echo and repeat, bearing "witness to the 'resurfacing of the drowned and oppressed' and transforming the desiccated, legal report into a cacophony of voices—wails, cries, moans and shouts that had earlier been banned from the text."[11] Tallis's *Spem in Alium* helped sustain Philip as she wrote the poems.[12] Both Tallis's piece and Philip's poems rely on Latin, the language of the church and the foundation of European

law. They also refer to the two meanings of *fugue*: Tallis's piece prefigures this contrapuntal composition, and *fugue* also refers to a kind of amnesia accompanied by a loss of identity. The legal judgment of *Gregson v. Gilbert* is itself a "representation of the fugal state of amnesia, serving as a mechanism for erasure and alienation." Philip's poems work to counter that forgetting.[13]

How, then, does one make sense of these poems? One does not, at least not in the same way one might try to make sense of the legal rationale that sanctioned the murders. In *The Human Condition*, Arendt quotes Isak Dinesen: "All sorrows can be borne if you put them into a story or tell a story about them."[14] But the sorrows Philip takes up in her poems are not ones that can be borne—to tell a story about them would be to reincorporate them into a larger narrative where the legal language makes its own sense, where the human "be-ing" of Africans and those of African descent is denied. This is a language to which the Africans on board the *Zong* in no way belonged, a saying that did not speak to them but rather murdered them in the saying. Philip's poems cannot be *about* the *Zong*.[15] The poems require a different kind of sensemaking. Reading them aloud allows for a sensibility to emerge—one not tied to the legal logos of the judgment but rather to an embodied logos that affirms life, one that allows for halting rhythms, stuttering, moans, and grunts. The poems work to "'Break and Enter' the text to release its anti-meaning."[16]

The story of *Zong!* is "the story of be-ing which cannot, but must, be told. Through not-telling."[17] It cannot be told in a logos that does not acknowledge the murder of the beings that appear only as possessions within its parameters. Philip's challenge was to expose its irrationality to reveal another kind of logos that allows for new possibilities. She begins with the unbearable sensemaking of the closed system of European logic that enabled, even encouraged, "a man to drown 150 people as a way to maximize profits."[18] This closed system has been reconfigured into the modern industrial prison complex, which imprisons racialized people at high rates and too often does not punish their murderers. Lisa Guenther, drawing on the work of Angela Davis and others, reminds us that "the Thirteenth Amendment only partly abolished slavery in the United States, making an exception for convicted criminals."[19] It is, Philip writes, "a painful irony that today so many of us continue to live, albeit in an entirely different way, either outside of the law, or literally imprisoned within it." But, she adds, "the creatures of fiat and law—always knew we existed *outside* of the law—that law—and that our be-ing was prior in time to fiat, law and word. Which converted us to property."[20] The system that relies on a logic

disengaged from embodied being, a "logic hiding the illogic," must be broken open.[21] This closed system imposes meaning on what or who is there. But "be-ing trumps the law every time."[22] It exceeds language. Philip's poems do not enact culture; they destroy it. But they do so by bringing readers to an experience with language: the experience of opening up a closed system of being and allowing for new possibilities to emerge.

I. Experiencing with Language

For Heidegger, an experience with language cannot be made to happen: it cannot be imposed, and it cannot be produced. It is the relation instituted by an event "that comes to word."[23] The word shapes and is shaped by the encounter with what is there—that is, with being. In his essays on language, he opens up the possibility that his readers will have such an experience.[24] As something that happens to one, "to undergo an experience with something—be it a thing, a person, or a god"—is to be touched, overwhelmed, and transformed.[25] Since an experience is not something that can be made to happen, it surprises us; it is out of our control. It is something we "endure" and "suffer." It is an event we actively receive and hence perceive.[26] But to have such an experience with language is nearly impossible in this age of Gestell, which orders, controls, and imposes. What is perhaps possible to experience is becoming aware of our relation to language, which is quite different from securing "information *about* language."[27] This means that to be attuned to being in this age is to be mindful of the realm in which we are called to impose a framework of appearance on all that is and to calculate, systematize, and seek efficiencies that deny the being of what is there. This realm includes planning and reckoning cut off from embodied perceptual cognition, from what we perceive in the here and now; it relies, instead, upon representation (*Vorstellen*).

But language is not only imposed on what is there. It can also come out of a relational attunement to being. Poets are privileged as artists because they dwell on this attunement and create new ways of bringing the world to appearance, of making sense of it. It is not a referential relation (*Beziehung*) they engage—that is, a shallow referral of words to things that does not actually touch upon what is there. Rather, poets are in relation to being (*Verhältnis*), which implies a holding and comporting of oneself in relation to what is there—to what is felt, seen, heard, and touched. Holding is different from placing (*Stellen*), which belongs to ordering, calculating, and systematizing. Holding, instead, has the measure of staying awhile (*Aufenthalt*) in the region where we are held.[28] Staying awhile is to take heed of

where we actually are in the present. While not referential, language is similarly not the closed formal system it is for postmodern philosophers.[29] Although embodied perceptual openness is shaped by language, we are not condemned to the systematicity of social construction that is secured by past structures. As embodied and hence open, we are capable of going beyond such structures and experiencing the way of being of what is actually there, which has its own way of being outside any imposed framework. Heidegger's insights into language undoubtedly motivated the linguistic turn in continental philosophy, but his understanding of language is not postmodern since language responds to what is there: "Language speaks by saying, this is, by showing."[30] Language might provide the possibilities of what can be said, but it still responds to the actual; this is not the same as a postmodern approach that takes language as a determining system of social construction or semiosis, a play between signifier and signified that never lands on or responds to the real.

My argument here is that Heidegger's phenomenological approach is helpful for understanding what Philip accomplishes in her poems, in their bringing to appearance that which has been covered over. But her challenge as a poet is how to respond to that which has not only been obscured as the presence of an absence but, because it was never recognized as present within the system, can accordingly never be recognized as absent within it. Her poems reveal the limits of language that does not simply cover over but in fact denies existence. Ultimately, Heidegger speaks from and to a closed culture of the same that forecloses encounters with the alterity of others. Alterity, in his understanding, is encountered as the mystery of being. He empties being of a grammatical subject-object agency with the "it gives" (*es gibt*) structure. And he displaces the subject of philosophy with *Dasein*, whose "proper abode" of "existence [is] in language."[31] Nonetheless, as Irigaray has so well described, the speaking subject of Western philosophy is singular; he speaks to himself. Although being is emptied of agential subjectivity, it haunts his thinking since there is only one speaking subject addressed in the grammar of the saying of language. Attunement to the language of the same imposes a framework on the alterity of others.[32] In revealing the limits of language, Philip's poems show how being exceeds imposed frameworks—how it exceeds what can be shown through the enframing of language. Her poems have the power to alter their readers.

As a poet she is well situated to do this, for to write poetry is to have an experience with language. The word "experience" (*Erfahren*), Heidegger tells us, means "to arrive at or touch something by going on a way."[33] The

poet *reaches* the relation between the word and thing. It is not *about* a relation between the word and the thing; rather, "the word itself is the relation" that "holds [*einbehält*] the thing in such a manner that it 'is' a thing."[34] The way of being of the thing is not its mere material presence. It is, rather, the way we experience the thing that is always already held in the word as a response to the giving of being.[35] The word itself is the relation between us and the things we experience within a particular region. A phenomenological description of my encounter with an artwork both comes out of the encounter with the work and also helps further articulate and deepen the encounter. At the same time, the description opens up what is around it in new ways; it reveals the ways we relate to what is there. To come closer to an experience with language, we must dwell in its neighborhood by saying or speaking in the presence of the work. Nonetheless, saying does not actually articulate our relation to language because the relation itself is our relation to being, and a relation in itself cannot be objectified. We come closer to an experience with language when we stumble, when we cannot find the right words for what "concerns us, carries us away, oppresses or encourages us."[36] It is in these moments of speechlessness that we experience how language does not merely designate some "thing" but actually creates and brings it into being *as* that thing. And then it is a question of whether or not we find the appropriate word for what has moved us, whether it is given to us or not.[37]

A poem, like an artwork that sets to work, can actually transform what is because it can transform the ways we understand—that is, the ways we encounter the real. It can itself creatively institute and open up an area where it is possible to experientially encounter both the work and what is found in the relational region opened up by the work because the poem facilitates this relational encounter, allowing what is to be revealed *as* what is. In this way, the poetic belongs to the same neighborhood, the same nearness or realm (*Bereich*), as thinking.[38] Both poetry and thinking respond to the real; they respond to what is, revealing the real, but they do so in their own ways. Thinking is not the calculation of the scientific method, which sets out an experimental framework that determines in advance what can appear so that nothing is ever encountered in the way it shows itself from itself.[39] Instead, thinking belongs to, and holds itself within, the region (*Gegend*) where it can move freely and encounter that which is given to be thought.[40] Thinking and poetry are the same in that they both engage in a relational encounter with the real through language. Phenomenological descriptions of encounters with artworks facilitate an encounter between poetry and thought in the presence of the real. Such encounters cannot be

made to happen; making belongs to fabrication, where one has the idea in advance. Instead, one who encounters what is there, what is other than one, is open to alterity, to what alters and transforms. One is moved by the experience through an attunement to "sadness, to the mood of" letting be what has touched one even as it withdraws.[41] Thinking and poetry are in touch with the world, and they reach out to what is there, which is why we cannot think from the removed Archimedean position looking down from above. Poetry and thinking do not come together in some kind of fusion or mixture. They are different ways of speaking—that is, of revealing the real, of bringing it into appearance. Bringing into appearance is itself transformative.[42]

Because poetry and thinking belong to and are in touch with the same region, they both, in their own ways, reveal the essence or way of being of the region and of the age. They are both grounded in embodied perceptual cognition.[43] Poetry provides something to think about. In his lectures on language, Heidegger does not provide a discussion about language as such. Instead, he wants his readers to be transformed. He wants to shift their relation to the real; he is "on the lookout for a possibility of undergoing an experience with language."[44] To think in this way is to reach out to that which beckons to us. Something presences because it persists, because it concerns us, moves us, and touches us.[45] If we are not so moved, touched, or concerned, we do not perceive what is there; it does not come into appearance for us. Signs are thus not merely conventional or arbitrary. They arise out of a realm because *the essential being of language is Saying as Showing,*" which is "not based on signs of any kind: rather, all signs arise from a showing within whose realm and for whose purposes they can be signs."[46]

Saying brings what concerns us and touches us into its own. Rather than imposing a meaning on what is there, saying allows what is there to show itself in itself, from where it is within the free space opened up by the region.[47] The saying of poetry and thinking brings into appearance what is near to us in the way what is near moves us. It distances what does not concern us. Saying allows beings to shine into appearance (*Scheinen*) and, when absent, "to fade from appearance."[48] The world appears through language because we address things that concern us, touch us, and move us. This is why to say is "to show, to let appear, to let be seen and heard."[49] Saying gathers together the movement of showing, seeing, and listening. Because languages emerge from the relation of embodied perception to the world, they are not only meaningful; they also "sound and ring and vibrate"; they "hover" and "tremble."[50] There is "a kinship between song

and speech" that reveals how the sensuous aspect of language is not merely physiological "as a production of sounds." Saying is a melodic response to the world; the ways we speak are responses to where we are, to the places that shape us.[51] Voices take up and resonate with the earth, with the sky, and with the divine; they respond as embodied mortals to place.[52]

But saying is not only a response to what is there, to what shows itself out of itself; it is also a listening to language itself because language also precedes us. It holds and sustains all the ways of perceiving and conceiving that have come before. Saying is simultaneously listening because saying comes out of language. When we listen to language, "we are *letting something be said to us.*"[53] Because saying gathers and brings to appearance through language, "listening to the language which we speak" reveals this relational attunement to what concerns us.[54] This means listening inheres in belonging to the same neighborhood that enables encounters—coming face-to-face (*gegen-einander*). As we saw in chapter 4, this neighborhood is both spatial—as it includes the interplay of earth, sky, human, and the divine—and temporal, since it allows for the past and future to meet in the present. Space and time understood in terms of parameters do not allow for such encounters since they provide only for a "succession of 'nows' one after the other" and for space "fixed at calculated distances." We do not come face-to-face—that is, encounter what is there—when "we talk 'about' it."[55]

Humans do not control language. Showing is not "exclusively, or even decisively, the property of human activity." Humans can only point to that which has let itself be shown through presencing (*anwesen*) or absencing. They respond to that which is other than them.[56] How else can one account for what is lost when what is lost has no material presence. The possibility of having an experience with language is freeing because it cannot be determined in advance, which does not mean it is completely open; it still belongs to and is given in relation to what is there within the possibilities provided by the language to which one belongs. As mentioned previously, "to belong" (*gehören*) has the same root in German as "listening" (*zuhören*). In the free area provided by the relational appearing of things—artworks, for example—pointing out simultaneously reveals and conceals. It gives ways that belong to this area.[57] What is spoken emerges from the "unspoken," whether it be what has "not yet been spoken" or what "must remain unspoken in the sense that it is beyond the reach of speaking."[58] In any realm there are possibilities that are given. Some are taken up and others covered over. But it is the way of being, or the essencing of the age, that provides the ways. As the moving way that makes ways,

it institutes all ways of making sense or making meaning, including the meditative thinking that reaches out as well as that which calculates.[59]

But language in this age of Gestell works otherwise; it imposes on what is there. Speaking is ordered and becomes information: "it informs itself *about* itself," securing a "formalized language, the kind of communication which 'informs' man uniformly, that is, gives him the form in which he is fitted into the technological-calculative universe."[60] In this age humans abandon "natural language": the language of physis, language that has not yet been formalized.[61] Heidegger suggests it is still possible to have a deeper experience with language, where language brings to appearance through the movement of showing, which allows "what has come to appearance [to] be perceived" and allows this perception to be "examined."[62] This is the phenomenological method of revealing what we perceive through language and then reflecting upon the language we engage in the description. But what has shifted in this age of technology is the relation between the showing and what is shown. Informational language does not rely on embodied perception that is in touch with what is there. In the shift in the sign from "something that shows [*Zeigenden*]" from out of itself to something that "designates [*Bezeichenenden*]," meaning is imposed from the outside. It is derived from the imposition of a method or structure that determines in advance what will appear.[63] Language that designates has nothing to do with experience, with what comes to appearance. Instead, informational language is referential; it does not touch on anything.

But poets do not take words as referential. They know that words bring things into appearance as they are and allow them to presence; they know that words hold and sustain (*hält und erhält*) things in their being.[64] They do not impose language because the "moving force" behind the showing of saying is the coming into one's own that is an event, but not in the sense of an occurrence. This saying that brings to light is not an imposition of a naming or a description; it is, rather, a saying that allows what is there to show itself as what it is, from itself and from the place where it abides.[65] Unlike the space of the experiment or that of enframing, a free space is the space of appearance that this saying allows. This coming into its own (*das Ereignen*) of the "event" coming "to word" is of a different order than work, making, or grounding, which assumes the imposition of an idea or eidos on what is there.[66] It can only be experienced as touching upon what is there or what is other to humans.[67]

Ultimately, listening to language, even the language of Gestell, opens up a free space, for Gestell also essences in the way of Ereignis. Even

though it orders everything according to calculative thinking, listening to the language of Gestell allows the essence of this age to come to appearance as this ordering.[68] Ultimately, Ereignis cannot be commandeered. All human language is in embodied relation even when it reveals the relational as an ordering calculation.[69]

Since the "appropriating, holding, self-retaining is the relation of all relations," saying, as a responding to what is there, is always relational. It can never be subsumed as a "mere reference [der bloßenBeziehung]"[70] Language cannot be known in terms of "cognition as representation [Vorstellen]" because we belong within the realm of language and cannot step outside it to represent it as such.[71] This is why an attunement to Gestell, a bringing it to appearance, also begins to move us out of the ordering systematicity.

But what happens when one is not able to appear within the language of the same, when one does not belong as one who speaks within its realm? The problem with Heidegger's house of being is that it is ultimately a closed system.[72] Although he describes the ways seeing, hearing, touching, moving, and being moved belong to experiencing language, it is still being to which mortals are attuned, to which they listen, and not to one another. As the language of the same, it "*is* monologue."[73] Irigaray suggests this one-way movement does not allow for the opening that differently embodied subjectivities bring to listening. Heidegger is attuned to epochal being but not to the different worlds in which we each dwell. Moving among languages, which is a present reality, imposes new challenges to listening to language. It is not only a matter of listening to the words but to the whole "linguistic and cultural context in which they take place, to the world they compose and construct."[74] She suggests we be attuned to or open to experiencing what is there before we impose on it the framing of language. If language is understood as the house of being, it is a singular and closed system.[75] To encounter all that is through the language one inhabits is to always already have imposed a particular cultural understanding, a way of being that does not grant a speaking subject position to all humans within its realm, often making it impossible to actually encounter the other as other and not as either a mirroring of oneself or a thing. Presencing into appearance requires a recognition of the limits of each subject, not the appropriation of the other into one's own world. Approaching the other does not begin with a "showing or making appear."[76]

Although language might be the house of being, if what is heard is only what is said within its enclosure, it does not provide sufficient space

for the cultivation of relations between humans and for the appearance of what is beyond human control. Heidegger's "open" is hermetically sealed, cutting off those who dwell in this language from new life and new energy. As we saw in chapter 4, an exchange requires that "the other touch us, particularly through words."[77] Whereas the naming that belongs to language can bring beings to appearance, the building of subjective identity requires more than the construction of structures or the demonstration of language. It also calls for the cultivation of relations—a perpetual movement, always with a difference, as a going out toward the other and a return to the self.[78]

For Heidegger, to speak also means to listen to silence, which is a co-responding to "the source of speaking."[79] The unspoken is that which "remains unsaid . . . is not yet shown, has not yet reached its appearance." This is the "mystery" of being out of which speaking comes.[80] For Irigaray, however, listening to silence makes possible the mystery of the appearance of the other. A "present and active" silence is needed to allow for "communicating and not merely transmitting information," a requisite for dialogue. To be fully present is to be corporeally attuned and to not impose meaning on who or what is there. Silence provides the other with a space-time that allows them to manifest, to come into presence as who they are. Silence acknowledges that in every appearance, every saying, there is that which remains concealed.[81] It is to recognize that there is that which cannot be brought to language, that remains "unspeakable" and yet nevertheless still is.[82]

II. The Story That Cannot Be Told but Must Be Told

Paying attention to our relation to language is inherent to Philip's methodological process. She does not tell her readers *about* the *Zong*; rather, her poems allow for the possibility of bringing readers to an experience with language. They reveal how there is no embodied sense to be made by the imposition of an external logic that serves making profit over any relation with what or who is there. But what happens when one's existence has always already been denied in the framework of language? Heidegger describes the poetic experience as the coming to "radiant light," as coming to appearance.[83] But what happens when absence cannot even presence as absence, when there is no material trace to be perceived?[84] What happens when moving freely to encounter that which is given to thought has been denied, when one's own language(s) has been forcibly silenced, forcibly abandoned, and the language in which one appears is one in which one cannot appear? If

one's own being has been denied in the way of being given by language, along with the structures (such as the law) that come into appearance through that language, how does one open up a realm through poetry to allow for an encounter with thinking? In Philip's words, "The law it was that said we were. Or were not."[85]

This is the challenge for the diasporic writer, but it is also her aid. If words grant things, then breaking up this "astounding power the word possesses" to turn humans into things is the challenge Philip takes on.[86] In the *Zong!* poems, the relationship of language to thinking given through grammar—through syntax and full sentences—has been abandoned. Instead, the poems open up spaces of silence for something new to sound, for a new way of sounding being. The voices begin their murmur from the margins; they float to the surface of the text; they take it over and destroy it. By opening up the text and breaking it apart, the "words break into sound," into song, and "return to their initial and originary phonic sound—grunts, plosives, labials—is this, perhaps, how language might have sounded at the beginning of time?"[87] Philip "murders" the text, allowing the being of the Africans to appear: "the African, transformed into a thing by the law, is re-transformed, miraculously, back into human."[88] Her poems allow for the possibility of an encounter because they bring those murdered to life in the present. This is not a saying of the same; it is "*the* story that simultaneously cannot be told, must be told, and will never be told."[89] It opens up a new relational way of being that takes existence—that is, living and not death—fully into account.

Nonetheless, as a writer she still confronts the problem of how one writes in a language that denies one's being but is nevertheless the language in which one writes.[90] The text she begins with is a legal text, but it is a text that is part of a whole symbolic system or world that systematically denies the being of racialized people. At the same time, this is the language with which she has to work. Her task as a poet requires breaking the system open as well as showing what escapes its framework. Drawing on different voices and different languages, the poems call on readers to give up the habit of hearing only what they understand and to listen for what they do not.[91] It is not even a matter of stumbling over words because that would be to assume one could even find the right ones and make sense within the system. Her task is to take the words of the judgment and give them the freedom to perform outside the grammar, the logic that has engendered them. The experience with language toward which Philip works is to break open the system completely. Whereas, for Heidegger, poets take their fleeting experiences with language and "found" them into a form that

will "endure and be," Philip's challenge is to resist sense, to break open that which endures.[92]

The poet draws on the text of the legal judgment as "a painter uses paint or a sculptor stone." The words that are her material are "preselected and limited." Like Henry Moore she removes "all extraneous material to allow the figure that was 'locked' in . . . to reveal itself"—in this case, the being of those denied that being.[93] The words take up the space they need; freed from the tight captivity of lineation, they expand across the page. They are apprehended visually through the ways they are spaced, sonorously through the repetition and stumbling of my reading, and palpably in the ways my mouth and tongue release them to the world; they are moving even if they do not often make "sense" in the way we think sense is supposed to be made according to the logic of syntax. They speak to another logos, one that relies on embodied perception. I begin to read the first poem. From the start I experience the water as an escaping howl: the juxtaposition of water to drown in and a thirst that cannot be quenched.[94]

```
        w w w      w      a  wa
              w        a       w a    t
   er              wa                s
```

It is a "want of water."[95] The words on the first page of the poem are spaced as though someone threw a pebble, or a heavier body, into the water; the words float outward from the empty center in little ripples of syllables pulled apart by the spread. What can it be to want water when there is so much water around, but not water that can hold up the weight of a body or water that can sustain life? It is water in which one drowns.

As I speak the words, I experience a shift in levels. The poems shift from living existence where water can nourish or kill to comparative quantifiers that reduce all that is to a measure of efficiency and profit. It is the measure of our age Philip questions in the fifth poem.[96] It provides a rhythm of spaced-out quantifiers "of days," "of died," "of rains," of "butts" of water, a kind of tallying of water, time, and the dead.[97] It is one that should not be since it is not grounded in what is actually there: "question therefore the age eighteen weeks and calm but it is said. . . . - - from the maps and contradicted by the evidence . . . question therefore the age."[98] Lived time is reduced to parametrical time, to a ledger that accounts for the monotony, of "weeks months weeks days months days weeks months weeks months weeks negroes was the bad made measure."[99] The measure of the logic that allows for the "etc of negroes" becomes the measure of this age.[100]

What happens when there is no sense to be made or the sense that is made makes no sense to embodied perceptual cognition, to relational existence, when "negroes exist for the throwing"?[101] Then, in reading, I try another strategy. I give over to the text and allow it to lead me. I cannot make the experience happen, but as I read, I experience this shift from an embodied and relational be-ing clearly given in the first poem with the experience of water into the measure of the age where Africans are revealed as property. In poem *Zong! #8*, throwing "property" who are also "fellow creatures" overboard is "justified" because the Africans "become our portion of mortality," as though murder can be measured out as "provision" in a "bad market."[102] But by *Zong! #9*, the measuring order is instituted with the disappearance of the subject into property: "to the order in destroyed the circumstance in fact the property in subject the subject in creature the loss in underwriter."[103] The reader is asked in *Zong! #15* to imagine a law where murder is justified in the name of profit: "where the ratio of just in less than is necessary to murder the subject in property the save in underwriter where etc tunes justice."[104]

Phenomenally, we read to make sense of what is there. A representational code such as a legal code has one thing stand in for another. A code imposes meaning onto something that is other than the thing itself. But in a relational world, representation cannot be so easily imposed. Being exceeds imposed meanings: "water means water."[105] In the poems that follow *Zong! #1*, a strict order governs. With a couple of exceptions, the words are lined up as they might be in a ledger with columns and rows. In *Zong! #18* the words form two vertical rows. The words can be read either vertically, "truth means sufficient means foul means necessity means perils," or horizontally, "means truth means overboard means sufficient means support means foul."[106] In this logic, this order of reading, it does not really matter. *Zong! #26* captures the frenzy and chaos of the voyage that should never have happened but was governed by an ordering measure that subsumed the frenzy under "the negroes was the cause."[107]

Existence is, for Heidegger, the relational meaning-making possibilities of being human. But the logic of reasoning that belongs to this age is revealed as one that should not be, should not exist, but it does: "the some of negroes over board the rest in lives drowned exist did not in themselves."[108] In *Zong! #4* the reader is beckoned to take heed of what comes to appearance through the silences, the gaps, and the absences, as well as to that which comes to appearance outside the framework provided by this judgment:

```
                              this is
              not was
                                      or
                      should be
              this be
                              not
              should be
                              this
              should
                              not
                    be
is.¹⁰⁹
```

The poem can be read horizontally or vertically in terms of succession or simultaneity. Either way, it exposes a binary structure of being and not being, of the existence of one being relying on the not being of the other and thus denying the other's appearance within its framework, structure, or world. Binaries belong to a closed system, but poetry does not.[110] The poems introduce relations where there were none before. Not only are sentences—indeed, the entire grammar—destroyed, but the words, too, begin to break up. Philip begins with what she calls "'mother' words" and then draws from them other words for her material.[111] Cutting off one letter changes the word's meaning, and yet the old word is connected to the new word in a kind of relational stutter: "tar them kin g at war with king."[112] Not despite but rather because of the spatial visual gap and the temporal gap in the saying, *Kin* is brought into relation with *king*; it breaks up the word *king* through force. The structure of the poems on the page sets up a new "web of relations."[113]

Reading the poems does not facilitate my corporeal ease of moving into them, allowing the text as text to fall into the background. It is not possible to forget the words, syntax, and grammar of the logos that "normally" recedes, becoming the ground against which everything appears. But this "normally" I inhabit is not one that those living in diaspora or exile, living between worlds, can ever fully experience—what Mariana Ortega calls the multiplicitous self who lives between worlds, who is a "being-between-worlds and a being-in-worlds, an in-between self."[114] Whereas, for Heidegger and Merleau-Ponty, the everyday world falls into the background, this is not possible for the multiplicitous self for whom the dissonance constantly juts through.[115] For Philip, as a multiplicitous self, the poet must take "revenge" on the language "of the colonizer," creating

the bones anew to support the flesh.[116] Creating new bones, a new structure, is what the poems in the first section, "Os," set out to do. Although this flesh is woven from many voices—"we are multiple and many voiced"—it is not "absolved of authorial intention."[117] Responsibility perdures in the ways we respond.

The judgment's measure as the singular voice of reason imposed on what is there gives way to a polyphonic chorus in the chapter "Sal." Like the salt of its name in Latin, the voices cannot be measured by counting. What has been suppressed by this logic begins to surface in this one long poem that weaves together multiple voices. I hear, see, and feel the texture of the frenzy that lies beneath the ordered system that is falling apart. There is no meaning on offer, only glimpses of sense—appearances—bobbing on the surface before they disappear again beneath the waves. The most insistent voice seems to come from a crewman, who writes to his girlfriend, Ruth, who waits for him at home. His voice describes horror and violence erupting from within a semblance of normality, "the tea men there was piss *cum* let s have some bile *cum* pus jam and bread port too & leaky teats there was only bilge wat er for tea i argue my case to you take ruth everything you must hear me i say *cum grano salis* with a grain of salt there was in surance again st sun not sin"[118]

As a polyphonic chorus of independent parts, this text offers no singular thread or narrative from the weave. In reading I choose certain strands of themes, lines of apparent narrative to follow. There could be another intertwining or set of dialogues that takes place between another reader and the text since the reader must work to engage with it. Nonetheless, the text is not open to the imposition of meaning: the materiality of the text juts through in the spacing and breaking up of words, as well as in the time it takes to sound them; these elements remain no matter how the poems are read. As the words break apart, various languages emerge, Yoruba, Shona, French; this means no one will have access to all the words, to all the threads of antimeaning. The poems provide different points of view on a situation that makes no sense to embodied perceptual cognition but nonetheless took place. But embodied perception belongs to existence and in these poems will have its say.

The Africans begin to surface as living subjects. The African women, completely absent from the legal text, appear in the references to violence and sexual assault described by the crewman through his guilt: "hi t her if she res ists i mis s the city ruth y our li ps it grow s d rear and sad and we are b ut slav es to sin."[119] But the women also appear in song: "the she negroes sin g sa d songs sing song voi ces at da wn."[120]

Another voice that emerges is that of Wale, an African on board separated from his wife, Sade, and child, Ase; he asks the crewman to write a letter to his Sade.[121] Ultimately, the crewman cannot make sense of what he is doing. He is caught in the vortex of this illogic that runs counter to his own embodied sensibility, expressed in his writing to Ruth that what they are doing is not right. He is caught up in a rhythm that only his own death might interrupt: "run ruth run from me & my sin mea sure the ease of over board."[122] Wale witnesses the crewman's suicide: "I am done he takes the paper eats it in then he falls on his lips. . . . He falls to the weight & wait in water I call his name & fall too to my once my nonce queen of the niger the sable one *nigra afra sade oh ye ye* africa oh over and over the *oba* sobs."[123]

I find I am beginning to move into the rhythms of the poems. In breaking up the meaning offered easily to cognition, Philip's poems invite the phenomenal body to come to the fore. As I read I phenomenally resonate with the downward pull of the words breaking up, sinking to the bottom of the page gasping for air: "a red dawn they were drawn down ward a re ed for air d own do wn dow n down water drag s against the grain no air in vain then they were ever gone" (see fig. 6.1).[124] As the written text breaks up, so too does the reasoning that could turn this murder into the loss of possessions: "a secret race under writers lives of writ s & rent s cede the truth to the right to be sure this is but an oration a tale . . . why are we here & where are we.[125] The horror seeps through the cracks that grow into an abyss where meaning floats away, bobbing only here and there at the surface: "bail & bail water water the wind rose is wet no help *omi* *omi omi* under wind & up wind we sail with every wind create a cat s cradle on the sea sing."[126] The horror I experience in reading is not only over the murder itself but also over a logic, framing, or limit within which these murders cannot appear as murder: "says the law is never wrong can never sin."[127] In Philip's poems any imposed logic there might have been disintegrates. There is no sense to be made from it: "are we mad or merely men without maps in an age where truth is rare."[128]

As I read, I must work at the text, which reminds me that reading is not a seamless transmission of ideas. I become complicit through the process of reading, implicated in the logic of which I try to make sense, and my citations from the text are my attempts to make sense. Someone else would cite the words and fragments in another way. As the text becomes more challenging to parse out, I feel pleasure when I do achieve some sense, as though there is sense to be made. At the same time, I am

called to consider how I can take pleasure in making sense of a tale that is untellable—inconceivable to a logos in touch with embodied perception. The phrases move between the everydayness of "port some jam & spuds we ate" to "how do we praise murder i grieve my fate my soul my late soul . . . i war with my self."[129] The embodied dissonance I experience reverberates with the text: pleasure and horror intertwined because even as I make some sense, I realize I am reading an account of an assault: "of pain between her and me."[130] It is a story that cannot be told in the logos of the legal judgment, but it can be phenomenally experienced as a story that cannot be told.

In legal language, the *ratio* is the central reason given for the judgment. The ratio for the legal judgment of *Gregson v. Gilbert* was that the ship's owners had not provided sufficient evidence to the court to support the decision to "'jettison their cargo,' that is, murder 150 African slaves."[131] Philip's *Zong!* has a different ratio. It "is the story of be-ing." Although "the law attempts to extinguish be-ing, as happened for 400 years as part of the European project," it cannot.[132] In the process of revealing the violence suppressed in the silences of the legal text, Philip does violence to the text itself. The long poem "Ferrum," which means *iron* in Latin, takes up the patter of raining words, but in this poem, even the words are exploded. The violence is hidden under scattered letters and syllables . . . it hides but is still there haunting the text: "we t her tie her by the h eel her nails ra ke my s kin she s pit s s how did w e get in to this me ss *act s*."[133]

The poems thus take us to the heart of the matter. In allowing living voices silenced by the abstract system of the law to surface, the judgment's ratio breaks down completely. The murder can only make sense according to the imposed logic that serves capital: "we sailed up the cunt of africa to found an out caste race can t you add a market waits."[134] It is the most abstract of representational systems, cut off as it is from embodied perceptual cognition: "the sea s feeds the lust for tin for gold comes to rest in rest rest my pet."[135] But the voices cannot be subsumed to the law in these poems. Here they come to life. It does not matter where I begin to read or where I break off, as the meaning does not form in statements or even phrases. It takes fleeting shape in wisps of meaning that swiftly shift into new forms, an oneiric mixing of voices that do not begin or end but nonetheless presence within the text.

I find it even harder now to stay with the text, and I start to resist it. I am reminded that reading is never a seamless process governed by one given meaning, a process that is usually too easily covered over. The words break up more and more. Just as I start to get the rhythm, I

stumble. I am emotionally exhausted, tempted to skip over pages, but then I will lose whatever threads there are even though, since it is not a narrative as such, one can move in and out of the text. I don't want to uncover all the violence and the pain. But I must bear witness to it, to each voice, to every poem.[136] Witnessing requires work to bring the glimpses of meaning, the flashes of images, to the surface. The work sometimes involves saying and reading the letters as though I were a child (or an adult in exile?), sounding out the syllables to see if the word will make sense to me, if it will fall into place in a sentence, but it never actually does—just phrases that dissipate before they land, glimpses of the turmoil, the violence, the overboard, the guilt.

Temporality cannot be reversed; the event cannot be undone. I am reminded by a quote from St. Augustine at the beginning of "Ferrum" that "the past is ever present."[137] I experience this phenomenally reading the words out loud. I cannot skip over the spatial gaps. I falter while reading. I read the word *sin* and then stutter over a floating *g*. My voice cannot go back and change the utterance to *sing* in a way that covers over the *sin*. I can only acknowledge the way the *g* modifies the *sin* through my hesitation but nonetheless turns it into song. The words are imbued by the violence that birthed them even as they become something else in this not telling the story. As the system is broken up, "murdered," it brings the past with it in the creation of something new. Retrieving the past and opening it up as Philip has done allows for new articulations of the past to emerge in the present and hence for articulating new possibilities for the future. In the final poem, "Ebora"—underwater spirits, in Yoruba—we see the spirits rising. The text is faint, and words overlap, crowded together so they are often illegible. There is no cognitive sense to be found in this poem. The spirits have claimed their existence over the text. The poems reveal the inherent violence of collapsing the temporality of living existence, of turning humans into disposable possessions, which can only happen when reason is closed off from embodied perceptual cognition. They also show how existence cannot be suppressed even when it is excluded from the logos or reasoning of an age.

III. BREAKING OPEN A CLOSED SYSTEM

Existence is excluded from reasoning subjectivity when reason becomes anchored by a binary system that denies embodied perceptual cognition. Achille Mbembe explains how establishing reason in a system of binary relations has been used to justify violence. What he calls "necropolitics" constitutes the limits of sovereignty in the modern age as "the capacity

to dictate who may live and who may die."[138] This capacity is seen as belonging to a democratic political body made up of "full subjects capable of self-understanding, self-consciousness, and self-representation."[139] One becomes such a reasoning subject through a confrontation with nature. Reason is not only established in a binary relation with nature but also with unreason, along with other binaries such as mind/body, life/death, white/black, and human/animal. Through this confrontation, free and equal subjects emerge capable of understanding, representing, and being conscious of themselves.[140] To become such a subject of reason, who is able to communicate with and recognize other autonomous subjects who have mastered embodied existence, reaches its highest expression in the struggle to confront death.[141] The violence of war and revolution provides the "state of exception" that allows for such confrontation since it is only possible outside legal parameters. But the colonies also provide a location "where the controls and guarantees of judicial order can be suspended." Echoing Arendt's description of the camps—which are ultimately part of the same system—the colonies provide a "zone where the violence of the state of exception is deemed to operate in the service of 'civilization.'"[142] Lawlessness can prevail in the colonies because the binary logic that supports the system comes from the "racial denial of any common bond between the conqueror and the native. In the eyes of the conqueror, *savage life is just another form of animal life* . . . something alien beyond imagination or comprehension."[143]

Colonization involves taking over a geographical territory, "seizing, delimiting, and asserting control."[144] Space becomes "the raw material of sovereignty and the violence" that goes with it.[145] Since time as historical belongs to "civilized subjects" who undergo a developmental process that includes overcoming nature, nature is considered to be spatial and not historical. This logic allows for the suspension of legal and institutional rules in the colonies; colonizers can and do murder with impunity. They do not perceive what they do as murder because the murders are not "legally codified" activities.[146] The imposed apartheid keeps colonizers and colonized spatially "separated across a y-axis," making encounters impossible.[147]

A "biopolitical experimentation" also delimits the space of the plantation. But here those enslaved experience the condition of a "triple loss." They lose their homes, their rights over their own bodies, and any "political status." These losses are equivalent to "absolute domination, natal alienation and social death (expulsion from humanity altogether)."[148] But even as enslaved Africans are reduced to possessions and hence to things

through the logic of the plantation, they nevertheless still exist. They are able to "draw almost any object, instrument, language, or gesture into a performance and then stylize it." They create outside the system, whether it be music, relations, ideas, or a sense of self.[149] Philip's poems allow for this creative, subjective embodied existence that cannot be suppressed, that will always exceed the colonizer's logos.

They also reveal, as Katherine McKittrick explains, how the closed system that supported colonization and slavery continues to thrive. She reads the *Zong!* poetry cycle as a "creative text" that breaches this system, that "both reveals and disproves the logic of race," that "work[s] within and think[s] outside a closed system."[150] She describes this system in terms of the feedback loop of scientific racism and social constructionism. On the one hand, there is the "biocentric conception of the human" that relies on the Darwinian explanation that humans are "purely biological and bio-evolutionary beings." They naturally evolve and have no authorship over this evolutionary process. These explanations situate "black subjects as naturally unevolved."[151] Recall here Arendt's descriptions of Darwinism in chapter 3 as an idea or process that touches on no one in particular. On the other hand, social constructionist critiques of this biocentrism seek to dismantle these Darwinian discourses but do so by drawing on the "habitual" and publicly validated discourses of "racial-biological human differences" that emerged in the eighteenth and nineteenth centuries.[152] In other words, even in critiquing biocentric discourses, science studies ultimately reinscribe the very concepts they seek to dismantle since there is still a "strong *belief*" in the "genetically natural" racial division of humans.[153] These discourses work within a closed "analytical system": "colonial and racial narratives are attached to and extend from the body outward, stabilize white supremacist logics, classify black life as unworthy, and loop back to mark the black body as an unworthy script that validates white supremacist logics."[154]

It is, McKittrick suggests, an autopoietic system—a "self-perpetuating and self-referencing closed belief system" that replicates Blackness and race in the same habitual ways of understanding that are "anti-black."[155] This system resembles the autopoietic system of a cellular network understood as a "closed and recursive system." It is a system in which any changes to cellular growth or to the cells themselves occur only through the "reconstitution of the system which houses and sustains the cells. The system is closed and self-referential."[156] Her argument is that human life is also organized as a kind of autopoiesis that replicates the social order. Any change within the system allows for a reorganization of the system

that allows it to regenerate and self-perpetuate "according to the *parameters of the existing social system*."[157] As such, biological determinism is perpetuated within science studies, even those that operate under the banner of social constructionism, because they draw on the racist classifications and taxonomies that underpin the system that is still invested in biological differences among races. This means that Black bodies are "reduced" to "analytical data" within the system. Their bodies continue to anchor "a liberatory trajectory," which means they can only "keep living" within this closed system by "moving from sub-humanness toward a genre of humanness that despises blackness."[158] The critiques of biological determinism can unintentionally reproduce these narratives by explaining how Blackness is socially constructed as racially defective. The problem is exposed as the separation of science and culture replicated in the binary division between biocentrically oriented empiricisms and social constructionism, between the human as "primarily *physiological*" and "*creativity*" as "an *extra-human* activity."[159]

For this explanation McKittrick turns to Wynter's articulation of autopoiesis as understanding humans as "simultaneously biological *and* cultural and alterable beings."[160] As Wynter formulates it: "we are, as humans, self-inscripting and inscripted flesh."[161] We are always already creative beings. This means that these closed systems "can be, and are, breached by creative human aesthetics that generate a point of view *away from* this consensual circular social system." Philip's *Zong!* provides such a point of view that dislodges the slave ship from the site of Black death that supports the system of biocentricity.[162] Philip could not tell a story about the *Zong* because that would be to work within the system expressed through the "discourse of emancipator benevolence."[163] The British establishment ends up abolishing slavery, and apparently the story of the *Zong* contributed to this event, but this abolishment takes place without disrupting the closed system that positions Black as defective.

The system remains closed because time is collapsed into space through the evacuation of the particular points of view that belong to racialized subjects. There is no recognition of flesh. There is no becoming.[164] Philip's poetry cycle works to rupture the system itself by destroying the language, the grammar, the logic of the code. It provides the space for the voices of those enslaved and murdered to appear as subjects, to sound from the gaps covered over by the legal document, and ultimately to overwhelm the closed system, revealing its illogic and breaking it open. Poetry and law are both concerned with language, but poetry admits sensibility; the legal judgment does not. The living particularity of those Africans aboard the

Zong comes through in the threads of their saying and in the names provided in the footnotes. Wale, the African taken from his wife and child, is given back his subjectivity and his agency, which could not appear within the system but are restored to him by the possibility of an encounter with him in the present saying of the poem. At the same time, the suicide of the European crewman is required for the destruction of the system: "It's akin to the idea that Columbus must die—for the world to live, that spirit of conquest, destruction, and domination that Columbus represents has to die."[165] The poems destroy the discourse of the autonomous subject who is transparent to *himself*, who stands over and above the world and others, by revealing the proximity and opacity that belongs to dwelling in the world with others.[166] Because we share a world, we are all implicated in what is done, in the ways we perceive, in the ways we encounter others or destroy them.

These poems do not participate in Black death because they announce Black living. They do not stay with the past to witness its repetition, which would be to once again collapse time into space. Instead, they set to work in the present as the poems are read, in their speaking to embodied perceptual cognition. They work to create an open future rather than a future determined by what has gone before. They reveal the silences and the silencing, what has not been sayable, what has been denied existence within the dominant discourses of reason. This is not to give up on reason but rather to open it up as embodied perceptual cognition—that is, to multiple iterations from different points of view that are in themselves multiplicitous. In so doing the poems break open metaphysics to new possibilities that "say without saying" since existence exceeds the language of the same.[167] In engaging embodied perceptual cognition, they reveal the proximity of relations within the structure or Gestell of the system that organizes the way things, people, and relations appear according to weights, measures, and costs. This is a story that cannot be told within the system of biocentric logic because the story exceeds it; it makes no sense within it. In the telling of the story by not telling it, this poetic logos goes beyond and in so doing breaks open the legal logic that scaffolded the violence.

My argument in this book has been that artworks can help cultivate our perception of the real that is the interrelationality that generates meaning from particular points of view, in order for us to think about how we are to dwell together in a global world. Cultivating perception has ethical, political, and cultural implications because it concerns how we make sense of the world we live in together with others even as we dwell in different worlds. We cannot make sense of this interrelatedness from the

Archimedean view from nowhere. This means all points of view are need-ed to give us an account of the real. When some points of view are not recognized as existing, it is not only unethical but also does not provide us with a full articulation of the real. Encountering and thinking according to artworks help open up a closed system because artworks can only be encountered spatially and temporally from particular points of view that are woven into the larger texture of flesh. These encounters can set to work to alter our perception of the real. They provide a creative opening up of a system, including the system we embody, by taking up the worlds around us, the worlds we live, the worlds in which we dwell. We respond to art-works because we are embodied and thinking beings; artworks draw on this embodied perceptual cognition when they set to work in the encoun-ter. The descriptions of the artworks I have encountered, as provided in this book, reveal how embodied perceptual cognition can help open up a closed system, showing us how we might dwell in our own worlds even as we share this global world.

Notes

1. M. NourbeSe Philip as told to the author by Setaey Adamu Boateng. Philip, *Zong!*.

2. The event took place at Wychwood Barns in Toronto on November 29, 2013, the an-niversary of the murders on the *Zong*, which took place on November 29, 1781. I am grateful to NourbeSe Philip for the invitation to participate. This same reading event took place in other communities across the world, such as in Brazil, Tobago, Trinidad, New York, and South Africa. See M. NourbeSe Philip, "Zong!DurationalReading2015X," posted December 7, 2015, YouTube video, 3:51, https://www.youtube.com/watch?v=xU74xqLn4vw.

3. Philip, *Zong!*, 189.

4. *Substance of the Debate on a Resolution for Abolishing the Slave Trade*, London, 1806, 178–179, quoted in Philip, *Zong!*, 189. As Philip asks, is it possible for enslaved people to die a "natural death"? Philip, *Zong!*, 189.

5. Philip, *Zong!*, 189. Interestingly, Lord Mansfield, chief justice of England who "presided at the appeal in *Gregson v. Gilbert*," had an adopted daughter, Dido, the offspring of his nephew, "a sea captain who had captured a Spanish slaving vessel and, it appears, fathered a daughter with an African woman on board that ship—the name of that child was Dido Elizbeth Belle Lindsay" (Philip, *Zong!*, 206). The African Queen Dido appears in Philip's poems.

6. Philip, *Zong!*, 194.

7. Philip, *Zong!*, 191.

8. Philip, *Zong!*, 199–200. Patricia Saunders, "Defending the Dead, Confronting the Archive: A Conversation with M. NourbeSe Philip," *Small Axe* 26 (June 2008): 77.

9. Philip, *Zong!*, 201. In the first chapter, "Os," we see names such as "Masuz Zuwena Ogun-sheye Ziyad Ogwambi Keturah Aba Chimanga Naeema Oba Eshe Wafor Yao Siyolo Bolade Kibibi Kamau" running along the bottoms of all the pages. Philip, *Zong!*, 3–5.

10. Philip, *Zong!*, 203. This "principle" resonates with Glissant's poetics of relation where "it is the network that expresses the ethics." Glissant, *Poetics of Relation*, 193.

11. Philip, *Zong!*, 203. She cites poet Maureen Harris in a talk given at the University of Toronto, 2006.

12. Philip, *Zong!*, 204. I was astonished to read this as I began my research for this chapter since Tallis's *Spem in Alium* is also central to Janet Cardiff's *Forty-Part Motet*, discussed in chapter 5.

13. Philip, *Zong!*, p. 204.

14. Arendt, *The Human Condition*, 175.

15. Philip, *Zong!*, 190

16. Philip, *Zong!*, 200. Philip notes that "Break and Enter" is a charge under the Criminal Code of Canada.

17. Philip, *Zong!*, 200.

18. Philip, *Zong!*, 195.

19. Guenther, *Solitary Confinement*, xvii.

20. Philip, *Zong!*, 207.

21. Philip, *Zong!*, 197.

22. Philip, *Zong!*, 200.

23. Krzysztof Ziarek, *Language after Heidegger* (Bloomington: Indiana University Press, 2013), 25. Ziarek's work is an extraordinary exploration of Heidegger on language.

24. In German, as Heidegger explains, the phrase *eine Erfahrung machen* is to make an experience with language, but this kind of making is not at all like the making of production. Heidegger, *On the Way to Language*, 57; *Unterwegs zur Sprache*, 149.

25. Heidegger, *On the Way to Language*, 57; *Unterwegs zur Sprache*, 149.

26. Heidegger, *On the Way to Language*, 57; *Unterwegs zur Sprache*, 149.

27. Heidegger, *On the Way to Language*, 58; *Unterwegs zur Sprache*, 150. Italics added.

28. Heidegger, *On the Way to Language*, 57; *Unterwegs zur Sprache*, 149.

29. For a fuller discussion of postmodern philosophy and the functionalism of the linguistic turn, see Olkowski, *Postmodern Philosophy and the Scientific Turn*, xi–xx.

30. Heidegger, *On the Way to Language*, 124; *Unterwegs zur Sprache*, 243.

31. Heidegger, *On the Way to Language*, 57; *Unterwegs zur Sprache*, 149.

32. See Irigaray, *The Way of Love*; I also take this up in my essay Helen A. Fielding, "Dwelling with Language: Irigaray Responds," in *French Interpretations of Martin Heidegger: An Exceptional Reception*, ed. David Pettigrew and François Raffoul (Albany, NY: State University of New York Press, 2008), 215–230. For a discussion of Irigaray's social science research that supports her claims about the sexed speaking subject position, see Marjorie Hass, "The Style of the Speaking Subject."

33. Heidegger, *On the Way to Language*, 66; *Unterwegs zur Sprache*, 159. The word *erfahren* has the root of *fahren*, "to drive, ride, or go."

34. Heidegger, *On the Way to Language*, 66; *Unterwegs zur Sprache*, 159.

35. Ziarek, *Language after Heidegger*, 20.

36. Heidegger, *On the Way to Language*, 58; *Unterwegs zur Sprache*, 150.

37. Heidegger, *On the Way to Language*, 59; *Unterwegs zur Sprache*, 151–152.

38. Heidegger, *On the Way to Language*, 84; *Unterwegs zur Sprache*, 177–178. *Bereich* has the root verb of *reichen*, which means "to reach."

39. Heidegger, *On the Way to Language*, 70; *Unterwegs zur Sprache*, 163.

40. Heidegger, *On the Way to Language*, 74; *Unterwegs zur Sprache*, 168. *Gegend* has the root of *gegen*, which encompasses the coming up against or around of the encounter.

41. Heidegger, *On the Way to Language*, 66; *Unterwegs zur Sprache*, 159.

42. It happens by way of an *Aufriss*, or cut. Heidegger, *On the Way to Language*, 90; *Unterwegs zur Sprache*, 184–185.

43. Heidegger, *On the Way to Language*, 90; *Unterwegs zur Sprache*, 184–185.

44. Heidegger, *On the Way to Language*, 92; *Unterwegs zur Sprache*, 187.

45. Heidegger, *On the Way to Language*, 95; *Unterwegs zur Sprache*, 190. Heidegger writes, "Es west an, wahrend geht es uns an, be-wëgt und be-langt uns."

46. Heidegger, *On the Way to Language*, 123; *Unterwegs zur Sprache*, 242. Italics in original.

47. Heidegger, *On the Way to Language*, 127; *Unterwegs zur Sprache*, 246–247.

48. Heidegger, *On the Way to Language*, 126; *Unterwegs zur Sprache*, 246. The German word *Scheinen* captures both these meanings of shining and appearing. *Verscheinen* is the fading away.

49. Heidegger, *On the Way to Language*, 122; *Unterwegs zur Sprache*, 241.

50. Heidegger, *On the Way to Language*, 98; *Unterwegs zur Sprache*, 193. In the German text, it reads, "klingt und schwingt, schwebt und bebt."

51. Heidegger, *On the Way to Language*, 98; *Unterwegs zur Sprache*, 193. Merleau-Ponty also writes of "singing the world": "We would then find that words, vowels, and phonemes are so many ways of singing the world, and that they are destined to represent objects, not through an objective resemblance, in the manner imagined by the naïve theory of onomatopoeia, but because they are extracted from them, and literally express their emotional essence." Merleau-Ponty, *Phenomenology of Perception*, 193; *Phénoménologie de la perception*, 218.

52. Heidegger, *On the Way to Language*, 99; *Unterwegs zur Sprache*, 193. This means those displaced from their homes are distanced from the saying of the world as it was first opened up for them, where things, people, and relations resounded with one another in meaningful ways, presuming, of course, that one begins with a home where the world unfolds in meaningful ways, which is too often not the case.

53. Heidegger, *On the Way to Language*, 124; *Unterwegs zur Sprache*, 243.

54. Heidegger, *On the Way to Language*, 123–124; *Unterwegs zur Sprache*, 243.

55. Heidegger, *On the Way to Language*, 104–105; *Unterwegs zur Sprache*, 199–200.

56. Heidegger, *On the Way to Language*, 123; *Unterwegs zur Sprache*, 242–243.

57. Heidegger, *On the Way to Language*, 91; *Unterwegs zur Sprache*, 187.

58. Heidegger, *On the Way to Language*, 120; *Unterwegs zur Sprache*, 240.

59. Heidegger, *On the Way to Language*, 92; *Unterwegs zur Sprache*, 186. In German, *Bewegung* is "movement" and *Weg* is "way." Heidegger reveals being as the *be-wëgende Weg*, "the moving way," through these relational roots.

60. Heidegger, *On the Way to Language*, 132; *Unterwegs zur Sprache*, 252. Italics added.

61. Heidegger, *On the Way to Language*, 132; *Unterwegs zur Sprache*, 252.

62. Heidegger, *On the Way to Language*, 115; *Unterwegs zur Sprache*, 233.

63. Heidegger, *On the Way to Language*, 115; *Unterwegs zur Sprache*, 234.

64. Heidegger, *On the Way to Language*, 65–66; *Unterwegs zur Sprache*, 158. In German the relation (*Verhältnis*) that happens among the words themselves appears visually and sonorously in excess of representation or cognition through the repetition of the semantic roots.

65. Heidegger, *On the Way to Language*, 127; *Unterwegs zur Sprache*, 246.

66. "The event comes to word" is Ziarek's definition of *Ereignis*. Ziarek, *Language after Heidegger*, 25.

67. Heidegger, *On the Way to Language*, 127; *Unterwegs zur Sprache*, 247.

68. Heidegger, *On the Way to Language*, 131–132; *Unterwegs zur Sprache*, 252.

69. The German word for perception, *wahrnehmen*, means what is taken as true.

70. Heidegger, *On the Way to Language*, 135; *Unterwegs zur Sprache*, 256.

71. Heidegger, *On the Way to Language*, 134; *Unterwegs zur Sprache*, 255.

72. See Luce Irigaray, *The Forgetting of Air in Martin Heidegger*, trans. Mary Beth Mader (Austin: University of Texas Press, 1999).

73. Heidegger, *On the Way to Language*, 134; *Unterwegs zur Sprache*, 254. Italics in the original.

74. Luce Irigaray, "Listening, Thinking, Teaching," in *Luce Irigaray: Teaching*, eds. Luce Irigaray with Mary Green (London: Continuum, 2008), 232.

75. Martin Heidegger, "Letter on Humanism," in *Martin Heidegger: Basic Writings*, ed. David Farrell Krell (London: Routledge, 1993), 214.

76. Irigaray, *Sharing the World*, 19–20.

77. Irigaray, *The Way of Love*, 17–18.

78. Irigaray, *The Way of Love*, 162–163.

79. Heidegger, *On the Way to Language*, 131; *Unterwegs zur Sprache*, 151.

80. Heidegger, *On the Way to Language*, 122; *Unterwegs zur Sprache*, 241–242.

81. Irigaray, *Sharing the World*, 5.

82. Irigaray, *Sharing the World*, 5.

83. Heidegger, *On the Way to Language*, 86; *Unterwegs zur Sprache*, 181.

84. This is, of course, the problem of the silences in the archive. See Rodney G. S. Carter, "Of Things Said and Unsaid: Power, Archival Silences, and Power in Silence," *Archivaria* 61 (2006): 215–235.

85. Philip, *Zong!*, 206–207.

86. Heidegger, *On the Way to Language*, 88; *Unterwegs zur Sprache*, 183.

87. Philip, *Zong!*, 205, 207.

88. Philip, *Zong!*, 196.

89. Philip, *Zong!*, 206.

90. See M. NourbeSe Philip, "The Absence of Writing or How I Almost Became a Spy," in *A Genealogy of Resistance* (Toronto: Mercury, 1997).

91. Heidegger writes we must give up "the habit [*abgewöhnen*] of always hearing only what we already understand." Heidegger, *On the Way to Language*, 58; *Unterwegs zur Sprache*, 150.

92. Heidegger, *On the Way to Language*, 68; *Unterwegs zur Sprache*, 161.

93. Philip, *Zong!*, 198.

94. Philip, *Zong!*, 3.

95. Philip, *Zong!*, 3, 210.

96. Philip, *Zong!*, 8–13.

97. Philip, *Zong!*, 10–11.

98. Philip, *Zong!*, 14. From here, as I cite from the poetry, I will indicate spacings between words and letters, but not the spacing among lines on the page. I recognize that the spacing is crucial, but quoting is always already a kind of desituating. I urge the reader to read Philip's poems in the original text.

99. Philip, *Zong!*, 51.

100. Philip, *Zong!*, 50.

101. Philip, *Zong!*, 34.

102. Philip, *Zong!*, 16.

103. Philip, *Zong!*, 17.

104. Philip, *Zong!*, 25.

105. Philip, *Zong!*, 32.

106. Philip, *Zong!*, 31.

107. Philip, *Zong!*, 45.

108. Philip, *Zong!*, 6.

109. Philip, *Zong!*, 7.

110. Glissant, *Poetics of Relation*, 82.

111. Philip, *Zong!*, 200.

112. Philip, *Zong!*, 130.

113. Heidegger, *On the Way to Language*, 112; *Unterwegs zur Sprache*, 231. Heidegger writes, "language itself has woven [*verflochten*] us into speaking." *Verflochten* can also be translated as "intertwined."

114. Ortega, *In-Between*, 50.

115. Ortega, *In-Between*, 60.

116. Philip, *Zong!*, 205.

117. Philip, *Zong!*, 205.

118. Philip, *Zong!*, 70.

119. Philip, *Zong!*, 163.

120. Philip, *Zong!*, 161.

121. Philip, *Zong!*, 88.

122. Philip, *Zong!*, 73–74.

123. Philip, *Zong!*, 172–173. This quoted passage is my rendition, my gathering of the words to make some sense of them. Here I provide a version that is closer to how they appear on the page: "i a m do ne he ta ke s the pa per e ats it the n he fa ll s on his li ps . . . he fa lls to the we ight & wa it in w ater i ca ll his na me & f all too t o my on ce my no nce queen of the ni ger the sa ble o ne *nig ra afra* sa *d e oh ye ye* afr i ca oh o ver and o ver the *o ba* s o b s."

124. Philip, *Zong!*, 91.

125. Philip, *Zong!*, 80–81.

126. Philip, *Zong!*, 84–85.

127. Philip, *Zong!*, 88.

128. Philip, *Zong!*, 90.

129. Philip, *Zong!*, 105.

130. Philip, *Zong!*, 107.

131. Philip, *Zong!*, 200.

132. Philip, *Zong!*, 200.

133. Philip, *Zong!*, 136–137.

134. Philip, *Zong!*, 97.

135. Philip, *Zong!*, 102.

136. "No one bears witness for the witness." Paul Célan quoted in Philip, *Zong!*, 100.

137. Philip, *Zong!*, 126.

138. Achille Mbembe, "Necropolitics," *Public Culture* 15, no. 1 (2003): 11.

139. Mbembe, "Necropolitics," 13.

140. Mbembe, "Necropolitics," 14.

141. Mbembe, "Necropolitics," 14. Here Mbembe draws on G.W.F. Hegel's *Phenomenology of Spirit*.

142. Mbembe, "Necropolitics," 24.

143. Mbembe, "Necropolitics," 24.

144. Mbembe, "Necropolitics," 25.

145. Mbembe, "Necropolitics," 26.

146. Mbembe, "Necropolitics," 25–26.

147. Mbembe, "Necropolitics," 26, 29. As we see in Philip's poems, the slave ship on the Middle Passage provided another spatial formation that brought colonizers and colonized into close proximity in a space somewhere between the colonies and Europe. The law of the state of exception ruled the treatment of the Africans, and yet, the captain of the ship appealed to English laws assumed to preside over a "civilized" country. Perhaps this is why the story of the *Zong* is said to have been significant to the abolishment of slavery.

148. Mbembe, "Necropolitics," 21.

149. Roger D. Abrahams, *Singing the Master: The Emergence of African American Culture in the Plantation South* (New York: Pantheon, 1992), quoted in Mbembe, "Necropolitics," 22.

150. Katherine McKittrick, "Diachronic Loops/Deadweight Tonnage/Bad Made Measure," *Cultural Geographies* 23, no. 1 (2016): 13.

151. McKittrick, "Diachronic Loops," 3–4.

152. McKittrick, "Diachronic Loops," 7; see also Angela Saini, *Superior: The Return of Race Science* (Boston, MA: Beacon, 2019). Saini recounts how biomedical scientists, often with the best of intentions, have drawn on habitual understandings of racial categories in attempts to find drugs

that will address apparently racially genetic specific conditions. For example, there is a much higher rate of hypertension in African Americans than in white Americans. Without examining the conceptual apparatus of race they drew on to provide them with racial categories, a team of scientists tried to establish the biological grounds for this discrepancy when they should have been looking to the social determinants of health that arise out of racializing relations. Saini, *Superior*, 181–202.

153. Dorothy Roberts, *Fatal Invention: How Science, Politics, and Big Business Re-Create Race in the Twenty-First Century* (New York: New Press, 2011), cited in McKittrick, "Diachronic Loops," 7. Italics in original.

154. McKittrick, "Diachronic Loops," 6–7.

155. McKittrick, "Diachronic Loops," 7.

156. McKittrick, "Diachronic Loops," 7. McKittrick draws here from the work of Humberto Maturana and Francisco Varela, *Autopoiesis and Cognition: The Realization of the Living* (Dordrecht, Netherlands: Kluwer, 1979).

157. McKittrick, "Diachronic Loops," 7.

158. McKittrick, "Diachronic Loops," 8. She paraphrases Frantz Fanon, *The Wretched of the Earth*, trans. C. Farrington (New York: Grove, 1963), 163.

159. McKittrick, "Diachronic Loops," 9. Italics in original.

160. McKittrick, "Diachronic Loops," 9.

161. Scott, "The Re-Enchantment of Humanism," 206. Merleau-Ponty writes, "Man is an historical idea, not a natural species. . . . Human existence is the change of contingency into necessity through the act of taking up. All that we are, we are on the basis of a factual situation that we make our own and that we ceaselessly transform through a sort of escape that is never an unconditioned freedom." Merleau-Ponty, *Phenomenology of Perception*, 174; *Phénoménologie de la perception*, 199.

162. McKittrick, "Diachronic Loops," 10.

163. McKittrick, "Diachronic Loops," 11.

164. Here I refer to Merleau-Ponty's understanding of flesh that is not in play when even history becomes spatialized, linking nations to identity and omitting the complex migration and interdwelling patterns. This understanding of space is, of course, a metaphysical one that does not take into account the creative becoming of materiality and its temporal nature.

165. Saunders, "Defending the Dead, Confronting the Archive," 75.

166. For a discussion of opacity, see Glissant, *Poetics of Relation*, 189–194.

167. Glissant, *Poetics of Relation*, 68.

BIBLIOGRAPHY

Abrahams, Roger D. *Singing the Master: The Emergence of African American Culture in the Plantation South.* New York: Pantheon, 1992.

Adams, James. "Janet Cardiff and George Bures Miller: Art That 'Gets Right into the Soul.'" *Globe and Mail*, April 3, 2013. https://www.theglobeandmail.com/arts/art-and -architecture/janet-cardiff-and-george-bures-miller-art-that-gets-right-into-the -soul/article10752440/.

Agamben, Giorgio. *Homo Sacer: Sovereign Power and Bare Life.* Translated by Daniel Heller-Roazen. Stanford, CA: Stanford University Press, 1998.

———. *The Man without Content.* Translated by Georgia Albert. Stanford, CA: Stanford University Press, 1999.

Albers, Patricia. *Joan Mitchell: Lady Painter.* New York: Alfred A. Knopf, 2011.

———. "Joan Mitchell: Painting as Cathedral." In *Synesthesia: Art and the Mind*, 49–54. Hamilton, ON: McMaster Museum of Art, 2008.

Alloa, Emmanuel. *Resistance of the Sensible World: An Introduction to Merleau-Ponty.* Translated by Jane Marie Todd. New York: Fordham University Press, 2017.

Alpers, Svetlana, and Margaret Carroll. "Not Bathsheba." In *Rembrandt's 'Bathsheba Reading King David's Letter,'* edited by Ann Jensen Adams, 147–175. Cambridge: Cambridge University Press, 1998.

Al-Saji, Alia. "A Phenomenology of Critical-Ethical Vision: Merleau-Ponty, Bergson, and the Question of Seeing Differently." *Chiasmi International* 11 (2009): 375–398.

———. "The Racialization of Muslim Veils: A Philosophical Analysis." *Philosophy and Social Criticism* 36, no. 8 (2010): 875–902.

———. "Too Late: Racialized Time and the Closure of the Past." *Insights: Institute of Advanced Study* 6, no. 5 (2006): 1–13.

Anderson, Keith. "Liner Notes." *The Best of Tallis.* C.D. Naxos, 2009.

Andrews, Jorella G. *The Question of Painting: Rethinking Thought with Merleau-Ponty.* London: Bloomsbury, 2018.

———. *Showing Off: A Philosophy of Image.* London: Bloomsbury, 2014.

Ardizzoni, Michela. "Unveiling the Veil: Gendered Discourses and the (In)Visibility of the Female Body in France." *Women's Studies* 33 (2004): 629–649.

Arendt, Hannah. *The Human Condition.* Chicago: University of Chicago Press, 1958.

———. *The Life of the Mind.* Vol. 1: *Thinking.* San Diego: Harcourt Brace, 1978 [1971].

———. "Organized Guilt and Universal Responsibility." In *Essays in Understanding, 1930–1954: Formation, Exile, and Totalitarianism*, edited by Jerome Kohn, 121–132. New York: Schocken Books, 1994.

———. *The Origins of Totalitarianism*. San Diego: Harcourt, 1968 [1952].

———. "Truth and Politics." In *Between Past and Future*, 227–264. New York: Penguin Books, 1993.

Bal, Mieke. *Louise Bourgeois: Memory and Architecture*. Madrid: Museo Nacional Centro de Arte Reina Sofía, 1999.

———. "Narrative Inside Out: Louise Bourgeois' 'Spider' as Theoretical Object." *Oxford Art Journal* 22, no. 2 (1999): 103–126.

———. "Reading Bathsheba: From Mastercodes to Misfits." In *Rembrandt's 'Bathsheba Reading King David's Letter,'* edited by Ann Jensen Adams, 119–146. Cambridge: Cambridge University Press, 1998.

Berger, John. *Ways of Seeing*. London: BBC and Penguin Books, 1972.

Bernadac, Marie-Laure. *Louise Bourgeois*. Translated by Deke Dusinberre. Paris: Flammarion, 1996.

Bernstock, Judith E. *Joan Mitchell*. New York: Hudson Hills, 1988.

Blakely, Alison. *Blacks in the Dutch World: The Evolution of Racial Imagery in a Modern Society*. Bloomington: Indiana University Press, 1993.

Bredlau, Susan. *The Other in Perception: A Phenomenological Account of Our Experience of Other Persons*. Albany: State University of New York Press, 2018.

Brozan, Nadine. "Chronicle." *New York Times*, October 3, 1996. https://www.nytimes.com/1996/10/03/style/chronicle-631043.html.

Butler, Judith. "Sexual Difference as a Question of Ethics: Alterities of the Flesh in Irigaray and Merleau-Ponty." In *Feminist Interpretations of Maurice Merleau-Ponty*, edited by Dorothea E. Olkowski and Gail Weiss, 107–125. University Park: Pennsylvania State University Press, 2006.

Cajete, Gregory. *Native Science: Natural Laws of Interdependence*. Santa Fe, NM: Clear Light, 2016.

Cardiff, Janet. "The Forty Part Motet." In *Janet Cardiff and George Bures Miller: The Killing Machine and Other Stories, 1995–2007*, edited by Ralf Beil and Bartomeu Mari, 119–120. Ostfildern, Germany: Hatje Cantz, 2007.

Carter, Rodney G. S. "Of Things Said and Unsaid: Power, Archival Silences, and Power in Silence." *Archivaria* 61 (2006): 215–235.

Casati, Roberto, Jerome Dokic, and Elivra De Bona. "Sounds." In *Stanford Encyclopedia of Philosophy*, April 10, 2020. https://plato.stanford.edu/entries/sounds/#SoundWave.

Casey, Edward S. *The World at a Glance*. Bloomington: Indiana University Press, 2007.

Cavarero, Adriana. *For More Than One Voice: Toward a Philosophy of Vocal Expression*. Translated by Paul A. Kottman. Stanford, CA: Stanford University Press, 2005.

Cermatori, Joseph. "On Matters of the Spirit." *A Journal of Performance and Art* 33, no. 3 (2011): 24–34.

Chanter, Tina. "Irigaray's Challenge to the Fetishistic Hegemony of the Platonic One and Many." In *Rewriting Difference: Luce Irigaray and "the Greeks,"* edited by Elena Tzelepis and Athena Athanasiou, 217–229. Albany: State University of New York Press, 2010.

Christoff, Kalina, Diego Cosmelli, Dorothée Legrand, and Evan Thompson. "Specifying the Self for Cognitive Neuroscience." *Trends in Cognitive Science* 15, no. 3 (2011): 104–107.

Cixous, Hélène. *Stigmata: Escaping Texts*. Translated by Catherine A. F. MacGillivray. New York: Routledge 2005 [1998].

Clark, Kenneth. *The Nude*. New York: Doubleday, 1956.

Cohen, Jem, director. *Anne Truitt: Working*. 16mm film. 13 minutes. Brooklyn: Gravity Hill Farms, 2008.

———. *Anne Truitt, Working—A Remembrance. In the Tower: Anne Truitt Symposium, Part III*. National Gallery of Art, Washington, DC, January 19, 2018. Posted February 21, 2018. YouTube video, 30:34. https://www.youtube.com/watch?v=5_02__pD578.

Cole, Michael, Sheila Cole, and Cynthia Lightfoot. *The Development of Children*. New York: Worth, 2005.

Colebrook, Claire. "Dynamic Potentiality: The Body That Stands Alone." In *Rewriting Difference: Luce Irigaray and "the Greeks,"* edited by Elena Tzelepis and Athena Athanasiou, 177–190. Albany: State University of New York Press, 2010.

Coole, Diana. *Merleau-Ponty and Modern Politics after Anti-Humanism*. Lanham, MD: Rowman & Littlefield, 2007.

Crowther, Paul. *The Phenomenologies of Art and Vision*. London: Bloomsbury Academic, 2013.

———. *Phenomenology of the Visual Arts (Even the Frame)*. Stanford, CA: Stanford University Press, 2009.

Curtis, Kimberley. *Our Sense of the Real: Aesthetic Experience and Arendtian Politics*. Ithaca, NY: Cornell University Press, 1999.

Danto, Arthur C. "Mitchell Paints a Picture." *The Nation* 275, no. 8 (September 16, 2002): 30–33.

De Souza, Jonathan. *Music at Hand: Instruments, Bodies, and Cognition*. New York: Oxford University Press, 2017.

Dias, Isabel Matos. "Merleau-Ponty: Une Esthésiologie Ontologique." In *Notes de cours sur L'orgine de la géométrie de Husserl*, edited by Renaud Barbaras, 269–288. Paris: Presses Universitaires de France, 1998.

Dyer, Richard. *White*. London: Routledge, 1997.

Eddington, Alex, and the Toronto Consort. *Janet Cardiff: Forty-Part Motet, Teacher's Guide*. National Art Gallery of Canada, Ottawa, 2015. https://torontoconsort.org/wp-content/uploads/2015/04/TeachersGuide-Forty-Part_Motet.pdf.

Eisenberg, Andrew J. "Space." In *Keywords in Sound*, edited by David Novak and Matt Sakakeeny, 193–207. Durham, NC: Duke University Press, 2015.

Evans, Fred. *Public Art and the Fragility of Democracy: An Essay in Political Aesthetics*. New York: Columbia University Press, 2018.

Fanon, Frantz. *Black Skin, White Masks*. Translated by Charles Lam Markmann. New York: Grove, 1967.

———. *Peau noir masques blancs*. Paris: Éditions du Seuil, 1952.

———. *The Wretched of the Earth*. Translated by C. Farrington. New York: Grove, 1963.

Fielding, Helen A. "Dwelling and Public Art: Serra and Bourgeois." In *Merleau-Ponty: Space, Place, Architecture*, edited by Rachel McCann and Patricia Locke, 258–282 Athens: Ohio University Press, 2016.

———. "Dwelling with Language: Irigaray Responds." In *French Interpretations of Martin Heidegger: An Exceptional Reception*, edited by David Pettigrew and François Raffoul, 215–230. Albany: State University of New York Press, 2008.

———. "A Feminist Phenomenology Manifesto." In *Feminist Phenomenology Futures*, edited by Helen A. Fielding and Dorothea E. Olkowski, vii–xxii. Bloomington: Indiana University Press, 2017.

———. "'Only Blood Would Be More Red': Irigaray, Merleau-Ponty and the Ethics of Sexual Difference." *Journal of the British Society for Phenomenology* 32, no. 2 (May 2001): 147–159.

———. "Questioning Nature: Irigaray, Heidegger and the Potentiality of Matter." *Continental Philosophy Review* 36, no. 1 (2003): 1–26.

———. "White Logic and the Constancy of Color." In *Feminist Interpretations of Merleau-Ponty*, edited by Dorothea E. Olkowski and Gail Weiss, 71–89. State Park: Pennsylvania State University Press, 2006.

Figal, Günther. *Aesthetics as Phenomenology*. Translated by Jerome Veith. Bloomington: Indiana University Press, 2015.

Foster, David H. "Color Constancy." *Vision Research* 51, no. 7 (2011): 674–700.

Fóti, Véronique. *Tracing Expression in Merleau-Ponty: Aesthetics, Philosophy of Biology, and Ontology*. Evanston, IL: Northwestern University Press, 2013.

Freud, Sigmund. "The Uncanny." In *The Penguin Freud Library*. Vol. 14, *Art and Literature*, edited by Albert Dickson, 339–376. London: Penguin, 1990.

Gaut, Berys. *Art, Emotion and Ethics*. Oxford: Oxford University Press, 2007.

Gikandi, Simon. *Sensibility and the Culture of Taste*. Princeton NJ: Princeton University Press, 2011.

Gines, Kathryn T. *Hannah Arendt and the Negro Question*. Bloomington: Indiana University Press, 2014.

Glazebrook, Patricia. *Heidegger's Philosophy of Science*. New York: Fordham University Press, 2000.

Glissant, Édouard. *Poetics of Relation*. Translated by Betsy Wing. Ann Arbor: University of Michigan Press, 1997.

Goldberg, David Theo. "Heterogeneity and Hybridity: Colonial Legacy, Postcolonial Heresy." In *A Companion to Postcolonial Studies*, edited by Henry Schwartz and Sangeeta Ray, 72–85. Oxford: Blackwell Publishing, 2005 [2000].

Goswani, Tanmoy. "Why We Need Hugs and Handshakes to Stay Healthy." *Correspondent*, June 12, 2020. https://thecorrespondent.com/526/why-we-need-hugs-and -handshakes-to-stay-healthy/69636720252-d995882a.

Grosz, Elizabeth. "Merleau-Ponty and Irigaray in the Flesh." *Thesis Eleven* 36, no. 1 (August 1993): 37–59.

Guenther, Lisa. "Critical Phenomenology." In *50 Concepts for A Critical Phenomenology*, edited by Gail Weiss, Ann V. Murphy, and Gayle Salamon, 11–16. Evanston, IL: Northwestern University Press, 2019.

———. "Merleau-Ponty and the Sense of Sexual Difference." *Angelaki* 16, no. 2 (2011): 19–33.

———. *Solitary Confinement: Social Death and Its Afterlives*. Minneapolis: University of Minnesota Press, 2013.

Hass, Lawrence. *Merleau-Ponty's Philosophy*. Bloomington: Indiana University Press, 2008.

Hass, Marjorie. "The Style of the Speaking Subject: Irigaray's Empirical Studies of Language Production." *Hypatia* 15, no. 1 (2009): 64–89.

Heidegger, Martin. "Bauen Wohnen Denken." In *Vorträge und Aufsätze*, GA Vol. 7, 146–164. Frankfurt am Main: Vittorio Klostermann, 2000 [1959].

———. *Being and Time*. Translated by John Macquarrie and Edward Robinson. New York: Harper & Row, 1962.

———. *Bemerkungen zu Kunst—Plastik—Raum*. St. Gallen, Switzerland: Erker-Verlag, 1996.

———. "Building Dwelling Thinking." In *Poetry, Language, Thought*, translated by Albert Hofstadter, 145–161. New York: Harper & Row, 1971.

———. "Das Ding." In *Vorträge und Aufsätze*, GA Vol. 7, 165–187. Frankfurt am Main: Vittorio Klostermann, 2000 [1954].

———. "Die Frage Nach der Technik." In, *Vorträge und Aufsätze*. GA Vol. 7, 5–36. Frankfurt am Main: Vittorio Kostermann, 2000 [1954].

———. *Identity and Difference*. Translated by Joan Stambauch. New York: Harper & Row Publishers, 1969.

———. *Introduction to Metaphysics*. Translated by Gregory Fried and Richard Polt. New Haven, CT: Yale University Press, 2000.

———. "Letter on Humanism." In *Martin Heidegger: Basic Writings*, edited by David Farrell Krell, 213–266. San Francisco: Harper Collins, 1993.

———. "On the Essence and Concept of *Physis* in Aristotle's *Physics B, 1 (1939)*." In *Pathmarks*, translated by William McNeill, 183–230. Cambridge: Cambridge University Press, 1998.

———. *On the Way to Language*. Translated by Peter D. Hertz. New York: Harper & Row, 1971.

———. *On Time and Being*. Translated by Joan Stambaugh. Chicago: Chicago University Press, 2002 [1972].

———. "The Origin of the Work of Art." In *Poetry, Language, Thought*, translated by Albert Hofstadter, 17–76. New York: Harper & Row, 1971.

———. "The Question Concerning Technology." In *The Question Concerning Technology and Other Essays*, translated by William Lovitt, 3–35. New York: Harper & Row, 1977.

———. "Science and Reflection." In *The Question Concerning Technology and Other Essays*, translated by William Lovitt, 155–182. New York: Harper & Row, 1977.

———. *Sein und Zeit*. Tübingen, Germany: Max Niemeyer, 1967 [1927].

———. "The Thing." In *Poetry, Language, Thought*, translated by Albert Hofstadter, 163–184. New York: Harper & Row, 1971.

———. *Unterwegs zur Sprache*. Frankfurt am Main: Vittorio Klostermann, 1985 [1959].

———. *Der Ursprung des Kunstwerkes*. Frankfurt am Main: Vittorio Klostermann, 2012 [1950].

———. "Vom Wesen und Begriff der *Physis* Aristoteles' *Physik B, 1*." In *Wegmarken*, GA Vol. 9, 309–371. Frankfurt am Main: Vittorio Klostermann, 1976.

———. "Wissenshaft und Besinnung." In *Vorträge und Aufsätze*, GA Vol. 7, 37–65. Frankfurt am Main: Vittorio Klostermann, 2000.

———. *Zur Sache des Denkens*. Frankfurt am Main: Vittorio Klostermann, 2007 [1969].

Hileman, Kristen. "Presence and Abstraction." In *Anne Truitt: Perception and Reflection*, edited by Kristen Hileman, 10–47. Washington, DC: Hirshhorn Museum and Sculpture Garden, 2009.

Hobbs, Robert. "Krasner, Mitchell, and Frankenthaler: Nature as Metonym." In *Women of Abstract Expressionism*, edited by Joan M. Marter, 58–66. New Haven, CT: Yale University Press, 2016.

Hoogendorn, Hinze. "From Sensation to Perception: Using Multivariate Classification of Visual Illusions to Identify Neural Correlates of Conscious Awareness in Space and Time." *Perception* 44 (2015): 71–78.

Huws, Ursula. *Labour in Contemporary Capitalism: What Next?* London: Palgrave Macmillan, 2019.

Irigaray, Luce. "Before and Beyond Any Word." In *Luce Irigaray: Key Writings*, edited by Luce Irigaray, 134–141. London: Continuum, 2004.

———. "Being Two, How Many Eyes Have We?" *Paragraph* 25, no. 3 (November 2002): 143–151.

———. *An Ethics of Sexual Difference*. Translated by Carolyn Burke and Gillian C. Gill. Ithaca, NY: Cornell University Press, 1993.

———. "Flesh Colors." In *Sexes and Genealogies*, translated by Gillian C. Gill. New York: Columbia University Press, 1993.

———. *The Forgetting of Air in Martin Heidegger.* Translated by Mary Beth Mader. Austin: University of Texas Press, 1999.

———. "Listening, Thinking, Teaching." In *Luce Irigaray: Teaching*, edited by Luce Irigaray with Mary Green, 231–240. London: Continuum, 2008.

———. *Sharing the World.* London: Continuum, 2008.

———. *To Be Two.* Translated by Monique M. Rhodes and Marco F. Cocito-Monoc. New York: Routledge, 2001.

———. "To Paint the Invisible." Translated by Helen A. Fielding. *Continental Philosophy Review* 37, no. 4 (2004): 389–405.

———. *The Way of Love.* Translated by Heidi Bostic and Stephen Pluháek. London: Continuum, 2002.

Irigaray, Luce, and Michael Marder. *Through Vegetal Being.* New York: Columbia University Press, 2016.

Jay, Martin. *Downcast Eyes: The Denigration of Vision in Twentieth-Century French Thought.* Berkeley: University of California Press, 1993.

Jenkinson, John. *A New Framework for Enactivism: Understanding the Enactive Body through Structural Flexibility and Merleau-Ponty's Ontology of Flesh.* PhD diss., University of Western Ontario, 2017. https://ir.lib.uwo.ca/etd/4383/.

Johnson, Galen A. *The Retrieval of the Beautiful: Thinking Through Merleau-Ponty's Aesthetics.* Evanston, IL: Northwestern University Press, 2010.

Jourdain, Robert. "The Birth of Harmony." In *Janet Cardiff and George Bures Miller: The Killing Machine and Other Stories 1995–2007*, edited by Ralf Beil and Bartomeu Mari, 121–134. Ostfildern, Germany: Hatje Cantz, 2007.

Kane, Brian. *Sound Unseen: Acousmatic Sound in Theory and Practice.* New York: Oxford University Press, 2014.

Kapchan, Deborah. "The Aesthetics of the Invisible: Sacred Music in Secular (French) Places." *Drama Review* 57, no. 3 (2013): 132–147.

Kaushik, Rajiv. *Art and Institution: Aesthetics in the Late Works of Merleau-Ponty.* London: Bloomsbury, 2011.

———. *Art, Language and Figure in Merleau-Ponty: Excursions in Hyper-Dialectic.* London: Bloomsbury, 2015.

Khan, Amina. "Getting Killed by Police Is a Leading Cause of Death for Young Black Men in America." *Los Angeles Times*, August 16, 2019. https://www.latimes.com/science/story/2019-08-15/police-shootings-are-a-leading-cause-of-death-for-black-men.

Kimmerer, Robin Wall. *Braiding Sweetgrass: Indigenous Wisdom, Scientific Knowledge, and the Teachings of Plants.* Minneapolis, MN: Milkweed Editions, 2013.

Kleiner, Fred S., and Christin J. Mamiya. *Gardner's Art through the Ages.* Vol. 2, *The Western Perspective.* Belmont, CA: Wadsworth, 2004.

Kohler, Lotte, ed. *Within Four Walls: The Correspondence between Hannah Arendt and Heinrich Blücher, 1936–1968.* Translated by Peter Constantine. New York: Harcourt, 2000.

Kozel, Susan. "The Diabolical Strategy of Mimesis: Luce Irigaray's Reading of Merleau-Ponty." *Hypatia* 11, no. 3 (1996): 114–129.

KQED Arts. "One Collective Breath: Janet Cardiff's 'The Forty Part Motet.'" December 4, 2015. YouTube video, 5:26. https://www.youtube.com/watch?v=rZXBia5kuqY.

Krause, Bernie. *The Great Animal Orchestra.* Foundation Carter pour l'art contemporain, http://www.legrandorchestredesanimaux.com/en.

———. *The Great Animal Orchestra: Finding the Origins of Music in the World's Wild Places.* New York: Little, Brown, 2012.

Kristensen, Stefan. "Le mouvement de la création: Merleau-Ponty et le corps de l'artiste." *Alter: Revue de la Phénoménologie* (2008): 243–260.

Landes, Donald A. *Merleau-Ponty and the Paradoxes of Expression*. New York: Bloomsbury, 2013.

Lawson, Erica S. "Mercy for Their Children: A Feminist Reading of Black Women's Maternal Activism and Leadership Practices." In *African Canadian Leadership: Continuity, Transition and Transformation*, edited by Tamari Kitossa, Erica S. Lawson, and Philip S. S. Howard, 190–210. Toronto: University of Toronto Press: 2019.

"Liberté against laïcité." *Economist*, April 20, 2019. The Americas. https://www.economist .com/the-americas/2019/04/17/quebec-wants-to-ban-public-servants-from-wearing -religious-clothing.

Livingston, Jane. *The Paintings of Joan Mitchell*. Berkeley: University of California Press, 2002.

MacDonald, Corina. "Scoring the Work: Documenting Practice and Performance in Variable Media Art." *Leonardo* 42, no. 1 (2009): 59–63.

Maclaren, Kym. "Touching Matters: Embodiments of Intimacy." *Emotion, Space and Society* 13 (2014): 95–102.

Macpherson, Ewan A., and Andrew T. Sabin. "Vertical-Plane Sound Localization with Distorted Spectral Cues." *Hearing Research* 306 (2013): 76–92.

Madden, Allan. "Louise Bourgeois, *Give or Take* 2002." Tate Modern. November 2014. https://www.tate.org.uk/art/artworks/bourgeois-give-or-take-al00343.

Mallin, Samuel B. *Art Line Thought*. Dordrecht, Netherlands: Kluwer, 1996.

———. *Body on My Mind: Body Hermeneutic Method*. Unpublished manuscript.

———. *Merleau-Ponty's Philosophy*. New Haven, CT: Yale University Press, 1980.

Malraux, André. *Man's Fate*. Translated by Haakon M. Chevalier. New York: Random, 1961.

Manning, Dolleen Tisawii'ashii. *Mnidoo-Worlding: Merleau-Ponty and Anishinaabe Philosophical Translations*. PhD diss., University of Western Ontario, 2018. https://ir.lib.uwo.ca/etd/5171/.

———. "The Murmuration of Birds: An Anishinaabe Ontology of *Mnidoo*-Worlding." In *Feminist Phenomenology Futures*, edited by Helen A. Fielding and Dorothea E. Olkowski, 155–182. Bloomington: Indiana University Press, 2017.

Maturana, Humberto and Francisco Varela, *Autopoiesis and Cognition: The Realization of the Living*. Dordrecht, Netherlands: Kluwer, 1979.

Maund, Barry. "Color." In the *Stanford Encyclopedia of Philosophy*, April 13, 2018. https://plato.stanford.edu/entries/color/.

Mbembe, Achille. "Necropolitics." *Public Culture* 15, no. 1 (2003): 11–40.

McGonagle, Joseph. "An Interstitial Intimacy: Renegotiating the Public and the Private in the Work of Zineb Sedira." *French Cultural Studies* 18, no. 2 (2007): 219–235.

McKittrick, Katherine. "Diachronic Loops/Deadweight Tonnage/Bad Made Measure." *Cultural Geographies* 23, no. 1 (2016): 3–18.

McNeill, William. *The Time of Life: Heidegger and Ethos*. Albany: State University of New York Press, 2006.

McRuer, Robert. "Compulsory Able-Bodiedness." In *50 Concepts for a Critical Phenomenology*, edited by Gail Weiss, Ann V. Murphy, and Gayle Salamon, 61–67. Evanston, IL: Northwestern University Press, 2019.

Merleau-Ponty, Maurice. "Cézanne's Doubt." In *Sense and Non-Sense*, translated by Hubert L. Dreyfus and Patricia Allen Dreyfus, 9–35. Evanston, IL: Northwestern University Press, 1964.

———. "Einstein and the Crisis of Reason." In *Signs*, translated by Richard C. McCleary, 192–197. Evanston, IL: Northwestern University Press, 1964.

———. "Eye and Mind." Translated by Carleton Dallery. In *The Primacy of Perception and Other Essays on Phenomenological Psychology, the Philosophy of Art, History and Politics*, edited by James M. Edie, 159–190. Evanston, IL: Northwestern University Press, 1964.

———. *Humanism and Terror*. Translated by John O'Neill. Boston: Beacon, 1969.

———. *Husserl at the Limits of Phenomenology*. Edited by Leonard Lawlor with Bettino Bergo. Evanston, IL: Northwestern University Press, 2002.

———. "Indirect Language and the Voices of Silence." In *Signs*, translated by Richard C. McCleary, 39–83. Evanston, IL: Northwestern University Press, 1964.

———. *Institution and Passivity: Course Notes from the Collège de France (1954–1955)*. Translated by Leonard Lawlor and Heath Massey. Evanston, IL: Northwestern University Press, 2010.

———. *La institution, la passivité: Notes de cours au Collège de France (1954–1955)*. Paris: Belin, 2003.

———. *Le monde sensible et le monde de l'expression: Cours au Collège de France Notes, 1953*. Edited by Emmanuel de Saint Aubert and Stefan Kristensen. Geneva: MētisPresses, 2011.

———. *Nature: Course Notes from the Collège de France*. Translated by Robert Vallier. Evanston, IL: Northwestern University Press, 2003.

———. *La nature: Notes cours du Collège de France*. Edited by Dominque Séglard. Paris: Seuil, 1995.

———. "New Working Notes from the Period of *The Visible and the Invisible*." In *The Merleau-Ponty Reader*, edited by Ted Toadvine and Leonard Lawlor, 415–446. Evanston, IL: Northwestern University Press, 2007.

———. *Notes des cours au Collège de France 1958–1959 et 1960–1961*. Edited by Stéphanie Ménasé. Paris: Gallimard, 1996.

———. *Notes de cours sur L'origine de la géométrie de Husserl*. Edited by Renaud Barbaras. Paris: Presses Universitaires de France, 1998.

———. *L'Œil et l'ésprit*. Paris: Gallimard, 1964.

———. *Phénoménologie de la perception*. Paris: Gallimard, 1945.

———. *Phenomenology of Perception*. Translated by Donald A. Landes. New York: Routledge, 2012.

———. "The Philosopher and His Shadow." In *Signs*, translated by Richard C. McCleary, 159–181. Evanston, IL: Northwestern University Press, 1964.

———. "The Primacy of Perception and Its Philosophical Consequences." In *The Merleau-Ponty Reader*, edited by Ted Toadvine and Leonard Lawlor, 89–118. Evanston, IL: Northwestern University Press, 2007.

———. *The Sensible World and the World of Expression: Course Notes from the Collège de France, 1953*. Translated by Bryan Smyth. Evanston, IL: Northwestern University Press, 2020.

———. *The Structure of Behavior*. Translated by Alden L. Fisher. Boston: Beacon, 1963.

———. "Two Unpublished Notes on Music." Translated by Leonard Lawlor. *Chiasmi International* 3 (2001): 18.

———. *The Visible and the Invisible*. Translated by Alphonso Lingis. Evanston, IL: Northwestern University Press, 1968.

———. *Le visible et l'invisible*. Paris: Gallimard, 1964.

——. *The World of Perception*. Translated by Oliver Davis. London/New York: Routledge, 2002.

Meyer, James. "The Bicycle." In *Anne Truitt: Perception and Reflection*, edited by Kristen Hileman, 48–63. Washington, DC: Hirshhorn Museum and Sculpture Garden, 2009.

Meyer, James, and Anne Truitt. "Grand Allusion." *Artforum International* 40, no. 9 (May 2002): 156–161.

Mildenberg, Ariane. *Modernism and Phenomenology: Literature, Philosophy, Art*. London: Palgrave Macmillan, 2017.

Mitchell, Andrew J. *Heidegger among the Sculptors: Body, Space and the Art of Dwelling*. Stanford, CA: Stanford University Press, 2010.

Murphy, Ann V. "Language in the Flesh: The Politics of Discourse in Merleau-Ponty, Levinas, and Irigaray." In *Feminist Interpretations of Maurice Merleau-Ponty*, edited by Dorothea E. Olkowski and Gail Weiss, 257–227. University Park: Pennsylvania State University Press, 2006.

Murray, James. "Liner Notes." *Thomas Tallis Spem in Alium: Lamentations of Jeremiah*. CD. Directed by Mark Brown. Pro Cantione Antiques, 2010.

Nancy, Jean-Luc. *Á l'écoute*. Paris: Galilée, 2002.

——. *Listening*. Translated by Charlotte Mandell. New York: Fordham University Press, 2002.

——. *The Muses*. Translated by Peggy Kamuf. Stanford, CA: Stanford University Press, 1996.

——. *Les Muses*. Paris: Galilée, 1994.

Nancy, Jean-Luc, and Federico Ferrari. "Bathsheba." In *Being Nude: The Skin of the Images*. Translated by Anne O'Byrne and Carlie Anglemire, 10–14. New York: Fordham University Press, 2014.

Neitz, Jay, and Maureen Neitz, "Colour Vision: The Wonder of Hue." *Current Biology* 18, no. 16 (August 26, 2008): R700–R702.

Ngo, Helen. "Racist Habits: A Phenomenological Analysis of Racism and the Habitual Body." *Philosophy and Social Criticism* 42, no. 9 (2016): 847–872.

Novak, David. "Noise." In *Keywords in Sound*, edited by David Novak and Matt Sakakeeny, 125–138. Durham, NC: Duke University Press, 2015.

Olkowski, Dorothea E. "The End of Phenomenology: Bergson's Interval in Irigaray." *Hypatia* 15, no. 3 (2000): 73–91.

——. *Gilles Deleuze and the Ruin of Representation*. Berkeley: University of California Press, 1999.

——. *Postmodern Philosophy and the Scientific Turn*. Bloomington: Indiana University Press, 2012.

——. *The Universal (In the Realm of the Sensible)*. New York: Columbia University Press, 2007.

Ortega, Mariana. "Hometactics." In *50 Concepts for a Critical Phenomenology*, edited by Gail Weiss, Ann V. Murphy, and Gayle Salamon, 169–173. Evanston, IL: Northwestern University Press, 2019.

——. *In-Between: Latina Feminist Phenomenology, Multiplicity, and the Self*. Albany: State University of New York Press, 2016.

Panofsky, Erwin. *Perspective as Symbolic Form*. Translated by Christopher S. Wood. New York: Zone Books, 1991.

Pape, Gerald. "Luigi Nono and His Fellow Travellers." *Contemporary Music Review* 18, no. 1 (1999): 57–65.

Patterson, Orlando. *Slavery and Social Death: A Comparative Study*. Cambridge, MA: Harvard University Press, 1982.

Peltier, Elian, and Aurelien Breeden, "A Sports Hijab Has France Debating the Muslim Veil, Again." *New York Times*, February 28, 2019. https://www.nytimes.com/2016/08/19/world/europe/frances-burkini-bans-are-about-more-than-religion-or-clothing.html.

Pett, Shaun. "Apocalypsis: Welcome to the Epic End of World Show at Luminato." *Guardian*, June 26, 2015. https://www.theguardian.com/music/2015/jun/26/apocalypsis-epic-show-lemi-ponifasio-luminato-festival.

Philip, M. NourbeSe. "The Absence of Writing or How I Almost Became a Spy." In *A Genealogy of Resistance*. Toronto: Mercury, 1997.

———. "Zong!DurationalReading2015X." Posted December 7, 2015. YouTube video, 3:51. https://www.youtube.com/watch?v=xU74xqLn4vw.

Philip, M. NourbeSe, and Setaey Adamu Boateng. *Zong!*. Middletown, CT: Wesleyan University Press, 2008.

Pinker, Steven. "How the Mind Works." *Annals New York Academy of Sciences* 882, no. 1 (1999): 119–127.

Plot, Martín. *The Aesthetico-Political: The Question of Democracy in Merleau-Ponty, Arendt and Rancière*. London: Bloomsbury Academic, 2014.

Rannard, Georgina. "Leopold II: Belgium 'Wakes Up' to Its Bloody Colonial Past." *BBC News*, June 13, 2020. https://www.bbc.com/news/world-europe-53017188.

Roberts, Dorothy. *Fatal Invention: How Science, Politics, and Big Business Re-Create Race in the Twenty-First Century*. New York: New Press, 2011.

Roelofs, Monique. *The Cultural Promise of the Aesthetic*. London: Bloomsbury, 2014.

Ruby, Tabassum F. "Listening to the Voices of Hijab." *Women's Studies International Forum* 29 (2006): 54–66.

Saini, Angela. *Superior: The Return of Race Science*. Boston: Beacon, 2019.

Saint Aubert, Emmanuel de. *Être et chair*. Paris: Vrin, 2013.

Sallis, John. *Senses of Landscape*. Bloomington: Indiana University Press, 2015.

Sands, Philippe. *East West Street*. London: Weidenfeld & Nicolson, 2016.

Saunders, Patricia. "Defending the Dead, Confronting the Archive: A Conversation with M. NourbeSe Philip." *Small Axe* 26 (June 2008): 63–79.

Schafer, R. Murray. *The Soundscape: Our Sonic Environment and the Tuning of the World*. Rochester, VT: Destiny Books, 1977.

Scott, David. "The Re-Enchantment of Humanism: An Interview with Sylvia Wynter." *Small Axe* 8 (September 2000): 119–207.

Sedira, Zineb. "Silent Sight." 2000. Posted February 20, 2011. YouTube video, 11:11. https://www.youtube.com/watch?v=9G2FP9rWE5Q.

Sjöholm, Cecilia. *Doing Aesthetics with Arendt: How to See Things*. New York: Columbia University Press, 2015.

Sluijter, Eric Jan. *Rembrandt and the Female Nude*. Amsterdam: Amsterdam University Press, 2006.

Snell, Bruno. *The Discovery of the Mind: In Greek Philosophy and Literature*. Oxford: Blackwell, 1953.

Snorten, C. Riley. *Black on Both Sides: A Racial History of Trans Identity*. Minneapolis: University of Minnesota Press, 2017.

Spillers, Hortense J. "Mama's Baby, Papa's Maybe: An American Grammar Book." *Diacritics* 17, no. 2 (Summer 1987): 64–81.

Spivak, Gayatri Chakravorty. "Echo." *New Literary History* 24, no. 1 (1993): 17–43.

Stoller, Silvia. *Phänomenologie der Geschlechtlichkeit*. Nijmegen, Netherlands: Radboud Universiteit Nijmegen, 2006.

Tanaka, Michele, Lorna Williams, Yvonne J. Benoit, Robyn K. Duggan, Laura Moir, and Jillian C. Scarrow. "Transforming Pedagogies: Pre-Service Reflections on Learning and Teaching in an Indigenous World." *Teacher Development* 11, no. 1 (2007): 99–109. DOI: 10.1080/13664530701194728.

Taub, Amanda. "France's Burkini Bans Are About More than Religion or Clothing." *New York Times*, August 18, 2016. https://www.nytimes.com/2016/08/19/world/europe /frances-burkini-bans-are-about-more-than-religion-or-clothing.html.

Tichkosky, Tanya. *Disability, Self, and Society*. Toronto: University of Toronto Press, 2003.

Thompson, Evan. *Colour Vision: A Study in Cognitive Science and Philosophy of Science*. New York: Routledge, 1994.

Truitt, Anne. *Daybook: The Journal of an Artist*. New York: Penguin Books, 1982.

———. *Turn: The Journal of an Artist*. New York: Viking Penguin, 1986.

Varela, Francisco J., Evan Thompson, and Eleanor Rosch. *The Embodied Mind: Cognitive Science and Human Experience*. Cambridge, MA: MIT Press, 1991.

Vasseleu, Cathryn. *Textures of Light: Vision and Touch in Irigaray, Levinas and Merleau-Ponty*. London: Routledge, 1998.

Voegelin, Salomé. *Listening to Noise and Silence: Towards a Philosophy of Sound Art*. New York: Continuum, 2010.

———. *Sonic Possible Worlds: Hearing the Continuum of Sound*. New York: Bloomsbury, 2014.

Wallach, Amei. "To an Artist, a Tender Image; to Others, a Grim Reminder." *New York Times*, August 25, 1997. https://www.nytimes.com/1997/08/25/arts/to-an-artist-a -tender-image-to-others-a-grim-reminder.html.

Weheliye, Alexander G. *Habeas Viscus: Racializing Assemblages, Biopolitics, and Black Feminist Theories of the Human*. Durham, NC: Duke University Press, 2014.

Weiss, Gail. *Refiguring the Ordinary*. Bloomington: Indiana University Press, 2008.

Wetering, Ernst van de. "Rembrandt's *Bathsheba*: The Object and Its Transformations." In *Rembrandt's 'Bathsheba Reading King David's Letter,'* edited by Ann Jensen Adams, 27–47. Cambridge: Cambridge University Press, 1998.

Whyte, Kyle P. "What Do Indigenous Knowledges Do for Indigenous Peoples?" In *Traditional Ecological Knowledge: Learning from Indigenous Practices for Environmental Sustainability*, edited by M. K. Nelson and D. Shilling, 57–82. Cambridge: Cambridge University Press, 2018.

Wiskus, Jessica. *The Rhythm of Thought*. Chicago: University of Chicago Press, 2013.

Wu, Charles Q. "A Neurologically-Based Two Stage Model for Human Color Vision." In *Human Vision and Electronic Imaging XVII*, edited by Bernice E. Rogowitz. Thrasyvoulos N. Pappas, SPIE Conference Proceedings, vol. 8291, 2012. DOI.10.1117/12.909692.

Yancy, George. "The Elevator Effect." In *Black Bodies, White Gazes: The Continuing Significance of Race*, 1–31. Lanham: Rowman & Littlefield, 2008.

Ziarek, Ewa Plonowska. "'Women on the Market': On Sex, Race and Commodification." In *Rewriting Difference: Luce Irigaray and "the Greeks,"* edited by Elena Tzelepis and Athena Athanasiou, 203–215. Albany: State University of New York Press, 2010.

Ziarek, Krzysztof. *Language after Heidegger*. Bloomington: Indiana University Press, 2013.

INDEX

abstract expressionism, 17, 81n7; colors as conceptless, 69–70; encounter with cognitive-linguistic region of existence, 62, 68–69, 71; logic level in, 65. *See also* Mitchell, Joan

abstraction: of legal system, 198; from perception, 8, 35–36

actualization, 16, 161, 165, 171

aesthetic objects, artworks as, 28, 39, 51, 124, 133, 135, 164–166

aesthetics: Enlightenment rationality supported by, 33–34; human, 202; political dimensions of, 18, 23n65; as social technology, 34

affect, 7, 13, 99, 118n72; and abstract expressionism, 62; affective region of existence, 48, 50; and color, 74, 106–107; embodied, 28–29; and music, 154–159, 165–166, 171; sentiments of the things themselves, 62–63; and touch, 128, 148n83

African Americans, 102–103, 105, 118nn80, 85, 209n152

Africans, enslaved: closure of subjectivity to, 19, 103; denial of being to, 19, 183–184, 191–198, 201–204; as figures in artwork, 33, 55n39; triple loss, 200. See also *Zong!*

Agamben, Giorgio, 119n87, 163–166

agency, 18–19, 22n46, 85n96, 119n105, 176n74, 203; and racist idealities, 107, 109–110; and singular subject, 185; under total terror, 98

Algerian war, 125

"Algeria Unveiled" (Fanon), 143

Alpers, Svetlana, 46

Al-Saji, Alia, 57n66, 105, 110, 120n142, 143

alterity, 184–185; acknowledging of, 17, 71, 80, 148n83; appropriation of, 53, 71–72, 75, 80, 137; in *Bathsheba*, 31–32; foreclosure of

encounters with, 132, 144, 185; fourfold of, 132–134, 136, 139, 188; openness to, 70–71, 187; and proximity, 137–138; relations with, 49, 52, 62, 75; responding to without appropriation, 17, 62, 70–72, 77–78

analytic attitude (intellectualism), 9, 64, 128–129

Anderson, Keith, 174n25

anonymity, 68, 76, 129, 140–141, 147n33

appearance, 7–8, 111; and alterity, 132; bringing into, 14–19, 31–35, 41–44, 70–71, 75, 80, 105; coming into, 35, 41; *Ereignis*, 134, 189–190, 206n66; law and, 126; painting reveals, 34–35; as between people, 144; presencing into, 21n39, 190; public space of, 18, 91–93, 99–100; self-presentation vs. self-display, 127

appropriation: of alterity, 53, 71–72, 75, 80, 137; limits of, 47–48; and mirror, 76–77, 134; by philosopher/painter, 17, 73–76; responding to alterity without, 17, 62, 70–72, 77–78; visual, 71, 75

Archimedean standpoint, 22n47, 91–92, 98, 187, 203–204

architectonics, 164

Ardizzoni, Michela, 125

Arendt, Hannah, 11–12, 18, 95–96, 117nn50, 55; appearance as between people, 144; on astrophysical world view, 90–91; on *Bathsheba*, 55n20; on "living space of freedom," 96; polis, view of, 125–126; racism not addressed by, 102, 117n56, 118n82; shared world, view of, 127; *Works: The Human Condition,* 91, 183; *The Origins of Totalitarianism,* 94, 102

Aristotle, 29, 83–84n61

Art Gallery of Ontario (AGO), 154

art history, 5, 15, 69; approaches to *Bathsheba,* 43–48

artists: bodies of, 44, 136; philosopher/paint-er, 17, 73–76; real, interrogation of, 24–35, 41; shared touch with, 129–130; and synes-thesia, 39, 81n8, 129–130, 134, 154; in touch with temporality, 164; views of own work, 52. *See also specific artists and artworks*

artworks: as aesthetic objects, 28, 39, 51, 124, 133, 135, 164–166; bending into, 49–53, 64–65, 70–71, 80, 112–113; cognition and making of, 92; cultivating perception through, 4–6, 14–15, 20n5, 28, 42, 49, 204; embodied logos of, 39; existence of, 48; fields of perception established by, 41; as generative, 51, 71; hermetic space of the canvas, 32, 34; as independent of human conception, 53–54; lighting in, 32, 38–40, 44–45, 64–67, 90, 100, 128; line, use of, 52, 69; logic of, 64–65; materiality of, 14–15, 46, 51–52, 69, 72, 89–90, 99, 101, 116nn8, 14, 196; painting the real, 71–80; points of view multiplied in, 40, 99–100; position of viewer, 32, 40, 61–65; and proximity, 131–133; reality grounded by, 99; rhythm in visual, 61–64, 74, 124; servants, role of in, 32–33; setting to work of, 4, 15, 29, 39, 47, 51, 68, 71, 128, 131–133, 153–155, 158, 161, 162, 165–166, 171, 186, 203–204; thinking alongside, 3–4, 9, 14–15, 49, 51; as transmission of truth, 79. *See also* auditory perception; poetry; *specific artworks*

astrophysical world view, 90–93

attentiveness, 3–4, 8, 53, 79, 144, 166–167, 171–172

attunement, 32, 42, 52, 107; to being in mod-ern age, 154–155, 166; and difference, 161, 165–166, 171–172; and efficiency, 170–171; to the epochal, 18, 163, 170–173; and language, 184; as listening, 163, 166; to relationships, 127, 154–155; to sounds, 18, 155–156, 160, 163

auditory perception, 18, 174n23; and acous-matic sound, 156; everyday noises, 154, 160–162; of fetus, 140; and intersubjectiv-ity, 156, 159; sonic epoch, 161–167, 170–173; sonic space, 155–161; time-space, polyphon-ic, 18–19, 154–157, 164–165; of voice, 157. See also *Forty-Part Motet* (Cardiff); music

autopoiesis, 201–202

awareness, 21n38, 48–49, 52, 79, 94; and othering, 107, 150n121

axioms, 92, 95–96

Bal, Mieke, 45–46

bare life, 103, 119n87

Bathsheba at Her Bath (Rembrandt), 17, 26, 27–48, 52–54, 55n20; alterity in, 31–32; art historical approaches to, 43–48; biblical story behind, 27, 32–33, 45, 58n108; context of in Rembrandt's life, 46–47; cultivating of perception in, 34–43; ethics enacted by, 28, 45, 47–48; incompossibles in, 39–40, 44–46; interiority of, 31, 33, 47; light and shadow in, 32, 44–45; luminescence of Bathsheba's body, 27, 32; multiple points of view in, 40, 44; as nude woman thinking, 31–32, 37, 40, 47, 49; presence in, 29, 31, 40, 42–43, 46, 49–51; proportions in, 44; as representative of modern age, 30–31; semiotics in, 45–46; servant depicted in, 31–33, 39–41, 44, 46; silence in, 27, 31, 35, 39, 51; viewer's body implicated in, 37, 40; X-ray of, 46, 58n117

becoming, 78, 140, 202, 209n164

being: attunement to in modern age, 154–155, 166; vs. be-ing, 183–184; being itself (*Sein*), 70; Being of, 100; circuit of, 41, 70; closed system of, 19, 183–184; coming into, 92, 189; contact with, 48, 50–51; creation required for, 167; denied to enslaved Africans, 19, 183–184, 191–198, 201–204; embodied, 6, 9, 12, 17, 53, 62, 72–73, 83–84n61, 184; epochal, 163, 190; *es gibt* (there is), 164, 176n74, 185; as essencing, 11–12, 39, 52–53, 188–189; ground of, 41–42; historical, 164, 209n161; horizontal dimension of, 137–139; of modern age, 14, 19, 50, 135, 166; and not being, 194–195; not dependent on human subject, 53–54; philosophy as foundation of, 15–16; relational, 4, 7, 53, 57n83, 140–141; temporality of, 164; total part of, 48; as *Verhältnis*, 184; vertical, 90, 114, 137, 139; ways of (*Sosein*), 11–12, 14, 19, 39, 49–53, 70, 101, 104, 118n75, 144, 164, 172, 185–192; wild (*l'être sauvage*), 53; world brought into through expression, 35. *See also* existence; subject

belonging, 76, 78, 97–98, 133–134, 188; ep-ochal, 163–165, 170–173

Berger, John, 54n14

binary logic, 28, 32–33, 50, 72–74; being and not being, 194–195; mind/body split, 7, 28–29, 50, 76, 200; Orientalist, 32, 125, 143–144; of pretechnological sound, 160–161; and slavery, 73, 199–200

blueprint, 38, 51–52

Boateng, Setaey Adamu, 181

body: anonymity of, 68, 76, 129, 140–141, 147n33; of artist, 44, 136; flesh distinguished from, 103–104; habits of, and racism, 108–110; hermeneutics of, 14, 48–54; immanence of, 31; as neither object nor subject, 9, 56n54, 101–102; as open system, 100, 107; phenomenal, 38–40, 42, 170–171, 197; racialized, 30, 109–110; sculptures as, 89–90, 135–136; signification accomplished by, 108–109; techniques of, 77. *See also* flesh
Boer War, 95
Bolsheviks, 95, 117n50
Bourgeois, Louise: *The Welcoming Hands,* 18, 122, 123–144, 145, 150n109

calculation, 28–29, 144, 163–166, 189–190; cognition as, 3, 7, 56n54; efficiency, 3, 11, 42, 132, 154, 163, 170–171, 184, 193; and encounter with other, 138; perspectivalism, 42; representation vs., 184; scientific, 21n39, 93, 176n67, 186, 188. *See also* modern age ("this age")
Caravaggio, 70
Cardiff, Janet. See *Forty-Part Motet* (Cardiff)
categories, 28–30, 57n59, 68–69, 71, 75; art historian's, 69; forms as, 71, 75, 84n61; racial, 208–209n152; vision's mimicry of, 75
Cézanne, Paul, 35, 40, 52, 67, 71, 112–113, 155
Chanter, Tina, 84n61
chiasm (intertwining), 5–6, 13, 83n56, 207n113; in *Bathsheba,* 38–39, 48–50, 52–54; colors, exchange of, 63–65, 74; embodied perception and reflection, 6; in *Forty-Part Motet,* 156–158, 162; four regions of existence, 49; ideas and matter, 38; imaginary and real, 39; Irigaray's view of, 76–78; language and culture, 5; Merleau-Ponty's concept of, 48–50, 52–54, 72, 74–78; in Mitchell's work, 63–65, 68–69, 77–78, 80; Möbius strip figure, 78; multiple, 54; ontology of, 38, 48–50, 52–54; past and future, 162; of perception, movement, and affect, 7, 13, 48; relational, 54, 56n52, 137–138; and reversibility, 11, 43, 48, 74–78, 139, 157; of science and art, 36, 56n52; sculpture and touching, 128, 138–139; of self and world, 42, 77–78, 170; of senses, 8, 38; of structures, 52; thickets, 52, 68; in Truitt's sculptures, 106, 113; in *The Welcoming Hands,* 123–124, 132, 138, 139–140; without human awareness, 52; in *Zong!,* 196, 198. *See also* shared world

Cixous, Hélène, 31–32
class system, 34, 73, 79, 117n50
closed system, 10–11, 78; of aesthetic object, 28; autopoietic, 201; breaking open, 199–204; of language, 19, 183–184, 190–191, 195
co-belonging, 78
coconstitutive relations, 18, 39, 107, 162–163
code, 194
cognition: as calculation, 3, 7, 56n54; cognitive-linguistic region of existence, 29, 35, 48–50, 62, 68–69, 71, 80, 131; encounter with abstract expressionism, 62, 68–69, 71; reliance on embodied perception, 28–29; thinking differentiated from, 92. *See also* embodied perceptual cognition
Colebrook, Claire, 165
Collingwood, Luke (slave trader), 181–182
colonialism, 16, 27–28; biopolitical experimentation, 200; colonizing perception, 30, 46; cultural project of, 28, 33, 103–105, 110, 118n83, 125, 143; destruction of colonialism in *Zong!,* 19, 184, 192–193, 195, 198–199; knowledge systems oppressed by, 80; and Latin language, 154, 182–183; in Merleau-Ponty's thinking, 145–146n4; and music, 161; Orientalist narrative, 32, 125, 143–144; reason and binary relations, 199–200; shift in praxis needed, 141, 149–150n106. *See also* racialization; racism
color, 39, 61–71; bending into artworks, 64–65, 70–71; and chiasmic exchange, 63–64, 74; and cognitive-linguistic region of existence, 62, 68–69, 71; as conceptless, 69–70, 74; constancy of, 66–67, 82nn24, 27; dominant, 64–65; as flesh, 64, 107; and ideology, 106; interrelationship of senses, 67–68; and movement, 90, 128; new dimensions of, 111–115; perception of, 65–67, 76; and position of viewer, 32, 40, 61–65; sensitivity to, 67–68, 129; time required for reflection, 61–64, 167, 170. *See also* vision
Columbus, 203
commodification, of women's bodies, 83–84n61
common sense, 11, 91–100, 115
communication, 17, 67, 77, 189
concentration camps, 94–99, 102–103, 200
consciousness, 37, 49, 76, 101, 112, 147n28
contemplation, 29, 63, 130
contemporaneity, 168, 171
contingency, 9, 11, 18, 115
Coole, Diana, 22n46

coparticipation, 17, 29, 63, 77, 80, 127, 144, 154–155

corporeal (carnal) essences, 34, 38–41, 45, 53, 61, 64, 69–70, 83n50

corporeal logos, 79–80, 99, 129; and racism, 41, 100, 107–111

corporeal schema, 107–112; and color, 74; and idealities, 100; intersensory, 107–109; and racism, 41, 100, 107–111; shared, 129

creativity, 42–43, 114, 142, 167, 201–202

Crematori, Joseph, 159

cultivating perception, 4, 14–15, 17, 20n5, 79–80; coparticipation, 77; ethical, political, and cultural implications of, 203–204; and responsibility, 98; and visibility, 41–43

cultivation, as social concept, 34

culture: colonialist project of, 28, 33, 103–105, 110, 118n83, 125, 143; cultural complicity, 79, 144; enacting of, 16–19, 74, 173, 184; ethics at core of, 18–19; forgetting of maternal-feminine, 139–140; monosubjective, 137

Curtis, Kimberley, 99

Darwinism, 95, 96, 201

Dasein, 185

Davis, Angela, 183

deepening, 10, 74, 130, 150n109; of identity, 70–71; of perception, 37, 50, 162

Delaunay, Robert, 53

Descartes, René, 94, 147n28

description, 5–8, 14–16, 50–51; phenomeno-logical, 6, 15, 30, 38, 43, 73, 131, 186–187

De Souza, Jonathan, 173n5

difference, 18, 50, 77–80, 127–128, 140–143, 146n5; and attunement, 161, 165–166, 171–172; and proximity, 137–138; racial-ization of, 73, 201–202; sexuate, 72–73, 83–84n61, 165

differentiation, 12, 15, 50, 130, 140–141; and color, 74; and proximity, 137–138; and slavery, 103–104; and space-time, 12, 154, 156–157

dimensions, 6, 18, 42; n-dimensionality, 52; time as four-dimensional, 164

Dinesen, Isak, 183

disembodied standpoint, 11

distance, 53, 93; and idealities, 100; and natu-ral world, 93; and proximity, 137–138; and Renaissance perspectivalism, 17, 36–37, 40, 56n56, 155; required for viewing art, 32, 36, 43, 45, 51, 61–62, 72–73; and sculpture, 123–124, 136–138, 142

divergences (écarts), 38, 111–112, 131

divine, the, 132–134, 136–137, 139, 154, 159, 172, 175n37

doubting, process of, 94

Drost, Willem, 47

dwelling, 18, 132–137, 150n121; co-dwelling, 75–76; in different worlds, 137–144; *un-heimlich* (unhomely), 136, 148n74

eidos, 51, 72, 100, 189

Einstein, Albert, 11

Eisenberg, Andrew, 161

ek-stasis, 162, 164

embodied being, 6, 9, 12, 17, 53, 62; disen-gagement from, 183–184; female, 72–73, 83–84n61

embodied perception, 3; artist's account of the real, 34–35, 41; cognition's reliance on, 28–29; and cognitive-linguistic region of existence, 29, 35, 48–50, 62, 69, 71, 80, 131; memories, 9, 62, 101, 106–107, 141, 156, 171; as open system, 7, 9, 43. *See also* embodied perceptual cognition; perception

embodied perceptual cognition, 7, 16–17; calculation vs. representation, 184; in modern age, 166; movement of, 98, 115; new dimensions for, 111–114; openness of, 49–50; and phenomenological reduction, 49–50; political significance of, 99. *See also* cognition; embodied perception

embodied subject, 6, 11–13, 107–109, 112–113, 171–172, 190

empiricism, 5, 9, 44, 67, 202

enactivism, 82n24, 85n96

enframing (*Gestell*). See *Gestell* (enframing)

English music, sixteenth century, 161–162

Enlightenment rationality, 33–34

episteme, 104

epoch, sonic, 161–167, 170–173

epochal, the: attunement to, 18, 163, 170–173; being, 163, 190; and forgetting, 28; poetic, 164–165, 172–173

equivalences, 69–70, 109

Ereignis (event), 134, 189–190, 206n66

Erfahren (experience; going on a way), 185–186

essences, 17, 31; carnal/corporeal, 34, 38–41, 45, 53, 61, 64, 69–70, 83n50; of historical be-ing, 164; idealities vs., 100; and incompos-sibles, 40, 46; piling up of, 70

essencing, 11–12, 39, 188–189

ethics: enacted by *Bathsheba*, 28, 45, 47–48; enacted by color in Mitchell's paintings,

70–71; of viewing, 45; and visibility, 16. See also *Bathsheba at Her Bath* (Rembrandt)
ethos, 18–19
Evans, Fred, 18
exception, state of, 200
existence: adapting and translating process, 48–49; affect-desire, 7, 48; cognitive-linguistic region of, 29, 35, 48–50, 62, 69, 71, 80, 131; embodied, 6, 154, 200–201; intentional arc of, 7, 16, 48; movement of, 7, 13, 48, 92, 108; regions of, 48–51, 58n129, 69; resistance to suppression of, 19; as world of the living, 94. *See also* being
existential phenomenologies, 48–49, 140
experience: emancipated from reason, 96–97; *Erfahren*, 185–186; experiential world, 8, 14–15, 91, 94–95, 99, 112, 158; Heidegger's view of, 185–186; and language, 184–191, 205n24; lived, 8–9, 12, 35, 44, 93, 98; reflection on experience of perception, 6, 13, 16, 38. *See also* perception; space; temporality
eye, 36–37
"Eye and Mind" (Merleau-Ponty), 28, 57n73, 73–76

fabrication, 92, 187
face-to-face encounters, 163, 176n67, 188
faith, perceptual, 8, 11–12, 98, 100
Fanon, Frantz, 30, 109–110, 143
feedback loop, 78, 85n96, 201
feminist phenomenology, 9, 14, 16, 20n24
Ferrari, Federico, 30–31, 34
fetus, 139–140, 143
field: and color perception, 66, 106; of perception, 9–10, 41, 49; of racist vision, 143–144; relational, 100, 128; social, 23n65; spatial, 127–128; subjectivity as, 101; visual, 16, 64, 66–68, 72, 108, 111, 113, 125
figure-background structure, 10, 109, 159–160, 167
film, 8, 176n76. See also *Silent Sight* (Sedira)
first peoples (Anishinaabe) thought, 53, 56n52
First Requiem (Truitt), 88, 89, 99
flesh, 34–43, 69, 71–72; body distinguished from, 103–104; carnal/corporeal essences, 34, 39, 41, 45, 64, 83n50; color as, 64, 107; hieroglyphics of, 104; ontology of, 22n46, 34–40, 53–54, 72, 76–77, 79, 100–102, 105, 156–157; reversibility of, 11, 43, 48, 74–77, 139, 157; sculptures as, 89–90; of world, 38–39, 41, 104–105. *See also* body
Floyd, George, 118n85

forgetting, 28, 72–74, 79–80, 165, 183; of maternal-feminine, 79, 139–140, 165; of sexuate difference, 72–73, 83–84n61; of slavery, 73, 83–84n61, 140
form, ideal, 30–31, 54n14, 92–93
forms, imposition of, 4–5, 29, 71–80, 101, 189
Forty-Part Motet (Cardiff), 18–19, 152, 175n37; ambient sounds in, 154; copies of, 153–154, 176n82; polyphonic time-space in, 18, 154–157, 164–165; as repetitive loop, 154, 162; and sonic epoch, 161–167, 171–173; and sonic space, 155–161; technology of, 154–155, 158–162, 164–165, 172; voices recorded individually, 166
Fóti, Véronique, 82n47, 83n50
fourfold (earth, sky, mortals, and the divinities), 132–134, 136, 139, 188
France, 127, 139, 143, 159; French Revolution, 41, 146n6; imperial and postrevolutionary architecture, 127–128; laïcité and headscarf, 125–127, 142–143, 146n6, 7, 19; Paris, 123–125, 134–135
freedom: and alterity, 137; of movement, 18; and racism, 111; of thought, 96–97
free space-time, 75, 77, 96, 138, 189–190
fugue, 183
Furian, Peter Hermes, 10
future, 4–5, 12–13, 48, 70, 85n109, 199, 203; in *Bathsheba*, 32, 40, 45; and ideology, 95–97, 106; and listening to music, 156, 162–164, 168

Galileo, 92, 94
Gaut, Berys, 47
gaze, 5–6, 8, 10, 17; in *Bathsheba*, 27–28, 32, 36–37, 40, 44–48, 54n14; binocular vision, 36–37; and Cézanne's paintings, 67–68; and Mitchell's paintings, 61–65, 67; racialized, 142–143; shared, 76; spatial anchoring of, 160. *See also* vision
generativity, 51, 53, 66, 71, 80, 189; and artworks, 51, 71
genocide, 102, 118n80
German South West Africa, 102
Gestalt theory, 10
Gestell (enframing), 5, 11, 14, 136, 163, 165, 184, 185, 189–190, 203. *See also* imposition
Gikandi, Simon, 33–34, 55n39
Gines, Kathryn T., 102
giving, 78–80, 85n109; jug as thing, 133–134; and sonic epoch, 162, 164
glance, 3, 7, 62, 81n4
Glissant, 117n61, 204n10, 209n166

gravity, law of, 93
Greek philosophy, 18, 29, 51, 54n5, 165; forgetting of sexuate difference, 72–73, 83–84n61
Gregson v. Gilbert, 16, 23n61, 182–183, 193, 198, 204n5
ground: of being, 41–42; and disruption of racism, 105; figure-background structure, 10, 109, 159–160, 167
Guenther, Lisa, 20n24, 117n56, 183

Haas, Lawrence, 56n59
habitats, sonic aspect of, 174n14, 178n125
habits, 108–111
Hass, Marjorie, 83n57
haunting, 76, 79, 138, 185, 198
headscarf: and French secularism, 125–127, 142–144, 146nn6, 7, 19, 159; in *Silent Sight,* 2, 3–8, 13, 19
Heidegger, Martin, 11, 20n5, 59n140, 78; *ethos,* view of, 19; experience, view of, 185–186; on face-to-face encounter, 163, 176n67; jug as thing, 133–134; language, view of, 184, 185; metaphysics of presence, 55n45; on sculpture in modern age, 135–136; *techne,* concept of, 51; technology, view of, 21n39
Hess, Audrey, 69
heterosexual matrix, 34
holding, 64, 101, 110, 176n74; in *Forty-Part Motet,* 164; and language, 184–185, 189; in *The Welcoming Hands,* 124, 127–135
The Human Condition (Arendt), 91, 183
Hume, David, 33, 34
Husserl, Edmund, 59n140
hyper-reflection, 6, 49

ideal form, 29–31, 54n14, 92–93
idealities, 100–102, 105–109, 118n72
identity: abstract, 127; building of, 137–140, 150n122; deepening of, 70–71; embodied, 61; gender, 73; modern, 33; multiplicitous, 150nn121, 122; social, 13; and spatialization of history, 209n164
ideology, 18; as colonial "totalizing ground," 105; and color, 106; goal and law as process, 95–96; as imposed system, 101–107, 112, 114–115; invisibility of, 41, 100; and movement, 95–96, 101, 108–109, 111–114; racism as, 100–107; reasoning of, 95–96
imaginary, 39, 74, 119n91, 125
imagination, 94, 111, 114, 200
imaging techniques, 46, 56n54, 58n117, 82n27
imperialism, 94–95

imposition: of forms, 4–5, 29, 71–80, 101, 189; of ideology, 101–107, 112, 114–115; and language, 184–185, 187–191, 194; of logic, 197–198; of past structures, 4–5, 7, 185; of representation, 194. See also *Gestell* (enframing)
incompossibles, 39–40, 44–46, 64, 69, 99, 101, 128
Indigenous peoples, 56n52, 102, 104, 118n80, 150n106
industrial prison complex, 183
inexhaustibility, 35, 42, 52, 59n153
information, 21n31, 184, 189, 191
intelligence, 7, 48
intentionality, 108–109, 120n120, 149n83
interdependence, 29, 127, 139–141, 144
interiority, 13, 62, 77, 106, 113; of *Bathsheba,* 31, 33, 47; and first relation, 140–141
interrelatedness, 11, 28, 39, 203–204; chiasmic, 38; and nature, 62; and use of light and shadow, 44–45
interrogation, 14, 35, 41, 82n47, 114, 143–144, 170; capacity to question, 136; visual, 63, 75
inter-sensory correspondences, 67
intersubjectivity, 16, 147–148n83, 156, 159
intertwining. See chiasm (intertwining)
invisibility, 6, 17, 79–80; and hypervisibility, 13, 144; of ideology and racism, 41, 100; of other metabolisms, 62, 71, 77, 80; self-holding, 52. See also visibility
Irigaray, Luce, 4–5, 14, 20n5, 71–80, 185; dwelling, view of, 137–138; maternal-feminine, view of, 72, 79, 139, 142–143; *Works:* "Women on the Market," 83–84n61

Jardin de Tuileries, 123–125, 128–129
Jay, Martin, 29
Jenkinson, John, 56n54
Johnson, Galen, 57n73
Jourdain, Robert, 158
jug as thing, 133–134

Kane, Brian, 156
Kant, Immanuel, 33
Kapchan, Deborah, 159
Kimmerer, Robin Wall, 85n109
Klee, Paul, 52, 78
knowledge, 29–30, 34, 37, 80, 109
Krause, Bernie, 174n14, 178n125

laïcité, 125–127, 142–143, 146nn6, 7, 19
language, 169–170; and attunement, 184; closed system of, 19, 183–184, 190–191, 195;

and denial of being to enslaved Africans, 19, 183–184, 191–198, 201–204; engagement with reality through, 186–187; experiencing with, 184–191, 205n24; Heideggerian as monologue, 190; and holding, 184–185, 189; and imposition, 184–185, 187–191, 194; and information, 184, 189, 191; Latin, 154, 173n7, 174n25, 182–183, 196, 198; as not representational, 94, 184, 190, 194, 198, 206n64; reading as complicity, 197–198; referential, 184–185, 189; region (*Gegend*) of, 186–187, 205n40; saying, 183, 185–188; as thinking, 186, 187, 192; and the unspoken, 188, 191; verbal constrictions of, 78; word as relation, 185–186

Latin, 154, 173n7, 174n25, 182–183, 196, 198

law, 19, 95, 124–125, 198

Lawson, Erica S., 119n105

Leopold II, 149n97

Lévi-Strauss, Claude, 53

light: light field artworks, 21n32; metaphor of, 73–74; movement of, 90; and space, 51–53

lighting, in artworks, 32, 38–40, 44–45, 64–67, 90, 100, 128

listening, 8, 137, 147n43, 156, 159, 161–163, 167–171; epochal, 166, 168; to language, 188; and philosopher, 167–170; to silence, 191

logic: of artworks, 64–65; imposition of, 197–198; irrational, 183; racist, 46, 183–184, 193–194, 198; and totalitarianism, 95–98; of world, 66–67. *See also* binary logic

logos, 4, 6, 39; cognitive, 29; corporeal, 41, 79–80, 99–100, 107–111, 129; of lines, 69

Louvre Museum, 27, 42, 124. See also *Bathsheba at Her Bath* (Rembrandt)

Maclaren, Kym, 148–149n83

making sense, 4–8, 10–18, 35; coconstitution of, 17–18; European logic of efficiency and murder, 183–184, 193–194, 197–198; and language, 183, 193–196; and modern age, 188–189; in new ways, 5, 16, 51, 68, 107–108, 111, 136, 184, 186, 199; political as, 115; Rembrandt's cultivation of perception, 28; as temporal, 98–99; vision privileged, 73. *See also* perception

Mallin, Samuel, 14–15, 20n8, 38, 48, 52

Malraux, André, 169

"Mama's Baby, Papa's Maybe: An American Grammar Book" (Spillers), 103–105

"Man," concept of, 41, 105, 165

"Man and Adversity" (Merleau-Ponty), 38

Manning, Dolleen Tisawii'ashii, 52, 56n52

Marx, Karl, 83–84n61, 95

materiality: of artworks, 14–15, 46, 51–52, 69, 72, 89–90, 99, 101, 116nn8, 14, 196; *hylë* or matter, 165; of reality, 5, 18, 99; of sculpture, 89–90; sensemaking in gap between artwork and senses, 14; of world, 7–9, 16, 18, 35, 38, 69

material presence, 8, 14–15, 37

maternal-feminine, 72, 79, 139, 142–143

mathematics, 92–93

Mbembe, Achille, 199–200

McKittrick, Katherine, 201–202

"measuring instruments," 92

memories, embodied, 9, 62, 101, 106–107, 141, 156, 171

Merleau-Ponty, Maurice, 6–9; "activist technocratic" pretensions, critique of, 76; analytical perception, view of, 9, 64, 128–129; "chiasm," concept of, 48–50, 52–54, 72, 74–78; colonialist stance, 145–146n4; color, view of, 64–69, 74, 106; consciousness, view of, 37, 76, 147n28; differentiation, view of, 10, 12, 50, 156–157; divergences (*écarts*), concept of, 38, 111–112, 131; on equivalences, 69–70, 109; first peoples as influence on, 53; "flesh," ontology of, 22n46, 34–42, 53–54, 72, 76–77, 79, 100–102, 105, 156–157; hyper-reflection, concept of, 49; idealities, concept of, 100–101; on intersensory world, 107–108; Irigaray's view of, 71–80; on liberty, 18; mirror as technique of the body, 76–77, 168; on music, 159, 161, 162, 166, 169–171, 175n40; painter, privileging of, 35–36, 43–44; on perception as anonymous, 68, 76; perceptual faith, concept of, 8, 11–12, 98, 100; philosopher/painter, view of, 17, 73–76; on philosophy as founding of being, 15–16; praxis, view of, 113; regions of existence, concept of, 48–50; science, critique of, 8, 66–67, 73; sedimentation, concept of, 106–110; on self-perceiving, 74–75, 101, 124, 130–131, 145–146n4, 147n41, 156–157; singing the world, 206n51; situatedness, view of, 34–39, 41, 155–156, 160; vision, view of, 34–37, 64, 71–73, 177n94; on voice, 157, 168; on Western humanism, 118n83; *Works*: Collège de France lecture, 74–75; "Eye and Mind," 28, 52, 57n73, 73–76; late lectures on Husserl, 169; "Man and Adversity," 38; *Phenomenology*, 28, 156; *The Visible and the Invisible*, 76. *See also* flesh; openness

metabolisms, invisible, 62, 71, 77, 80

metaphysics, 52–53, 57n73, 79, 84n61, 142, 203, 209n164; grand narratives of, 34; limits of taught through artworks, 41; narcissism of, 71–72; of presence, 55n45, 104–105

metastructuring, 49

Miller, George Bures, 173n6

mimesis, 71, 82n47, 130, 135, 138, 167–169

mind, 6–7, 21nn31, 38, 56nn54, 55; and ontology of the flesh, 34, 39, 42; structure of, 92–93

mind/body split, 7, 28–29, 50, 76, 200

minimalist art, 18, 91, 116n14. See also Truitt, Anne

mirror, 76–77, 134, 168

Mitchell, Andrew, 135

Mitchell, Joan, 17, 60–71, 77–80; color ethics of, 61–71; on language, 78–79; other metabolisms in work of, 62, 71, 77, 80; painting of sentiments of the things themselves, 62–63; reception history of, 81n7; synesthesia of, 39, 81n8; *Works: Sunflower III*, 70–71, 83n50; *Un jardin pour Audrey*, 60, 63–69; *Wet Orange*, 61–62

Möbius strip, 78

modern age ("this age"), 27–28; astrophysical world view, 90–93; attunement to being in, 154–155, 166; *Bathsheba* as representative of, 30–31; being of, 14, 19, 50, 135, 166; and *Gestell* (enframing), 5, 11, 14, 136, 163, 165, 184, 185, 189–190, 203; humans shaped by subjective representations, 132; influence of on philosophers, 79; interiority of, 33; and making sense, 188–189; necropolitics, 199–200; out of tune with embodied existence, 154–155; placelessness of, 132; projection of cognitive representations or ideas, 51; regulatory systems of, 3; representation privileged over relation, 135; visuality as predominant, 131–132, 162. *See also* calculation

monstration, 167–171

Moore, Henry, 154, 167, 172, 193

Morning Choice (Truitt), 89

motor region of existence, 7, 48, 50, 108

movement, 176n67, 206n59; of chiasm, 78; and color, 69–70, 90, 128; of embodied perceptual cognition, 98, 115; of existence, 7, 13, 48, 92, 108; and freedom, 18, 96; and ideology, 95–96, 101, 108–109, 111–114; as intersensory, 107–109; of life, 170–171; of looking, 63–65, 90, 99, 112, 128, 130; and

music, 154, 157–158, 160, 162; perpetual, 138, 191; and racism, 109–110, 161; of showing, 187, 189–191; and stability, 112–113; and touch, 130–131

Mshkode-bzhikiikwe baa, Rose Manning, 53

multiplicitous self, 13, 150nn121, 122, 195–196, 203

music: and affect, 154–159, 165–166, 171; and colonialism, 161; counterpoint, 158; depth in, 158, 162; homophony, 157–158; keynotes/soundmark, 160; polyphony, 157–158; sacred, in secular spaces, 159; and spatial levels, 156–157, 160–161; visual terms for, 159–160. *See also* auditory perception; *Forty-Part Motet* (Cardiff); space-time; *Spem in Alium* (Tallis)

Muslim women, 125–127, 142–144, 146n6, 159

"mute Being," 73

naming, 29–30, 138, 189, 191

Nancy, Jean-Luc, 30–31, 34, 167–168

Narcissus and Echo story (Ovid), 168–169, 177n104

nature: alterity of, 62; cyclical processes of, 92; as physis, 51, 66, 71, 80, 189; racism focused on, 96

Nazi death camps, 94–95, 102

nearness/proximity, 107, 128, 140, 163–164; of artworks, 131–133; and difference/distance, 136–138; of dwelling, 142, 203; face-to-face encounters, 163, 176n67, 188; realm (*Bereich*), 186

Necker cube, 10

necropolitics, 199–200

Netherlands, 27–28, 33

Newton, Isaac, 65, 93

Ngo, Helen, 110

nowhere, 132; Archimedean standpoint from, 22n47, 91–92, 98, 187, 203–204; Middle Passage as, 34, 103–104; points of view from, 11, 22n47, 34, 37, 62, 128, 142, 203–204

nude, as ideal human subject, 17, 30–31, 54n14

object, 9–10, 56n54, 63–64, 116n32, 148n51; aesthetic, 28, 39–40, 47, 164, 166; body as neither object nor subject, 101, 136; and doubt, 94; and musical structure, 162–166, 174n23, 176n83; subject-object relation, 93, 185; and touch, 128, 133; viewing of, 36–37, 63, 66, 68, 72; writing sets up, 50

objectivity, 37, 142

Olkowski, Dorothea E., 22n47

ontology: chiasmic, 38, 48–50, 52–54; of the
flesh, 11–12, 22n46, 34–42, 53–54, 72, 76–77,
79, 100–102, 105, 156–157
opacity, 98, 110, 117n61, 203
openness, 6, 185; to alterity, 70–71, 187; of
body, 100, 107; embodied perception as,
7, 9, 43; of embodied perceptual cogni-
tion, 28, 49–50; primordial, 7, 128; to racist
ideologies, 100–102; regional styles, 53; to
the world, 4–6, 53, 101–102
"Optics" (Descartes), 57n73
Orientalist narrative, 32, 125, 143–144
The Origins of Totalitarianism (Arendt), 94,
102
Ortega, Mariana, 13, 150nn121, 122, 195
overlapping of senses and viewpoints, 6,
12–13, 39–44, 72, 81n8, 199; in music, 157,
161; and sculpture in public space, 17–18, 132
Ovid, 168–169, 177n104

Panofsky, Erwin, 36, 56–57n58
participation, 17–18, 48, 109, 125–127, 147n33,
203, 204n2; coparticipation, 17, 29, 63, 77,
80, 127, 144, 154–155; and *Forty-Part Motet*,
154–156, 161, 165–170; and listening, 167–168
past: in classical physics, 22n47; and listening
to music, 156; meaning ascribed to, 13;
structures, imposition of, 4–5, 7, 185
patriarchal order, 41, 72, 103–105
perceiver, 14, 36, 38, 44, 65
perception: abstraction from, 8, 35–36;
according to light, 74; a-human, 52, 202;
ambiguous, 7–8, 112, 160; analytical, 9, 64,
128–129; colonizing, 30; of color, 65–67,
76; as creative, 42–43; cultivating through
artworks, 4–6, 14–15, 20n5, 28, 42, 49, 204;
deepening of, 37, 50, 162; as expressive,
42, 167; knowing, 130; phenomenal, 35, 37,
39–40, 42–43, 45, 49, 68, 77, 105, 170; as
prepersonal, 68, 129; primordial, 67–68, 73;
as qualitative, 10; reflection on experience
of, 6, 13, 16, 38; responsibility for, 13, 15, 80;
situatedness of, 6, 34–35, 100. *See also* audi-
tory perception; embodied perception;
embodied perceptual cognition; experi-
ence; making sense
perceptual faith, 8, 11–12, 98, 100
perceptual structures, 5–6, 8, 49, 67–69, 106
perspectivalism, Renaissance, 17, 36–37, 40,
56n56, 155
phenomenal perception, 35, 37, 39–40, 42–43,
45, 49, 68, 77, 105, 170

phenomenological description, 6, 15, 30, 38,
43, 73, 131, 186–187
phenomenological methodologies, 8–9, 73,
131, 185
Phenomenology (Merleau-Ponty), 28, 156
Philip, M. NourbeSe: *Zong!*, 16, 23n61, *180*,
181–184, 191–203, 208n123
philosopher, and listening, 167–169
physics, 21n39, 22n47, 93
Physics (Aristotle), 29
physis (nature as generativity), 51, 53, 66, 71,
80, 189
Pinker, Steven, 21n31
Pith (Truitt), 89
placing (*Stellen*), 184
Plato, 29, 72, 74
Plot, Martín, 23n65
poetry, 184–189; as thinking, 186–187;
transformational work of, 186–187. *See also*
Zong! (Philip)
points of view, 11–14, 28, 40–44, 47–48, 92,
109; Archimedean standpoint, 22n47,
91–92, 98, 187, 203–204; of captive bodies,
103; ideal, 65; multiple, 11–12, 18, 34–35, 40,
99–100; from nowhere, 11, 22n47, 34, 37, 62,
128, 142, 203–204; overlapping of senses
and viewpoints, 6, 12–13, 17–18, 39; polit-
ical denial of, 18, 94–99; shifting through
reflection, 37–38; simultaneous, 11–13;
situated, 11, 99, 155
polis, 125–126
politics, 16; aesthetic dimensions, 18, 23n65;
and coconstitution of meaning making,
17–18; denial of multiple points of view, 18,
94–99; and making sense, 115; as relational,
103. *See also* ideology
possibility, 13, 98, 114–115
postmodern philosophy, 11, 185
potentiality, 12, 72, 99, 126, 165
praxis, 112, 141, 149–150n106, 164
prereflective world, 35, 48, 79, 110, 113
presence: of absence, 43, 185, 191, 194, 196; in
Bathsheba, 29, 31, 40, 42–43, 46, 49–51; ma-
terial, 8, 14–15, 37; metaphysics of, 55n45,
104–105; of singularities, 34; and sound, 156
presencing, 21n39, 50–51, 53, 83n50, 133–137;
into appearance, 188, 190; jug as thing,
133–134; and sound, 154, 168, 172
production, 92, 163–164, 205n24; into appear-
ance, 132–133
progress, narrative of, 95–96
proprioception, 140

proximity. *See* nearness/proximity

public space, 17–18, 136; agora, 29; appearance as between people, 144; and differentiation, 140–141; first experience with, 139–142; interdependence in, 127; polis, 125–126; reality grounded by materiality in, 99; and responsibility, 92–94, 113–115; and science, 92–93; shared, 91–92, 99–100, 106, 114–115

public sphere, 97, 99–100, 116n16, 139–141

racialization, 28, 30, 105, 109–111, 149n97, 192; of difference, 73, 201–202; of gaze, 142–143; of other, 33–34

racism, 79, 84n61; analytical system of, 201–202; and corporeal logos, 41, 100, 107–111; cultural, 143; disruption of, 105, 111, 119n105; European logic of murder, 183–184, 193–194, 197–198; as habit, 108–110; and idealities, 100–102, 105–107, 109; as ideological system, 100–107; industrial prison complex, 183; and kinship, 104–105; logic of, 46, 183–184, 193–194, 198; and movement, 109–110, 161; profit as essence of, 104–105; scientific, 201–202, 208–209n152; and situatedness, 109–111, 201, 207n98; of totalitarianism, 95, 96, 102. *See also* colonialism

Rannard, Georgina, 149n97

rationality, 18, 33, 36, 48

real, the, 9, 11, 17–18, 54, 203–204; accounts of, 5, 29, 34–35, 79, 164; artist's interrogation of, 34–36, 41–45, 114–115, 133, 144, 186–187; and racism, 107, 111–112

reality, 29; and auditory perception, 154; and changing viewpoints, 18; engagement with through language, 186–187; light and shadow, 44–45; materiality of, 5, 18, 99; painting the real, 71–80; plurality of, 99–100; poetry's response to, 186; as relational, 71, 99–100; science transforms relation to, 93; shared, and common sense, 11, 91–100, 115; and subject-object relation, 93

reason, 28, 48, 94; and binary relations, 199–200; experience emancipated from, 96–97; failure of to dismantle racism, 111

recognition, 71

reduction, phenomenological, 49–50

referentiality, 91, 106, 185, 189, 201

reflection, 13, 16; on *Bathsheba*, 28–29, 37–38; cognitive, 6–7, 29; as corporeal, 39; on experience of perception, 6, 13, 16, 38;

hyper-reflection, 6, 49; limits of, 67; prereflective world, 35, 48, 79, 110, 113; and self-affection, 75; time required for, 61–64, 167, 170

regions of existence, 48–51, 69

relationality: attunement to, 127, 154–155; and auditory perception, 168–169; binary, 199–200; of description, 50; holding, 64, 101, 110, 124, 127–132, 135, 138; to language, 184; primordial, 140–141; of reality, 71, 99–100; and sculpture, 90–91

relational world, 5, 15, 35, 56n52, 194

relativity/relativism, 11–12, 93

Rembrandt, Saskia, 46

Rembrandt Harmensz van Rijn, 17, 27–48, 52–54; relationship with Hendrickje Stoffels, 46–47; resistance to Enlightenment rationality, 33–34; respect for subjects, 48; *Two Negroes*, 33, 55n39. *See also Bathsheba at Her Bath* (Rembrandt)

Renaissance perspectivalism, 17, 36–37, 40, 56n56, 155

repetition compulsion, 104

representation: classic economy of, 74; language exceeds, 94, 184, 190, 194, 198, 206n64; privileged over relation, 135; *Vorstellen*, 54, 59–60n162, 163, 184, 190

responsibility, 45, 91–94, 98–99, 110; and cultivating perception, 98; for perception, 13, 15, 80; and public space, 92–94, 113–115; and totalitarianism, 92, 94, 98

responsivity, 12, 36, 91, 98, 114–115, 168–170

Return (Truitt), 89

reversibility, 11, 43, 48, 74–77, 139, 157

Roelofs, Monique, 34

Saini, Angela, 208–209n152

Salisbury Cathedral Choir, 152, 153

Sands, Philippe, 118n60

savage, concept of, 53, 200

The Savage Mind (Lévi-Strauss), 53

Schafer, R. Murray, 159, 175n52

science, 8, 56n52, 186; aesthetics as, 33; based on structure of human mind, 92–93; experimental approach, 36, 67; open-system thermodynamics, 22n47; operational thinking, 34–36, 73; scientific racism, 201–202, 208–209n152; shift from idea to demonstration, 92; as structure of the mind, 91

sculpture: as body, 89–90, 135–136; and distance, 123–124, 136–138, 142; materiality of, 89–90; minimalist, 88–121; in modern age,

135–136; in outdoor space, 124; relational interplay among, 90–91; space and place instituted in, 17–18; and touch, 123–124, 128–130, 138–139. *See also* Bourgeois, Louise; *The Welcoming Hands* (Bourgeois); Truitt, Anne

sedimentation, 4–5, 8, 36, 42, 50, 68–69; as active concept, 110; and ideology, 101, 106–110; and music, 147n53, 156, 167; and touch, 130–131

Sedira, Zineb, 2, 3–8, 13, *19*

self: ideal, 28; intertwining of with world, 42, 77–78, 170; modern, 28; in modern age, 33; multiplicitous, 13, 150nn121, 122, 195–196, 203; others of, 28, 33–34. *See also* subject

self-affection, 74–75

self-presentation, vs. self-display, 127

semiosis, 45–46, 185

senses, 35; feedback loop, 78, 85n96, 201; interrelationship of, 67–68; as openings on existence, 9–10; passive, 73–74, 129; vision and touch combined, 129–130. *See also* auditory perception; touch; vision

sensibility, 12–13, 33, 47; reversing of, 74–77

sensibles, 10, 30, 68; overlap with sensing, 38, 129; world as, 5–10, 38, 56n52

sensitivity, 7, 68–69, 129

September 11, 2001 terrorist attacks (9/11), 158–159

sexuate difference, 72–73, 83–84n61, 165

shared world, 115, 140–142, 171; common sense and reality, 11, 91–100, 115; and corporeal logic, 129; and gaze, 76; and public space, 91–92, 99–100, 106; and self-display, 127; and universalism, 76. *See also* chiasm (intertwining); world

silence, 4, 5, 191, 207n84; in *Bathsheba*, 27, 31, 35, 39, 51

Silent Sight (Sedira), 2, 3–8, 13, *19*

simultaneity, 38, 41, 43, 62, 171, 177n94, 195, 202; and listening, 156–158, 166, 168, 188; multiplicity of, 115; and saying, 188, 192; and touch, 129–131; of viewpoints, 11–13

singing the world, 167, 187–188, 206n51

singularities, 31, 34, 65, 80, 102, 108

singular subject: male, narcissism of, 71–72; philosopher/painter as, 73–76

situatedness, 6–18, 137, 140; in *Bathsheba*, 28; of Bourgeois's work, 132, 142, 144; of eye, 36–37; of ideologies, 101–102, 108–115; Merleau-Ponty's view, 34–39, 41, 155–156, 160; of Mitchell's work, 62, 66–67; of

perception, 6, 34–35, 100; primordial, 156; and racism, 109–111, 201, 207n98; and totalitarianism, 92, 94, 96–102; of Truitt's work, 91, 99–100, 107, 111–114; vertical being, 90, 114; of vision, 36–37

slavery: forgetting of, 73, 83–84n61, 140; Middle Passage, 34, 208n147; plantation, logic of, 200–201; social death, 103, 119n87, 200–201; world destruction as legacy of, 97–98, 102–103

slave ships, 96, 102, 103–104, 208n147; *Gregson v. Gilbert*, 16, 23n61, 182–183, 193, 198, 204n5

slave trade, and artworks, 27–28, 33

Sluijter, Eric Jan, 43

Snell, Bruno, 54n5

social constructionism, 201–202

social death, 103, 119n87, 200–201

sonic space, 155–161

sound artworks. *See* auditory perception; Forty-Part Motet (Cardiff)

South Africa, 95

sovereignty, 199–200

space: and colonization, 199–200; colonization of, 200; and light, 51–53; as measurable, 163–164; sonic, 155–161; spatialization of history, 209n164; "three-dimensional," 155; time-space of flesh, 12, 156

space-time, 22n47; of flesh, 12, 156; free, 75, 77, 96; polyphonic, 18–19, 154–157, 164–165; and silence, 191; sonic epoch, 161–167, 170–173

spatiality, 12, 182; and aural depth, 158, 162; spatial levels, 127–128, 131, 156–157, 160–161; of temporality, 18, 104

spectacle, 6, 64, 77, 161, 173n7

Spem in Alium (Tallis), 152, 153–159, 172, 173n6, 174n25; structure of, 157–158; and *Zong!*, 182–183, 205n12

Spillers, Hortense, 103–105

Spivak, Gayatri Chakravorty, 177n104

Stimme (voice), 163

Stoffels, Hendrickje, 46–47

subject: captive vs. liberated, 103; *Dasein* as, 185; decentered, 12–13, 80; embodied, 6, 11–13, 107–109, 112–113, 171–172, 190; and field, 101; maternal-feminine, 142–143; self-affection, 74–75; singular, 12–13, 71–76, 79–80, 84n63, 137, 143, 185, 196; universal, 13, 71, 92. *See also* being; self

subjectivism, 66, 165

subject-object relation, 93, 185

Sufi dhikr (chanting), 159

Sunflower III (Mitchell), 70–71, 83n50
surrounding world (*umwelt*), 140, 149n105
symbolic order, 103–104, 119n91
synesthesia, 39, 81n8, 129–130, 134, 154
systematicity, 50, 91, 114, 144, 171, 190, 192

Tallis, Thomas: *Spem in Alium*, 152, 153–159,
 172, 173n7, 174n25, 182–183, 205n12
techne, 51, 134
technology, 5, 21n39, 134–136; enframing
 (*Gestell*), 11; of *Forty-Part Motet*, 154–155,
 158–162, 164–165, 172; pretechnological
 sound, 160–161
temporality, 4, 7, 12–13, 59n140, 147n35, 199;
 and dwelling, 138; four-dimensional, 164;
 of listening and the visible, 168; as repre-
 sentation of three-dimensional space, 163;
 sonic epoch, 161–167, 170–173; spatiality of,
 18, 104; of subjectivity, 101; time-space of
 flesh, 12, 156
terror, total, 96–98
thing, as verb, 134
things in themselves, 52–53; essences in place
 of, 70; humans conditioned by, 132; jug as
 thing, 133–134; and vision, 74
Thirteenth Amendment, 183
thought: freedom of, 96–97, 102; language,
 relation to, 186, 187, 192; perception,
 reliance of, 6–7; poetry as, 186–187;
 scientific view of, 92. *See also* cognition;
 embodied perception
time-space. *See* space-time
totalitarianism, 94–99; contradiction not
 tolerated, 96–97; isolation and loneliness
 combined, 97, 117n56; and logic, 96–98;
 total visibility, 17, 40–41, 105
total logic, of artwork, 64
touch, 38–39, 67–69, 72–79, 101, 148–149n83;
 deprivation of, 149n95; "knowing," 130;
 passive, 129, 131; perception shaped by,
 130–131; and sculpture, 123–124, 128–130,
 138–139; and spatial level, 128, 131. *See also*
 senses
transcendence, 17, 113, 173n7
transcendental structures, 9, 38
trauma, 107, 138, 140–141
Truitt, Anne, 18, 88–91, 93, 99–100, 106–107,
 115–116n8, 120n111; narrative quality of
 works, 99; new dimension of sculptures,
 111–115; referential works, 91, 106; *Works:
 First Requiem*, 88, 89, 99; *Morning Choice*,
 89; *Pith*, 89; *Return*, 89

truth, 11–12, 49–50, 79, 94, 98
Turrell, James, 21n32

uncanny, 18, 123, 135, 144, 164. *See also*
 unheimlich
"unfit," elimination of, 96
unheimlich (unhomely), 136, 148n74
universal, the, 39, 71, 76–77, 90–96, 157; and
 building of identity, 140–141
Un jardin pour Audrey (Mitchell), 60, 63–69
unthinkable, the, 94–95, 181–182
usefulness, 3, 11, 42, 50, 78, 91–92, 149n105,
 193; and attunement, 170–171

Van Gogh, Vincent, 83n50
vanishing point, 17, 36, 40, 155
Vasseleu, Cathryn, 72
vertical being, 90, 114, 137, 139
visibility, 75–77; anonymous, 76; cultivating
 perception, 41–43; hypervisibility, 13, 144;
 multiplicity of, 34–35; total, 17, 40–41, 105.
 See also invisibility
The Visible and the Invisible (Merleau-Ponty),
 76
vision: as appropriative, 71, 75; and cultivating
 perception, 79; knowledge tied to, 29;
 mimicry of categories, 75; opponent
 process theory of, 74; passivity of, 73–74;
 privileging of, 73, 138; and reversibility,
 74–77; situatedness of, 36–37; trichromatic,
 65. *See also* color; gaze
Voegelin, Salomé, 159
voice, 157, 168. *See also* *Forty-Part Motet*
 (Cardiff)
Vorstellen (representation), 54, 59–60n162,
 163, 184, 190

Weheliye, Alexander, 102–103, 119n87
The Welcoming Hands (Bourgeois), 122,
 123–144, 145; at Battery Park location,
 123, 145n2; holding in, 124, 127–135; and
 passersby, 18, 123–124, 126, 129–132, 138–139,
 141, 150n109
Western thinking, 17, 72–73, 80, 118n83, 125,
 143–144; European logic of murder, 183–184,
 193–194, 197–198. *See also* racialization;
 racism
Wetering, Ernst van de, 44–45
Wet Orange (Mitchell), 61–62
whiteness, 34, 57n83
Wiskus, Jessica, 158, 162–163
"Women on the Market" (Irigaray), 83–84n61

world: "common," 140; encountered through perception, 3–6; experiential, 8, 14–15, 91, 94–95, 99, 112, 158; flesh of, 38–39, 41, 104–105; gearing into, 6, 9–10, 37, 42, 47, 66–67, 100, 108–111, 115; intertwining of with self, 42, 77–78, 170; logic of, 66–67; material, 7–9, 16, 18, 35, 38, 69; objectification of, 35–36; as sensible, 5–10, 38, 56n52; structured according to calculation, 28–29, 42. *See also* shared world

World War I, 138

Wynter, Sylvia, 105, 202

Yancy, George, 110–111

Ziarek, Ewa Plonowska, 83–84n61

Zong! (Philip), 16, 23n61, *180*, 181–184, 191–203; Africans as living subjects in, 196–198, 203; anti-meaning of, 183; as creative text, 201; destruction of colonialism by language of, 19, 184, 192–193, 195, 198–199; "Ebora," 199; "Ferrum," 198–199; *Gregson v. Gilbert* as text in, 182–183, 193, 198; methodological process, 191; "mother" words, 195; relational principle in, 182; spacing of words and lines, 181–182, 193–199, 207n98, 208n123; speaking of out loud, 181, 193–199. *See also* Africans, enslaved

Zong (slave ship), 16, 181–182, 204n2

HELEN A. FIELDING is Professor of Philosophy and Gender, Sexuality, and Women's Studies at the University of Western Ontario. She is editor (with Christina Schües and Dorothea E. Olkowski) of *Time in Feminist Phenomenology* and (with Dorothea E. Olkowski) *Feminist Phenomenology Futures*.

CPSIA information can be obtained
at www.ICGtesting.com
Printed in the USA
JSHW020729161021
19611JS00001B/84